AN ILLUSTRATED IDENTIFIER AND ENCYCLOPEDIA

WILD FLOWERS
AND FLORA

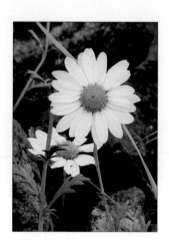

AN ILLUSTRATED IDENTIFIER AND ENCYCLOPEDIA

WILD FLOWERS
AND FLORA

An authoritative guide to more than 750 wild flowers of the world
Beautifully illustrated with more than 1700 specially commissioned
botanical illustrations, clear photographs and maps

Mick Lavelle

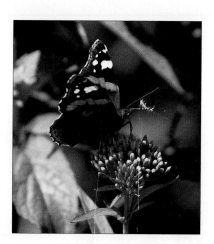

LORENZ BOOKS

This edition is published by Lorenz Books,
an imprint of Anness Publishing Ltd,
108 Great Russell Street, London WC1B 3NA;
info@anness.com

www.lorenzbooks.com; www.annesspublishing.com

If you like the images in this book and would like to investigate using
them for publishing, promotions or advertising, please visit our website
www.practicalpictures.com for more information.

A CIP catalogue record for this book is available from the British Library.

Publisher: Joanna Lorenz
Editorial Director: Helen Sudell
Editor: Simona Hill
Photographers: Peter Anderson and Jerry Sires
Illustrators: Mike Atkinson, Peter Barrett, Penny Brown and Stuart Jackson-Carter
Designer: Nigel Partridge
Production Controller: Pirong Wang

PUBLISHER'S NOTE
Although the information in this book is believed to be accurate and true at the
time of going to press, neither the authors nor the publisher can accept any legal
responsibility or liability for any errors or omissions that may have been made.

Page 1: Ox-eye daisy, *Leucanthemum vulgare*.
Page 2: A wildflower meadow.
Page 3: Red admiral butterfly on red valerian, *Centranthus ruber*.
Below, from left to right: Yellow asphodel, *Asphodeline lutea*; Foxglove,
Digitalis purpurea; Cardinal flower, *Lobelia cardinalis*.
Opposite, from top to bottom: Columbine, *Aquilegia vulgaris*; Snowdrops,
Galanthus nivalis; Fennel, *Foeniculum vulgare*; Thrift, *Armeria maritima*;
Fountain grass, *Pennisetum setaceum*.

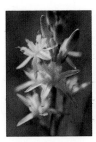
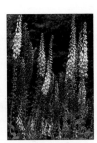

CONTENTS

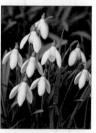

WHAT IS A WILD FLOWER?

The question of what a wild flower is seems steeped in controversy. Purists argue that they must be native to that area, and conservationists often demonize introduced species, despite their having become naturalized and essentially "growing wild".

Flowers are generally considered to be "wild" if they grow without someone having planned where they should be planted. We think of wild flowers as growing in their natural state, with no interference from us, but if we consider the wild species that spring up in gardens, backyards, streets and fields the picture becomes more complex. These plants are indeed wild but thrive in habitats created by humans. In fact, despite every attempt to interfere with their growth, they may well continue to plague farmers, gardeners and city maintenance teams.

Wild flowers are plant species that are at home in a particular place, whether their habitat is natural or the result of human intervention. In any location, from high mountain pastures to great forests, some plants will prosper and others do less well. Each pretty wild flower is the result of countless generations of plants that have striven to exist against staggering odds to ensure that their evolutionary "line" will survive into the future. Some flowers have become highly adapted in order to grow

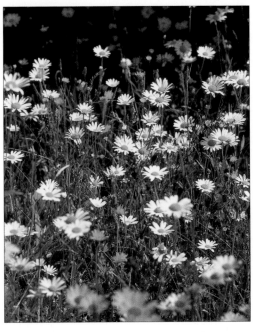

Above: Traditional meadows are home to many showy species of wild flower.

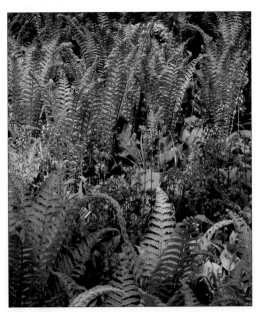

in these places. They may be dependent not only upon their surroundings but upon other plants, for example by providing shelter from weather, or a stem to scramble through; and even dependent upon animals for their survival, for example, to help spread seed or promote root growth by grazing. Many strange and wonderful plant species have been shaped by their homes, their weather and other inhabitants of their habitat into the perfect form for survival.

It is the showiest flowers that we tend to spend most time looking at – how easily we walk past myriad delicate wild flowers to gaze at one large bloom. Every time we walk across a grassy patch we may carelessly crush hundreds of flowering plants

Left: Plants of deciduous woodland, like these bluebells, grow, flower and set seed before the leaf canopy excludes the light in summer.

Above: Shady banks and overgrown roadsides often harbour a rich variety of species that have disappeared from the surrounding area.

underfoot. They are everywhere and many deserve a closer look. A detailed inspection of even the commonest wayside flower reveals an intricacy and beauty that the work of human hands can rarely approach. Wild flowers are among nature's loveliest gifts: carefree and simple, abundant and serendipitous, they provide an ever-changing panorama of colours, shapes, sizes and textures. It is precisely the informal spontaneity of wild flowers – the random mingling of colours and species, and the way that they change through the seasons – that delights us.

The natural floral jewellery that adorns so much of the Earth's surface has enraptured scientists, artists and writers throughout our history, yet it is easy to forget the true depth of this bounty. Its richness is what this book is all about. All flowering plants – even the tiniest ones – deserve our attention, and to understand them fully we must look both closely and carefully. Describing the wonders of just one flower could fill a whole book; to attempt to include here all the flowering plants in the world

would be impossible. This book aims to present a selection: it could be described as a "look through the keyhole" at a world more beautiful than can easily be comprehended. Many plants have had to be omitted and perhaps some of your own favourites are missing. Hopefully, however, you will be inspired to go out and take a fresh look at wild flowers and marvel over these truly remarkable phenomena growing all around us.

Below: Even close-mown or grazed turf may harbour an abundance of small yet colourful wild flower species.

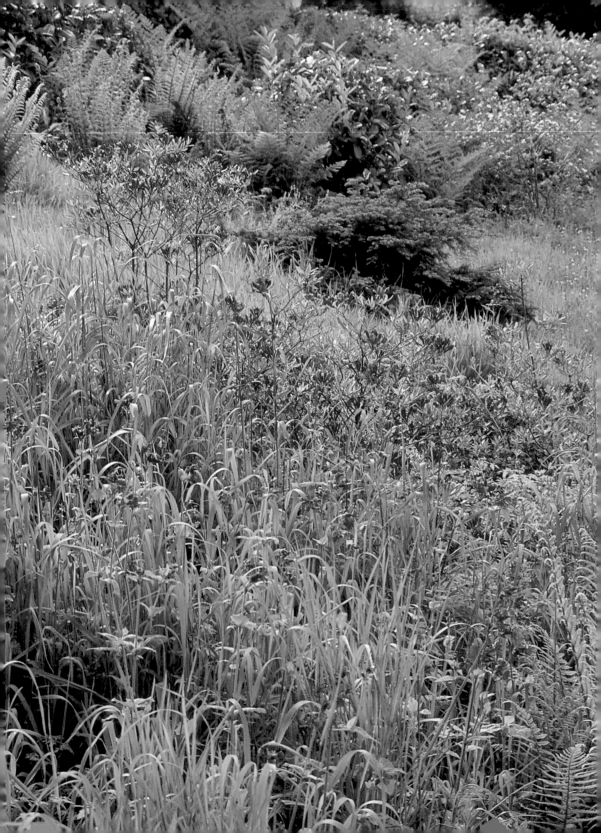

HOW FLOWERS LIVE

Flowering plants are the most diverse and widely studied group in the plant kingdom. They are found all across the Earth's surface, wherever plants have learned to live. From mountaintops and the high Arctic to lush tropical forests, flowers are a familiar feature of every landscape. This wide range of habitats has led to flowers assuming a huge diversity of form. In some cases, the flowers have become so reduced as to be insignificant when compared to the plant as a whole. In others, however, the plant itself may hardly be noticed until it produces a huge flower that seems to arrive from nowhere.

Flowers have even driven the process of evolution, harnessing an army of helpers that include almost every conceivable form of land or air living creatures to help with every phase of their reproductive cycle. Many of the showiest flower types trade rich, nutritious, sugary nectar in return for the services of the "diner" in cross fertilization. Flowers are the courtship vessels of plants and are often highly adapted to receive the attention of just a few creatures, some of which are adapted solely to exploit the food source. Others use a variety of tricks and even entrapments to fulfil this need and yet others have abandoned the need for animals, preferring the wind to do the job for them.

Even once the seed is fertilized, the relationship of many species with animals does not end. There are a whole range of ingenious methods by which they recruit animals into spreading their seed for them, and by doing this they not only guarantee the survival of future generations but may also spread the offspring far and wide from the parent plants.

Left: The vivid colours of wild flowers are designed to attract pollinators but have also long attracted the attention of humans.

HOW PLANTS ARE CLASSIFIED

In an attempt to understand the world, humans have become fascinated with the classification of every aspect of it. While such classifications are useful to us, they do not naturally occur in nature and are at best approximations of the true nature of diversity.

Classification helps us to recognize millions of individual species of plants. In pre-literate times plant recognition was a practical necessity, since eating the wrong plants could be fatal.

The earliest written record of a system of plant classification can be attributed to Theophrastus (*c.*372–287BC), a student of Plato and Aristotle, to whom even Alexander the Great sent plant material that he encountered on his expeditions. In his *Enquiry into Plants* and *On the Causes of Plants*, Theophrastus included the classification of species into trees, shrubs, subshrubs and herbs, listing about 500 different plants; he also made a distinction between flowering and non-flowering plants.

The binomial system

The shift toward modern systems of classification began at the time of the Renaissance in Europe (1300–1600). Improvements in navigation, which opened up the world and enabled plants to be collected from much further afield, coincided with the invention of the printing press, which meant information about the new

discoveries could be published widely. Interest in plants increased enormously, and by the 17th century the number of known species was becoming too high to manage without a classification system. The British naturalist John Ray is credited with revising the concept of naming and describing organisms. However, most were classified using a whole string of words that resembled a sentence rather than a name. During the 18th century, the Swedish botanist Carl von Linné (1707–78), who published his work under the Latinized form of his name, Carolus Linnaeus, created a referable system of nomenclature that became the foundation of the system used today. He is often cited as the "father" of modern taxonomy, or hierarchical classification.

Linnaeus chose to use Latin, then the international language of learned scholars, which enabled scientists speaking and writing different native languages to communicate clearly. His system is now known as binomial

Above: The rose has been highly bred, and many of the types now in cultivation bear little resemblance to wild types. The genus name Rosa, *is the original Latin name for the plant.*

nomenclature (from *bi* meaning "two", *nomen* meaning "name" and *calatus* meaning "called"). Each species is given a generic name – something like a surname – and a specific name, the equivalent of a personal or first name. We still use this system, which has been standardized over the years, for naming and classifying organisms.

The generic (genus) name comes first, and always starts with a capital letter. It is followed by the specific (species) name, which is always in lower case. This combination of genus and species gives a name that is unique to a particular organism. For example, although there are many types of rose in the genus *Rosa*, there is only one called *R. rubiginosa* – commonly known as the sweet briar. (These names are italicized in print.)

The names of plants sometimes change. Name changes usually indicate reclassification of plant species, often as a result of advances in molecular biology. For example, the

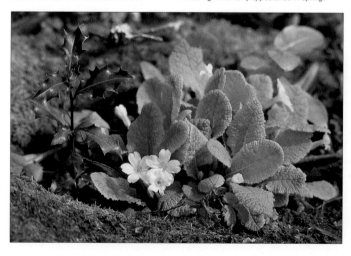

Below: Primula vulgaris, the primrose gets its genus (first) name from the Latin primus referring to its early appearance in spring.

Chrysanthemum genus has recently been split into eight different genera, including *Dendranthema*, *Tanacetum* and *Leucanthemum*. It may take the botanical literature years to reflect such changes, and in the meantime inconsistencies in the printed names of plants can appear.

Plant families

Another useful way of classifying plants is by family. Many families are distinctive in terms of their growth characteristics and preferences, while others are very large and diverse, including numerous different genera. There are 380 families of flowering plants, containing all the species known to science that have already been classified. The largest family is the Asteraceae (aster family), which contains 1,317 genera and 21,000 species. In contrast, some plant families are very small: an example is the Cephalotaceae, or saxifragales family, of which a single species, *Cephalotus follicularis*, is found growing along a small stretch of coast in western Australia.

As our understanding increases, and more species are discovered and classified, there is sure to be intense debate over the placement of new and existing species within families.

Below: Geranium *(shown here) is often confused with the closely related genus* Pelargonium *due to Linnaeus (mistakenly) classifying both as* Geranium *in 1753.*

Above: Ferns and mosses represent an ancient lineage of plants that do not produce flowers or seed and as such, are classified as lower plants.

*Below: Salad burnet (*Sanguisorba minor*) is a small herbaceous plant in Rosaceae, yet at first glance it does not appear even remotely similar to the woody genus* Rosa.

THE ORIGIN OF SPECIES

The earliest flowering plants appeared on Earth around 350 million years ago in the ancient carboniferous forests, although they really began their "takeover" of the planet 120 million years ago, when the dinosaurs ruled the world.

The first flowers were probably quite insignificant by current standards, but their appearance, coupled with their ability to produce a protective fruit around the seed, marked the beginning of a new era. Despite their rather low key entrance in the early Cretaceous period, by the time the dinosaurs met their end some 55 million years later, most of the major flowering plant groups had already appeared.

Two distinct ways of life emerged for flowering plants. Some continued to reproduce as they had always done – letting the wind control whether pollen from one flower met another flower of the same type. Others, however worked in harmony with insects and other animals, which they enticed with sweet nectar and large, colourful flowers. The relationship was very successful and led to the almost infinite variety of forms and colours that we see around us in plants today.

Below: 500 million years ago non-vascular plants such as hornworts, liverworts, lichens, and mosses grew on Earth.

The first living things

The Earth is around 4.5 billion years old, and life is estimated to have begun around 3.75 billion years ago: for around 750 million years the Earth was (as far as we know) lifeless. It was a hostile environment, with a surface hot enough to boil water and an atmosphere that would have been poisonous to us, yet life is likely to have begun as soon as the surface was cool enough for water to lie on its surface. It was not life as we know it – more a thick soup of chemicals than the miracle of creation – but it was life. This was the situation for 500 million years, until a strange twist of fate assured the rise of the plants.

Primitive single-celled bacteria, which we now know as cyanobacteria, evolved from the existing life forms. They probably appeared remarkably similar to their counterparts, but with one spectacular difference. These cells

Below: 425 million years ago seedless vascular plants such as club mosses, early ferns and horsetails became evident.

were able to take carbon dioxide (which was then very abundant in the Earth's atmosphere) and water and convert them into sugar (an energy-rich food) and oxygen. The effect would have been barely noticeable at first, but over a period of a few hundred million years it changed the atmosphere from one rich in carbon dioxide to one that was at one point almost one-third oxygen. Over this time many of the formerly dominant species died out, but the plant-like bacteria gained the ascendance.

Despite this, plants remained water-bound for another 2.5 billion years. It was not until 425–500 million years ago (a date that is still hotly contested) that they made their first tentative appearance on land. The earliest forms were very simple in comparison to modern plants, but their descendants still exist and probably look similar in many respects – mosses and liverworts

Below: 200 million years ago seeded vascular plants such as the gymnosperms, seed ferns, conifers, cycads and ginkgoes thrived.

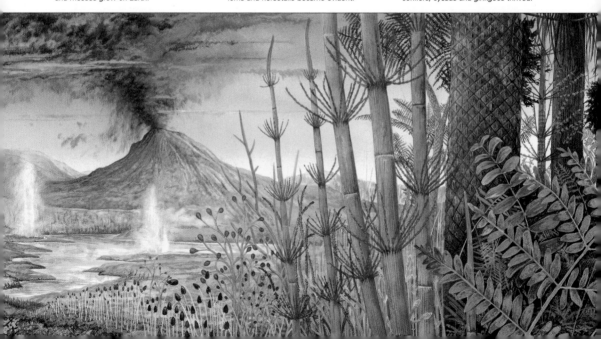

are the best examples. The first advance that we know of was marked by the appearance of a plant called *Cooksonia*, 430 million years ago. Within 70 million years, species had diversified and evolved to form lush tropical forests; despite being relatively new to the land, plants had made up for lost time in spectacular style.

The fossil record

Evidence of early plants has been found in the fossil record. As mud and other sediments were deposited, forming rocks, pieces of living organisms were deposited with them. Surviving as fossils, these give us an extraordinary picture of what the Earth was like at any one time. In addition, the chemistry of the atmosphere and hydrosphere (the oceans, rivers, lakes and clouds) of the time can be determined by analysis of the rock. These signs allow us to piece together the story and understand how plants have changed over time.

Darwin's theory of evolution

In 1859, the British naturalist Charles Darwin published *On the Origin of Species*. The work caused a stir at the

Below: 120 million years ago recognizable species of seeded vascular plants, such as magnolias and water lilies evolved.

time as it opposed conventional Church doctrine. Darwin argued that the Earth had been created not tens of thousands of years ago (as the Church claimed) but billions of years ago. The idea was seen as revolutionary or even heretical, but in fact it reflected a growing school of thought that recognized that animal and plant species could change over time. Darwin's grandfather had written on the topic, and Darwin himself acknowledged 20 predecessors who had added to the subject. His original contribution, however, was to sift through this increasing body of evidence and combine it with his own observations during his travels around the world from 1831 to 1836.

Darwin determined that single species, through environmental influence, were able to change over time to suit their surroundings. These changes happened not within the lifetime of an individual organism but through the inheritance of characteristics that were valuable in aiding survival and competing with other organisms for the essentials of life. Though he did not then understand the mechanism by which this happened, Darwin concluded that all modern species have evolved through the process of natural

Above: Though it is a modern species, this Magnolia *flower is very similar to the earliest flower forms of 120 million years ago.*

selection, or "survival of the fittest". The theory revolutionized the study of biology and his work remains a cornerstone of evolutionary science.

Since Darwin's time, the body of evidence has grown. There is still much that we do not know, but many evolutionary scientists believe that there are more species on the planet today than at any time in its entire history. We now mostly understand how changes are passed on to offspring and have been able to piece together an evolutionary hierarchy, where we can see when plants first appeared and how they have changed over time.

Below: Today there are more species of flowering plants in the world than there ever have been at any other time.

THE PARTS OF A PLANT

While plants have undergone many individual changes over millions of years, most of them still have features in common. Flowering plants generally possess roots, stems, leaves and, of course, flowers, all of which may be useful in identifying them.

Learning to recognize species is essentially a question of simple observation combined with knowledge of plant structure. This is because all modern flowering plants have evolved from a common ancestry – just as most mammals, birds and reptiles possess one head, four limbs, up to five toes per leg and sometimes a tail, because they are all variants of a prior design. Even when plants have become highly specialized, the common features still persist, albeit in a modified form, and this often betrays a relationship between species that appear unrelated.

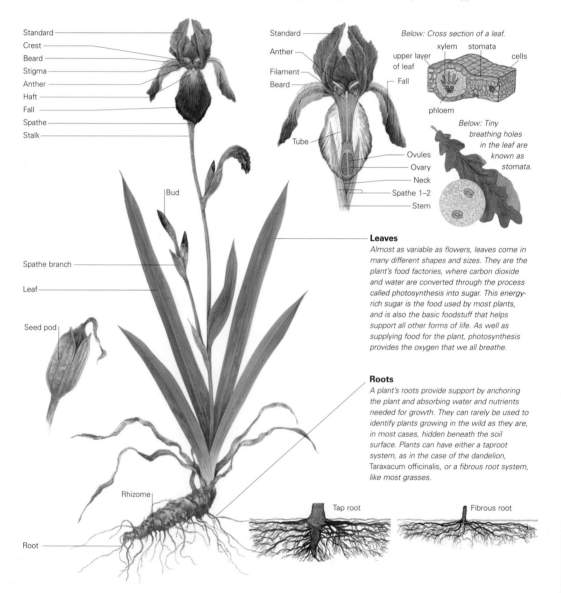

Standard
Crest
Beard
Stigma
Anther
Haft
Fall
Spathe
Stalk

Bud

Spathe branch

Leaf

Seed pod

Rhizome

Root

Standard
Anther
Filament
Beard

Tube

Fall

Ovules
Ovary
Neck
Spathe 1–2
Stem

Below: Cross section of a leaf.

upper layer
of leaf

xylem stomata

cells

phloem

Below: Tiny breathing holes in the leaf are known as stomata.

Leaves

Almost as variable as flowers, leaves come in many different shapes and sizes. They are the plant's food factories, where carbon dioxide and water are converted through the process called photosynthesis into sugar. This energy-rich sugar is the food used by most plants, and is also the basic foodstuff that helps support all other forms of life. As well as supplying food for the plant, photosynthesis provides the oxygen that we all breathe.

Roots

A plant's roots provide support by anchoring the plant and absorbing water and nutrients needed for growth. They can rarely be used to identify plants growing in the wild as they are, in most cases, hidden beneath the soil surface. Plants can have either a taproot system, as in the case of the dandelion, Taraxacum officinalis, or a fibrous root system, like most grasses.

Tap root

Fibrous root

Perianth

Corolla

Stamen — Anther
— Filament

Sepal

Stigma

Style

Ovules

Ovary

Neck

Petal

Pedicel
(flower stalk)

Leaf

Vein

Lamina
(leaf blade)

Midrib

Flowers

There are many flower types, differing in size, shape and colour, and flowers are possibly the most important part of a plant for identification. However, most flowers have the same basic parts. The arrangement of the female part (the pistil) and the male part (the stamen) is important in determining which family and genus the plant belongs to. Petals are also important in identification. Many plants have brightly coloured petals to attract pollinators, such as bees and butterflies. Behind the petals are smaller, green, leaf-like parts called sepals. These protect the flower when it is in the bud. In some species the petals are very small and insignificant, and the flowers are accentuated by showy, coloured modified leaves called bracts.

Seedpod

Bud

Toothed leaflet

Pinnate leaf

Thorn

Petiole (leaf stalk)

Stems

Plant stems carry the water and nutrients taken up by the roots to the leaves; the food produced by the leaves then moves along the stems to other parts of the plant. Stems also provide support, allowing the leaves to reach the sunlight they need to produce food. Stems may be very distinctively shaped and are frequently helpful in identifying plants.

Stem

Hip

Remains of style

Remains of stamen

Remains of sepal

Seeds

Flesh

Root system

LEAF FORMS AND SHAPES

*While leaves vary considerably in appearance, all are basically similar in terms of their internal anatomy.
Leaves are the factories within which plants produce their own food, although in some plants, they have
become highly adapted and may fulfil a variety of other roles.*

Leaves are able to breathe: air passes freely in and out through specialized pores known as stomata, which are usually found on the lower leaf surface, or epidermis. The stomata can be opened and closed by the plant to regulate water evaporation. This is crucial as it allows the plant to cool down, preventing damage through overheating, though the leaves of some plants (those in dry climates) have few stomata in order to conserve water. Leaves also contain vascular tissue, which is responsible for transporting water to the leaves and food from the leaf to other parts of the plant. The veins are easily visible on both the surface and the underside of most leaves. The same types of tissue are present in the plant's stems and collectively they form a continuous link from root tip to leaf tip.

Leaf fall
When leaves have finished their useful life the plant sheds them. Deciduous trees and shrubs shed all their leaves annually and enter a dormant phase, usually in the autumn in temperate areas or immediately preceding a dry season in warmer climates, to avoid seasonal stresses such as cold or excessive heat damage. Herbaceous

Leaf arrangements
*How leaves are attached or arranged on a stem
can be a useful tool in plant identification.*

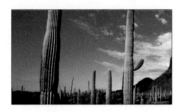

*Above: Cacti live in very harsh dry conditions
and have leaves that are reduced to small
spiny pads.*

plants (also known as herbs) and other non-woody plants normally lose all of their top growth, including the leaves, for similar reasons. Many plants of the arctic, temperate and dry regions fall into this category.

Plants that do not shed all their leaves at once are said to be evergreen. These plants ride out harsh conditions but may also enter a dormant phase where no new growth commences until conditions improve. Evergreen plants also shed leaves, but tend to do so all through the year, particularly during active growth periods. Many tropical plants fit into this category.

Leaf modifications
Leaves are arguably the most highly modified of all plant organs, and show a vast diversity of form and function. Flower petals are thought to have arisen from leaves. The adaptations in leaves often reflect ways in which

plants have changed in order to cope with specific environmental factors in their natural habitats.

Cactus spines are an example of an extreme leaf modification. The spines are part of a modified leaf called an areole. They are in fact modified leaf hairs, and the small furry base of the spine, or spine cluster, is all that remains of the leaf itself. Cacti and some other succulents have altered so that the stem is the main site of food production, and the leaves have adopted a defensive role.

Other leaf modifications include the development of tendrils to help plants climb, coloured bracts around flowers to attract potential pollinators, and – the most celebrated – traps that attract and ensnare insects to supplement the plant's mineral requirements.

Leaf shape
Leaves grow in a tremendous variety of sizes and shapes, which can be useful in helping to identify the plant.
• Leaf margins, or edges, occur in a variety of forms. The simplest is a smooth, continuous line, which is described as "entire". Often, however, the edge is broken up in a definite pattern, such as "serrated" or "lobed".
• The apex, or leaf tip, may vary in shape, even between closely related species. This may reflect environmental factors. The base of the leaf is also variable and is considered along with the way the leaf is attached to the stem.
• Veination may form an identifiable trait. Monocotyledonous plants have parallel veins that run the length of the leaf. Dicotyledonous plants have a netted arrangement that is complex.
• Leaves can be categorized as simple or compound. A simple leaf is one single leaf blade on a stalk. Compound leaves are made up of a group of leaflets, with a single stalk, attaching the group to the stem.

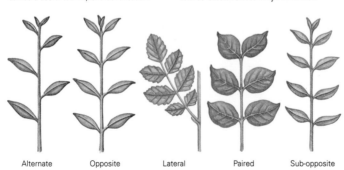

Alternate	Opposite	Lateral	Paired	Sub-opposite

Leaf shapes

Leaves are almost as varied as flowers in respect of their shapes, although they offer less of a clue as to the relationships *between even quite closely related species. Similar shapes, sizes and colours of leaf may occur on quite unrelated species and it is* *thought that this is mainly due to the original environmental circumstances that a plant evolved within.*

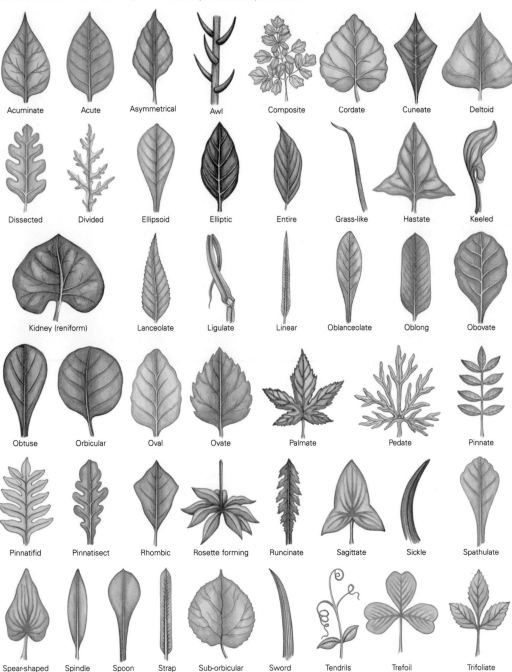

Acuminate

Acute

Asymmetrical

Awl

Composite

Cordate

Cuneate

Deltoid

Dissected

Divided

Ellipsoid

Elliptic

Entire

Grass-like

Hastate

Keeled

Kidney (reniform)

Lanceolate

Ligulate

Linear

Oblanceolate

Oblong

Obovate

Obtuse

Orbicular

Oval

Ovate

Palmate

Pedate

Pinnate

Pinnatifid

Pinnatisect

Rhombic

Rosette forming

Runcinate

Sagittate

Sickle

Spathulate

Spear-shaped

Spindle

Spoon

Strap

Sub-orbicular

Sword

Tendrils

Trefoil

Trifoliate

FLOWERS AND FLOWER FORMS

A flower is the reproductive organ of plants classified as angiosperms – plants that flower and form fruits containing seeds. The function of a flower is to produce seeds through sexual reproduction. The seeds produce the next generation of a species and are the means by which the species is able to spread.

It is generally thought that a flower is the product of a modified stem, with the petals being modified leaves. The flower stem, called a pedicel, bears on its end the part of the flower called the receptacle. The various other parts are arranged in whorls on the receptacle: four main whorls make up a flower.

• The outermost whorl, located nearest the base of the receptacle where it joins the pedicel, is the calyx. This is made up of sepals (modified leaves that typically enclose the closed flower bud), which are usually green but may appear very like petals in some flowers, such as narcissus.

• The next whorl is the corolla – more commonly known as the petals. These are usually thin, soft and coloured, and are used to attract pollinators such as insects.

• The androecium (from the Greek *andros* and *oikia*, meaning "man's house") contains the male flower parts, consisting of one or two whorls of stamens. Each stamen consists of a filament topped by an anther, where pollen is produced.

• The last and innermost whorl is the gynoecium (from the Greek *gynaikos*

Flower shapes

Flowers display a wide variety of shapes that may be the result of individual flowers or the close arrangement into a flower-like compound inflorescence.

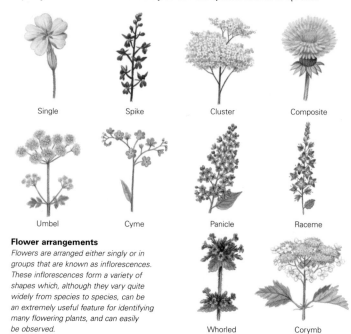

Single Spike Cluster Composite

Umbel Cyme Panicle Raceme

Whorled Corymb

Flower arrangements
Flowers are arranged either singly or in groups that are known as inflorescences. These inflorescences form a variety of shapes which, although they vary quite widely from species to species, can be an extremely useful feature for identifying many flowering plants, and can easily be observed.

and *oikia*, meaning "woman's house"), which consists of a pistil with one or more carpels. The carpel is the female reproductive organ, containing an ovary with ovules. The sticky tip of the pistil – the stigma – is where pollen must be deposited in order to fertilize the seed. The stalk that supports this is known as the style.

This floral structure is considered typical, though many plant species show a wide variety of modifications from it. However, despite the differences between genera, most flowers are simply variations on a theme and a basic knowledge of their arrangement is all you really need to get started with their identification.

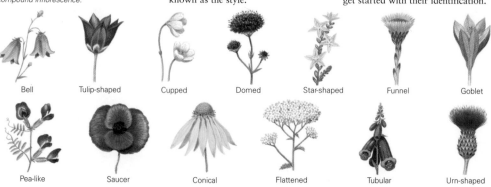

Bell Tulip-shaped Cupped Domed Star-shaped Funnel Goblet

Pea-like Saucer Conical Flattened Tubular Urn-shaped

Monoecious and dioecious plants

In most species, the individual flowers have both a pistil and several stamens, and are described by botanists as "perfect" (bisexual or hermaphrodite). In some species, however, the flowers are "imperfect" (unisexual) and possess either male or female parts only. If each individual plant has either only male or only female flowers, the species is described as dioecious (from the Greek *di* and *oikia*, meaning "two houses"). If unisexual male and female flowers both appear on the same plant, the species is described as monoecious (from the Greek *mono* and *oikia*, meaning "one house").

Attracting pollinators

Many flowers have evolved specifically to attract animals that will pollinate them and aid seed formation. These commonly have nectaries – specialized glands that produce sugary nectar – in order to attract such animals. As many

Different growing habits

Plants exhibit a variety of growing habits, often reflecting the type of habitat or niche they have specifically evolved to occupy. These are often important features to note when identifying a plant as the flowers may not be present all year round. The growing habits shown below describe all of the flowers that are featured in this directory.

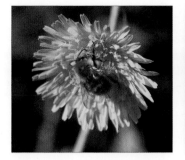

Above: Flowers that attract bees will often have petals that form a wide surface for landing and copious amounts of nectar.

Above: Flowers whose petals form a protective cup or tube are especially attractive to butterflies or other insects with long mouthparts.

pollinators have colour vision, brightly coloured flowers have evolved to attract them. Flowers may also attract pollinators by scent, which is often attractive to humans – though not always: the flower of the tropical rafflesia, for example, which is pollinated by flies, produces a smell like that of rotting flesh.

There are certain flowers whose form is so breathtaking as to render them almost unnatural to our eyes. Flowering plants such as orchids have developed a stunning array of forms and many have developed intricate relationships with their pollinators. Flowers that are pollinated by the wind have no need to attract animals and therefore tend not to be showy.

Types of inflorescence

Some plants bear only one flower per stem, called solitary flowers. Many other plants bear clusters of flowers, which are known as inflorescences. Most inflorescences may be classified into two groups, racemes and cymes.

In a raceme, the individual flowers making up the inflorescence bloom progressively from the bottom of the stem to the top. Racemose inflorescences include arrangements called spike, raceme, corymb, umbel and head. In the cyme group, the top floret opens first and the blooms continue to open downward along the peduncle, or inflorescence stalk. Cymes may be simple or compound.

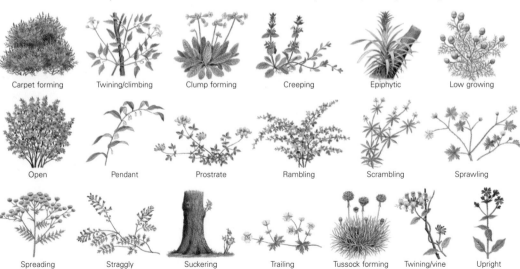

Carpet forming Twining/climbing Clump forming Creeping Epiphytic Low growing

Open Pendant Prostrate Rambling Scrambling Sprawling

Spreading Straggly Suckering Trailing Tussock forming Twining/vine Upright

THE LIFE CYCLE OF FLOWERING PLANTS

All flowering plants, from giant forest trees that live for thousands of years to the most ephemeral desert annuals that live for only a few weeks, follow the same pattern of life. Their lifespan, size, apparent durability and survival strategies vary considerably, but they have much in common.

Above: Field poppy, Papaver rhoeas, *is an annual that completes its life cycle in one season.*

Above: Wild carrot, Daucus carota, *is a biennial that grows one year and flowers the next.*

Above: Yellow flag, Iris pseudacorus, *is a perennial that lives and flowers for many years.*

All flowering plants begin life as seeds. These are in essence tiny, baby plants that have been left in a state of suspended animation with enough food to support them in the first few days of their new life. In order to grow, seed must be viable (alive). It is a misconception that seed is not living. It is and, like all living things, has a life-span. However, many types of seed can remain dormant for decades, waiting for the right opportunity to commence their cycle of growth and development.

Eventually, the seed will be triggered into germinating by the right combination of moisture, temperature and a suitable soil or growing medium.

Some seeds have specific needs; proteas and banksias must be exposed to smoke to prompt germination, and many berries, such as mistletoe, need to be exposed to the stomach acid of an animal. In most cases, the germinating plant is totally reliant on the energy stored in the seed until it pushes its growing tip above the soil.

The maturing plant

Once above ground the stem grows up toward the light and soon produces leaves that unfold and begin to harvest light energy. As the stems grow upward the plant also extends its roots down into the soil, providing

stability and allowing the plant to harvest both water and minerals that are vital to its growth.

Once the plant reaches its mature phase of growth, changes in its internal chemistry enable it to begin flowering. When this happens depends upon the species, but many plants – except those with the briefest life cycles – continue to grow while they produce flower buds. These buds develop into flowers, which are pollinated by the wind or by pollinators such as bees, moths or other animals.

Once a flower has been pollinated, it will usually fade quickly before turning into fruit, as the fertilized

Yearly life cycle of herbaceous plants
All flowering plants begin life as a seed. Some grow and flower within the first season, while others grow for several years before they flower. Herbaceous plants whether annual or perennial, grow and flower before dying back down at the end of the season.

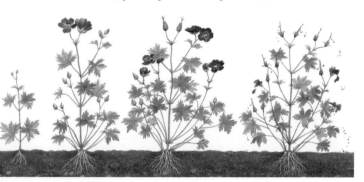

ovary swells and the new seeds develop. The seeds will continue to develop within the fruit until the embryos are fully mature and the seeds are capable of growing into new plants. This may be very quick in the case of small herbs, but in some shrubs and trees it can take two or more seasons for the seeds to develop fully.

Plants may take just one season to reach flowering stage, or may live for many years before they flower. Once flowering begins, certain species flower repeatedly for many seasons, some lasting decades or even centuries. There is much variability between species, but most plants follow one of three main types of life cycle.

Annuals

Plants that live for a single growing season, or less, are called annuals. Their life cycle is completed within a year. In this time the plant will grow, flower, set fruit containing seeds, and die. Many common flowering plants adopt this strategy which has the advantage of allowing them to colonize areas quickly and make the best of the available growing conditions.

Biennials

Plants that need two growing seasons to complete their life cycle are known as biennials. Generally, biennials germinate and grow foliage in the first growing season before resting over the winter. In the second growing season the plant enters a mature phase, in which it flowers, sets fruit and then dies. A biennial flowers only once before dying. A few plants may grow only foliage for several years before finally flowering and dying.

Perennials

All the remaining plant types live for three or more years, and may go on growing, flowering and producing fruit for many years. Some perennial species may take a number of years to grow to flowering size, but all of them are characterized by a more permanent existence than that of annuals and biennials.

Life cycle of a dandelion

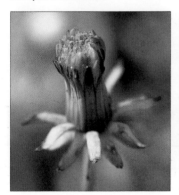

Above: The flower begins life as a tight bud that opens from the tip to reveal the yellow petals of the tiny individual flowers.

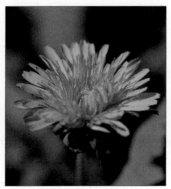

Above: As the flower opens further, it widens and flattens in order to make a perch for the bumblebees, which are its pollinators.

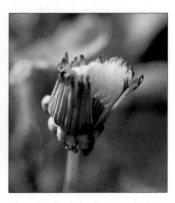

Above: Once the flower has been pollinated, it closes up again and the plant commences the process of seed production.

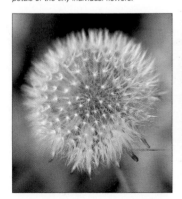

Above: Once the seed is ripened, the flower bracts re-open, and the parachute-like seed appendages (achenes) spread to form a globe.

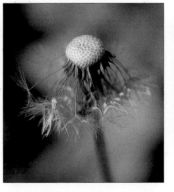

Above: As the ripened seed dries, it is easily dislodged and is carried away from the parent plant by even a light breeze.

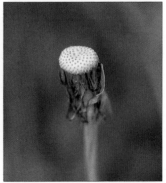

Above: Once the seed has been dispersed, the flower stalk is redundant and quickly withers, leaving only the leafy rosette.

WHAT IS POLLINATION?

Before a flower can develop seeds for reproduction it must be pollinated: pollen must be moved from the male anthers to the female stigma. Some flowers self-pollinate – pollen from their own anthers is deposited on the stigma – but most need some outside help.

Wind moves the pollen for some plants, such as grasses, but others require the assistance of an animal pollinator. These move pollen from the anthers to the stigma of a flower, and also often carry it between different flowers or plants of the same species. Animals that commonly perform this task include butterflies, bees, hummingbirds, moths, some flies, some wasps and nectar-feeding bats.

The benefits of pollination
Plants benefit from pollinators because the movement of pollen allows them to set seed and begin a new generation. For the pollinators this action is an incidental by-product of their efforts to collect nectar and/or pollen from flowers for themselves. In evolutionary terms it is an example of two unrelated species adapting to mutual dependence, where both benefit. Some plants have become so dependent on a particular pollinator that their flowers have adapted to favour them.

Flower forms and pollinators
Wind-pollinated plants often have small, numerous and inconspicuous flowers. They produce huge amounts of pollen, which saturates the air to ensure that some reaches nearby plants.

Below: Pollinators, such as this swallowtail butterfly, feed upon the energy- and protein-rich nectar while pollinating the plant.

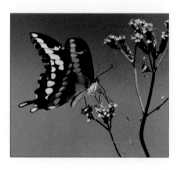

Plants pollinated by bees may have fragrant yellow or blue flowers that produce sweet nectar. Some plants are pollinated by beetles. Their flowers are usually white or dull in colour, mostly with yeasty, spicy or fruity odours. Flowers that rely on fly pollination are usually dull red or brown and have foul odours. Butterflies mainly pollinate flowers that are long and tubular – although this can vary – while moths typically pollinate flowers that are yellow or white and fragrant as they visit them at night.

Some plants are pollinated by birds, though they are far fewer than those visited by insects. Plants that attract hummingbirds, for example, have brightly coloured flowers but very little fragrance, since the birds have no sense of smell. All bird-pollinated flowers are similar in structure to those pollinated by butterflies, in that they have a long tubular shape.

Self and cross-pollination
While it is possible for some individual plants to pollinate their own flowers, this is not ideal. Many plants have developed some factor that promotes cross-pollination between different individuals of the same species.

Dioecious plants (those with separate male and female plants) easily achieve cross-pollination. Self-pollination is simply not possible.

Monoecious plants (those that produce both female and male flower parts on the same plant) avoid self-pollination by having their male or female parts mature at different times. In cases where the male and female structures mature at the same time, the physical separation of the stamens and stigma can help prevent self-pollination. However, self-pollination is the norm in some species and is advantageous in environments where there are few pollinators.

Fertilization

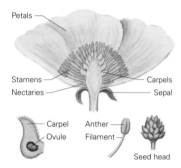

Above: In this buttercup the male flower parts (stamens, each comprised of an anther and a filament) are laden with pollen and surround ovule (egg) containing female parts (carpels).

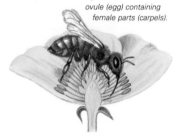

Above and below: Bees tend to visit flowers whose petals form a wide enough surface for them to land upon. As they take the nectar the bees are dusted with pollen, which brushes on to the flowers they visit next.

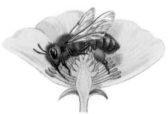

Once a pollen grain has landed on the stigma, it must reach the ovaries of the flower in order to fuse with the female cell and begin to form a seed. It does this by germinating and growing a long thin tube that reaches down the style into the flower's ovaries. The pollen tube provides a pathway for the male chromosomes to reach the egg cell in the ovule. One pollen grain fertilizes one egg cell, and together they form the new seed.

SEEDS AND SEED DISPERSAL

For flowering plants, seed production is the main method of reproduction. Seeds have the advantage of providing the plants with a way to spread and grow in new places, which in some cases may be at a distance from the parent. Their ability to do this is extremely important.

If seeds were not dispersed the result would be many germinating seedlings growing very close to the parent plant, leading to a crowded mass of the same species. Each would be in competition with the others, and with the parent plant, for nutrients, light, space and water. Few of the offspring (or the parent) would prosper.

Seeds are dispersed using a number of strategies. The majority are carried by wind, water or animals, though some plants have adopted the strategy of shooting seeds out explosively.

Wind dispersal

Seeds that depend upon wind dispersal are usually very light. Orchid seeds, for example, are as fine as dust. In addition, composite flowers such as the dandelion, *Taraxacum officinalis*, have hairy appendages on each seed that act like parachutes, carrying the seeds over long distances.

The small size of wind-dispersed seeds is reflected in the amount of food reserves stored in them. Larger seeds contain greater food reserves, allowing the young seedlings more time to grow before they must begin manufacturing their own food. The longer a seedling

has before it must become self-sufficient, the greater its chance of becoming successfully established. However, large seeds are disadvantaged by the fact that they are more difficult to disperse effectively.

Explosions

Some plants have pods that explode when ripe, shooting out the seeds. Many members of the pea family, Papilionaceae, scatter their seeds in this way. Once the seeds are ripe and the pod has dried, it bursts open and the seeds are scattered. In some of these plants, such as common gorse, *Ulex europaeus*, seed dispersal is further enhanced because the seeds possess a waxy cuticle that encourages ants to carry them around, moving them further from the parent plant.

Water dispersal

The fruit and seeds of many aquatic or waterside plants are able to float. Water lily seeds, for example, are easily dispersed to new locations when carried by moving water, and coconuts can travel huge distances across seas and oceans, which is why coconut palms grow on so many Pacific islands.

Animal dispersal

The production of a nutritious, fleshy fruit that animals like to eat is another strategy that many plants have adopted. An animal eating the fruit digests only the fleshy outer part. The well-protected seeds – the stones or pips in the fruit – pass through the animal's digestive system and are excreted in droppings that provide a rich growing medium. The seeds are often deposited a long way from the parent plant by this means.

Many types of mistletoe have sticky fruits that are attractive to birds. The sticky berries create equally sticky droppings that the bird needs to "rub off" on the branches of trees. The seeds are deposited, with the droppings, on the bark to grow into new plants.

A few plants, such as common burdock, *Arctium pubens*, produce seeds with hooks that catch on the fur of animals and are carried away. The animal eventually removes the burrs through grooming or moulting, and the seeds are then deposited.

Fire

Some plants living in fire-prone areas have evolved traits that allow them to use this to their advantage when reproducing or regenerating. For most of these species, the intensity of the fire is crucial: it must be hot, but not so hot that it cooks the seed. In addition, fires should not occur too frequently, as the plant must have time to mature so that new seed can be produced.

Many fire-tolerant species have cones that open only after a fire. Many plants that grow in the Australian bush or in the fynbos (the natural vegetation of the southern Cape) are reliant on fire. In many cases the heat triggers seed dispersal but it is the chemicals in the smoke that initiate seed germination.

Below: In some species such as the opium poppy, Papaver somnifera, *the wind sways the ripe fruits, shaking out the seeds like pepper from a pepper pot. The wind then carries the seeds away from the parent plant.*

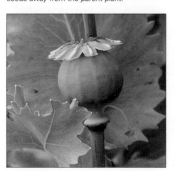

Below: The Mediterranean squirting cucumber, Ecballium elaterium, *has a fleshy, almost liquid fruit that, when ripe, squirts its jelly-like contents – along with the seeds – some distance from the plant.*

HERBACEOUS PLANTS

Looking at plants in the wild, it quickly becomes apparent that there are two basic types. Those that have permanent woody stems, whose shoots do not die back, are generally referred to as trees and shrubs. The remainder lack permanent stems and are often described as herbaceous plants, or herbs.

Herbaceous plants are those that die to the ground each year and produce new stems in the following growing season. The word is used in a broader sense, however, to describe any plant with soft, non-woody tissues, whether it is an annual, perennial or bulb.

To understand how these plants live

Below: Grasslands are an ideal habitat for many herbaceous plants and provide a home for a rich diversity of species.

and grow, we can begin by looking at a seedling. In all seedlings and small plants it is the water content of the cells in the leaves and stems that holds the plants erect. All young plants are similar in this respect but as they grow, woody plants begin to build up the strengthening layers of their characteristic structure. Non-woody plants, on the other hand, always retain soft stems.

Above: The water hyacinth, Eichhornia crassipes, *is a non-woody plant that has become adapted to an aquatic lifestyle.*

Stem structure

Soft stems remain upright because their cells have rigid walls, and water in the cells helps retain their shape. This has the obvious disadvantage that during a dry period water can be drawn out of the cells; the cells become limp and the plant droops or wilts. Many species have stems with a soft inner part – commonly called the pith – that is used to store food. Others, however, have hollow cylindrical stems. In these, the vascular bundles (the veins that transport water, nutrients and sugars around the plant) are arranged near the outside of the stem. This cylindrical formation gives the stem a much greater strength than a solid structure of the same weight.

The relatively short lifespan of non-woody plants (compared with that of many woody plants) and the lack of a strong, rigid structure generally limit the height to which they can grow. Despite this, plants such as the giant hogweed, *Heracleum mantegazzianum*, can easily reach heights of 3–4m/10–13ft – larger than many shrubs. Such giants are rare, however, and most herbaceous plants are no more than 1–2m/3–6½ft in height.

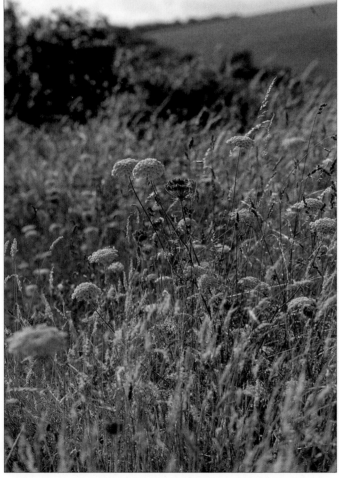

Survival strategies

Non-woody plants usually produce completely new stems each year, because cold or other adverse weather (such as drought) causes the stems to die back to the ground. The climate in which the plant grows greatly affects the survival strategy it adopts. Some species survive periods of cold by forming underground bulbs or tubers for food storage, while others – the annuals – complete their life cycles within one growing season, after which the whole plant dies.

Herbaceous plants are generally divided into those with broad leaves (called forbs) and grass-like plants with very narrow leaves (called graminoids). Some species have become herbaceous vines, which climb on other plants. Epiphytes have gone one step further: they germinate and live their whole life on other plants, never coming in contact with the soil. Many orchids and bromeliads are epiphytes. Other species have adapted to life largely submerged in water, becoming aquatic plants. Many of these are rooted in the sediment at the bottom of the water, but a few have adapted to be completely free floating.

Below: Open woodland and forest clearings are often rich in herbaceous plants that enjoy the shelter and light shady conditions.

Right: Bulbs such as this petticoat daffodil, Narcissus bulbocodium, flower in spring in alpine pasture before dying down to avoid the hot dry summer.

A few species have adapted to use the efforts of other plants to their own ends. Some are semi-parasites – green plants that grow attached to other living, green plants. These unusual plants still photosynthesize but also supplement their nutrients by "stealing" them directly from their unfortunate host plants. A few species, however, are wholly parasitic – totally dependent upon their host for nutrition. They do not possess any chlorophyll and are therefore classed as "non-green" plants. Many remain hidden, either inside the host plant or underground, appearing to the outside world only when they produce flowers.

Subshrubs

Some plants, while they are woody in nature, resemble non-woody plants because of their small size coupled with their ability to shoot strongly from ground level or from below ground. They are known as "subshrubs", a term borrowed from horticulture, where it is used to describe any plant that is treated as a herb in respect of its cultivation. In terms of wild plants it is used rarely to describe low-growing, woody or herbaceous evergreen perennials whose shoots die back periodically.

Small plants

The world's smallest plant species is water meal, *Wolffia globosa*, a floating aquatic herb which, when mature, is not much larger than the full stop at the end of this sentence. Despite its small size, it is a flowering plant. The flowers occur only rarely and would be hard to see without the aid of a microscope. It mainly reproduces vegetatively and quickly forms a large floating colony on the surface of slow-flowing or still water.

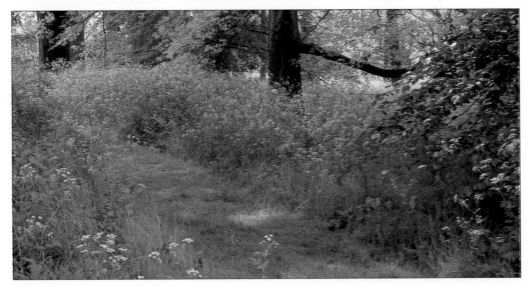

WOODY PLANTS

Any vascular plant with a perennial woody stem that supports continued growth above ground from year to year is described as a woody plant. A true woody stem, however, contains wood, which is mainly composed of structured cellulose and lignin.

Cellulose is the primary structural component of plants, and lignin is a chemical compound that is an integral part of the cell walls. Most of the tissue in the woody stem is non-living, and although it is capable of transporting water it is simply the remains of cells that have died. This is because most woody plants form new layers of tissue each year over the layer of the preceding year. They thus increase their stem diameter from year to year and, as each new layer forms, the underlying one dies. So big woody plants are merely a thin living skin stretched over a largely lifeless framework of branches. In effect, as a woody plant grows, the proportion of living material compared to the non-living parts steadily decreases.

Bamboos appear to be woody plants, and indeed do have permanent woody stems above the ground, but are more akin to the grasses, to which they are closely related, than to the commoner woody species. Essentially, they grow a dense stand of individual

Above: All woody plants can be defined by their permanent, often long-lived growth.

stems that emerge from underground stems called rhizomes. In many ways their biology is more like that of non-woody plants, despite their appearance.

Pros and cons of woody stems

There are more than 80,000 species of tree on earth and a considerably higher number of shrubby species. Although the exact number is not known, it is obvious even to a novice plant spotter that woody plants are an extremely successful group. This is because they are bigger than other plants, so they are able to gather more light and therefore produce more food. In areas where inclement weather induces plants to enter a seasonal dormant period, woody plants have the advantage of a head start when growth restarts. They do not have to compete with other emerging plants and can start producing a food from the moment they recommence growth.

Despite their obvious success, however, woody plants have not managed to dominate the entire

land surface. Only the largest trees are fully immune to the effects of large plant-eating mammals, and in some areas, such as the tundra, weather patterns are so extreme that only low-growing woody plants can survive, and they must compete with the surrounding herbage.

Support strategies

As well as trees and large shrubs, there are woody species that exploit other woody plants around them. Lianas, for instance, germinate on the ground and maintain soil contact, but use another plant for support. Many common climbers or vines are lianas.

Somewhat more unusual are the hemi-epiphytes, which also use other plants for support, at least during part of their life: some species germinate on other plants and then establish soil contact, while others germinate on the ground but later lose contact with the soil. The strangler figs, *Ficus* species, are interesting examples: they begin life as epiphytes,

Below: Bamboos are the only examples of the grass family to have evolved permanent stems above ground.

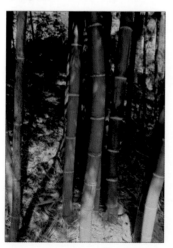

Below: Woody plants include the largest living plant species, the giant redwood Sequoiadendron giganteum, among their ranks.

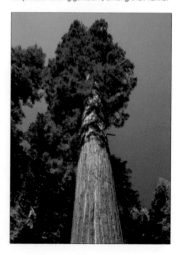

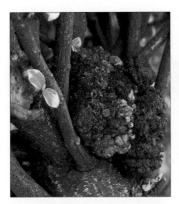

Above: The permanent stems of woody plants are prone to disease, such as this canker, and older specimens contain much deadwood.

Above: Mistletoe is a shrubby plant that has adapted to be partially parasitic on other, larger woody plants such as trees.

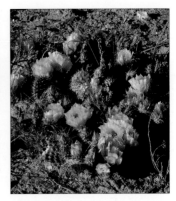

Above: Cacti are highly specialized plants that are descended from woody ancestry and have highly specialized permanent stems.

growing on other trees, unlike other tree seedlings that have to start their struggle for survival on the forest floor. The young strangler fig grows slowly at first, as little water or food is available to it, but its leathery leaves reduce water loss. It then puts out long, cable-like roots that descend the trunk of the host tree and root into the soil at its foot. Now readily able to absorb nutrients and water, the young fig tree flourishes. The thin roots thicken and interlace tightly around the supporting tree trunk. The

Below: Evergreen shrubs, such as this Rhododendron ponticum, *produce food all year round and may form dense understory in deciduous woodland.*

expanding leafy crown of the strangler shades the crown of the support tree and its roots start to strangle its host. The host tree eventually dies and slowly rots away, leaving a totally independent strangler fig, which may live for several hundred years.

Other woody plants, such as the mistletoe, "plug" themselves into a branch of a living tree and harvest nutrients directly from it. Apart from a free supply of food and water they gain the added advantage of being high above competing plants and trees, so that they receive enough light to photosynthesize. Mistletoe is a partial parasite that retains its woody stems and green leaves.

The largest plants

The identity of the world's largest plant is debatable, not only because woody plants are only partly living tissue, but also because it has still not been fully researched. In practice, it is extremely difficult to measure how much of a tree is actually living tissue, although the usual candidate is the giant redwood, *Sequoiadendron giganteum*. The banyan tree, *Ficus benghalensis*, can easily cover an area of 2 hectares/5 acres, and the related *Ficus religiosa* can allegedly cover even more. Whether any of these species are really the largest is a moot point, but it is certain that the title of largest flowering plant will always be held by a woody species.

The oldest plants

Among the oldest plants on Earth are the bristlecone pines, *Pinus longaeva*. Some individuals are known to be more than 4,000 years old and others are estimated to be 5,000 years old. Some creosote plants, *Larrea divaricata* ssp. *tridentata*, are even older. The creosote plant sends up woody stems directly from ground level, so that all the stems in a dense stand are clones of the original plant. An ancient stand in California's Mojave Desert, known as the King's Clone, is estimated to be 11,700 years old, although the individual stems live for much shorter periods.

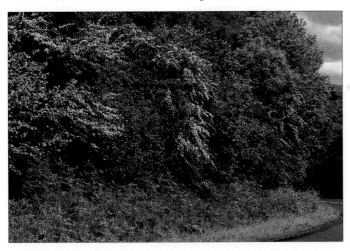

ECOLOGY AND HABITATS

The study of the ways in which plants, animals and their environment interact with one another is known as ecology. All evolutionary change takes place as a direct response to the ecological pressures that affect the plants and animals in a particular habitat.

Any given habitat will have a number of ecological pressures. Plants may be grazed by animals – or the plant species that thrive may be the result of changes in the wider environment, such as the changing seasons or the effect of flooding.

Interaction

To understand the complexities of even relatively small habitats, three basic principles must be remembered. First, living things do not exist as isolated individuals or groups of individuals. They are part of a continuum of life that stretches across the entire surface of the Earth. Second, all organisms interact with other members of their own species, with other species, and with their physical and chemical environments. Third, all organisms have an effect on each other and their surroundings, and as they interact with both they may actually change them over time: for example, trees gradually modify the soil they grow in by constantly dropping dead leaves that decompose and are incorporated into it.

Below: Plants such as the California poppy, Eschscholzia californica, are vulnerable to habitat loss.

Plant groups

The plants within an environment are grouped together in a number of ways.
• A "species" is a natural group that interbreeds, or has the potential to do so, and will not normally interbreed with other related groups.
• A "population" describes all the individuals of a given species in a defined area, such as all the dandelions in an area of grassland.
• A "community" refers to the grouping of all the different populations that occur together in a particular area.
• An "ecosystem" is the community, or series of communities, together with the surrounding environment. It includes the physical and chemical environment, such as the rocks, water and air.

In an ecosystem, all the organisms composing the populations and communities require energy for survival. In the case of the plants, that energy comes from the sun: plants use sunlight for photosynthesis, which converts the light energy into basic sugars, which the plant uses as its food and stores in the form of sugars, starches and other plant material. Any animals in the ecosystem derive their energy from this store, either by eating the plants or by eating other animals that feed on the plants.

Habitats

The location where a particular species is normally found is its "habitat". A single ecosystem may contain many different habitats in which organisms can live. Salt-marsh ecosystems, for example, include areas that are flooded twice daily by tides as well as areas that are inundated only by the highest tides of the month or the year. Different plants inhabit each of these areas, though there may be some overlap, but they are all considered inhabitants of the same ecosystem.

Above: Grazing animals may change or even destroy habitats where densities of animals become too high.

Some plants can thrive and reproduce in different habitats, as long as each provides the appropriate combination of environmental factors. The correct amount of light, water, the necessary temperature range, nutrients, and a substrate on which to grow – sand, clay, peat, water or even another plant may be appropriate. All these factors must be within the range of the plants' tolerance. Even a common plant will disappear from a habitat if an essential environmental factor shifts beyond its range of tolerance. For example, sun-loving plants, such as the common daisy, *Bellis perennis*, flourish in full sun but gradually disappear when surrounding trees and shrubs grow large enough to shade the area.

Common plants tend to be those that have adapted to withstand a range of conditions, whereas rare species survive where narrowly defined environmental conditions exist. It is due to their narrow range of tolerance that some plants become rare. Their lack of habitat may be due to gradual changes over thousands of years, such as climate change, that reduce suitable areas. Increasingly, loss of habitat is due to humans altering the landscape.

CONSERVING ENDANGERED SPECIES

Many plant species are now classified as endangered, because their long-term survival is under threat. There are many reasons for this, such as the erosion of a habitat, or the extinction of a key pollinator, and in some cases it is likely that the plant was never particularly numerous.

Extinction is a normal part of evolution, without it there would be no room for new species, but scientists are becoming increasingly concerned that the current rates of extinction are far above the rate at which species can easily be replaced. Attempts are now being made to prevent further loss of the world's rare plants.

Collecting wild plants

Though it may be tempting to pick wild plants, it is worth asking yourself why you want to do this. While it is true that some collections are undertaken as part of scientific research, some plants have been overpicked to the extent that they have become critically endangered. In the UK, for instance, the lady's slipper orchid, *Cyprepedium calceolus*, was so admired by enthusiasts and collectors that it was eventually reduced to a single wild specimen. The impact of collecting one plant may seem insignificant, but the small actions of many collectors can lead to extinction.

Introduced alien plants

Many plants have become endangered because of competition from a new arrival. When plants are taken from their native environments and introduced elsewhere, they can often become highly invasive, ultimately displacing the native plants. There are numerous instances worldwide of whole native plant communities being threatened by introduced plant species.

Climate change

It is likely that climate change will have a considerable impact on most or all ecosystems in the 21st century, and that changing weather patterns will alter the natural distribution ranges of many species or communities. If no physical barriers exist, it may be possible for species or communities to migrate. Habitats such as forest or grassland, for instance, may move to higher latitudes or higher altitudes if average temperatures increase. There is nothing new about this: at the end of the last ice age (12,000–10,000 years ago) many plant communities moved north or south in response to the rapid global warming that followed.

In most cases, the real danger to habitats arises where natural or constructed barriers prevent or limit the natural movement of species or communities. Many national parks, nature reserves and protected areas are surrounded by urban or agricultural landscapes, which will prevent the migration of species.

Protected areas

Every country in the world has defined areas that are managed for the conservation of animals, plants and other natural and cultural features. Only conservation *in situ* allows the natural processes of evolution to operate on whole plant and animal communities. It permits every link in the web of life, including invertebrates, soil microbes and mycorrhiza (fungi associated with plant roots), to

Below: Over collection of the edelweiss, Leontopodium alpinum, *has resulted in it needing legal protection in Europe.*

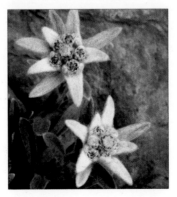

function and interact fully within the ecosystem and is essential to allow the continued development of resistance to fungal and other diseases.

Plant collections

Living collections of rare and endangered plants are a necessary inclusion in many botanic gardens. Their role is often indirect in relation to conservation; they serve to inform visitors of the danger of extinction that faces many species. However, the expertise developed in growing these plants can be useful when growing stocks for reintroduction to the wild and may improve our understanding of the needs of threatened plant species.

Seed banks ensure that plants that are threatened with extinction can be preserved. The seed is gathered by licensed collectors and, after treatment, is stored at sub-zero temperatures. The seed bank works out the best method to grow the seed so that, if the wild plants vanish, the species can be successfully re-introduced.

Re-introduction of wild plants

When plants have become rare, endangered or even extinct, it is occasionally possible to re-introduce them to areas or habitats where they formerly grew. This is rarely a simple matter, however. Its success depends on the removal of whatever pressure made the plant rare in the first place.

The café marron, *Ramosmania rodriguesii*, was thought to have been extinct for 40 years in Rodrigues in the Indian Ocean. However, in 1980 a teacher sent his pupils out on an exploratory trip to find interesting plants. One pupil unearthed a small shrub half-eaten by goats which the teacher identified as the café marron. Recent work has resulted in its producing seed for the first time, and it may yet be re-introduced to the wild.

WILD FLOWER HABITATS

Flowering plants live on every continent and can be found from the ocean shores to the mountains. They are the most successful group of plants on earth, but there are very few that can boast the ability to live anywhere. Even the most widespread species have their limits and, ultimately, their preferred habitats.

Wetlands

All plants need water to live, but many species are likely to suffer and die if they get too much. If there is excessive water in the soil it forces the air out, ultimately suffocating the roots. Some plants, however, are specially adapted to living in wetlands.

Wetland plants grow in seasonally waterlogged or permanently wet conditions. There are many types of wetlands, including swamps, bogs, salt marshes, estuaries, flood plains, lakeshores and riversides. Wetlands occasionally support trees: these areas, known as wet woodland or swamp forests, are filled with rare species that tolerate wet, shady conditions.

Wetlands are rich in flowers, demonstrating that where land and

water meet a rich habitat usually results. Until recently huge areas of wetland were being drained and turned into grassland or filled for development. While this continues apace in some places, wetlands are gaining a new stature in the 21st century. Many are now highly valued as natural sponges, in which water is retained on the land surface instead of flowing quickly to the sea, causing erosion and flooding as it goes.

Woodlands

Forest and woodland are extremely important habitats for many types of flowering plants, not least trees. Tree cover was once the natural vegetation over much of the Earth's surface and great forests stretched across vast tracts of every continent except Antarctica. Over the last 10,000 years

human activity has removed considerable amounts of this natural cover, particularly in Eurasia, and over the last century the trend has become a global one.

Despite the loss of forest, many areas remain and are very important havens for forest-dwelling flowers. Such flowers need to cope with low light levels for much (or even all) of the year, but trees provide a rich growing medium, through their decomposing fallen leaves, and may also provide homes for flowering climbers and epiphytes.

Exposed habitats

Where tree cover is not the dominant vegetation – whether due to human intervention or through natural

Below: A British hedgerow represents a complete ecosystem, mirroring a natural woodland edge.

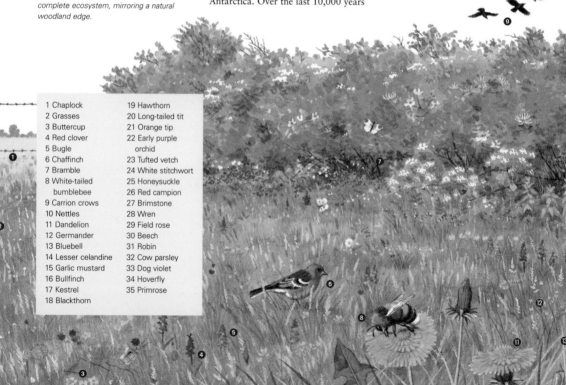

1 Chaplock	19 Hawthorn
2 Grasses	20 Long-tailed tit
3 Buttercup	21 Orange tip
4 Red clover	22 Early purple
5 Bugle	orchid
6 Chaffinch	23 Tufted vetch
7 Bramble	24 White stitchwort
8 White-tailed	25 Honeysuckle
bumblebee	26 Red campion
9 Carrion crows	27 Brimstone
10 Nettles	28 Wren
11 Dandelion	29 Field rose
12 Germander	30 Beech
13 Bluebell	31 Robin
14 Lesser celandine	32 Cow parsley
15 Garlic mustard	33 Dog violet
16 Bullfinch	34 Hoverfly
17 Kestrel	35 Primrose
18 Blackthorn	

Above: Flowers and all kinds of flora can survive in many seemingly inhospitable places.

that are the result of human intervention, such as traditional hay meadows, are capable of supporting many flowering species. These rich habitats have become increasingly rare over the last 100 years, due mainly to agricultural improvement programmes, making those that remain precious.

Life in the extreme

In challenging locations from frozen mountain peaks to the hottest deserts, flowering plants have learned to eke out a living. Habitats of this kind are often referred to as fragile, and while the idea of a fragile desert or mountaintop may seem strange, it is entirely accurate. Extreme survival specialists are finely tuned to make the best of scarce resources. If the conditions change even

slightly, plants do not always possess the right adaptations and may face extinction. Alpine plants, for instance, are much beloved by gardeners, but need specialist care, and treatment that mimics, as closely as possible, the conditions they enjoy in the wild, if they are to survive in cultivation.

changes – conditions are much more favourable to those species that need a lot of light. Exposed areas are mainly either grassland or scrubland and many support a truly dazzling array of wild flowers.

In temperate zones, open spaces are among the most diverse wild flower habitats to be encountered. Even open areas

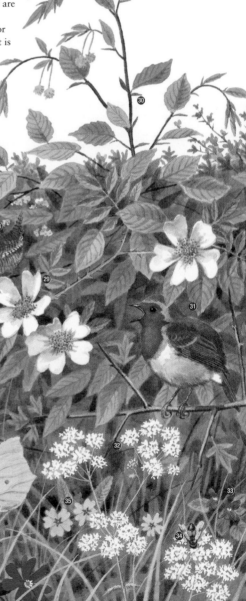

SCRUBLAND AND DESERT

Much of the Earth's surface is characterized by land that is dry for much of the year. The plants that live in dry areas are specifically adapted to deal with the harsh extremes of these environments and many have become highly distinctive in appearance.

Mediterranean scrubland

Regions described as Mediterranean scrubland tend to have hot, dry summers followed by cool, moist winters. These conditions occur in the middle latitudes near continental west coasts: the Mediterranean itself, south central and south-western Australia, the fynbos of southern Africa, the Chilean matorral, and the chaparral of California. Most rainfall occurs from late autumn to early spring, and for many plants this is the prime growing and flowering season.

Although rare, this habitat features an extraordinary diversity of uniquely adapted plants – around 20 per cent of the Earth's plant species live in these regions. Most plants that grow in these areas are fire-adapted, and actually depend on this disturbance for their survival.

Deserts

While they occur on every continent, deserts vary greatly in the amount of annual rainfall they receive and their average temperature. In general, evaporation exceeds rainfall. Many deserts, such as the Sahara, are hot all year round, but others, such as the Gobi Desert, become cold in winter.

Temperature extremes are a characteristic of most deserts. Searing daytime heat gives way to cold nights. Not surprisingly, the diversity of climatic conditions – though harsh – supports a rich array of habitats. Many are ephemeral in nature and often reflect the scarcity and

Above: Where vegetation is present, woody-stemmed shrubs and plants tend to be characteristic of desert regions.

seasonality of available water. Despite their harsh conditions, many deserts have extraordinarily rich floras that in some cases feature high numbers of species that are endemic.

Below: Australian mallee grows at the edge of desert regions and contains plants that are both fire- and drought-resistant.

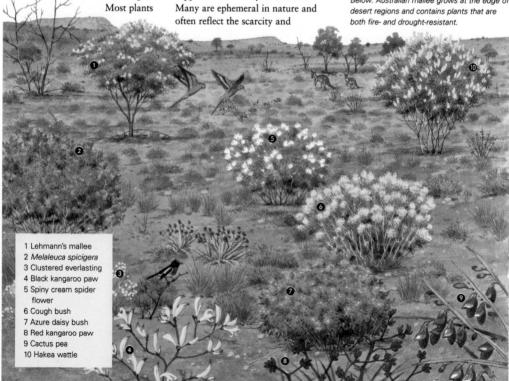

1 Lehmann's mallee
2 *Melaleuca spicigera*
3 Clustered everlasting
4 Black kangaroo paw
5 Spiny cream spider
 flower
6 Cough bush
7 Azure daisy bush
8 Red kangaroo paw
9 Cactus pea
10 Hakea wattle

CONIFEROUS WOODLAND

Among the most ancient of flowering plants, conifers once dominated the whole of the Earth's surface. In modern times, however, they have become more restricted as broad-leaved flowering plants have become the dominant group.

Boreal forest

Also known as taiga or northern coniferous forest, boreal forest is located south of tundra and north of temperate deciduous forests or grass-lands. Vast tracts of this forest span northern North America, Europe and Asia. Boreal forests cover around 17 per cent of the Earth's surface. They are characterized by a cold, harsh climate, low rainfall or snowfall and a short growing season. They may be open woodlands with widely spaced trees or dense forests whose floor is in shade. The dominant ground cover is mosses and lichens, with a few specialized flowering plants.

Below: A conifer forest of north-western North America contains a wide variety of flowering plants.

Above: Coniferous woodland has a simple structure, a canopy layer and an understorey.

Tropical coniferous forest

Found predominantly in North and Central America, in tropical regions that experience low levels of rain and moderate variability in temperature, these forests feature a thick, closed canopy, which blocks light to the floor and allows little to grow beneath. The ground is covered with fungi and ferns and is usually relatively poor in flowering plants.

Temperate rainforest

In temperate regions, evergreen forests are found in areas with warm summers and cool winters. Conifers dominate some, while others are characterized by broadleaved evergreen trees.

Temperate evergreen forests are common in the coastal areas of regions that have mild winters and heavy rainfall, or in mountain areas. Temperate conifer forests sustain the highest levels of plant material in any land habitat and are notable for trees that often reach massive proportions.

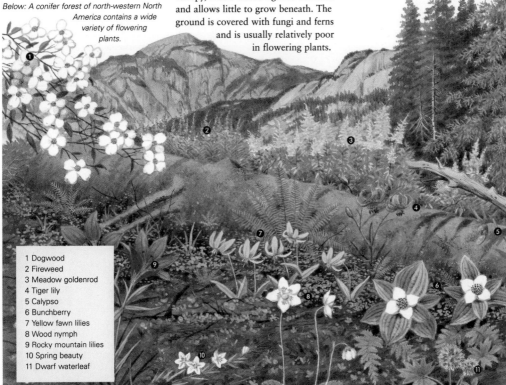

1 Dogwood
2 Fireweed
3 Meadow goldenrod
4 Tiger lily
5 Calypso
6 Bunchberry
7 Yellow fawn lilies
8 Wood nymph
9 Rocky mountain lilies
10 Spring beauty
11 Dwarf waterleaf

HEDGEROWS

*Many agricultural landscapes are defined by hedgerows, which are important habitats for many plants.
A hedgerow is formed of a row of intermeshing shrubs and bushes and sometimes trees that form a
boundary to keep in live stock, and are home to a diverse range of creatures.*

Land clearance

Though a product of human activity,
not all hedgerows were planted. As
villagers and landowners cleared forest
areas for agricultural purposes,
especially in the UK, they would leave
the last narrow strip of woodland to
mark the boundaries of their land.

At the heart of an ancient
hedgerow is a dense shrub layer; at
intervals along it trees form a broken
canopy. At ground level a rich layer of
herbs grows along the base of the
hedge, at the field edge. The older the
hedgerow, the greater diversity of
animal and plant life it will support.
The easiest way to age a hedge is to
mark out a 30m/33yd stretch then
count the number of different species
of trees and shrubs it contains. It is
reckoned to take about 100 years for
each woody

plant to establish itself, so for each
different species you find add a century
to the age of the hedge. Hedgerows are
effectively 'corridors' for wildlife,
allowing species to disperse and move
from one habitat area to another.
While it is difficult for most plants to
spread across open fields, they can
'travel' along the base of a hedge.

Vanishing hedgerows

The agricultural policies of recent
decades have led to concern about the
rate at which hedgerows are
disappearing. Between 1984 and 1993,
the length of managed hedgerows in
the UK alone decreased by nearly a
third. Hedgerow loss occurs not only
when hedges are deliberately removed

*Above: Hedgerows are often rich in species
that have been driven from much of the
surrounding landscape.*

to make larger fields, but also when
they are left to become derelict: if
they are not regularly cut and
managed, they grow into open lines of
bushes and trees.

Pesticide or fertilizer damage can be
a particular problem on intensively
managed farmland, where weedkillers
have often been applied to hedge
bottoms to eliminate weeds. This has
proved to be damaging for the natural
wild flower population of hedgerows.
Almost as damaging is fertilizer 'drift'
(unintentional overspill) into the hedge
base, as it promotes the growth of
certain plant species at the expense
of others. Often, the species
that are favoured are of little
conservation value.

*Below: Hedgerows combine
attributes of merging
habitats.*

1 Dog rose
2 Honeysuckle
3 Lesser celandine
4 Red campion
5 Foxglove
6 Blackthorn

BROAD-LEAVED FOREST

Many types of forest can be classified as broad-leaved. The principal types are temperate lowland forests, tropical rainforests and cloud forests, and tropical and sub-tropical dry forests. All of these typically have large, broad-leaved trees as their dominant vegetation.

Forest flora

There are considerable variations between the species of wild flowers and flora that thrive in different types of forests and the location has a direct bearing.

Temperate deciduous forest

In cool, rainy areas forests are characterized by trees that lose their leaves in the autumn, in preparation for winter. By shedding its leaves, a tree conserves resources, avoiding the hardship of maintaining a mass of foliage through winter. Once on the forest floor the leaves decompose and provide a wonderfully rich soil.

Many low-growing plants that live in these areas take advantage of the winter and early spring when the trees are bare. During this time the absence of shade allows them to complete their life cycle in a few months while (for them) light levels are highest. The seed of some species wait in the soil until trees fall, or are felled, before they germinate and grow in the resulting clearing. These plants may make a dense, showy stand for a few years before the forest canopy closes once more and shades them out.

Temperate deciduous forests are found around the globe in the middle latitudes: in the Northern Hemisphere they grow in North America, Europe and eastern Asia, and in the Southern Hemisphere there are smaller areas, in South America, southern Africa, Australia and New Zealand. They have four distinct seasons – spring, summer, autumn and winter – and the growing season for trees lasts about six months.

Tropical rainforest

Very dense, warm and wet, rainforests are located in the tropics – a wide band around the equator, mostly in the area between the Tropic of Cancer (23.5° N) and the Tropic of Capricorn (23.5° S). They grow in South America, West Africa, Australia, southern India and South-east Asia.

A fairly warm, consistent temperature, coupled with a high level of rainfall, characterizes tropical rainforests. They are dominated by semi-evergreen and evergreen trees. These number in the thousands and contribute to the highest levels of species diversity of any major terrestrial habitat type. Overall, rainforests are home to more species than any other forest habitat.

Dry forest

Tropical and subtropical dry forests are found in Central and South America, Africa and Madagascar, India, Indochina, New Caledonia and the Caribbean. Though they occur in climates that are warm all year round and may receive heavy rain for part of the year, they also have long dry seasons that last several months. Deciduous trees are the dominant vegetation in these forests, and during the drought a leafless period occurs, allowing the trees to conserve water. Throughout this period, sunlight is able to reach ground level and plants grow and flower beneath the trees.

Below: In the Northern Hemisphere, bluebells take advantage of the extra light in spring, when trees are bare, in order to grow and flower. They finish flowering just as the tree canopy above starts to fill in.

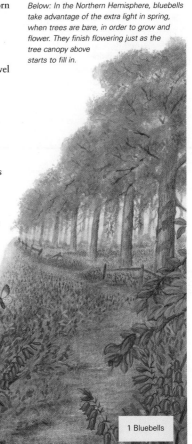

1 Bluebells

GRASSLAND

Windy and partly dry, grassland generally lacks woody vegetation, and the dominant plant type is, of course, grasses. Almost one quarter of the Earth's land surface is grassland, and in many areas grassland is the major habitat separating forests from deserts.

Grasslands, also known as savanna, pampas, campo, plain, steppe, prairie and veldt, can be divided into two types – temperate and tropical.

Temperate grassland

Located north of the Tropic of Cancer and south of the Tropic of Capricorn, temperate grasslands are common throughout these ranges. They experience a range of seasonal climatic variations typified by hot summers and cold winters. The combination of open, windy sites and dense stands of grasses mean that the evaporation rate is high, so little of the rain that falls reaches the rich soil.

The extraordinary floral communities of the Eurasian steppes and the North American plains have been largely destroyed due to the conversion of these lands to agriculture. In surviving areas of North American tall-grass prairie, as many as 300 different plant species may grow in 1 hectare/2.5 acres.

Tropical grassland

The annual temperature regime in tropical grassland is quite different to that of temperate grassland: in tropical regions it is hot all year, with wet seasons that bring torrential rains interspersed with drier seasons. Tropical grasslands are located between the Tropic of Cancer and the Tropic of Capricorn and are sometimes collectively called savannas. Many savannas do have scattered trees, and often occur between grassland and forest. They are predominantly located in the dry tropics and the subtropics, often bordering a rainforest. The plant diversity of these regions is typically lower than that of other tropical habitats and of temperate grassland.

Montane grassland

At high elevations around the world montane grasslands occur. They are found in tropical, subtropical and temperate regions, and the plants they contain often display striking adaptations to cool, wet conditions and intense sunlight, including features such as rosette structures or waxy surfaces on their leaves or stems. In the tropics these habitats are highly distinctive: examples include the heathlands and moorlands of Mount Kilimanjaro and Mount Kenya in East Africa, Mount Kinabalu in Borneo, and the Central Range of New Guinea, all of which support ranges of endemic plants.

Flooded grassland

Common to four of the continents, flooded grassland (as the name suggests) is a large expanse or complex of grassland flooded by either rain or river, usually as part of a seasonal cycle. These areas support numerous plants adapted to wet conditions. The Florida Everglades, for example, which contain the world's largest rain-fed flooded grassland, are home to some 11,000 species of flowering plants.

Below: Characteristic plants of montane grasslands display features such as rosette structures, waxy leaf or

1 Iris
2 Feverfew
3 Anemone
4 Yellow asphodel

FIELDS

Farmland, fields or paddocks are essentially an environment constructed by humans, who have altered the natural landscape for the purposes of agriculture. The general term 'pasture' describes grassland, rough grazing land and traditionally managed hay meadows.

Rough pasture

There are two types of pasture – permanent and rough. Permanent pasture is closed in, fertilized and sown with commercial grass species. It is often treated with herbicides that allow only a few species of grass to grow, so that it does not support a wide range of wildlife species. Rough pasture is usually much older and is typically land that is very difficult to plough so is left undisturbed.

Pasturelands owe their existence to farm livestock, and are very sensitive habitats that can easily be over- or undergrazed. They generally contain a single early stage of native vegetation, which is prevented from developing further by grazing; if the animals are removed, shrubs quickly establish and woodland develops soon afterwards. This is because many livestock animals graze very close to the ground and, while this does not damage grasses (which regrow from just above their roots), many taller plants cannot tolerate it. Grazing animals also

Above: California poppies and lupines form colourful swathes in North American grasslands.

remove nutrients from the environment so many traditional grassland areas are fairly infertile.

The wildflowers of pasture are species that grow low and thus avoid being eaten by animals. They may creep or form low rosettes of leaves and, although diminutive in general, they often have large, showy flowers that readily attract pollinators.

Below: Pasture that has been left undisturbed and unmanaged is full of life, some of which may be readily found only in that habitat.

Meadows

A true meadow is a field in which the grasses and other plants are allowed to grow in the summer and are then cut to make hay. The plants are cut while still green and then left in the field to dry. In many countries this has been the traditional method of providing feed for cattle during the winter. Hay meadows support a huge range of wild flowers, some of which have become extremely rare as traditional haymaking has been superceded by modern farming methods.

Crop fields

Many fields are used to grow crops other than grass, such as grains or vegetables. In these situations, weed species often find the conditions to their liking and thrive there. Many of these are annual flowers and some – such as cornflowers, *Centaurea cyanus*, or poppies, *Papaver rhoeas*, in wheat fields – are colourful additions to the agricultural landscape.

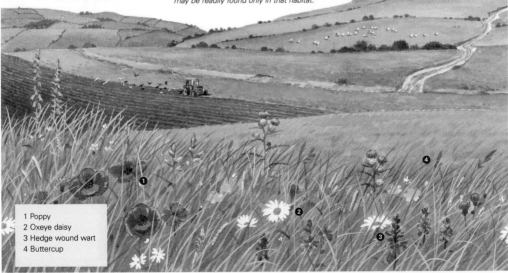

1 Poppy
2 Oxeye daisy
3 Hedge wound wart
4 Buttercup

HEATHS

Heaths are open landscapes that are usually treeless. Their vegetation consists largely of dwarf woody shrubs such as heathers. They are divided into two main types: upland heath (usually called moorland) and lowland heath.

Lowland heath

These habitats are under threat. They are restricted to the British Isles, northern Germany, southern Scandinavia and adjacent, mainly coastal, parts of western Europe, but equivalent vegetation types occur in cooler regions elsewhere in the world.

Lowland heath usually occurs where forest cover has been removed, usually as a result of human action, so to a large extent this is a habitat created by people. However, it can also occur on the drying surfaces of blanket bogs and fenland. In all cases, the soil under heathland is poor, with most of the nutrients having been leached from the topsoil by water. Heathland also occurs near the sea. Coastal heaths are more likely to be the result of natural factors such as the soil type and especially the exposure to high wind, which suppresses tree growth.

Above: Coastal heathlands are often exposed to high winds that cause a stunted growth.

Climate and soil

For lowland heath to occur, the climate must be 'oceanic', with relatively high annual rainfall (60–110cm/24–43in) spread evenly throughout the year. The relative humidity remains moderately high even in the driest months. Winters are rarely very cold and summers rarely get very hot.

The continuous rain seeping into and through the soil promotes leaching (the loss of plant nutrients) and soils are poor as a result. If forest establishes in these areas it does not suffer from this nutrient loss – trees can maintain virtually all their nutrients within the living vegetation. It is possible that slow nutrient loss from a forest ecosystem will eventually lead to a patchwork of forest, scrub and heath. Under normal circumstances, either grazing or fires are necessary to prevent the re-invasion by scrub or colonizer tree species.

Plant adaptations

The term 'heath' is derived from the heather plant, and heathers, *Erica* species, form a major part of the vegetation. Heathlands are mostly species-poor. All the species that are present in a given area ultimately look remarkably similar. In open and often windswept conditions all the species present will possess minute leaves with adaptations such as sunken stomata to minimize water loss through transpiration.

Below: Heathland is often species-rich despite the poor soils.

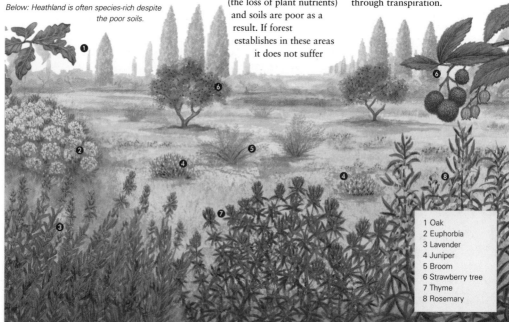

1 Oak
2 Euphorbia
3 Lavender
4 Juniper
5 Broom
6 Strawberry tree
7 Thyme
8 Rosemary

MOUNTAINS AND MOORLAND

Collectively, mountains and upland areas make up around 20 per cent of the world's landscape, and about 80 per cent of our fresh water originates in them. Upland heath, or moorland, occurs at altitudes above 300m/1,000ft in most temperate zones but may be found at much higher altitudes in the tropics.

Mountains

All mountain ranges feature rapid changes in altitude, climate, soil, and vegetation over very short distances. The temperature can change from extremely hot to below freezing in a matter of a few hours. Mountain habitats harbour some of the world's most unusual plants, and collectively they are home to a huge range of species. This diversity is due to their range of altitude, which results in distinct belts, or zones, of differing climates, soils and plantlife.

Vegetation on a mountain typically forms belts. This is because as the altitude increases the temperature steadily decreases – by about 2°C per 300m/3.5°F per 1,000ft. This, coupled with the thinning of the atmosphere, leads to unusually high levels of

ultraviolet light and means that as plants grow higher on the mountainside they need special adaptations to survive. Typically as the altitude increases the plant species become increasingly distinct.

Below: Mountains are often isolated habitats and may contain a unique diversity of species.

Left: Mountain vegetation often forms distinct belts according to the altitude.

Moorland and upland heath

The vegetation in moorland regions is similar in character to that of lowland heath, but it grows on deep layers of peaty or other organic soil. Moorland characteristically occurs below the alpine belt and (usually) above the tree line. It is typically dominated by dwarf shrubs, such as heather, over an understorey of small herbs and mosses.

Natural moorlands (those which are largely unmanaged by people) are generally diverse habitats, containing stands of vegetation at different stages of growth. Animal grazing and burning may be the only factors preventing them from developing into scrub or woodland.

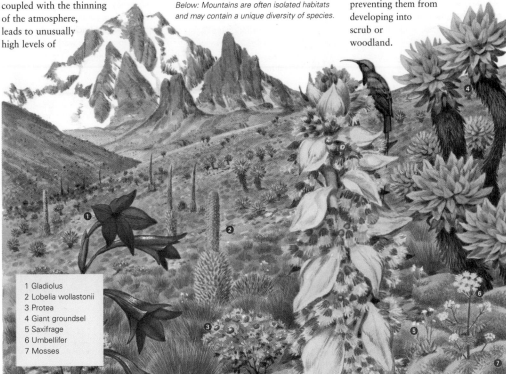

1 Gladiolus
2 Lobelia wollastonii
3 Protea
4 Giant groundsel
5 Saxifrage
6 Umbellifer
7 Mosses

TUNDRA AND ALPINE HABITATS

In the areas nearest the poles, and in the high mountainous places of the world, the conditions for plant growth become extreme. These cold, often frozen, environments present plants with a real challenge that only the hardiest species can withstand.

Cold places

The predominant habitat in the outer polar regions and on mountaintops is known as tundra. Although arctic and alpine (mountain) tundra display differences, they often support plants with similar adaptations.

Tundra is a cold, treeless area, with very low temperatures, little rain or snow, a short growing season, few nutrients and low species diversity. It is the coldest habitat to support plantlife.

Arctic tundra

The frozen, windy, desert-like plains of the arctic tundra are found in the far north of Greenland, Alaska, Canada, Europe and Russia, and also in some sub-Antarctic islands. The long, dry winters of the polar regions feature months of total darkness and extreme cold, with temperatures dipping as low as -51°C/-60°F. The average annual temperature is -12– -6°C/ 10–20°F. The annual precipitation is very low, usually amounting to less than 25cm/10in. Most of this falls as snow during the winter and melts at the start of the brief summer growing season. However, a layer of permafrost (frozen subsoil), usually within 1m/3ft of the surface, means that there is very little drainage, so bogs and ponds dot the surface and provide moisture for plants. The short growing season, when the sun gains enough strength to melt the ice, lasts for only 50–60 days. Ironically, the surface snow that marks the end of the growing season acts as an insulating blanket, ensuring that the plants do not freeze solid in winter.

The tundra supports communities of sedges and heaths as well as dwarf shrubs. Most of these plants are slow-growing and have a creeping habit, interweaving to form a low springy mass. This adaptation helps to avoid the icy winds and lessen the chances of being eaten by large grazing animals.

Above: Despite their harshness, tundra and alpine regions often support showy species.

Alpine tundra

Above the tree line and below the permanent snow line, alpine tundra is located high in mountains worldwide. In contrast to the arctic tundra, the soil of alpine tundra is very well drained and may become quite dry during the growing season, which lasts for about 180 days. Nighttime temperatures are usually below freezing.

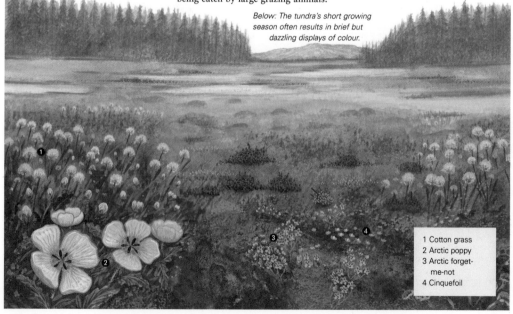

Below: The tundra's short growing season often results in brief but dazzling displays of colour.

1 Cotton grass
2 Arctic poppy
3 Arctic forget-me-not
4 Cinquefoil

CLIFFS AND ROCKY SHORES

Rocky coasts and cliffs occur where the underlying rocks are relatively resistant to the constant pounding
of the sea, rain and wind. They are found along coasts. Often the landscape is one of grandeur,
characterized by steep cliffs, rocky outcrops and small bays with deep, usually clear, offshore waters.

Coastlines

Rocky coasts are often quite exposed and the constant exposure to salt-laden winds, coupled with a shortage of soil in which plant roots can anchor themselves, reduces the range of plants to a few specialist species.

Cliffs

Coastal cliffs, especially those in exposed locations, are often drenched in salt spray as the sea is driven on to the shore. Plants that grow above the spray line, out of reach of the waves and regular salt spray, are likely to be salt-tolerant, whereas those on the beach at the bottom of a cliff, or in rock crevices that are sometimes washed by salt spray, must be tolerant of salt to survive. Plants rarely grow near the base of cliffs that rise directly from the sea because the high wave energy prevents them from becoming established.

Above: Many coastal plants, such as thrift, flower profusely despite their small size.

The exposure and lack of soil in all but the deeper rock crevices means that the plants that live on cliffs often face a similar challenge to those found in the higher rocky areas in mountain ranges. This is why they often show similar adaptations, such as deep roots, creeping or hummocky growth habit and the ability to withstand exposure and drought.

The rocky coast may include indentations known as fjords, formed by glaciers wearing away depressions that were subsequently flooded by the rising water following the end of the last ice age, 10,000 years ago. These fjords may have salt marshes at their head and may be surrounded by steep-sided wooded slopes, creating a rich and varied habitat.

Rocky shores

Bedrock outcrops and boulders dominate rocky shores. The lower zones of the rocks are flooded and exposed daily by the tides and support only marine plants, whereas the upper zones are flooded during unusually high tides or in strong storms. In spite of being frequently washed by seawater, salt-tolerant land plants survive here by being well rooted in crevices in the lower-lying rocks.

Below: The high winds of coastal regions mean that plants growing there are often short and ground hugging.

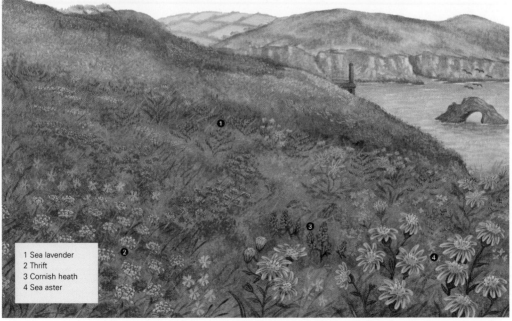

1 Sea lavender
2 Thrift
3 Cornish heath
4 Sea aster

BEACHES AND SAND DUNES

Coastlines are often areas of extreme biological diversity. Areas where one habitat meets another always offer an array of flora and fauna, as animals and plants from both habitats merge. Beaches may seem like the exception where plants are concerned, as they often have limited vegetation.

Beaches

Generally, beaches are made up of sand, gravel, cobbles (shingle) and fragments of seashells, corals or other sea creatures. The proportions of all of these vary from beach to beach. Level areas of sand that are exposed only during low tide are called sandflats. Although an amazing variety of animals thrive in this habitat, very few flowering plants survive, mainly because of wave action and the saltiness of seawater. Those that do grow on them usually occur near the high tide line.

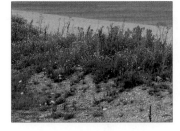

Above: The salty conditions and unstable sandy soil can be challenging for plants.

Above: The showy flowerheads of sea holly, Eringium Maritinum, are common on dunes.

Sand dunes

Usually occuring immediately inland from sandy beaches, sand dunes are found in many parts of the world but are less well developed in tropical and subtropical coastal zones, due to lower wind speeds and damper sand. There

are exceptions, however, such as the vast desert dune expanses of the Namib Desert in south-western Africa.

Sand is blown from the beach and initially accumulates in a characteristic steep windward face and more gently sloping leeward face. A change to dune meadow or dune heath eventually happens as grasses establish and stabilize the dune system, usually some

way inland. These dune slacks become dominated by low scrub, which rarely exceeds 90cm/3ft in height and is often much smaller. A few larger shrubby species are also capable of invading sand dunes to form scrub and can ultimately revert to woodland.

Below: Sand dunes are mobile, and may shift by several metres per year.

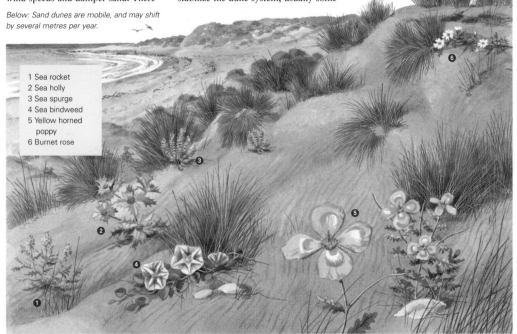

1 Sea rocket
2 Sea holly
3 Sea spurge
4 Sea bindweed
5 Yellow horned
 poppy
6 Burnet rose

RIVERSIDES AND WETLANDS

Wetlands are being lost at an alarming rate and many species that live in them are suffering. The habitats along rivers, waterholes and streams are critical landscapes: they help to maintain water quality and the shape and form of streams, as well as supporting species diversity in surrounding habitats.

Riversides

In their upper reaches, rivers are fast flowing with no vegetation in the water, although bankside vegetation is usually present. In the lower reaches, the water is calmer, and floating leaved and semi-aquatic plants can survive.

Riverside habitats are diverse. Grazed riverside pastures, flood meadows, marshes, reedbeds and riverine forest are common features beside many rivers, although the natural richness of the soil in the river flood plain has led people to cultivate and plant crops right to the edge of the

Below: Rivers are often home to a rich and varied selection of plant and animal life.

water in many regions. Rivers may also be altered, with their curves straightened and banks raised to create flood defences. All these factors mean that truly natural riverside habitats are scarce in areas of human occupation.

Wetlands

Marshes and flood meadows are low-lying wet areas that often flood on a seasonal basis. Reedbeds occur on land that is flooded for most of the year, often at the edges of lakes or in shallow lagoons, and often support a very diverse range of plants. Fens are areas where peat has been deposited over a long period and are often associated with extensive tracts of

Above: Reedbeds are often home to a rich diversity of plant and animal species.

marshes and reedbeds. They may contain large areas of open water and shallow, slow-flowing rivers, and are found on ground that is permanently, seasonally or periodically waterlogged.

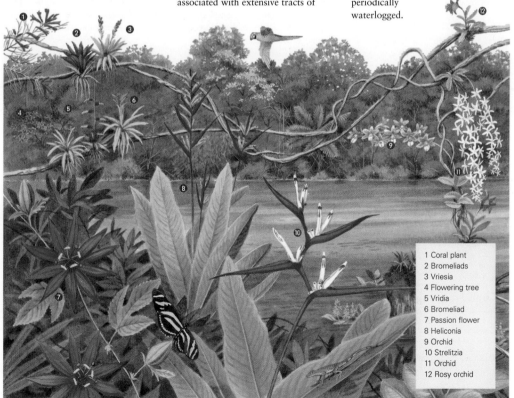

1 Coral plant
2 Bromeliads
3 Vriesia
4 Flowering tree
5 Vridia
6 Bromeliad
7 Passion flower
8 Heliconia
9 Orchid
10 Strelitzia
11 Orchid
12 Rosy orchid

ESTUARIES, SWAMPS AND COASTAL MARSHES

Rivers eventually end by flowing out into the sea. As the river slows, the material that it has carried in the water is deposited, and sedimentary deltas, wetlands, lagoons, salt marshes and swamps may be formed.

River mouth habitats are usually extremely diverse and include abundant and rare species.

Deltas

A delta is formed where a river flows into a calm sea. As the river slows down it drops its sediment, which builds up over years to create a delta. Over time, the river splits into smaller channels called distributaries. Occasionally this can happen inland where a river flows into a low-lying basin. It forms an immense low-lying wetland, such as that of the Okavango Delta in Botswana, Africa.

Below: Tropical and sub-tropical marshlands are home to many beautiful plant species.

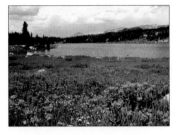

Above: Saltwater marshes are among the most productive habitats on earth.

Marshes and swamps

Salt marshes are made up of plant communities that are tolerant of being submerged for short periods by the tide. They can be 'transitional zones', which merge with nearby areas of reed swamp, sand dune, shingle, freshwater wetland or woodland, and are particularly rich in a wide variety of

plants. They are often brackish (less salty than the sea but saltier than the river) and may contain a mixture of riverside and coastal vegetation types.

The term 'swamp' is usually applied to warm, wet areas that are teeming with both animal and plant life. They are often (but by no means always) heavily forested, with trees that are highly adapted to waterlogged ground. Some of these areas may be very extensive and include both coastal and freshwater habitat, such as are found in the Florida Everglades.

Mangroves are marine tidal forests that are generally most luxuriant around the mouths of large rivers or sheltered bays, growing in both salt and freshwater. They are found mainly in the tropics where annual rainfall is fairly high.

1 Bald cypress
2 Floating hearts
3 Scarlet ladies tresses
4 *Thalia dealbata*
5 Sawgrass
6 Palmetto
7 Water spider orchid
8 Ghost flower orchid
9 Night fragrance orchid
10 Golden club
11 Water lettuce

OPEN WATER

Flowering plants face possibly their biggest challenge in open water. Plants living in this environment must be able to survive either submerged beneath or floating on the surface of a body of water, and all are specially adapted to allow them to do this.

Obtaining sufficient oxygen is the greatest problem facing plants that live in water. The muddy sediment at the water bottom has few air spaces, and therefore barely any oxygen present.

Lakes and ponds
A lake describes any large body of fresh water, ranging from small ponds to huge bodies of water. They can be an extremely variable habitat, ranging from almost lifeless, acidic mountain tarns to lowland lakes teeming with life. Lakes are closely associated with rivers, chiefly because some lakes are the source for rivers. Both are fresh

Below: Although certain plant species have evolved to live in the water, the richest diversity occurs where land and water meet.

Above: Open water is a challenging habitat for plants to survive in.

water and share similar characteristics, and many species are common to both habitats.

A pond is a body of water shallow enough to support rooted plants, which in time may grow all the way across it.

Slow-flowing rivers and streams
When rivers flow slowly they may support aquatic plants in a similar way to lakes. Plants that grow in slow-flowing rivers will be species that are able to root into the bottom sediment, to stop them being washed away.

As the river runs more slowly it warms up, favouring plant growth, though in areas where the banks are tree-lined this can reduce plant growth in the water. Some river plants are only semi-aquatic, growing out of the water on the bank when the stream dries up, before being re-flooded during rainy seasons.

1 Great willow herb
2 Flowering rush
3 Branched bur weed
4 Water crowfoot
5 White water lilies
6 Reed sweet grass
7 Yellow flag iris
8 Marsh marigold
9 Hemlock water
 dropwort
10 Marsh thistle
11 Bullrush

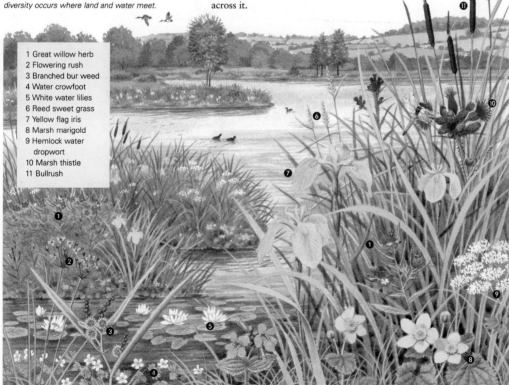

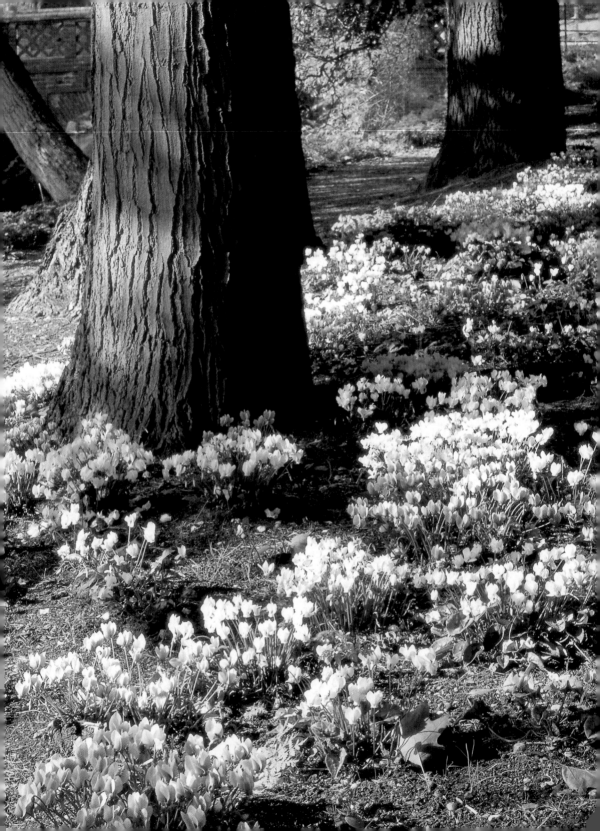

WILD FLOWERS OF THE WORLD

Learning to identify wild flowers can be a fascinating pastime. It is something that you can do practically anywhere and is a vital first step in helping you to understand more about the natural habitats in an area. Every flowering plant has specific characteristics that you can learn to recognize. It is simply a matter of practice and once you learn the basics you can quickly become hooked.

It would be impossible to include every flowering plant in a single book of any size: more than 245,000 species of flowering plants are "known" to science, and many of these are rare or inconspicuous. The sections that follow show some of the commoner types of flowering plants found worldwide. Each of the represented species is accompanied by a description to help you identify the plant and better understand how and where it lives. As well as the common species others have been included which, although they are less abundant, show some of the fascinating traits that have led to flowering plants becoming the most successful and diverse group of plants that have ever lived on earth.

Left: Cyclamen are hardy plants with attractive leaves that are visible for much of the year in northern Europe. The flowers appear en masse from late winter into spring.

HOW TO USE THE DIRECTORY

The directory of flowers that follows the introduction includes a diverse selection of the most beautiful, wild flowers. The information below shows you how to use the directory.

The plant kingdom can be divided into two major groups: flowering plants that produce seeds (known as "higher plants") and those that do not flower, but instead produce spores (sometimes called "lower plants"). The latter group includes the mosses, liverworts, ferns and their allies. Though many of these plants are important components of habitats worldwide, it has not been possible to feature this latter group here. Among the flowering plants, the gymnosperms (conifers and cycads) have been omitted. The choice made for this book concentrates on the

showy specimens that may be encountered in the wild, but also aims to illustrate the tremendous diversity of flower forms in the world.

The plants featured fall into two groups – the dicotyledonous plants are the large group, so-named because their seed has two distinct cotyledons, or embryonic leaves. The second group, the monocotyledons, contains plants that have only one seed leaf. The two groups differ evolutionarily, but both contain stunning examples of wild flower diversity.

How the directory is organized

The flowers are arranged according to their families, then genus and then species. Each family features four main plants, and up to four other flowers of note contained within a tinted box.

The introduction to each family describes common characteristics.

Each main entry discusses the primary characteristics of the plant. Wherever possible, this includes some helpful information about the type of habitat that the plant may be found in and may include other interesting facts about the species, how it interacts with wildlife and how people have used or exploited it over time. Any technical terms used in this description are supported by the glossary at the back of the book. It is followed by a detailed description to aid identification together with an accurate watercolour. A tinted box on the page describes other wild flowers of interest within the same family. Coloured maps show, at a glance, the natural distribution of the wild flowers.

Plant Family

Each wild flower belongs to a plant family. The directory of flowers is mostly arranged according to family. Each family shares a group of common characteristics, though visually the plants may seem quite different.

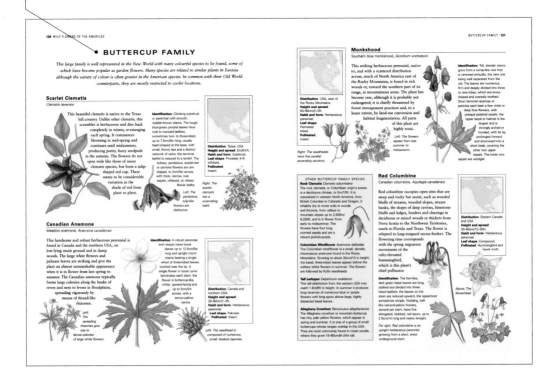

Other Common Name(s)
Some wild flowers have different common names in other regions and countries. These are listed underneath its primary common name.

Common Name
This is the most popular, non-scientific name for the wild flower entry.

Botanical Name
This is the internationally accepted botanical name for the wild flower entry. It is always in Latin.

Introduction
This provides a general introduction to the wild flower and may include information on usage, preferred conditions, and other information of general interest.

Identification
This description will enable the reader to properly identify the wild flower. It gives information on flower and leaf shape, size, colour and arrangement, and type of flower.

Canadian Anemone
Meadow anemone, *Anemone canadensis*

This handsome and robust herbaceous perennial is found in Canada and the northern USA, on low-lying moist ground and in damp woods. The large white flowers and palmate leaves are striking and give the plant an almost unmistakable appearance when it is in flower from late spring to summer. The Canadian anemone typically forms large colonies along the banks of rivers and next to levees in floodplains, spreading vigorously by means of thread-like rhizomes.

Left:
The spreading rhizomes give rise to dense colonies of large white flowers.

Identification: A robust perennial, with deeply lobed basal leaves up to 12.5cm/5in long and upright round stems bearing a single whorl of three-lobed leaves, toothed near the tip. A single flower or loose cyme terminates each stem: the flower is buttercup-like, white, upward-facing and up to 5cm/2in across, with a lemon-yellow centre.

Distribution: Canada and northern USA.
Height and spread: 30–60cm/1–2ft.
Habit and form: Herbaceous perennial.
Leaf shape: Palmate.
Pollinated: Insect.

Left: The seedhead is composed of numerous, small, beaked capsules.

Habit
The habit is the way in which a plant grows. For example, it could have an upright, sprawling or rambling habit.

Profile
The profile is a botanically accurate illustration of the plant at its time of flowering.

Plant Detail
A small detail shows an important identifying feature of the plant.

Distribution: Canada and northern USA.
Height and spread: 30–60cm/12–24in.
Habit and form: Herbaceous perennial.
Leaf shape: Palmate.
Pollinated: Insect.

Pollinated
Flora can be pollinated by many different animals and insects, as well as by the action of air.

Map
The map shows the area of natural distribution of the featured plant. The relevant area is shaded in yellow. The natural distribution shows where in the world the plant originated. It does not mean that this is the only place where the plant now grows.

Distribution
This describes the plant's natural distribution throughout the world.

Height and spread
Describes the average dimensions the plant will grow to given optimal growing conditions.

Habit and form
Describes the plant type and shape.

Leaf shape
Describes the shape of the leaf.

Other family species of note
The flora featured in this tinted box are usually less well-known species of the family. They are included because they have some outstanding features worthy of note.

Species names
The name by which the plant is most commonly known is presented first, followed by the Latin name and any other common name by which the plant is known.

Entries
The information given for each entry describes the plant's main characteristics and the specific features it has that distinguish it from better known species.

● OTHER BUTTERCUP FAMILY SPECIES
Rock Clematis *Clematis columbiana*
The rock clematis, or Columbian virgin's-bower, is a deciduous climber, to 3m/10ft. It is naturalized in western North America, from British Columbia to Colorado and Oregon. It inhabits dry to moist soils in woods and thickets, from valleys to mountain slopes up to 2,500m/8,200ft, and is in flower from early to midsummer. The flowers have four long, pointed sepals and are a vibrant pinkish-purple.

● **Columbian Windflower** *Anemone deltoidea*
The Columbian windflower is a small, slender, rhizomatous anemone found in the Rocky Mountains. Growing to about 30cm/1ft in height, the basal, three-lobed leaves appear before the solitary white flowers in summer. The flowers are followed by fluffy seedheads.

Tall Larkspur *Delphinium exaltatum*
This tall delphinium from the eastern USA may reach 1.8m/6ft in height. In summer it produces long racemes of numerous blue or purple flowers with long spurs above large, highly dissected basal leaves.

Allegheny Crowfoot *Ranunculus allegheniensis*
The Allegheny crowfoot or mountain buttercup has tiny, pale yellow flowers, which appear in spring and summer. It is one of a group of small buttercups whose ranges overlap in the USA. They are most commonly found in moist woods, where they grow 15–60cm/6–24in tall.

WILD FLOWERS OF EURASIA AND AFRICA

 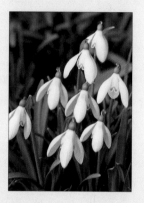

Europe, Africa and Asia, are collectively described as the "Old World", to
differentiate this region from the "New World" – the name that was
given to the newly discovered Americas. The botanical diversity of the
Old World regions is huge, with some of the best-known and most
spectacular flowers gracing their lands. Even so, vast tracts of the
continents of Europe, Asia and Africa remain largely unexplored, and
botanists have only a sketchy idea of the plants that live in those areas.
However, these continents are home to around two-thirds of the world's
human population and the consequent pressure on natural habitats
increases almost daily.

Above from left: Wild carrot (Daucus carrota), greater masterwort (Astrantia major) and snowdrops (Galanthus nivalis).

Svalbard

Severnay
a Zemlya

New
Siberian
Islands

Novaya
Zemlya

Iceland

Sweden
Norway Finland
European
Russia

Asiatic
Russia

United Denmark
Kingdom Belarus
Ireland Germany Poland
France 7 8 4 Ukraine
 5 6
 12 Romania
 9
 10
 11 Turkey
Spain Italy
Portugal
Morocco Tunisia
Algeria Libya Egypt
Mauritania
Mali Niger Chad Sudan
Nigeria C.A.R
Senegal Congo
Guinea Togo.
Ivory Coast
Ghana
Cameroon Angola
Gabon
Namibia Zimbabwe
Botswana
South
Africa

Uzbekistan Kazakhstan Mongolia
Turkmenistan N. Korea
 S. Korea Japan
Syria Iraq Iran Afghanistan China
Israel Taiwan
Lebanon Pakistan
Jordan Saudia India Myanmar
Saudia Arabia Oman Thailand Vietnam
Yemen Cambodia Philippines
Ethiopia Malaysia
Kenya Somalia Indonesia Papua New
Tanzania Guinea
Zambia Mozambique
Madagascar

1 Estonia
2 Latvia
3 Lithuania
4 Czech Republic
5 Austria
6 Hungary
7 Belgium
8 Netherlands
9 Yugoslavia
10 Bulgaria
11 Greece
12 Switzerland

BUTTERCUP FAMILY

There are around 1,800 species in the buttercup family (Ranunculaceae), and they are found mainly in the colder regions of the world. Many are well-known wild flowers, while some are more familiar as garden flowers. The group includes buttercups, anemones, delphiniums, aquilegias and clematis. Some genera are poisonous. Nearly all the buttercup family are herbaceous – clematis is the only woody genus.

Columbine

Culverwort, Granny's bonnet, *Aquilegia vulgaris*

A familiar plant because it is often seen as a garden escapee, columbine typically grows in light and medium soils and always prefers a moist situation. It is highly adaptable and can grow in full sun, the dappled shade of light woodland or in semi-shade.

Identification: A variable plant with stems branched in the upper parts to support numerous nodding, scented flowers, 2.5–4cm/1–1½in, usually blue, with spreading sepals, behind which are very short, strongly hooked spurs. It is in flower from mid-spring to midsummer. The leaves are mainly basal, dark green flushed blue, and much divided.

Far left: The distinctive flower-heads are held above the mainly basal foliage.

Right: The seedhead splits at the top to disperse seeds when rocked by breezes.

Far right: Aquilegia *self seeds and spreads quickly. It has a rangy habit.*

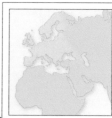

Distribution: Europe.
Height and spread: 30–70 x 50cm/12–28 x 20in.
Habit and form: Herbaceous perennial.
Leaf shape: Compound trifoliate.
Pollinated: Bee, particularly bumblebee.

Meadow Buttercup

Tall crowfoot, *Ranunculus acris*

The golden-yellow spring flowers of the European buttercup are a common sight across its natural range, but it is also widely naturalized in eastern North America, through agricultural importation. It is common in damp grassland, on roadsides and in high pastures. Unlike the equally common creeping buttercup, *R. repens*, the meadow buttercup reproduces solely by seed rather than by runners (spreading overground stems that root at the leaf joints as they touch the ground) and so forms clumps.

Identification: A tall erect herb with smooth or slightly hairy flower stalks that are held high above the foliage. The lower leaves are strongly divided into three to seven lobes. They are toothed, hairy and occasionally marked with black, with none of the lobes stalked. The showy yellow flowers are to 2cm/¾in across, with five rounded, glossy petals, which are produced in great profusion from late spring to early autumn. The sepals are pressed flat against the flower, not downturned. The fruits are rounded, with short, hooked beaks.

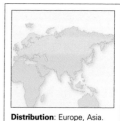

Distribution: Europe, Asia.
Height and spread: 30–90cm/1–3ft.
Habit and form: Herbaceous perennial.
Leaf shape: Palmate.
Pollinated: Insect.

Above left: The small distinctive spiky round fruits swell as soon as the petals drop.

Left: The foliage is mostly basal. The flowerheads are held above this on stout, sparsely leaved stems.

Right: The distinctive sunshine-yellow flowers of the buttercup are held aloft singly, on long thin stems.

Lenten Rose

Hellebore, *Helleborus orientalis*

This highly variable plant grows in shade or semi-shade in deciduous woodland on lower mountain slopes. There is much uncertainty as to the number of subspecies. The fact that it is such a beautiful and reliable flower of winter and early spring has resulted in its widespread cultivation, with many cultivars and hybrids being grown in gardens. As a result, it commonly occurs as a garden escapee, often way beyond its original natural distribution.

Distribution: Eastern Europe to western Asia.
Height and spread: 45cm/18in.
Habit and form: Evergreen perennial.
Leaf shape: Palmate.
Pollinated: Insect.

Identification: Smooth or slightly hairy stems rise from a stout rhizome. The large, leathery, evergreen leaves are mainly basal, divided into seven or nine lance-shaped segments with highly serrated edges and purple stalks. The branched flower stalks bear one to four nodding or outward-facing, saucer-shaped, unscented flowers, each 6–7cm/2¼–2¾in across. The overlapping petals are cream tinged green flushed with purple, gradually changing to green following fertilization, with green nectaries and wide, funnel-shaped green anthers. The nodding, saucer-shaped blooms appear from late winter onward, before the new foliage.

Left: The flowerheads droop.

Above: Lenten roses flower in winter.

OTHER BUTTERCUP FAMILY SPECIES
Pheasant's Eye *Adonis annua*
This annual, also known as the flower of Adonis, grows to a height and spread of 15–30cm/6–12in. It forms clumps of green, fern-like foliage topped with deep red, anemone-like flowers in summer, chiefly on cultivated land.

Winter Aconite *Eranthis hyemalis*
This clump-forming tuberous perennial from central Europe may form quite large colonies. In late winter or early spring it produces bright yellow flowers 2–3cm/¾–1¼in across, each borne above a ruff of dissected, bright green leaves.

Monkshood
Aconitum napellus
Monkshood is a variable, erect perennial, common across much of northern and central Europe. In mid- to late summer the tall, erect flowering stems bear dense racemes of indigo-blue flowers, held above the rounded, deeply lobed, dark green leaves.

Pasque Flower *Pulsatilla vulgaris*
This clump-forming perennial is found chiefly on free-draining chalky or alkaline soils across much of Europe. The finely divided, feathery, light green leaves are very hairy when young and are topped in spring with upright or semi-pendent, silky, purple flowers.

Delphinium

Larkspur, *Delphinium elatum*

Delphiniums were so named by the ancient Greeks, who thought the shape of the flower bud resembled a dolphin. The flowers appear from early to late summer, and are mostly blue, occasionally pinkish or whitish, arranged loosely around almost the entire length of the flower spike, on robust upright stems. In Tudor England, some species in cultivation were called larkspur because the nectary looked similar to a lark's claw. The plant is encountered on roadsides and in fields, usually as a garden escapee.

Identification: The large rounded leaves are fairly deeply divided into five to seven or more coarsely toothed lobes. Each flower is 2.5–4cm/1–1½in long and up to 2.5cm/1in wide, with golden filaments in the centre and five petal-like sepals, the rear one elongated into a long, slender, curving spur; the two upper petals are united. The fruits are erect, smooth pods tipped with short beaks, open on one side.

Far right: The flower spikes are impressive, held above the foliage.

Distribution: Central and eastern Europe.
Height and spread: 90–120 x 30–60cm/3–4 x 1–2ft.
Habit and form: Herbaceous perennial.
Leaf shape: Palmate, lobed.
Pollinated: Chiefly bee.

Below: Delphinium flower spikes are made of many flowerheads.

ROSE FAMILY

The rose family (Rosaceae) includes trees, shrubs and herbs and comprises about 100 genera and 3,000 species. Most members of the family have similar flowers, commonly with five petals and numerous stamens, but their fruiting arrangements vary considerably. The rose family includes some of our best-known wild flowers and has many showy flower species in its ranks.

Sweet Briar

Eglantine, *Rosa rubiginosa*

This rose is noted for its flowers and also for the unique aroma of its leaves, which are particularly fragrant after rain. Strangely, while the leaves are so fragrant, the flowers are almost entirely without scent. It is most commonly found in open copses and old hedgerows, usually on limy soils, and will sometimes colonize chalk grassland. Because of its apple-scented foliage the sweet briar has held a cherished place in many old-fashioned gardens.

Left: Sweet briar forms an open, spreading shrub on chalky soils.

Right: Each bloom lasts a few days. New ones replace them over a period of weeks.

Identification: The sweet briar is a vigorous, arching, prickly stemmed, deciduous shrub. The leaves are dark green, with five to nine oval leaflets 2.5–4cm/1–1½in long, with a finely toothed margin. Cupped, single flowers up to 2.5cm/1in across, usually bright rose pink, appear in early to midsummer, and are followed by oval to spherical, orange-scarlet hips in late summer.

Distribution: Europe, North Africa to western Asia.
Height and spread: 2.5m/8ft.
Habit and form: Deciduous shrub.
Leaf shape: Pinnate.
Pollinated: Bee, fly, moth and butterfly.

Right: The bright red hips often last well into the winter.

Japanese Quince

Chaenomeles speciosa

The Japanese quince is noteworthy for the fact that it commences its flowering before the leaves emerge and can be in flower in late winter. It should not be confused with the related genus *Cydonia*, which is the source of the cultivated quince fruit. The plant tolerates a wide range of soils, although it prospers best in moist, well-drained soil.

Identification: A vigorous, deciduous, spreading shrub with tangled, spiny branches and oval, glossy, dark green leaves 4–9cm/1½–3½in long. In spring the branches bear clusters of two to four scarlet to crimson, five-petalled, cupped flowers, up to 4.5cm/1¾in across. The flowers are borne on bare stems and may continue well into the spring, after the foliage has emerged, followed by aromatic, green-yellow fruit.

Distribution: East Asia and China, but long cultivation has obscured its natural habitat.
Height and spread: 3 x 5m/ 10 x 16ft.
Habit and form: Deciduous shrub.
Leaf shape: Ovate.
Pollinated: Bee.

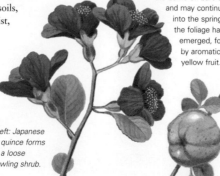

Left: Japanese quince forms a loose sprawling shrub.

Left: Despite the name, this quince does not yield sweet fruit like the cultivated form of Cydonia oblongata.

Blackberry

Bramble, *Rubus fruticosa*

An extremely common plant, the fast-growing bramble is found in hedgerows, woodland, meadows and on waste ground. Its blossoms and fruits (both green and ripe) may be seen on the bush at the same time, which is an unusual feature. Blackberries have a tremendous range of site and soil tolerances and can grow in full shade (deep woodland), semi-shade (light woodland), or in sun. They can tolerate drought and strong winds but not maritime exposure. Opinions differ as to whether there is one true blackberry with many aberrant forms, or many distinct types.

Distribution: European origin, but transported worldwide by humans.
Height and spread: 3m/10ft.
Habit and form: Deciduous shrub.
Leaf shape: Variable, palmate lobed or pinnate.
Pollinated: Insect, can self-pollinate.

Identification: The leaves are borne on long, arching, tip-rooting stems. Brambles often form dense, impenetrable thickets along hedgerows or woodland margins. All blackberries have five-petalled, saucer-shaped, pink or white flowers, which appear in great profusion between late spring and early autumn, followed by tight clusters of black, spherical fruits.

Above: The stems carry thorns.

Far left: the blackberry forms an untidy, layered and spreading thicket.

Left: the berries ripen from midsummer onwards.

OTHER ROSE FAMILY SPECIES

Dog Rose *Rosa canina*
The dog rose flowers in early summer. Its general habit can be quite variable. The single flowers vary widely from almost white to a very deep pink, with a delicate but refreshing fragrance. The hips are produced in autumn.

Shrubby Cinquefoil *Potentilla fruticosa*
This deciduous shrub, with a height and spread of about 120cm/4ft, is in flower from early to midsummer. The yellow flowers are dioecious and are pollinated by bees and flies.

Scarlet Geum *Geum coccineum* 'Borsii'
The moisture-loving scarlet avens originates in the Balkans and northern Turkey. A compact, clump-forming plant, it is noteworthy for its display of beautiful orange-scarlet flowers with prominent yellow stamens, on 30cm/12in stems, in late spring to late summer.

Mountain Avens *Dryas octopetala*
The small mountain avens is distinguished from all other plants of the Rosaceae by its oblong, deeply cut leaves, which have white downy undersides, and by its large, handsome, anemone-like white flowers, which have eight petals. It blooms in midsummer.

Dropwort

Filipendula vulgaris

This tall, scented, vigorous perennial of dry soils is easily confused with meadowsweet, *F. ulmaris*, which prefers damp or seasonally waterlogged grassland. Dropwort prefers alkaline soil and cannot grow in the shade; for this reason it can sometimes be found growing at the base of an old wall. The plant is especially noted for attracting wildlife.

Identification: The abundant, fern-like dark green leaves are finely divided, toothed and hairless, with eight or more leaflets, each about 2cm/¾in long. In early and midsummer, slender, branching stems bear loose clusters, to 15cm/6in across, of white, rather sweetly scented, often red-tinged flowers. The seeds ripen from midsummer to early autumn.

Above: Each flower gives rise to tiny fruits from mid-summer onward.

Far right: The flower-heads are sweetly scented and noted for attracting wildlife.

Distribution: Northern Eurasia.
Height and spread: 75 x 40cm/30 x 16in.
Habit and form: Herbaceous perennial.
Leaf shape: Pinnate.
Pollinated: Insect, can self-pollinate.

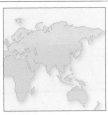

Below: Dropwort forms a tall and attractive clump of flowering stems above the fern-like foliage.

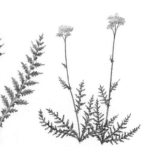

LEGUMES

The Papilionaceae, or legumes, are so-named because of their butterfly-shaped flowers, are found in temperate and tropical areas. Ecologically, legumes are well known for fixing nitrogen in the soil through a symbiotic relationship with bacteria, which infect the roots: the plant supplies sugars for the bacteria, while the bacteria provide the biologically useful nitrogen absorbed by the plant.

Black Medick

Medicago lupulina

This common roadside plant resembles clover until the yellow flowers appear, but is distinguishable when not in flower by the extra long stalk of the middle leaflet or by the black seeds that follow flowering. It tolerates a wide range of soils but prefers well-drained ground and is common in fields and dry downland. It is one of the plants identified as shamrock and worn by the Irish to celebrate St Patrick's Day.

Identification: The leaves of this prostrate plant are three-lobed, light to mid-green with slightly serrated ends and occasional black markings. The small, pale yellow flowers emerge from the leaf axils and appear from mid-spring to late summer. They are self-fertile and are followed by small black, slightly coiled seedheads, which ripen from midsummer to early autumn.

Above: The small yellow flowers of black medick emerge from the leaf axils and often appear at the same time as the tightly coiled seedheads.

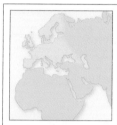

Distribution: Europe.
Height and spread: 45cm/18in.
Habit and form: Creeping herbaceous perennial.
Leaf shape: Trifoliate.
Pollinated: Insect.

Right: The small, black, slightly coiled seedheads are the feature of this plant that lead to its common name of black medick.

White Clover

Trifolium repens

This small creeping perennial is common in many grassland situations such as fields, pasture and lawns where it often forms extensive patches. It is most easily identified by the numerous erect white flowerheads that appear just above the grass. In many areas this very variable species is derived from cultivated stock rather than native plants, chiefly because of its inclusion in agricultural grass seed mixes. It is extremely common across much of Eurasia and has been spread further through agriculture. It is often mistaken for red clover, *T. pratense*, as its flowers can be tinged pink, but they lack leaves close below the flowerhead.

Identification: The prostrate stems creep extensively, rooting as they go, and white clover often forms large mats in grassy places. The leaves are trifoliate, with oval leaflets, generally about 1.5cm/⅝in across, usually with a whitish band encircling the base. The flowerheads are held on erect, leafless stalks 20–50cm/8–20in tall; they are generally white, sometimes pink-tinted, and contain up to 100 florets. The flowers persist, turning brown, to enclose the brown pods of one to four seeds.

Distribution: Eurasia.
Height and spread: 20–50cm/8–20in; indefinite spread.
Habit and form: Creeping herbaceous perennial.
Leaf shape: Trifoliate.
Pollinated: Bee.

Above: The flowers droop and turn brown once fertilized and enclose the small seedpods.

Cancer Bush

Kankerbos, balloon pea, *Sutherlandia frutescens*

A curious South African plant, the cancer bush is an attractive, small, soft-wooded shrublet that occurs naturally throughout the dry parts of southern Africa. The leaves, which have a very bitter taste, are made into tea to alleviate a variety of ailments, including stress, depression, anxiety and stomach problems. The lightweight, papery, inflated seedpods enable the seed to be dispersed easily by wind, giving rise to the common name of balloon pea.

Distribution: South Africa.
Height and spread: 50–100cm/20–39in.
Habit and form: Shrub.
Leaf shape: Pinnate.
Pollinated: Sunbird.

Identification: The pinnate leaves, with leaflets 4–10mm/⅛–⅜in long, are grey-green, giving the plant a silvery appearance. The bright scarlet flowers, up to 3cm/1¼in long, are carried in short racemes at the ends of the branches from late spring to midsummer. The fruit is a large, bladder-like pod, which is almost transparent.

Right: The attractive, bright scarlet flowers are followed by the inflated papery seed pods that can be blown off and carried in the wind.

OTHER LEGUMES OF NOTE

Hare's Foot Clover *Trifolium arvense*
This upright species grows up to 20cm/8in tall, with spreading leaves. The trefoil leaves have stipules with long spiny points. The large, mostly pink, cylindrical flowerheads are covered in soft, creamy-white hairs.

Gorse *Ulex europaeus*
An evergreen shrub from the Atlantic margin of Europe, introduced to and spreading in many parts of the world. It grows quickly on rough open ground, and has a very long flowering period, with abundant golden-yellow, scented flowers clothing the spiny branch tips.

Pride of the Cape *Bauhinia galpinii*
This medium to large clambering shrub grows in the moister areas of the southern African veldt, climbing through other trees and shrubs in dense vegetation. It has evergreen foliage and brick-red, orchid-like flowers in summer.

Everlasting Pea *Lathyrus sylvestris*
This perennial climber is widespread over most of Europe, and has stems up to 2m/6½ft long. Each leaf has one pair of leaflets and ends in a branching tendril. Large pink- and-red flowers appear on very long flower stems.

Tufted Vetch

Vicia cracca

A widespread and common climber, the tufted vetch favours grassy places, hedgerows, scrub, thickets and field boundaries. Its flower-laden stems festoon the hedgerows and long grasses of wayside places, attached by means of tendrils. It is quite variable across its range, especially in the shape and hairiness of the leaves, and is easily confused with similar species.

Identification: This scrambling perennial grows from a creeping rhizome, with angular, softly hairy stems. The pinnate leaves comprise up to 12 pairs of narrow, oblong leaflets, usually with hairy undersides, and end in a branched tendril. Flower spikes up to 4cm/1½in long, with 10–40 bluish-purple flowers in dense clusters on one side of the stalk, appear from early to late summer. They are followed by flattened, brown seedpods, 1–2.5cm/⅜–1in long, on short stalks.

Right: Each cluster has numerous purple flowers.

Far right: Tufted vetch has a scrambling habit.

Distribution: Europe.
Height and spread: Up to 2m/6½ft.
Habit and form: Climbing herbaceous perennial.
Leaf shape: Pinnate.
Pollinated: Insect.

CABBAGE FAMILY

The Brassicaceae, or cabbages, are herbs or, rarely, subshrubs. The family includes familiar food plants such as cabbage, cauliflower, broccoli, Brussels sprouts, kohlrabi and kale, which have all been derived from a single wild plant through human selection. Members of the cabbage family are found throughout temperate parts of the world, with the greatest diversity in the Mediterranean region.

Honesty

Money plant, Silver dollar, *Lunaria annua*

Honesty can often be encountered in uncultivated fields across much of Europe, although most of the plants seen in the vicinity of human habitation are probably garden escapees. The eye-catching spring blooms are rich in nectar and therefore popular with butterflies. Later in the year the plant produces masses of attractive, translucent, silvery seedpods, which are used in floral arrangements.

Identification: The plant has stiff, hairy stems and heart-shaped to pointed leaves, coarsely toothed and up to 15cm/6in long. The cross-shaped flowers appear in mid- to late spring, borne in broad, leafy racemes up to 18cm/7in long. The green seedpods are 2.5–7.5cm/1–3in across, flat and circular and firmly attached to the stems. The large seeds are strongly compressed in two rows. A thin, translucent wall is formed between the two valves of the pod during the ripening process, creating the classic "silver penny" when the seeds disperse.

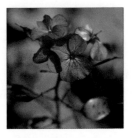

Above: The flowers are pink-purple and occasionally white.

Right: The cross-shaped flowers are in loose clusters above the leaves.

Far right: The seedpods are flat and papery.

Distribution: South-east Europe and western Asia.
Height and spread: 60–90 x 30cm/24–36 x 12in.
Habit and form: Annual or biennial.
Leaf shape: Cordate-acuminate.
Pollinated: Insect.

Wallflower

Erysimum cheiri

The wallflower is very widely distributed, though it is actually a garden escapee across much of its range. It is thought to have been the result of a cross between two closely related species from Greece and the Aegean region, but this ancestry is obscure and the plant is now regarded as a species in its own right. It requires good drainage and can grow in nutritionally poor and very alkaline soil, so it is often seen colonizing old walls. It tolerates maritime exposure.

Identification: This shrubby, evergreen, short-lived perennial is in flower from mid-spring to early summer. It forms mounds of stalkless, narrow, spear-shaped, dark green leaves, to 23cm/9in long, the margins of which are smooth or have well-spaced teeth. Open, sweetly scented, bright yellow-orange flowers, up to 2.5cm/1in across, are produced in short racemes in the spring.

Distribution: Southern Europe, but widely naturalized.
Height and spread: 25–75 x 30–40cm/10–30 x 12–16in.
Habit and form: Partly woody subshrub.
Leaf shape: Lanceolate to obovate.
Pollinated: Bee and fly.

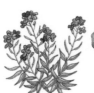

Far left: Wallflower has an open habit.

Left: The flowers are cross-shaped.

Left: The short, dense inflorescence is very attractive when it appears in the spring.

Hoary Stock

Matthiola incana

Distribution: Europe.
Height and spread: 60 x 30cm/24 x 12in.
Habit and form: Short-lived, slightly woody perennial.
Leaf shape: Lanceolate or linear lanceolate.
Pollinated: Insect, especially butterfly.

Hoary stock often resembles a wallflower growing on chalk cliffs and beside roads, where it could easily be mistaken for a garden escapee. It is the parent of the garden stocks. The flowers are highly fragrant and are said to smell of cloves. The plant prefers well-drained alkaline soils and can tolerate maritime exposure, actually prospering best in a cool, moist environment such as sea cliffs. This attractive species is noted for its tendency to attract insects, especially butterflies and bees.

Right: The long, cylindrical seed pods ripen in late summer and split along their length to disperse the seeds.

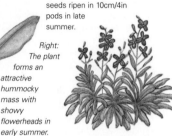

Identification: A woody-based perennial or subshrub with narrow, grey-green to white hairy leaves, which are 5–10cm/2–4in long, and are mostly entire but occasionally deeply segmented or lobed. The upright racemes of sweetly scented flowers, mostly mauve or purple but also occasionally violet, pink or white, up to 2.5cm/1in across, are borne from late spring to midsummer, and the seeds ripen in 10cm/4in pods in late summer.

Right: The plant forms an attractive hummocky mass with showy flowerheads in early summer.

OTHER CABBAGE FAMILY SPECIES

Candytuft
Iberis sempervirens
Perennial candytuft is a short, woody shrub that forms a dense mound of small, evergreen leaves, with heads of many tiny, white flowers in flat, terminal clusters at a height of 25cm/10in in spring. It is found throughout the mountains of Europe and Asia Minor.

Sweet Alyssum *Lobularia maritima*
More usually known by its previous name of *Alyssum maritinum*, this short-lived perennial from the Mediterranean forms a dense mound of small green leaves, covered from late spring in compact heads of tiny, perfumed, white or occasionally pale purple-pink flowers.

Lady's Smock *Cardamine pratensis*
Also known as cuckoo flower, this elegant plant grows in damp meadows, ditches, by ponds and streams and along woodland edges. It produces clusters of large, pale mauve to pink flowers in late spring. It is distributed across northern Eurasia and the USA.

Garlic Mustard *Alliaria petiolata*
This biennial, with dark green, kidney-shaped leaves, has a distinct garlic odour when crushed. A single flower stalk appears in spring carrying a profusion of small white flowers. Native to Europe, it is an invasive weed in many areas.

Aubretia

Wallcress, *Aubrieta deltoidea*

This carpet-forming perennial is found growing naturally among scree and on high moorland. It is very similar to rockcress, the *Arabis* species, but flowers a little later and blooms for a longer period. Its popularity in cultivation has led to its common appearance as a garden escapee, although many such plants are hybrids and the true species is generally restricted to mountains in southern Europe. The plant prefers moist but well-drained soil, although it tolerates a wide range of soil types and can survive drought and periods of hot dry weather.

Identification: An evergreen, mat-forming, slightly woody perennial, it has small, mid-green, oval leaves, hairy and slightly toothed along the margin. The blue or purple, cross-shaped, four-petalled flowers, 1.5cm/⅝in across, are produced in great profusion on small racemes, and cover the mat of leaves in late spring. The seeds ripen in early summer.

Above: The attractive, flowers appear prolifically in late spring.

Right: Aubretia forms a dense mat of stems.

Distribution: South-east Europe, Turkey.
Height and spread: 15 x 30cm/6 x 12in.
Habit and form: Slightly woody, creeping perennial.
Leaf shape: Ovate to obovate.
Pollinated: Bee.

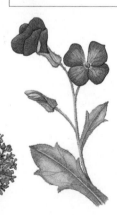

POPPIES AND FUMITORIES

The Papaveraceae, or poppies, are herbs or rarely shrubs or trees comprising 25 genera and 200 species that usually have milky or coloured sap. The largest genus in this group is the poppies, Papaver, with about 100 species, many of which are notable for their large, showy flowers. The Fumariaceae, or fumitories, include about 19 genera, found mostly in the Northern Hemisphere.

Field Poppy

Common poppy, *Papaver rhoeas*

The field poppy is a species classically associated with heavily disturbed ground, hence its symbolic association with the battlefields of World War I. One of the reasons for this is that it has a particularly persistent seed bank. It is a common weed of cultivated land and waste places, in all but acid soils, although it is now becoming far less frequent due to modern agricultural practices.

Identification: Erect or semi-erect branching stems, sparsely bristled, exude a white sap when cut. The oblong, light green, downy leaves, to 15cm/6in long, are deeply segmented with lance-shaped lobes. Solitary, bowl-shaped, brilliant red flowers, sometimes marked black at the petal bases, to 8cm/3¼in across, are borne on short, downy stalks from early to late summer. The flowers are followed by hairless, spherical seed capsules, which release the seed from an upper ring of pores; they ripen from late summer to early autumn.

Distribution: Europe, widely spread through agriculture.
Height and spread: 60 x 15cm/24 x 6in.
Habit and form: Annual.
Leaf shape: Pinnatifid.
Pollinated: Insect.

Right: Field poppies form an erect, branching plant.

Above: The fruiting capsule scatters tiny seeds when shaken by late summer winds.

Left: Although individual flowers are short lived, they are produced prolifically over the summer.

Himalayan Blue Poppy

Meconopsis betonicifolia

This is the classic blue poppy "discovered" by Lt Col F.M. Bailey in southern Tibet in 1913, and brought into cultivation by Frank Kingdon-Ward in 1926. It is from the rocky mountain slopes of the Himalayas and grows there in moist acidic soils, in which the blue colour develops its greatest intensity. The plant is perennial but sometimes short-lived, and though much cultivated rarely naturalizes as a garden escapee outside its natural range.

Identification: Large basal rosettes of leaves are produced in spring; they are toothed, heart-shaped or flat at the base, 15–30cm/6–12in long and light blue-green, covered with rust-coloured hairs. In early summer the flower spike grows up to 90cm/3ft. Drooping to horizontal, saucer-shaped, bright blue, sometimes purple-blue or white flowers, 7.5–10cm/3–4in across, with yellow stamens, are borne on bristly stalks up to 20cm/8in long, singly or sometimes clustered toward the top of the stem. It occasionally occurs as a pure white form var. *alba*, which is striking but is only rarely encountered outside cultivation.

Distribution: South-western China, Tibet, Burma.
Height and spread: 90 x 45cm/36 x 18in.
Habit and form: Herbaceous perennial.
Leaf shape: Oblong to ovate.
Pollinated: Insect.

Far left: The striking, erect and robust flower stems are held high over the leafy rosette.

OTHER POPPY AND FUMITORY SPECIES

Welsh Poppy *Meconopsis cambrica*
The Welsh poppy is the only species of *Meconopsis* found outside Asia and is from the woodlands and mountain rocks of western Europe. The leaves are deeply divided into irregular lobes. In spring and summer small, yellow or rich orange flowers are borne singly on slender stems.

Opium Poppy *Papaver somnifera*
The opium poppy is a robust, erect, blue-green, sparsely bristly annual that sports papery mauve, lilac or scarlet flowers that are usually purplish at the base. Although Asiatic in origin, its exact natural distribution is obscure as it has long been cultivated for its narcotic properties.

Greater Celandine *Chelidonium majus*
The greater celandine has erect slender branching stems up to 60cm/24in tall, with numerous small yellow flowers in groups of three to six in loose umbels, giving way to smooth cylindrical seedpods. It inhabits waysides and waste places in Europe, Asia and north-eastern North America.

Plume Poppy *Macleaya cordata*
The plume poppy is a handsome and vigorous perennial from Japan and China. Its stems reach 2.5m/8ft, with very large panicles of small buff white flowers that have the overall appearance of a soft creamy plume, above elegant blue-green downy leaves.

Yellow Horned Poppy

Glaucum flavum

The showy yellow horned poppy is a familiar sight along much of the coastline of Europe, North Africa and western Asia, where it occurs on shingle or gravel beaches. The golden yellow flowers of this short-lived perennial are followed in the latter part of the summer, by unusual, long, curling seedpods, which are often known as horns, hence the name. The plant exudes a yellow, foul-smelling latex when it is broken. All parts of it are poisonous.

Identification: A rosette-forming, slightly hairy plant with deeply lobed, hairless, rough, blue-green leaves, 15–30cm/6–12in long, the lobes incised or toothed. It produces branched grey stems of bright golden-yellow or orange, saucer-shaped flowers in summer; up to 5cm/2in across, they have golden anthers and a pale green pistil. The flowers are followed by the curling seedpods in late summer, which can be up to 30cm/12in long.

Distribution: Europe, West Africa, Canary Islands, western Asia.
Height and spread: 30–90 x 45cm/12–36 x 18in.
Habit and form: Herbaceous perennial.
Leaf shape: Pinnatifid.
Pollinated: Insect.

Above: The blooms are a striking yellow.

Right: The long thin seed-heads are the so-called horns that give the plant its name.

Bleeding Heart

Lyre flower, *Dicentra spectabilis*

Distribution: China, north-eastern Asia.
Height and spread: 80 x 45cm/32 x 18in.
Habit and form: Herbaceous.
Leaf shape: Two-ternate, fern-like.
Pollinated: Insect.

Far right: The delicate, arching, stems are extremely striking.

The bleeding heart is named for its rosy heart-shaped flowers, with white inner petals, which dangle from arching stems. It grows in moist soils in light woodland cover, and is a particularly handsome plant, especially from mid-spring onwards, as the light green, deeply divided leaves emerge from the ground below the arching flower stems. It often dies down to ground level before the end of summer. All parts of the plant are mildly poisonous if ingested and can irritate the skin. An old English common name is "Lady in the Bath", referring to the appearance of the flower when turned upside down.

Identification: A clump-forming perennial with thick, fleshy roots and pale green, compound, almost fern-like leaves, 15–40cm/6–16in long, with oval, sometimes lobed leaflets. Arching, fleshy stems support arching racemes of pendent, heart-shaped flowers, 2–3cm/¾–1¼in long, with mid-pink outer petals and white inner ones, in late spring or early summer. The stems rarely persist for long past mid-summer and by late summer the entire plant dies down to ground level until the following spring.

PINKS AND GERANIUM FAMILIES

The Caryophyllaceae, or pinks, are herbs or rarely subshrubs. The flowers typically feature a corolla of five distinct, frequently clawed petals, and the common name "pink" is derived from a word meaning scalloped, characterizing the petal edges of many in this family. The Geraniaceae, or geraniums, are a varied family, featuring five-petalled flowers and a beaked fruit that often disperses the seed explosively.

Clove Pink

Carnation, *Dianthus caryophyllus*

This native of Eurasia has been cultivated since ancient times and there are classical Greek and Roman allusions to its use in garlands. The name *Dianthus* derives from the Greek *dios* (god) and *anthos* (flower), and literally means "flower of the gods". Despite its ancient history the wild form of this flower is rare and most wild populations are probably derived from cultivated stock.

Identification: Slightly woody perennial with glabrous and glaucous stems and leaves. The leaves are linear, flat and soft in texture and entire along the margins, with conspicuous sheaths around swollen nodes. The conspicuous, fragrant, mostly solitary flowers have five broad petals with toothed edges, mostly flesh-coloured or pink, and are produced in loose cymes on stiff, ascending stems during the summer months. A variable plant that is often the result of escape from cultivation from which many forms have been derived.

Left: The ragged petal edges appear zigzagged, hence the use of the word "clove" meaning divided in the common name.

Distribution: Eurasia: widely naturalized but rarely found wild except perhaps in some Mediterranean countries.
Height and spread: 30–60 x 25–30cm/12–24in x 10–12in.
Habit and form: Herbaceous perennial.
Leaf shape: Linear.
Pollinated: Moth and butterfly.

Meadow Cranesbill

Geranium pratense

This genus should not be confused with the showy geraniums grown in pots for greenhouse or home decoration, or for summer bedding, which are correctly known as pelargoniums. True geranium species, commonly known as cranesbills because of their beak-like seedpods, are a group of hardy perennials chiefly found in the temperate regions of Eurasia and North America. The meadow cranesbill is the most widespread and robust, with large, conspicuous blue flowers. The flowers are produced in abundance from early summer to mid-autumn.

Right: The large, blue flowers are followed by the long, pointed seedheads that give rise to the common name of cranesbill.

Identification: This hairy perennial, with a woody rootstock forming conspicuous clumps, has erect stems, which are sticky in the upper part, and long-stemmed, dark green leaves divided into seven to nine thin, toothed and divided segments. The 2.5–4cm/1–1½in saucer-shaped, pale violet-blue flowers are borne in clusters above the foliage. The flowers are followed by hairy, beak-like fruits, which curve down after flowering but become erect as they ripen. They have five segments that curl upwards explosively to disperse the seeds.

Right: The bright blue flowers are produced abundantly during the summer months.

Distribution: Europe.
Height and spread: 50cm/20n.
Habit and form: Herbaceous perennial.
Leaf shape: Palmate.
Pollinated: Bee or other insect.

Zonal Pelargonium

Pelargonium zonale

Distribution: South Africa.
Height and spread:
90cm–3m/3–10ft.
Habit and form: Subshrub.
Leaf shape: Circular.
Pollinated: Insect.

This plant, familiar in cultivation for growing in pots and bedding schemes, has its origins on the dry rocky hills, stony slopes and forest margins of South Africa, from the Southern Cape to Natal. The flowers of this strikingly beautiful species range from all shades of red to pink and pure white, and in its natural habitat it is an abundant and often conspicuous feature. *Pelargonium zonale* flowers throughout the year, with a peak in spring.

Left: *The flowers are produced on conspicuous heads, ranging from red, through pink to pure white. The new growth of the characteristic "horseshoe-marked" leaves are the perfect foil for the flowers.*

Far right: *The flowerheads are produced so prolifically in spring.*

Identification: This erect or scrambling, softly woody, evergreen shrub usually grows up to 90cm/3ft but can reach heights up to 3m/10ft. The young branches are almost succulent and usually covered with hairs, but harden with age. The large leaves are often smooth and a characteristic dark horseshoe-shaped mark is often present. The distinctly irregular flowers are borne in a typically umbel-like inflorescence.

OTHER PINKS AND GERANIUM SPECIES
Musk Storksbill *Erodium moschatum*
The purple flowers of this annual or biennial species from Europe are clustered in a flower-head at the top of the stems, from which develop long, pointed seedheads – hence the name. The somewhat fern-like leaves are hairy and slightly toothed.

Red Campion *Silene dioica*

A showy herbaceous perennial that is widespread and abundant, red campion is most often associated with woodland, shady places and hedgerows, although it can occur in open situations such as sea cliffs. It hybridizes quite freely with the related white campion, *S. latifolia*: the hybrids resemble red campion but are taller, with pale pink flowers.

Ragged Robin *Lychnis flos-cuculi*

With its apparently ragged, deeply lobed petals, ragged robin is one of the most attractive flowers of wet meadowland. Like other wetland plants, it has declined in recent years, as a result of habitat destruction by modern agricultural practices.

Corncockle

Agrostemma githago

This attractive and once common weed of cornfields has become rare in the wild due to modern agricultural practices. The flower is at first male, the anthers shedding their pollen before the stigmas are mature; these are arranged at the mouth of the tube so that the visiting butterflies push their faces among them and pick up pollen. A day or two later the flower "becomes" female and the stigmas occupy the mouth in the same way to receive pollen.

Identification: This annual herb has a tall, slender stem with a dense coat of white hairs. Narrow, lance-shaped leaves, 10–12.5cm/4–5in long, are produced in pairs and their stalkless bases meet around the stem. The large, solitary flowers, which appear from early to late summer, have very long stalks that issue from the leaf axils. The flowers are 4–5cm/1½–2in across, with purple, pale-streaked petals and a woolly calyx with five strong ridges and five long, green teeth that far exceed the length of the petals. The fruit is a sessile (stalkless) capsule, which opens with five teeth.

Distribution: Europe.
Height and spread:
60–150cm/2–5ft.
Habit and form: Annual.
Leaf shape: Lancoleate.
Pollinated: Insect.

Below: *The long, green "teeth" of the woolly calyx exceed the length of the petals and give this flower a distinctive appearance.*

PRIMULA AND DOGBANE FAMILIES

The Primulaceae, or primulas, occur mainly in temperate and mountainous regions of the Northern Hemisphere. Many species of Primula *are cultivated for their attractive flowers. The genera and species of the Apocynaceae (dogbane family) are distributed primarily in the tropics and subtropics and are poorly represented in temperate regions. Plants of the Apocynaceae are often poisonous.*

Primrose

Primula vulgaris

Without doubt this plant is one of the most attractive and best known of the primula family. It has long been cultivated and its name derives from the Latin *prima rosa* meaning "first rose". It frequently hybridizes with the related cowslip, *P. veris*, although the flowers remain pale yellow. Other colours arise through hybridization with cultivated stock.

Identification: The rootstock becomes knotty with the successive bases of fallen leaves and bears cylindrical, branched rootlets on all sides. The leaves are egg-shaped to oblong, about 12.5cm/5in long and 4cm/1½in across in the middle, smooth above with prominent, hairy veins and veinlets beneath, the margins irregularly toothed, tapering into a winged stalk. The fragrant flowers are pale yellow with a darker centre and sepals forming a bell-shaped, pleated tube. They appear from late winter to late spring, each borne on a separate stalk and followed by an egg-shaped capsule enclosed within a persistent calyx.

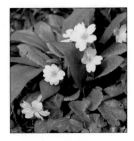

Above: The primrose is a woodland or hedgerow plant.

Left: The conspicuous flowers are held above a low rosette of shiny geen leaves.

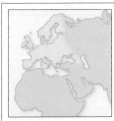

Distribution: Europe.
Height and spread: 5–20cm/2–8in.
Habit and form: Herbaceous perennial.
Leaf shape: Obovate to oblong.
Pollinated: Insect.

Right: Pink flowers, growing wild are the result of crosses with cultivated plants.

Giant Cowslip

Primula florindae

The aptly named giant cowslip is native to south-east Xizang in Tibet, where it grows in marshes and along streams in the constantly waterlogged soils. The species was named by the renowned Himalayan plant explorer, Frank Kingdon-Ward, in honour of his wife Florinda. It was a true compliment as it is one of the most imposing wild primroses to be seen and is very fragrant. It requires a very moist, acidic soil and flowers mainly from early to late summer.

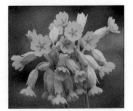

Above and left: The yellow or rarely red flowers have a sweet spicy scent.

Identification: Heart-shaped, toothed, shiny mid-green leaves with rounded tips, on stout winged stalks 4–20cm/ 1½–8in long and often tinged red, form large herbaceous rosettes below flowering stems that can reach 1m/3ft in height. Each inflorescence consists of up to 40 pendent, funnel-shaped, sulphur-yellow flowers, smelling strongly of nutmeg or cloves. Both the stems and flowers are farinose (dusted with a mealy coating) and the overall habit of the plant is quite robust.

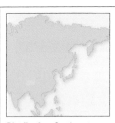

Distribution: South-east Tibet.
Height and spread: Up to 90cm/3ft.
Habit and form: Herbaceous perennial.
Leaf shape: Ovate
Pollinated: Insect.

Left: The flowerheads are held high above a rosette of foliage.

Oleander

Rose bay, *Nerium oleander*

When oleander grows in the wild it occurs along watercourses, in gravel soils and damp ravines. It is widely cultivated, particularly in warm temperate and subtropical regions, where it grows in parks, gardens and along roadsides. It prefers dry, warm climates and may naturalize in such areas. The whole plant, including the sap, is toxic.

Right: Oleander forms a loose, attractive, evergreen shrub that is widely cultivated for its appearance.

Distribution: North Africa, eastern Mediterranean and South-east Asia.
Height and spread: 4m/13ft.
Habit and form: Evergreen shrub.
Leaf shape: Lanceolate.
Pollinated: Insect.

Right: The individual flowers are five petalled and may be pink or white. They are highly fragrant.

Identification: Oleander is a summer-flowering evergreen shrub with narrow, entire, short-stalked, leathery, dark or grey-green leaves, 10–23cm/4–9in long, with prominent midribs, usually arising from the stem in groups of three. The terminal flowerheads are usually pink or white; each five-petalled flower is about 5cm/2in in diameter and the throat is fringed with long, petal-like projections. The fruits are long, narrow capsules, 10–12.5cm/4–5in long and 6–8mm/¼–⅜in in diameter, which open to disperse fluffy seeds.

OTHER PRIMULA AND DOGBANE SPECIES

Cowslip *Primula veris*
This spring-flowering plant, appears at the same time as the primrose, but is not as widespread (or as conspicuous) as that plant. It has a tight rosette of small, deep green, crinkled leaves and drooping clusters of small delicately scented deep yellow flowers on tall 25cm/10in stems.

Madagascar Periwinkle *Catharanthus roseus*
An evergreen perennial 45–120cm/18–48in tall with flowers of white, pink and intermediate colours, above deep green, glossy, oval leaves. Originally a native of Madagascar, it is now widely naturalized in many tropical countries as a garden escapee.

Primula vialii
The pyramidal flowers of this highly unusual primula look like miniature red hot pokers. They are bicolored, with purple at the base and reddish fuchsia at the tip, borne on 40cm/16in stems during the summer months. It is originally native to China although it is now widely cultivated in gardens.

Yellow Loosestrife *Lysimachia punctata*
This erect-growing perennial from south-eastern

and central Europe has lance- to elliptic-shaped, mid-green leaves that grow in whorls of three or four. The small, bright yellow flowers are borne in the leaf axils at the ends of the stems during the summer.

Ivy-leaved Cyclamen

Sowbread *Cyclamen hederifolium*

This pretty little cyclamen has a wide distribution stretching from south-eastern France, through central Europe, Greece (including Crete and many of the Aegean islands) and western Turkey. It inhabits woodland, scrub, and rocky hillsides from sea level to 1,300m/4,250ft, although its popularity in cultivation has led it to spread to other areas. The flowers are usually pink, but there is also a white-flowered form, though this is rare in the wild.

Identification: The pink flowers, with a purple-magenta, V-shaped blotch at the base of each petal, appear from mid- to late autumn. The leaves are very variable, and can be every shape from almost circular to lance-shaped. They vary from dull or bright plain green to plain silver with various forms of hastate (spear-shaped) pattern in between, with the pattern in silver, grey, cream or a different shade of green. The undersides can be green or purple-red.

Left: The flowers and foliage arise from a rounded tuber.

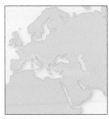

Distribution: Europe, chiefly the Mediterranean.
Height and spread: 15cm/6in.
Habit and form: Herbaceous perennial.
Leaf shape: Variable, chiefly ivy-shaped.
Pollinated: Insect.

Right: After flowering, the flower stalks coil down to the soil surface to deposit the seeds.

Below: The flowers mainly appear before the young leaves.

GENTIANS AND BELLFLOWERS

Worldwide, the Gentianaceae, or gentians, comprise mainly herbaceous perennials but also include a few shrubs or small trees, and are particularly well represented in mountain areas. The Campanulaceae, or bellflowers are herbs, shrubs, or rarely small trees, usually with milky sap, comprising about 70 genera and 2,000 species. Many of the species of both families are highly ornamental and familiar plants.

Stemless Gentian

Gentianella, Gentiana acaulis

In the wild this gentian grows in the Alps and Carpathian Mountains in dry acid grasslands, bogs, on rubble and scree slopes and occasionally in alpine woods, at elevations of 1,400– 3,000m/4,600–9,850ft. Although it usually grows in acid soils it can sometimes also be found on chalky limestone or sandstone. Its intense blue, funnel-shaped flowers, which almost obscure the foliage, make it one of the showiest alpine plants that can be seen in Europe, when it appears in early summer.

Right: The low mat of foliage can be inconspicuous until the flowers appear in early summer.

Identification: The leaves in the basal rosette are 2.5–4cm/1–1½in long, lance- to egg-shaped and glossy dark green. On the short flower stems the leaves are smaller and broader. The solitary 5cm/2in trumpet-shaped, lobed flowers are vivid dark blue, spotted green within. They are produced terminally on short stalks in spring and early summer and are followed by stalked, ellipsoid seed capsules.

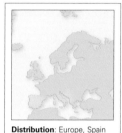

Distribution: Europe, Spain to the Balkans.
Height and spread: 10 x 100cm/4 x 39in.
Habit and form: Slow-growing perennial.
Leaf shape: Lanceolate.
Pollinated: Bee and butterfly.

Autumn-flowering Gentian

Gentiana sino-ornata

This plant, discovered by the Scots plant hunter George Forrest in 1904 in south-west China, yields the richest tones of blue trumpets among the fallen leaves of late autumn. It is a native of north-west Yunnan and adjacent Tibet, and grows in wet ground. It prefers a rich acid soil, which drains well but will hold moisture, and is often found growing in well-oxygenated, moving water. The flowers exhibit a range of colour from royal blue to purple-blue, interspersed with greenish-yellow bands.

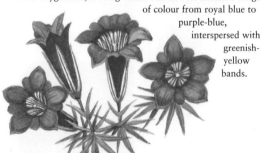

Identification: The stems of this prostrate perennial, 15–20cm/ 6–8in long, ascend at the tips and root at nodes. The basal leaves form loose rosettes; on the stems the dark green leaves are paired, narrowly lance-shaped, about 4cm/1½in long. The deep blue, tubular flowers, up to 5cm/2in across, are borne singly on the ends of the stems, with lobes twice the length of the tube. They have five bands of deep purple-blue, panelled green-white, on the outside and are paler within, sometimes with a streaked throat.

Right: The bright blue flowers appear at the end of the stems in damp acidic soils and give a stunning autumnal display.

Distribution: South-west China and Tibet.
Height and spread: 15–20cm/6–8in.
Habit and form: Prostrate herbaceous perennial.
Leaf shape: Lanceolate.
Pollinated: Insect.

Yellow Wort

Blackstonia perfoliata

Distribution: Europe.
Height and spread:
45cm/18in.
Habit and form: Herbaceous perennial.
Leaf shape: Ovate, appearing perfoliate on flower stems.
Pollinated: Insect.

Yellow wort is an almost unmistakable plant that is able to grow in very alkaline soil. It is most commonly found growing on dry grassland over shallow chalk, limestone soils and occasionally on dunes. The eight-petalled, yellow flowers close in the afternoon and the waxy blue-green leaves are highly distinctive. The plant was given its botanical name in honour of an 18th-century London apothecary and botanist, John Blackstone.

Left: The basal rosette is inconspicuous when growing in grassland but the distinctive, blue-green, tall, upright stems with their encircling, slightly cup-shaped leaves are unmistakable.

Identification: The oval leaves, which are bluish-green and hairless, are stalkless and form a loose rosette at the base of the stem. The leaves on the stem are in pairs with their bases fused together, making it appear as if the stem passes through the middle of a single leaf. Between early summer and mid-autumn the yellow flowers appear on 45cm/18in stems. They have eight petals, joined at the base to form a short tube.

Below: The tight, green buds give rise to showy, yellow blooms.

OTHER GENTIANS AND BELLFLOWERS

Sea Rose *Orphium frutescens*
The glossy pink stars of this bushy, evergreen perennial always attract attention, especially when the surrounding vegetation goes brown and dormant. The sea rose is found in South Africa, along the south-west coast of the Cape, growing in clumps on sandy flats and marshes.

Feverwort *Centaurium erythraea*
The feverwort is a small, erect annual or biennial herb that is indigenous to Europe, western Asia and North Africa, and has become naturalized in North America. The stem grows up to 30cm/12in high and is topped with numerous pink or red flowers. It favours dry, shady banks, waysides and pastures.

Bonnet Bellflower *Codonopsis ovata*
This plant from the western Himalayas has small, oval, greyish and somewhat downy leaves, and two or more flowers on a stem. The drooping, bell-shaped flowers appear from early summer; they are pale greyish-blue with purple reticulations and an orange-and-white base inside.

Harebell *Campanula rotundifolia*
This little wildflower is found beside streams, on heaths and moors, and in grassy places. It has a basal rosette of rounded or kidney-shaped leaves, with smaller thin, pointed leaves up the stem, and large, pale blue bellflowers.

Peach-leaved Bellflower

Campanula persicifolia

The peach-leaved bellflower is an extremely pretty wildflower noted for its tall, thin stems with a few scattered leaves, and large, open bellflowers, which are borne freely during the summer months. It was at one time grown as a culinary vegetable, but is now more commonly grown as an ornamental plant, this having led to its occurrence as a garden escapee in many areas. The plant prefers well-drained, alkaline soils and can grow in light woodland or open situations such as grassland.

Identification: The plant is a rosette-forming perennial with slender, white rhizomes and evergreen, narrow basal leaves, which are lance-shaped to oblong or oval, toothed, bright green and 10–15cm/4–6in long. Short terminal racemes of two or three, occasionally solitary, slightly pendent, cup-shaped flowers up to 5cm/2in across, varying from white to lilac-blue, are produced on slender stems or from the leaf axils, in early or midsummer. The seeds ripen from late summer to mid-autumn.

Distribution: Europe to western and northern Asia.
Height and spread: 100 x 45cm/39 x 18in.
Habit and form: Herbaceous perennial.
Leaf shape: Lanceolate.
Pollinated: Bee, fly, beetle, moth and butterfly.

Below: The tall, thin, showy flower stems support numerous open, slightly pendent, blue bellflowers.

EUPHORBIA AND ASPHODEL FAMILIES

The Euphorbiaceae, or euphorbias, are one of the largest families of herbs, shrubs, and trees, generally characterized by the occurrence of milky, often toxic sap. They are mostly monoecious (bearing flowers of both sexes on one plant) and sometimes succulent and cactus-like. The Asphodelaceae, or asphodels, range in size from minute succulents to large trees, and the family is generally quite diverse in form.

Wood Spurge

Robb's euphorbia, *Euphorbia amygdaloides* var. *robbiae*

The wood spurge is an attractive perennial plant of broadleaved woodland and shady banks. It spreads by underground runners until eventually the evergreen leaves form a low carpet over the ground, smothering smaller plants. Upright spikes of lime-green flowers emerge in spring and persist through early summer. The species is widespread across Europe, with this subspecies being restricted to north-west Turkey. The species has become popular in cultivation and can often be found outside its natural geographical range.

Identification: This bushy, softly hairy, evergreen perennial has reddish-green, biennial stems and spoon- to egg-shaped, leathery leaves, 2.5–7.5cm/1–3in long. The leaves are shiny dark green, becoming much darker in winter, and are closely set on the stems. From mid-spring to early summer it bears terminal flattened flower clusters, 18cm/7in tall, of greenish-yellow cyathia (groups of male and female flowers lacking petals and sepals) surrounded by cup-shaped bracts.

Distribution: North-west Turkey.
Height and spread: 60 x 30cm/24 x 12in.
Habit and form: Evergreen perennial.
Leaf shape: Obovate.
Pollinated: Insect.

Above left: The greenish-yellow cup-shaped flowers.

Left: The flowers are held in spikes.

Castor Oil Plant

Ricinus communis

This fast-growing species, originally a native of north-eastern Africa to western Asia, has long been cultivated both for its ornamental value and also for the castor oil yielded by the seeds, which are highly toxic. As a result, the plant's range has been greatly extended and it is now a common wayside species in many tropical and subtropical locations worldwide.

Identification: The succulent stem is 7.5–15cm/3–6in in diameter, and very variable in all aspects. The smooth leaves are alternately arranged, circular, palmately compound. The flowers are numerous in long inflorescences, with male flowers at the base and red female flowers at the tips; there are no petals in either sex, but three to five greenish sepals. The flower is followed by a round fruit capsule, 2.5cm/1in in diameter, on an elongated stalk that is usually spiny. The fruit is green at first, ripening to brown, and usually contains three attractively mottled seeds.

Right: The flowerheads have male flowers at the base, and female flowers at the top.

Below: The leaves are 15–45cm/6–18in long, with 6–11 toothed lobes.

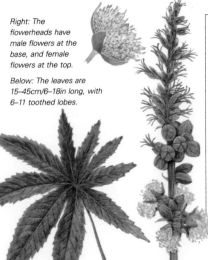

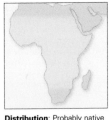

Distribution: Probably native to Africa, but widely cultivated.
Height and spread: Up to 10–13m/33–42ft.
Habit and form: Shrubby perennial.
Leaf shape: Palmate.
Pollinated: Insect.

Krantz Aloe

Aloe arborescens

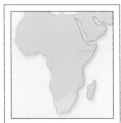

The krantz aloe is a distinctive species that develops into a multi-headed shrub with striking grey-green leaves, armed with conspicuous pale teeth, arranged in attractive rosettes. It is most closely related to the smaller, but somewhat similar, *Aloe mutabilis*, which can generally be distinguished by its red-and-yellow flowers and broader leaves.

Distribution: Southern Africa.
Height and spread: 2–3m/6½–10ft.
Habit and form: Shrubby succulent.
Leaf shape: Sickle-shaped and rounded.
Pollinated: Bird (particularly sunbird), bee.

Identification: The succulent, greyish-green to bright green, sickle-shaped leaves, borne in rosettes, vary considerably in length but average 50–60cm/20–24in. The leaf margins are commonly armed with firm teeth, which are white or the same colour as the leaves. There is also a form with smooth margins. Two or more flower spikes up to 90cm/3ft long arise from each rosette in late winter and spring, usually simple but occasionally with up to two side branches. The scarlet, orange, pink or yellow flowers are borne in conical racemes and are rich in nectar.

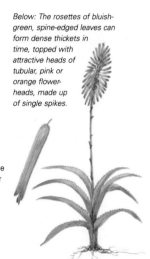

Below: The rosettes of bluish-green, spine-edged leaves can form dense thickets in time, topped with attractive heads of tubular, pink or orange flower-heads, made up of single spikes.

OTHER EUPHORBIAS AND ASPHODELS

Basketball Euphorbia *Euphorbia obesa*

This slow-growing, ball-shaped plant is a native of South Africa's Great Karoo. It consists of a single, smooth-bodied, spineless, olive-green, swollen stem, covered in mauve to pale green striped markings. As it matures it becomes slightly columnar rather than globular. Flowers are produced in summer near the growing tip.

Indian Acalypha *Acalypha indica*

Also known as the Indian copperleaf, this erect annual herb grows up to 75cm/30in. It has numerous long, angular branches covered with soft hair and thin, smooth, egg-shaped leaves. The flowers are borne in long, erect spikes, and are followed by small, hairy fruits and minute, pale brown seeds.

Aloe vera

This succulent aloe is almost stalkless. Its pea-green leaves, spotted with white when young,

are 30–50cm/12–20in long and 10cm/4in broad at the base. Bright yellow, tubular flowers,25–35cm/10–14in long, are arranged in a slender, loose spike. This plant has long been cultivated for medicinal use and its exact origin is a mystery.

Red Hot Poker

Kniphofia caulescens

Red hot pokers are more often orange than red but resemble the colour of glowing embers nonetheless. They are a distinctive group of plants, with their strong outlines making them instantly recognizable. They are frequented by nectar-feeding birds, such as sunbirds and sugarbirds, as well as certain insects. The genus *Kniphofia* is very closely related to the genus *Aloe*. As a result, the first *Kniphofia* to be described, *K. uvaria*, was initially named *Aloe uvaria*. *K. caulescens* is notable for its stems, which become woody, giving it the appearance of a small shrub. It is a widely cultivated plant that may occur as a garden escapee far outside its natural range.

Distribution: Eastern South Africa.
Height and spread: 90cm/3ft or more.
Habit and form: Slightly woody herbaceous perennial.
Leaf shape: Linear.
Pollinated: Bird, sometimes insect.

Below: Red hot pokers are clump-forming.

Identification: The plant is an evergreen perennial with short, thick, woody-based stems and arching, linear, keeled, finely toothed, glaucous leaves, to 1m/3ft long, which are purple at the base. Coral-red flowers fading to pale yellow, 2.5cm/1in long with protruding stamens, are borne in short, cylindrical racemes on 1.2m/4ft stems from summer to autumn.

STONE PLANTS AND CRASSULAS

The Aizoaceae, or stone family, is particularly strongly represented in southern Africa. Many of its species are decorative, so are widely cultivated and some have become naturalized outside their normal range. The Crassulaceae, or crassulas, are mostly succulents, with flowers that are very similar to those of members of the rose and saxifrage families.

Houseleek

Hens and chicks, *Sempervivum tectorum*

This commonly cultivated perennial succulent plant is very occasionally found as a persistent colonist of old walls. It was formerly also frequent on thatched roofs of houses, but is now rarely found in this habitat. The genus *Sempervivum* comprises a range of succulent, rosette-forming, evergreen perennials that originate in the mountainous areas of Europe, central Asia and North Africa, often growing in crevices in the rocks. The plant requires well-drained soil and can tolerate drought. Each rosette is monocarpic (it blooms once and then dies).

Identification: An evergreen, mat-forming, succulent perennial, it has open rosettes up to 10cm/4in across of thick, oval to narrowly oblong, bristle-tipped leaves, to 4cm/1½in long, blue-green often suffused red-purple. Leaves often show seasonal variations in colour. In early to midsummer, it bears cymes, 5–10cm/2–4in across, of red-purple flowers on upright, hairy stems growing to 15cm/6in tall. The seeds ripen from mid- to late summer.

Left: The fleshy rosettes form are tightly packed.

Left: Each red-purple flower has numerous petals.

Right: One flowerhead arises from the centre of the rosette.

Distribution: French and Italian Alps.
Height and spread: 10–30cm/4–12in.
Habit and form: Succulent, evergreen, rosette-forming perennial.
Leaf shape: Obovate to narrowly oblong.
Pollinated: Insect.

Silver Jade Tree

Crassula arborescens

Found on granite or in quartzite areas, this distinctive, large, shrubby succulent is perfectly at home growing between boulders or in crevices. The plants are mainly found in areas of winter rainfall and are very tolerant of drought. The species has a scattered distribution in South Africa, from the Little Karoo to the Hex River Valley.

Right: The flowers appear in autumn to winter.

Below: Though tree-like it is actually a shrub.

Identification: Cylindrical branches bear grey-green leaves, tinged purple, to 7.5cm/3in long, with red margins that continue down both sides of the leaf. The leaves are oval, with rounded tips, tapering below, with entire margins; leaf stalks are absent or very short. The old leaves gradually become deciduous. The succulent stems are up 12.5cm/5in in diameter, frequently branched, and older specimens have peeling bark. The grey flowers are tinged pink at the tips, with five to seven petals, which are borne on long flower stalks.

Right: The pale grey-blue colour is in part due to the grey bloom that is naturally present.

Distribution: South Africa.
Height and spread: 4m/13ft.
Habit and form: Shrubby succulent.
Leaf shape: Ovate.
Pollinated: Insect.

OTHER STONE PLANTS AND CRASSULAS

Lithops terricolor
These so-called "living stones" have evolved to
survive dry conditions while also evading
detection by browsing animal species. They are
masters of deception, producing pairs of stone-
shaped succulent leaves that resemble the
pieces of quartz among which they grow.

Conophytum minutum
A species of succulent plants native to the winter-
rainfall deserts of South Africa and Namibia. They
are commonly known as stone plants because
of their cryptically mineralesque appearance until
the autumn, when the first rains stimulate the
appearance of pink-lavender or white flowers.

Rosea Ice Plant *Drosanthemum floribundum*
This ground-hugging perennial, with small,
stubby, light green, succulent leaves, produces
dazzling metallic-purple flowers each spring. It is
known to survive in very hot, dry conditions and
easily colonizes large, flat, open spaces in South
Africa's Little Karoo, with one plant covering an
area as large as 2sq m/22sq ft.

Stonecrop *Sedum acre*
A loosely tufted, mat-forming, evergreen
perennial, widespread through much
of Europe, the Mediterranean region
and Turkey and naturalized
in the eastern USA. Its
bright yellow flowers appear in
small cymes from early to mid-
summer. It thrives in dry gravel
soils and is drought tolerant.

Hottentot Fig

Ice plant, pigface, *Carpobrotus edulis*

A vigorous, prostrate plant, rooting as it
spreads, with flowers that open only in the
afternoon, the so-called hottentot fig is an
immensely showy plant when encountered
en masse and is extremely tolerant of
maritime exposure. Although it was
originally restricted to coastal and exposed
areas around the South African coast,
human activities have resulted in it
spreading over large parts of Australia,
southern Europe and California, where
conditions are similar to those in its
original home.

Identification: The stems are spreading or
prostrate, up to 2m/6½ft long, 8–12mm/
⅜–½in thick, with two cleft angles;
flowering shoots have two fleshy
internodes. The three-sided leaves
are 4–7.5cm/1½–3in long,
8–15mm/⅜–⅝in wide, bright
green, often tinged red along
the edges; the upper surfaces
are distinctly concave, causing
them to curl slightly inwards; the
keel is minutely toothed. Daisy-like
flowers, 7–9cm/2¾–3½in across,
open after noon in sun in spring and
summer; they are yellow at first, becoming
flesh coloured to pink, usually densely
streaked when dry. Fig-like, edible fruits
follow the flowers.

Distribution: Cape Province,
South Africa.
Height and spread: 10 x
90cm/4 x 36in.
Habit and form: Mat-forming
succulent perennial.
Leaf shape: Triangular.
Pollinated: Insect.

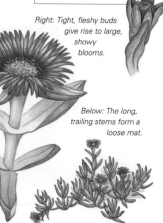

*Right: Tight, fleshy buds
give rise to large,
showy
blooms.*

*Below: The long,
trailing stems form a
loose mat.*

Tiger's Jaws

Faucaria tigrina

This interesting little succulent, commonly known as tiger's
jaws (the genus name *Faucaria* is derived from the Latin for
"jaws") due to the teeth-like structures on the leaves, is a
native of South Africa. The triangular leaves with pointed
fleshy parts, are concave on the upper part, making them
look like open jaws.

Distribution: Eastern Cape
Province, South Africa.
Height and spread: 10 x
50cm/4 x 20in.
Habit and form: Low
shrubby succulent.
Leaf shape: Triangular to
rhombic.
Pollinated: Insect.

Identification: The plant forms
succulent rosettes of triangular
to diamond-shaped or oval
leaves, tapered on the upper
surface with very rounded lower
surfaces, with the tips pulled
forward and chin-like. The
leaves are grey-green with
numerous white dots
arranged in rows and
nine to ten stout,
recurved, hair-
tipped teeth
along each
margin.

*Above: The plant builds woody
stems with age and tolerates
very droughty conditions.*

*Far left and left:
Large, stalkless,
daisy-like,
yellow flowers,
5cm/2in across,
are produced in
late summer and
early autumn.*

SAXIFRAGE AND VIOLET FAMILIES

The Saxifragaceae, or saxifrage family, include herbaceous perennials and deciduous shrubs. In cultivation the family includes food and ornamental plants, although in the wild they are typical of arctic and boreal regions. The violet family is widely distributed in temperate and tropical regions of the world: the northern species are herbaceous, while others, abundant natives of tropical areas, are trees and shrubs.

Purple Mountain Saxifrage

Saxifraga oppositifolia

The purple saxifrage is frequently found on damp mountain rocks. It also sometimes grows at the foot of a mountain, from seeds washed down by fast-flowing streams, but rarely persists here as it is easily out-competed by other vegetation. It is an extremely widespread species, stretching from the Arctic down into the mountains of Europe, western Asia and North America. It tends to be variable due to the environmental variance across its large range. The plant is well known for its ability to flower very early in the year, but may produce a few additional flowers later in the summer. The flower colour is unusual among wild saxifrages.

Identification: A flat, mat-forming, opposite-leaved saxifrage, it has rosettes of stiff, oblong or elliptic, dark green leaves, to 5mm/⅕in long, on branching stems. The leaves are very densely packed and often secrete lime at the tips, giving the appearance of white flecks. In early summer, the plant bears solitary, almost stemless, cup-shaped, deep red-purple to pale pink or rarely white flowers, to 2cm/¾in across.

Below right: This tiny plant flowers profilically in spring and early summer.

Distribution: Arctic, Eurasia and North America.
Height and spread: 2.5 x 20cm/1 x 8in or more.
Habit and form: Mat-forming, evergreen perennial.
Leaf shape: Oblong to elliptic.
Pollinated: Insect.

Heartleaf Saxifrage

Elephant's ears, Bergenia cordifolia

Found chiefly in damp, rocky woodland and meadows in northern Asia, heartleaf saxifrage forms clumps, which can become quite extensive, of large, evergreen leaves with a leathery texture. The clusters of small flowers, borne in late winter, are easily visible above the persistent, dark green, purple-tinged leaves. The flowers may persist for several weeks, gradually fading in colour. Although it grows in shade and moist ground, it is extremely drought tolerant, and its general appearance and dimensions may vary considerably, according to the particular habitat it is growing in.

Identification: This clump-forming perennial grows from tough, thick rhizomes in distinctive rosettes of circular to heart-shaped leaves, to 30cm/12in long, with rounded or serrated, toothed margins and hairless, sometimes puckered surfaces. The leaves are deep green, sometimes tinged red-purple in winter. Panicle-like cymes of pale red to dark pink flowers on red flower stems appear in late winter and early spring. The entire inflorescence may be 40cm/16in or more tall, sometimes much larger than the leaves.

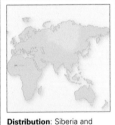

Distribution: Siberia and Mongolia.
Height and spread: 40cm/16in or more.
Habit and form: Evergreen perennial.
Leaf shape: Rounded to heart-shaped.
Pollinated: Insect.

Heartsease

Wild pansy, *Viola tricolor*

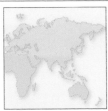

Distribution: Eurasia from the Arctic to the southern Mediterranean.
Height and spread: 5–15 x 30cm/2–6 x 12in or more.
Habit and form: Annual or short-lived herbaceous perennial.
Leaf shape: Lanceolate to ovate.
Pollinated: Insect, especially bumblebee.

The heartsease is a variable species but it may always be readily distinguished from the other violets by the general form of its foliage, which is very deeply cut. The species is an annual or short-lived perennial, but crosses from it and other species have given rise to garden pansies. It is very widely distributed, and is found from the Arctic to North Africa and north-west India. Several varieties have been distinguished as subspecies.

Identification: The stems are generally very angular, erect to ascending and free branching. The leaves are deeply cut into rounded lobes, the terminal one being largest, with blunt tips and round-toothed margins; the upper leaves are lance-shaped to oval. The flat-faced flowers, 6mm–3cm/¼–1¼in across, vary a great deal in size and colour: they are purple, yellow or white, and most commonly a combination of all three. The upper petals are generally the most showy and purple, with the lowest and broadest petal usually yellow. The base of the lowest petal is elongated into a spur, as in the violet.

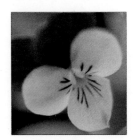

Below: The small, usually tricoloured flowers vary in colour.

Saxifraga fortunei
A deciduous perennial herb from Japan, with large panicles of white blossoms that rise in profusion on 50cm/20in red stems from rosettes of handsome, large, dark green, glossy, rounded leaves during the autumn.

Astilbe chinensis
This herbaceous perennial from China and Korea reaches 70cm/28in and is at its most handsome when the short, white, flushed pink or magenta flower panicles arise above the coarse mid- to light green foliage during the summer months.

Viola cornuta
The strong purple flowers of this plant emerge from early to late summer. It originated in the Pyrenees, and is found in pastures and rocky grassland on calcareous soils at 700–2,300m/2,300–7,500ft. It was once used extensively in crosses with Victorian pansy stock to introduce its vigorous tufted growth and perennial habit to cultivars.

Golden Saxifrage *Chrysosplenium oppositifolium*
From mid-spring until midsummer the tiny flowers of this low, slightly hairy, creeping perennial deck roadside ditches and other damp places. The flower petals are golden green and the young, stalked, wavy-edged, evergreen, opposite leaves are similar, so may not easily be seen.

Sweet Violet

Viola odorata

The classic florist's violet, the sweet violet was exported widely from Europe in colonial times as it was a popular cut flower in the late 19th and early 20th centuries. It is highly fragrant, and on a still day its scent can be detected before the flower is seen. It is the parent of many violet cultivars, and is still grown commercially.

Identification: Robust, prostrate stolons creep and spread this stemless, perennial plant. The leaves are heart-shaped, with scalloped or slightly serrated edges, dark green, smooth, sometimes downy underneath; they arise alternately from stolons, forming a basal rosette. Flower stalks arise from the leaf axils from early spring to early summer, each bearing a single deep purple, blue to pinkish or even yellow-white bloom. The flower is five-petalled, the lower petal lengthened into a hollow spur beneath and the lateral petals with a hairy centre line, with a pair of scaly bracts placed a little above the middle of the stalk. In autumn, small, insignificant flowers, without petals and scent, produce abundant seed.

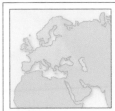

Distribution: Europe.
Height and spread: 15cm/6in.
Habit and form: Herbaceous perennial.
Leaf shape: Heart-shaped.
Pollinated: Insect, especially bee.

Right: The seed capsule splits into three when ripe.

Below: The showy, fragrant, mostly blue flowers give this plant its name.

CARROT FAMILY

The Apiaceae, or carrot family, are mostly temperate herbs, with the highest diversity in the northern, world and tropical uplands. They are characterized by flowers in umbels, hollow stems and sheathing flower stalks. Many species are important as food crops, and for aromatic compounds that are used as spices, although this usage masks the fact that the majority of species in this family are highly toxic.

Sea holly

Eryngium alpinum

There are more than 200 species of *Eryngium* or sea holly as it is more commonly known, and while they do not all come from maritime locations, they do all share a tendency to grow on very well drained sites. This particular species looks rather like a teasel (*Dipsacus* spp.), although it is not related at all. Its tough, bright green, veined basal leaves become more and more pointed and divided as they go up the stem, and end in a ruff of spiky bracts that look like steely blue feathers, inside which is the matching domed flowerhead.

Identification: A perennial with basal rosette of leaves, 7.5–15cm/3–6in long, that are persistent and ovate to triangular-cordate, spiny toothed and soft. The upper leaves are more rounded, palmately lobed and blue tinged. The cylindrical-ovoid disc of sessile flowers comprises 25 or more small steel-blue or white flowers held among spiny bracts. These are followed by small, scaly fruits.

Distribution: West and central Balkans.
Height and spread: 45cm/18in.
Habit and form: Herbaceous perennial.
Leaf shape: Rounded.
Pollinated: Bees.

Left and far left: The "teasel-like" flowers are held high above the basal rosette of leaves.

Fennel

Foeniculum vulgare

Fennel is a well known culinary herb, often grown in gardens and as a consequence it has been spread far beyond its original range. It is found naturally in the Mediterranean areas of Europe where it grows in dry, stony calcareous soils near the sea, and while it is in leaf all year, it is chiefly noticed when the scented flowers appear from August to October. It often has a coastal distribution, though it cannot stand high wind so is usually found a little way inland.

Identification: A slender, glaucescent, aromatic perennial or biennial growing to 2m/6½ft with soft, hollow stems that are finely striate, ascending and branching alternately at flowering. The leaves, to 30cm/12in, have sheathing bases and are triangular in outline, 3–4 pinnate and extremely finely cut with segments. The flowers appear in the summer and are in compound umbels, 10–40 rayed, bisexual and yellow; followed by ovoid-oblong, ridged fruits.

Distribution: Europe.
Height and spread: 2m/6½ft.
Habit and form: Herbaceous perennial.
Leaf shape: Pinnate (filiform).
Pollinated: Insect, especially bees and flies.

Left: The tall flowering stems are very striking although the plant often goes unnoticed when not in flower.

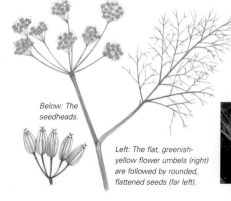

Below: The seedheads.

Left: The flat, greenish-yellow flower umbels (right) are followed by rounded, flattened seeds (far left).

Ground elder

Aegopodium podagraria, Goutweed, Bishop's weed

Distribution: Europe, often spread further by cultivation.
Height and spread: 70cm/28in.
Habit and form: Herbaceous perennial.
Leaf shape: Bipinnate.
Pollinated: Insects, especially bees.

Right: The pretty white umbels of this flower are very noticeable and appear around midsummer.

This small herbaceous plant is common in hedgerows and cultivated land and a common garden weed. Ground elder was once greatly valued as a pot herb, and for its medicinal qualities, leading to its being transported well outside its natural range, where it has since become a problem plant. The large, pretty, white flowers appear in early to midsummer and in warmer regions are followed by flattened seed vessels, which when ripe are detached and blown about by the wind.

Identification: A herbaceous plant with stems arising from elongated rhizomes and fibrous roots, multiple from the base, with a strong scent, glabrous, to 70cm/28in tall. Basal leaves are long petiolate, bipinnately divided with long petiole, leaflets mostly glabrous or with a few short stiff hairs on the main veins below, ovate to oblong, serrate to doubly serrate. Small, five-petalled, white flowers appear in terminal pedunculate compound umbels. Fruits are slightly compressed, ellipsoid, glabrous, with a conspicuous groove although they are only viable in warmer regions.

OTHER CARROT FAMILY SPECIES

Great masterwort
Astrantia major
This clump-forming perennial has rounded flowerheads, surrounded by papery, whitish, faintly pink bracts. It is found in moist woodlands and on the banks of streams in sub-alpine regions across central and eastern Europe.

Cow parsley *Anthriscus sylvestris*
This familiar plant of European temperate woodland edge, wayside and pasture looks very similar to some poisonous species so care must be taken when identifying it. Its large white umbels are extremely showy and often form a major constituent of unimproved grassland.

Carom *Trachyspermum ammi*
An important source of an aromatic spice, carom is very common to Indian and African cuisine. It closely resembles thyme in flavour. India is one of the most important sources of the plant, although it is probably of eastern Mediterranean origin, perhaps from Egypt.

Wild carrot *Daucus carota*
This flower occurs naturally on cultivated and

wasteland, among grass, especially by the sea and on chalk, throughout Europe, parts of Asia and North Africa. It has long been domesticated for human use.

Parsley

Petroselinum crispum

Parsley was native to central and southern Europe although cultivation of the plant for use as a herb has led to its becoming widely naturalized elsewhere, especially within the temperate regions fo the Northern Hemisphere. The plant naturally inhabits grassy places, walls, rocky outcrops and dry hedgerow banks. It is a biennial herb that is in flower from June to August, displaying tiny, star-shaped, green-yellow flowers in flat-topped umbels.

Identification: A stout, erect glabrous biennial, with a clean, pungent smell when crushed. Stems are solid and striate, with branches ascending. The three-pinnate leaves are bright green, with 4–12 pairs that are ovate in outline, cuneate at the base and toothed, with a long petiole. The upper cauline leaves are small. Yellowish flowers appear in flat-topped, compound umbels, to 5cm/2in across in summer, followed by small, rounded flattened seeds. Oblong, greyish-brown fruits 3mm/⅛in long, with spines on the curved surface, ripen from late summer to early autumn.

Distribution: Southeast Europe, Sardinia.
Height and spread: 30–75cm//12–30in.
Habit and form: Biennial.
Leaf shape: Pinnate.
Pollinated: Insect, especially flies.

Above right and right: The small, greenish-yellow flowerheads can easily be overlooked in the wild when plants grow among other vegetation.

BORAGE AND LOBELIA FAMILIES

The Boraginaceae are herbs, shrubs or trees that are found worldwide in tropical, subtropical and temperate areas but are most concentrated in the Mediterranean region. The Lobeliaceae family contains flowering plants native to both hemispheres, including annual and perennial herbs, shrubs and trees. The family is included by some authorities in the bellflower family, Campanulaceae.

Green Alkanet

Evergreen bugloss, *Pentaglottis sempervirens*

Green alkanet is a member of the forget-me-not family, but it is unusual in that the flowers do not grow in a curved spike as in most members of the family. The plant is native to south-west Europe, but is now naturalized in hedge banks and woodland edges in many areas outside this range. It is especially common close to towns and villages, probably due to its having been used at one time as the source of a red dye that was extracted from the roots. It can grow in deep woodland shade or open positions, although it usually requires moist soil and is common in damp, shady places, or by roads and in hedges, near the sea.

Distribution: Western Europe.
Height and spread: 30cm–1m/12–39in.
Habit and form: Herbaceous perennial.
Leaf shape: Ovate.
Pollinated: Insect.

Identification: A coarsely hairy, taprooted perennial, with strong, erect to ascending, fairly leafy stems, arises from a basal rosette of pointed, oval to oblong, rough-hairy, mid-green leaves, 10–40cm/4–16in long; the stem leaves are rather smaller. From spring to early summer, it bears small leafy clusters of bright blue flowers, to 12mm/½in across, with stamens hidden inside the short, narrow flower-tube, five spreading lobes and a white eye.

Right: The small seedhead contains numerous seeds.

Left: Tall flower stems arise from the spreading leafy base.

Right: The flowers are eyecatching.

Common Borage

Borago officinalis

Borage is a hardy annual with obscure origins. It grows wild from central Europe to the western Mediterranean but has been used by people for so long that it is now naturalized in most parts of Europe; mostly near dwellings. It has been grown as a herb – the leaves taste like cucumber, despite their texture – and for its flowers, which yield excellent honey. The numerous bright blue flowers, held in loose, branching heads appear from late spring onward.

Below: Borage has a messy straggly habit.

Above and far right: The showy, star-shaped flowerheads sport numerous blue flowers, and are favoured by bees.

Identification: Borage is a robust, freely branching annual, with lance-shaped to oval, dull green leaves up to 15cm/6in long, covered with white, stiff, prickly hairs. The leaf margins are entire, but wavy. The round stems, 60cm/2ft high, are branched, hollow and succulent, with alternate, stalkless, lance-shaped leaves, supporting branched clusters of five-petalled, star-shaped, bright blue flowers up to 2.5cm/1in across, over a long period in summer. The flowers are easily distinguished from those of every other plant in this order by their prominent black anthers, which form a cone in the centre. The fruit consists of four brownish-black nutlets.

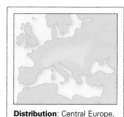

Distribution: Central Europe, though widely naturalized elsewhere.
Height and spread: 60cm/2ft.
Habit and form: Annual.
Leaf shape: Ovate to lanceolate.
Pollinated: Bee.

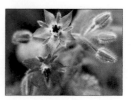

Giant Lobelia

Lobelia deckenii

The giant lobelia grows on Kilimanjaro in Kenya, between 3,700–4,300m/12,000–14,000ft, in an alpine region dominated by small shrubs. The plant is endemic to the area and exceptionally striking. In order to protect the sensitive leaf buds from the sub-zero night-time temperatures, it closes its leaves around the central core while the covered rosettes secrete a slimy solution that helps to insulate and preserve them. It is pollinated by birds, especially the brightly coloured sunbirds that inhabit the area. Several related subspecies exist on the mountains of East Africa, including *L. deckenii* ssp. *keniensis* on Mount Kenya. The plants are monocarpic – each rosette dying after flowering – but are characterized by extremely long lifespans.

Distribution: Restricted to a few east African mountains.
Height and spread: Up to 3m/10ft or more.
Habit and form: Rosette-forming evergreen perennial.
Leaf shape: Ovate to oblong.
Pollinated: Bird.

Right: Each flower is shaped for the bills of visiting sunbirds that feed on the rich nectar.

Identification: The thick, hollow flower stem, growing up to 3m/10ft, arises out of the centre of a tight rosette of leaves that are broadly oval to oblong, glaucous to shiny, strongly ridged down the midrib on the lower side, with clearly defined veination at almost right angles to the midrib. In immature specimens, the rosette of leaves is arranged in a tight spiral, with a cabbage-like central bud. The flower spike is covered with spiralling, triangular bracts that conceal blue flowers.

OTHER BORAGE AND LOBELIA SPECIES

Viper's Bugloss
Echium vulgare
A European native, viper's bugloss is a bushy, upright biennial with narrowly lance-shaped to linear, toothed, white, bristly-hairy leaves. In early summer it produces short, dense spikes of bell-shaped flowers, blue in bud but ranging from purple or vibrant blue to pink or white.

Siberian Bugloss *Brunnera macrophylla*
A native of woodlands in the Caucasus. Its leaves, up to 15cm/6in across, are roughly kidney shaped and provide an attractive foil for the sprays of starry, pale blue, forget-me-not-like flowers that appear shortly after the leaves.

Scrambling Gromwell *Lithodora diffusa*
Native to France, Spain and Portugal, this plant is recognized by its sprawling habit. It has linear, deep green leaves and strikingly deep blue flowers, borne profusely from mid-spring to early summer. It prefers well-drained, moist, acid soil.

Omphalodes verna
This charming spreading perennial, a relative of the forget-me-nots, grows from the south-east Alps to Romania. Its dark green, grooved leaves cover the ground and in spring, small, white-centred, deep blue flowers appear on short, branched stems, each with two to four blooms.

Tower of Jewels

Echium wildpretii

The tower of jewels is endemic to the Canary Islands. It produces a tall spike of crimson flowers with beautiful rosettes of silver leaves. Growing on mountains where it is mostly dry, cold and exposed to high ultraviolet radiation, this species shows similarities with other isolated alpine plant species, such as lobelias and groundsels, by attaining giant size to cope with alpine conditions instead of the more common miniature proportions usually associated with alpine plants. The plant is monocarpic: when the flowers fade, it dies, leaving behind a vast amount of seed.

Identification: A woody-stemmed, unbranched biennial or occasionally short-lived perennial, with a dense rosette of narrowly lance-shaped, silvery, hairy, light green leaves, to 20cm/8in long. In its first year it develops only leaves but in the following year it produces a dense, column-like cyme, 2.5m/8ft tall or more, of funnel-shaped, red or pink flowers, which are often bird-pollinated.

Distribution: Canary Islands.
Height and spread: 2–3m x 75cm/6½–10 x 2½ft.
Habit and form: Biennial.
Leaf shape: Lanceolate.
Pollinated: Bird, bee.

Above: Each flower spike is made up of a multitude of tiny, pink flowers.

NETTLE AND DEADNETTLE FAMILIES

The nettle family, Urticaceae, is widely spread over the world. Most are herbs but a few are shrubs or small trees, mainly tropical, though several occur widely in temperate climates. Many of the species have stinging hairs on their stems and leaves. The Lamiaceae, or deadnettle family, are mostly herbs or shrubs, distributed all over the world. They include many well-known herbs, ornamental plants and weeds.

Stinging Nettle

Urtica dioica

The common stinging nettle is an upright perennial that grows in damp forests or wherever land has been disturbed by humans. It has a much-branched yellow rhizome, which spreads over large areas, and from which grow numerous leafy shoots. The unisexual flowers are borne on separate plants, although monoecious specimens sometimes occur. All parts of the plant are covered in fine, stinging hairs: it is soon recognized, often through harsh experience!

Above: Tiny female flowers appear on separate plants to male ones (left).

Distribution: Northern Eurasia.
Height and spread: 1.2m/4ft.
Habit and form: Herbaceous perennial.
Leaf shape: Cordate or lanceolate.
Pollinated: Wind.

Identification: Numerous erect, quadrangular stems commonly grow to 1.2m/4ft tall, although they may far exceed this in favourable conditions. They are covered with long stinging hairs and short bristly hairs. The opposite, stalked, heart-shaped or lance-shaped leaves are serrated at the margin and covered on both sides with translucent stinging hairs. The flowers are arranged in drooping panicles, growing in groups from the upper leaf axils from late spring to early autumn.

Left and right: These robust plants spread to form extensive colonies.

China Grass

White ramie, *Boehmeria nivea*

This shrubby perennial from eastern Asia has the overall appearance of a stinging nettle, but lacks any stinging hairs. It can sometimes be encountered in the wild in rocky places up to a height of 1,200m/4,000ft. It is often found outside its original range due to its having been extensively cultivated for its fibres, which, when extracted from the stems, are the longest and strongest of any plant. It is sometimes found wild in India, Malaysia, China and Japan, and is probably a native of India and Malaysia.

Identification: A number of straight, coarse, bristly shoots are sent up from a perennial underground rootstock each season. The alternate leaves are broadly oval, 15cm/6in long or more, with pointed tips, wedge-shaped or rounded at the base, serrated along the margin, white-woolly underneath, giving a silvery appearance. The minute, greenish flowers are closely arranged along a slender axis, on densely branched panicles, mostly shorter than the flower stalk.

Distribution: Eastern Asia.
Height and spread: 1–1.8m x 1m/3–6ft x 3ft.
Habit and form: Shrubby, herbaceous perennial.
Leaf shape: Ovate.
Pollinated: Wind.

OTHER NETTLE AND DEADNETTLES

Sage *Salvia officinalis*
Sage originates in southern Europe, growing on dry banks and in stony places, usually where there is very little soil. A small evergreen shrub, rarely exceeding 60cm/2ft, it sports scented, purple flowers from early to late summer. The whole plant is extremely aromatic, hence its long culinary use.

Pellitory of the Wall *Parietaria judaica*
This perennial, grows to 60cm/2ft, in semi-shade or an open position. It is often found on hedge banks and dry walls, hence the name. It has the reputation of being a medicinal plant, and is often found growing around ruined castles, churches and monasteries.

Water Mint *Mentha aquatica*
One of the commonest wild mints, often found around marshes, fens, near rivers, streams and ponds, and in wet woods. When crushed it imparts a characteristic rich aroma. It hybridizes easily with other mints, often crossing with spearmint, *M. spicata*, to produce peppermint, *M. x piperita*.

Roman Nettle *Urtica pilulifera*
The Roman nettle bears its female flowers in little compact, globular heads, followed by ornamental seedpods, and was a medicinal plant of choice for the ancient Romans. It is also smooth except for the stinging hairs, which contain a much more virulent venom than that of the common stinging nettle.

Aluminium Plant

Watermelon pilea, *Pilea cadierei*

This familiar plant is widely grown in gardens, or as a houseplant, although its origins are in the warm humid forests of Vietnam. It is instantly recognizable due to the variegated foliage that is unlike any other, with shiny silver, irregularly-shaped markings parallel to the lateral veins. These leaves are held opposite each other on square, green stems and they rapidly produce a thick ground cover in patches of open forest. Its small white flowers are produced at the ends of the stems in the summer but are mostly overshadowed by the conspicuous foliage.

Identification: Spreading to erect herb or sub-shrub, to 45cm/1½ft, with greenish or pink-tinged, soft, round stems, becoming rigid with age and woody at the base. The leaves are obovate to oblong-oblanceolate to 7.5cm/3in long, held in opposite pairs, simple, quilted, green with interrupted bands of silver centrally and on margins, with coppery-maroon veins. The flowers are minute, whitish becoming pinkish, perianth with four segments in male flowers, three in female.

Distribution: Vietnam.
Height and spread: 50cm/20in.
Habit and form: Spreading evergreen perennial.
Leaf shape: Oval.
Pollinated: Bee.

Below: The shiny, irregular markings on the leaves are instantly recognizable and give rise to this plant's common name.

Mind-your-own-business

Soleirolia soleirolii

This semi-evergreen, creeping perennial, which forms a dense mat about 5cm/2in high, was originally introduced as an ornamental from Corsica across much of its modern range. It prefers moist soil and partial shade, spreading rapidly using pink, thread-like stems. It sometimes forms extensive mats and is considered to be an invasive weed in many areas where it has been introduced. It prefers moist, sheltered habitats and is especially well adapted for colonizing urban areas.

Distribution: Corsica, but now very widespread.
Height and spread: 5cm/2in, with indefinite spread.
Habit and form: Creeping herbaceous perennial.
Leaf shape: Rounded.
Pollinated: Wind.

Identification: The slender stems, which grow to 20cm/8in and root at the nodes, are delicate, intricately branching, translucent, pale green sometimes tinged pink. The leaves, 2–6mm/¹⁄₁₆–¼in, are alternate and near-circular, short-stalked, minutely and sparsely hairy with a smooth margin. The solitary flowers, borne in the leaf axils, are minute, white, sometimes pink tinged, and followed by the glossy, one-seeded fruit, enclosed in a persistent calyx.

FIGWORT FAMILY

The Scrophulariaceae, or figwort family, comprise mostly herbs but also a few small shrubs, with about 190 genera and 4,000 predominately temperate species. They include many that are partial root parasites and a few that are without chlorophyll and are wholly parasitic. They have a cosmopolitan distribution, with the majority found in temperate areas, including tropical mountains.

Cape Fuchsia

Phygelius capensis

The common name of this plant reflects the flower shape, with long tubular flowers bearing a resemblance to those of the quite unrelated fuchsia. It has a very long flowering season, sometimes lasting four or five months. Originating from alongside streams in South Africa, this beautiful plant has long been cultivated for its racemes of brilliant scarlet flowers. Consequently, it is occasionally encountered as a garden escapee, usually near to habitations. It spreads extensively by root suckers and the top growth may die back to ground level if winter conditions become extremely cold.

Identification: A sprawling, stoloniferous, suckering, shrub or subshrub with lance-shaped to oval, dark green leaves up to 9cm/3½in long. They are mostly opposite in pairs, with the upper leaves sometimes alternate. In summer, it bears upright panicles, up to 60cm/2ft long, of showy, yellow-throated, scarlet-orange tubular flowers, each 5cm/2in long, with five lobes, curved back toward the stems.

Distribution: South Africa.
Height and spread: 1.2 x 2.5m/4 x 8ft.
Habit and form: Suckering subshrub.
Leaf shape: Lanceolate to ovate.
Pollinated: Insect, bird.

Left and far left: The showy, yellow-throated flowers, shaped rather like the unrelated Fuchsia genus, appear in upright panicles during the summer and give rise to the plant's common name.

Foxglove

Digitalis purpurea

A common biennial or occasionally short-lived perennial of woodlands, hedge banks and wayside, wherever soil is disturbed, the foxglove provides a colourful display in midsummer. The flowers are most commonly purple but can be white and occasionally pale pink. It seeds profusely: a single plant can produce up to two million seeds. It does best in sandy, well-drained areas. It is distributed throughout Europe, though is absent from some calcareous districts.

Identification: Rosette-forming and very variable, the foxglove has oval to lance-shaped, usually toothed, sometimes white, woolly, dark green leaves, 10–25cm/4–10in long. Tall stems with alternate leaves support one-sided spikes of purple, pink or white, inflated, tubular, bell-shaped, two-lipped flowers, to 6cm/2¼in long, spotted maroon to purple inside, and produced in early summer. Oval fruits, longer than the tube formed by the sepals, ripen to brown.

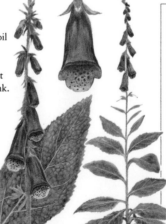

Top: Each flowerhead is composed of single flowers.

Distribution: Europe.
Height and spread: 1–2m x 60cm/3–6½ x 2ft.
Habit and form: Herbaceous biennial.
Leaf shape: Ovate to lanceolate.
Pollinated: Insect, chiefly bumblebee.

Left: The whole plant, including the roots and flowers, is poisonous.

Chinese Foxglove

Rehmannia glutinosa

This perennial plant from northern China is found in woodlands and stony sites and sports large, foxglove-like flowers. The species name *glutinosa* is derived from the word glutinous, referring to the sticky nature of the root. The plant received its generic name in honour of Joseph Rehmann, a 19th-century physician in the Russian city of St Petersburg. This possibly alludes to the fact that *Rehmannia*'s root is used medicinally in China, where it has been cultivated for more than 2,000 years.

Distribution: Northern China.
Height and spread:
15–30cm/6–12in.
Habit and form: Herbaceous perennial.
Leaf shape: Obovate.
Pollinated: Insect, especially bee.

Far right: Large, attractive, foxglove-like flowers emerge from the middle of the leaf rosette in the spring and summer.

Identification: This sticky, purple-hairy perennial has slender runners and rosettes of egg-shaped, scalloped, conspicuously veined, basal leaves, up to 10cm/4in long, which are mid-green above and often red tinted beneath. From mid-spring to summer, branched, leafy stems bear pendent, tubular, two-lipped flowers up to 5cm/2in long, in cyme-like racemes of a few flowers, or singly on long flower stalks, from the leaf axils. The flowers have reddish-brown tubes, marked with darker reddish-purple veins, and pale yellow-brown lips.

OTHER FIGWORT FAMILY SPECIES
Dark Mullein *Verbascum nigrum*
The dark mullein is a widely distributed plant, found all over Europe and in temperate Asia as far as the Himalayas. In the eastern states of North America it is abundant as a naturalized weed. Its yellow flower spike, up to 1.2m/4ft tall, rises from a basal rosette of soft, felted leaves in summer.

Snapdragon *Antirrhinum majus*
The snapdragon is a native of south-west Europe that has naturalized across the world, and thrives on old walls and chalk cliffs, having escaped from gardens during a long period of cultivation. Its botanical name, *Antirrhinum*, refers to the snout-like form of the flower.

Toadflax *Linaria vulgaris*
In most parts of Europe toadflax grows wild on dry banks, by the wayside, and at the borders of fields and meadows. It is especially abundant in gravelly soil and in limestone districts. It has grey-green, narrow leaves and yellow, snapdragon-like flowers on a spike up to 75cm/30in tall from midsummer to mid-autumn.

Germander Speedwell *Veronica chamaedrys*
Commonly found on banks, in pastures and woods, germander speedwell flowers in spring and early summer. It has a creeping, branched rootstock, and strong stems that sport bright blue flowers streaked with darker lines and a white eye in the centre. The flower closes at night and also in rainy weather.

Knotted Figwort

Common figwort, *Scrophularia nodosa*

The knotted figwort, common throughout western Europe, is similar in general habit to the water figwort, *S. auriculata*, though it is not distinctly an aquatic like that species. It is frequently found in woodland glades, hedge banks and in damp shady places with fairly rich soil, either in cultivated or waste ground. The "fig" in its name is an old English word for haemorrhoids, which both the globular red flowers and the root protuberances were thought to resemble.

Identification: It is an upright perennial, hairless except for the glandular inflorescence. Short rhizomes, which are irregularly tuberous, give rise to sharply four-angled, non-winged stems, which support a panicle of flower clusters growing from the axils of the bracts. The lowest bracts are leaf-like, and the flowers are two-lipped, yellowish-green, up to 12mm/½in long, each with a brown upper lip. The leaves are oval, pointed and coarsely toothed, and often unequally decurrent down the leaf stalk.

Distribution: Europe.
Height and spread:
40–80cm/16–32in.
Habit and form: Herbaceous perennial.
Leaf shape: Ovate.
Pollinated: Wasp (chiefly) and bee.

Right: The tall flower stems emerge during late spring and early summer.

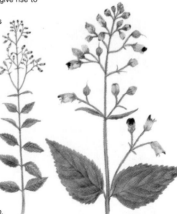

Left: The individual flowers are small and yellowish-green with a brown upper lip.

ACANTHUS FAMILY

The Acanthaceae, or acanthus family, are mostly herbs or shrubs comprising about 250 genera and 2,500 species. Most are tropical herbs, shrubs or twining vines, while others are spiny. Only a few species are distributed in temperate regions. Typically, there is a colourful bract subtending each flower; in some species the bract is large and showy. The family is closely allied to the Scrophulariaceae (figworts).

Bear's Breeches

Acanthus mollis

This plant is a native of warmer parts of south-western Europe as far as the Balkans, and parts of North Africa. It is most commonly found in woodland scrub and on stony hillsides. In summer, creamy-white to slightly pink or purplish flowers appear on tall, erect stalks above the foliage. The generic name derives from the Greek *akantha*, meaning "spine", referring to the toothed foliage of some species.

Identification: This large, clump-forming perennial has oval, deeply cut, smooth, bright green foliage. The basal leaves are 20–60cm/8–24in long on long leaf stalks; those on the upper stem are 1–3cm/½–1¼in long, more or less oval, toothed and stalkless. The leaves can be quite variable, being cut, lobed, or even deeply pinnately divided. The irregular and unusual flowers form on stiff, erect spikes, well above the foliage from early to late summer. The flower is tubular, with a large, three-lobed lower lip. It is suspended by spine-tipped bracts and a large calyx lobe; another enlarged calyx lobe forms a hood.

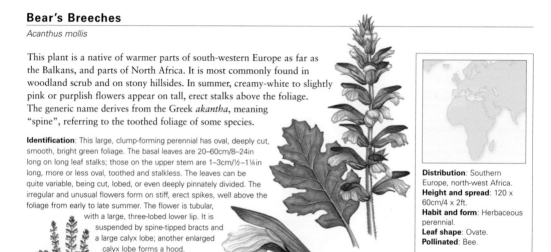

Left: The large, spiny leaves form a dense clump from which the flower spikes emerge.

Left: Each flower spike contains many small white flowers.

Distribution: Southern Europe, north-west Africa.
Height and spread: 120 x 60cm/4 x 2ft.
Habit and form: Herbaceous perennial.
Leaf shape: Ovate.
Pollinated: Bee.

Persian Shield

Strobilanthes dyerianus

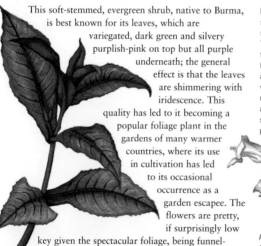

This soft-stemmed, evergreen shrub, native to Burma, is best known for its leaves, which are variegated, dark green and silvery purplish-pink on top but all purple underneath; the general effect is that the leaves are shimmering with iridescence. This quality has led to it becoming a popular foliage plant in the gardens of many warmer countries, where its use in cultivation has led to its occasional occurrence as a garden escapee. The flowers are pretty, if surprisingly low key given the spectacular foliage, being funnel-shaped, pale violet, and arranged on short spikes.

Identification: An evergreen subshrub with soft (not woody) stems, square in cross section. The unequal pairs of elliptic, toothed, dark green, opposite leaves, 10–18cm/4–7in long, have a puckered texture and are variegated dark green and silvery-metallic, purplish-pink on top and all purple underneath. It bears short spikes of funnel-shaped, pale blue flowers, 3cm/1¼in long.

Left: The pretty, violet flowers appear on short spikes.

Distribution: Burma.
Height and spread: 120 x 90cm/4 x 3ft.
Habit and form: Evergreen subshrub.
Leaf shape: Elliptic.
Pollinated: Insect.

Right: Although the plant adopts a shrubby character, the stems remain quite soft and brittle.

Acanthus spinosus
Much like its relative *A. mollis*, this herbaceous plant from west Turkey grows about 1m/3ft tall, but its leaves are more spiny and narrower. In summer, white flowers wrapped in pretty, spiny, mauve-purple bracts are borne on tall, erect stalks above the foliage.

Firecracker Flower *Crossandra infundibuliformis*
The firecracker flower is a tropical shrub, native to southern India and Sri Lanka. Fan-shaped flowers appear in clusters on long stems, growing from the leaf axils. The flowers are yellow or salmon-orange in colour and can bloomcontinuously for weeks.

Bengal Clock Vine
Thunbergia grandiflora
The Bengal clock vine, or blue trumpet vine, is a vigorous, woody-stemmed climber from northern India, with broad-lobed leaves, bearing pendent racemes of large, showy violet or whitish flowers, with pale yellow tubes, which may reach 4cm/1½in long and 7.5cm/3in across.

Acanthus hungaricus
A large, evergreen, clump-forming, herbaceous perennial from the Balkans, Romania and Greece, with long, handsome, shiny, deeply cut, thistle-like, basal leaves. Tall spikes of white or pink-flushed flowers with red-purple bracts emerge in early to midsummer.

Black-eyed Susan

Thunbergia alata

This familiar climbing plant, usually grown in cultivation as an annual, is actually an evergreen perennial in tropical climates. It is often found outside its natural range as a garden escapee. It is a fast-growing climber, native to tropical areas of east Africa, which twines around any convenient support, and bears bright orange flowers with black centres throughout summer. The genus name honours Carl Peter Thunberg, an 18th-century Swedish botanist.

Identification: This tropical evergreen twining vine, climbing or trailing, has triangular to egg-shaped leaves, sharply pointed, shaped like an arrowhead at the base, up to 7.5cm/3in long, entire or with a few coarse teeth; the leaf stalks are winged, about as long as the leaf. Solitary, flat, five-petalled, orange-yellow flowers, rarely white, to 5cm/2in wide, with black-purple flower tubes, are borne from the leaf axils on stalks longer than the leaf stalks. The flattened round seed capsule is about 12mm/½in wide, with a beak 12mm/½in long; the seeds are warty and ribbed.

Distribution: Tropical east Africa.
Height and spread: 6 x 1.8m/20 x 6ft.
Habit and form: Evergreen climbing perennial.
Leaf shape: Deltoid or ovate.
Pollinated: Insect.

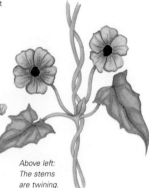

Left: A vigorous climbing habit and free-flowering nature have made this plant popular in cultivation.

Above left: The stems are twining.

Adhatoda

Malabar nut tree, Adulsa, Vasaka, *Justicia adhatoda*

Adhatoda is common in India, especially in the lower Himalayas (up to 1,300m/4,250ft above sea level) and to a slightly lesser extent in Sri Lanka. It favours open plains and is commonly found growing on wasteland. It is a small tree or large shrub that flowers in the cold season. Adhatoda leaves have been used extensively in Ayurvedic medicine for more than 2,000 years.

Identification: Adhatoda has smooth, ash-coloured bark, which is smoother on the branches. The opposite, broadly lance-shaped, taper-pointed, smooth or slightly downy leaves, which are 12.5–15cm/5–6in long, are borne on short leaf stalks. The solitary flower spikes emerge from the exterior axils on long stalks, the whole end of the branchlet forming a leafy panicle enveloped with large bracts. The white, tubular flowers are spotted with small rust-coloured dots; the lower part of both lips is streaked with purple. The fruit is a small, four-seeded capsule.

Below: The rust-speckled white flowers are streaked with purple.

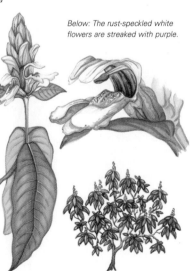

Distribution: Indian subcontinent.
Height and spread: 3 x 1.5m/10 x 5ft.
Habit and form: Evergreen shrub.
Leaf shape: Broadly lanceolate.
Pollinated: Insect.

Far right: Adhatoda is a usually erect and sparsely branched evergreen shrub, spreading with age.

DAISY FAMILY

The Asteraceae, or daisy family, are herbaceous plants, shrubs or, less commonly, trees. This is arguably the largest family of flowering plants, comprising about 1,100 genera and 20,000 species. The species are characterized by having the flowers reduced and organized into a composite arrangement of tiny individual flowers called a capitulum – a tight cluster that superficially resembles a single bloom.

Daisy

Bellis perennis

Arguably the most widely recognized of all wild flowers, the daisy grows on roadsides, in gardens, and is often an unwanted weed. The plant is most commonly found growing in short grassland, particularly in cultivated lawns. It requires moist soil and the seeds usually germinate on worm casts left on the surface.

Identification: A stoloniferous, evergreen, rosette-forming perennial, with a flat basal rosette of spoon-shaped, bright green leaves, 1.2–6cm/½–2½in long. From late winter to late summer, slightly hairy stems, 2.5–10cm/1–4in tall, carry single, large, white compound flowers, 1.2–3cm/½–1¼in across, with white ray florets, often tinged maroon or pink, and yellow disc florets, from pink buds.

Below: Daisy flowers open outright in full sun.

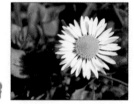

Distribution: Europe and Turkey.
Height and spread: 15cm/6in.
Habit and form: Evergreen perennial.
Leaf shape: Obovate.
Pollinated: Bee, fly and beetle.

Dandelion

Taraxacum officinalis

This familiar plant is probably native to all parts of the north temperate zone, in pastures, meadows and on waste ground, and is so plentiful that it is often considered a troublesome weed. Its flowers are more conspicuous in the earlier months of the summer, although it may be found in bloom almost throughout the year. It is not native to the Southern Hemisphere, although it has been widely introduced accidentally through agriculture and human activity.

Identification: The dandelion is a rosette-forming perennial with a thick taproot that is dark brown, almost black on the outside, white and milky within. Long, deeply cut, shiny, hairless leaves have margins cut into large jagged teeth, either upright or pointing backwards, with the teeth occasionally cut into smaller teeth. Shiny, purplish flower stalks, rising straight from the root, are leafless, smooth and hollow and bear single heads of composite, bright yellow flowers, made up of numerous strap-shaped florets, to 5cm/2in across. A bitter, milky juice is exuded when the stem is broken.

Right: Dandelion flowers and leaves are a familiar sight.

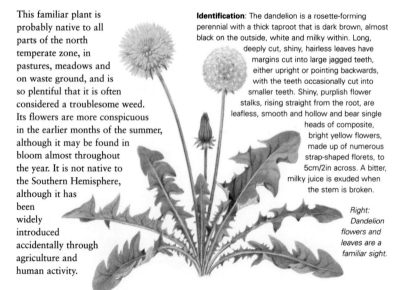

Distribution: Worldwide in temperate regions, often introduced elsewhere.
Height and spread: Up to 30cm/1ft.
Habit and form: Herbaceous perennial.
Leaf shape: Runcinate.
Pollinated: Insect, especially bumblebee.

Sweet Coltsfoot

Giant butterbur, Japanese butterbur, fuki, *Petasites japonicus*

Distribution: East Asia: China, Japan and Korea.
Height and spread: 60 x 150cm/2–3ft.
Habit and form: Herbaceous perennial.
Leaf shape: Reniform.
Pollinated: Insect.

Far right: The large leaves appearing in summer offer stark contrast to the small bracts of the flower stems.

This species is a native of eastern Asia, naturally inhabiting damp, marshy areas, especially along riverbanks, although it is widely naturalized elsewhere as a garden escapee in moist woods and thickets. The plant is a master of metamorphosis, as it changes from an unimposing small flower stalk to a mound of large, kidney-shaped leaves on long, edible stalks. Individual plants are either male or female and both sexes must be present if seed is to be set. It can form very large colonies where conditions are favourable for its growth. The name "butterbur" comes from a related European species reportedly used to wrap butter, despite the unpleasant smell.

Identification: Growing from a rhizome, the plant has kidney-shaped, irregularly toothed, basal leaves up to 80cm/32in across, hairy beneath, borne on stalks 90cm/3ft long. Densely clustered corymbs of yellowish-white flowerheads, to 1.5cm/⅝in across, with oblong bracts below, are borne before the leaves in late winter and early spring.

Leopard Plant *Ligularia przewalskii*
A native of northern China, this clump-forming perennial has huge, heart-shaped, leathery, deeply cut, toothed, dark green leaves that emerge purplish-red, but turn to brownish-green. Tall, narrow spikes of clear yellow, daisy-like flowers appear from mid- to late summer.

Globe Thistle *Echinops ritro*
A native from central Europe to central Asia, growing to 50cm/20in or more. The stiff, spiny leaves are dark green and "cobwebby" above and white-downy below. In summer it bears spherical flowerheads, up to 5cm/2in across, which change from metallic blue to bright blue as the florets open.

Ox-eye Daisy *Leucanthemum vulgare*

A familiar sight in fields throughout Europe and northern Asia. The generic name, derived from Greek means "white flower". The familiar yellow-centred, white flowerheads appear from late spring until midsummer.

Cornflower *Centaurea cyanus*
The cornflower, with its star-like blossoms of brilliant blue, is a most striking wildflower. It is fairly common in cultivated fields and by roadsides, though is in decline due to changing agricultural practices. The down-covered stems are tough and wiry.

Namaqualand Daisy

Dimorphotheca sinuata

This showy annual grows naturally in the winter rainfall areas of south-western Africa, usually in sandy places in Namaqualand and Namibia. It creates sheets of brilliant orange when it flowers in early spring, drawing visitors from near and far. The genus name is derived from Greek *dis* (twice), *morphe* (shape) and *theka* (fruit), referring to the different kinds of seeds produced by the ray and disc flowers.

Identification: The aromatic leaves are slender, oblong to lance-shaped, or sometimes spoon-shaped, with coarsely toothed margins, light green, up to 10cm/4in long. The stems are reddish and covered by the masses of leaves around them. The orange, or occasionally white to yellow flowers, up to 8cm/3¼in across, borne singly at the tip of each stem in winter, have orange centres (sometimes yellow). They need full sun to open and always face the sun. Around the centre at the bottom of the petals is a narrow, greenish-mauve ring.

Distribution: South-west Africa.
Height and spread: 30cm/1ft.
Habit and form: Annual.
Leaf shape: Oblong to lanceolate or obovate.
Pollinated: Insect.

Left: The brilliant orange, tall-stemmed daisy-like flowers grow out of a mat of foliage.

ERICACEOUS PLANTS

The Ericaceae are a large family, mostly shrubby in character, comprising about 125 genera and 3,500 species of mostly calcifuge (lime-hating) plants, generally restricted to acid soils. The family is cosmopolitan in distribution, except in deserts, and includes numerous plants from temperate, boreal and montane tropical zones. The chief centre of diversity is in southern Africa.

Scarlet Heath

Erica coccinea

A rather variable species of heather, the scarlet heath is commonly found in the fynbos vegetation of the south-west Cape in South Africa, although it is most often noticed during its peak flowering season. This is mainly during the wetter, winter months but it can be variable depending upon the form. As with many of the long-flowered heathers, this species is typically pollinated by small birds or more occasionally insects and has long tubular flowers that reflect this relationship.

Identification: An erect, much-branched evergreen shrub with numerous short, lateral, leafy branchlets, tightly clustered along the main branches. They are covered in small, needle-like leaves, 4–8mm/⅛–⅜in long, arranged in whorls of three. Both leafy and flowering growth is mainly hairless. Pendent, showy flowers, growing from just below the branch end are 6–15mm/¼–⅝in long, in a range of colours from red, pink and orange, to yellow or green.

Distribution: South Africa.
Height and spread: 1.2m/4ft.
Habit and form: Evergreen shrub.
Leaf shape: Linear.
Pollinated: Bird, occasionally insect.

Above left: The long tubular flowers of this species of heather are often pollinated by small birds.

Rhododendron ponticum

A fast-growing, evergreen, small tree or large shrub, which occurs naturally in three main regions: around the Black Sea, in the Balkans and in the Iberian Peninsula. It can grow up to 6m/20ft in favoured conditions, which are, generally, acidic moorland and woodland. However, it is happy in almost any conditions, from open sunny spots to quite dense shade, and has become an invasive pest in Britain and other European countries. Fossil evidence in Irish peat deposits reveals that this plant once occurred as a native there, approximately 302,000–428,000 years ago, in a warm period that interrupted the most recent ice age, suggesting that it was once far more widespread than it is currently.

Identification: This vigorous, evergreen shrub has inversely lance-shaped to broadly elliptic, leathery leaves, 6–18cm/2¼–7in long, glossy, dark green above and paler beneath. In early summer it bears trusses of broadly funnel-shaped, reddish-purple, mauve or occasionally white flowers, up to 5cm/2in long, often spotted yellowish-green inside.

Distribution: Europe and Western Asia.
Height and spread: 6m/20ft.
Habit and form: Evergreen shrub.
Leaf shape: Broadly elliptic.
Pollinated: Insect, especially bee.

Left: The tightly arranged flowerheads appear in mid-spring.

Right: Rhododendron ponticum can form a large bush in time and often forms dense stands in light woodland cover.

Bearberry

Arctostaphylos uva-ursi

The bearberry is a small shrub, distributed over the greater part of the Northern Hemisphere, being found in the northern latitudes and high mountains of Europe, Asia and North America, throughout Canada and the United States. It is common on heaths and barren places in hilly districts.

Distribution: Circumpolar.
Height and spread: 30cm/1ft.
Habit and form: Trailing evergreen shrub.
Leaf shape: Obovate.
Pollinated: Insect.

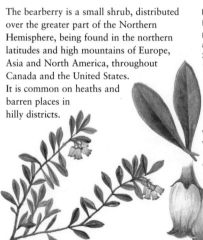

Identification: A much-branched, evergreen shrub, it has irregular, short, woody stems covered with a pale brown bark, scaling off in patches, which trail along the ground forming thick masses, 30–60cm/1–2ft in length. Evergreen, leathery leaves, 12–25mm/½–1in long, are spoon-shaped, tapering gradually towards the base to a very short stalk, with entire, slightly rolled back margins. The upper leaf surface is shiny dark green with deeply impressed veins; the underside is paler, with prominent veins forming a coarse network. The young leaves are fringed with short hairs. Small, waxy-looking, urn-shaped flowers, reddish-white or white with a red lip, transparent at the base, contracted at the mouth, in small, crowded, drooping clusters, appear at the ends of the branches in early summer, before the young leaves.

Far left: The evergreen, branching growth often forms a dense mass that hugs the ground.

Left: The small flowers appear on the branch tips in early summer. The leaves are simple.

OTHER ERICACEOUS PLANT SPECIES

Bilberry *Vaccinium myrtillus*
The bilberry, or whinberry, is a small, branched shrub of heaths and mountainous areas, with wiry angular branches, bearing globular waxy flowers and edible black berries, which are covered with a delicate grey bloom when ripe. The leathery leaves are at first rosy, then yellowish-green, turning red in autumn.

Heather *Calluna vulgaris*
Heather, or ling, is an abundant, sometimes dominant plant over large areas of heath and moorland, particularly along the Atlantic fringe of Europe. An evergreen shrub growing to 60cm/2ft, it sports a profusion of small, bell-shaped, pink flowers in late summer.

Marsh Andromeda
Andromeda polifolia
Known as bog rosemary, this subshrub chiefly occurs on raised bogs in northern Eurasia and the USA. The flowers are small, spherical, pink and produced in spring and early summer. The plant is threatened by the destruction of its habitat.

Enkianthus campanulatus
This deciduous, bushy, spreading, tree-like shrub from Japan has an upright, narrow, layered branch habit and red shoots with tufts of dull green leaves that turn bright red in autumn. In spring, large terminal flower buds open to reveal small, bell-shaped, red-veined, creamy-yellow flowers.

Rhododendron ambiguum

Rhododendrons are a hugely diverse genus, with their centre of diversity occurring in Asia, especially in the east. This attractive, yellow-flowered rhododendron is native to near Mount Omei and Kangding in west Sichuan, China, where it grows in thickets on wooded hillsides and rocky, exposed slopes from 1,800–3,000m/5,900–9,850ft.

Identification: On this upright but compact, evergreen shrub, the bark of mature shoots is usually smooth, red-brown and peeling. The leaves are narrowly oval to elliptic, up to 7.5cm/3in long, shiny dark green above and blue-green beneath with a strong midrib. Loose trusses of between three and five widely funnel-shaped flowers, to 4cm/1½in, arise from terminal inflorescences in mid-spring. They are pale to greenish-yellow, often with greenish spots on the upper lobe, and with lobes as long as the tube.

Distribution: Sichuan and Guizhou, China.
Height and spread: 2m/6½ft or more.
Habit and form: Evergreen shrub.
Leaf shape: Ovate.
Pollinated: Bee.

Below: This rhododendron forms an upright, but relatively compact, bush.

Left: The attractive trusses of funnel-shaped, pale greenish-yellow flowers appear in spring.

NIGHTSHADE AND BINDWEED FAMILIES

The Solanaceae, or nightshade family, are herbaceous perennials, shrubs, or trees of about 85 genera and 2,800 species. They are frequently vines or creepers, and while some are edible, others are considered very poisonous. The bindweed family are twining herbs or shrubs, sometimes with milky sap, comprise 1,500 species. Many have heart-shaped leaves and funnel-shaped solitary or paired flowers.

Henbane

Hyoscyamus niger

A widespread, but infrequent annual or biennial, henbane is found throughout central and southern Europe to India and Siberia, often occurring on waste ground, near buildings and in stony places from low-lying ground near the sea to lower mountain slopes. As a weed of cultivation it now also grows in North America and Brazil. It is poisonous in all its parts, and is the source of the chemical hyoscine, used medicinally as a sedative.

Identification: A variable, coarse, leafy, branched, strong-scented plant, henbane is conspicuously sticky and hairy, especially the stout stem. The stalkless leaves are alternate and numerous, often on one side of the branches. They are oval to broadly lance-shaped, 5–20cm/2–8in long, rather shallowly pinnately lobed, with up to ten unequal, triangular, pointed segments. Numerous funnel-shaped flowers appear between late spring and late summer, in one-sided rows on long, downward-curving branches. The flowers are 2.5–5cm/1–2in long and nearly or quite as wide at the top, prominently purple-veined on a pale, often greenish-yellow background, more distinctly purple in the throat.

Below: The fruit capsules contain up to 500 seeds.

Below: Henbane is woody.

Right: The five rounded lobes of the flowerheads are slightly unequal.

Distribution: Eurasia.
Height and spread: 90cm/3ft.
Habit and form: Annual or biennial.
Leaf shape: Ovate.
Pollinated: Insect.

Chinese Lantern

Winter cherry, *Physalis alkekengi*

Chinese lantern is a widespread species, found from Central Europe to China. The name *Physalis* is from the Greek *phusa* (bladder), referring to the bladder-like calyx enclosing the fruit. The shape of the calyx also accounts for the plant's common name. The berries are edible and very juicy, if acrid and bitter; all other parts of the plant, except the ripe fruit, are poisonous. The calyx and skin of the fruit include a yellow colouring matter that has been used for butter.

Left: The tall stems arise each season from underground rhizomes.

Far right: The creamy flowers give rise to the showy "lanterns".

Identification: This vigorous, spreading, rhizomatous perennial has triangular-oval to diamond-shaped leaves, up to 12.5cm/5in long. Nodding, bell-shaped, cream flowers, 2cm/¾in long, with star-shaped mouths, are produced from the leaf axils in midsummer. They are followed by large, bright orange-scarlet berries, enclosed in five-sided, papery, red calyces, that greatly increase in size by the autumn to form large, leafy bladders up to 5cm/2in across.

Distribution: Caucasus to China.
Height and spread: 30 x 60cm/1–2ft.
Habit and form: Herbaceous perennial.
Leaf shape: Triangular-ovate.
Pollinated: Bee.

Giant Bindweed

Calystegia silvatica

Distribution: Eurasia and North America.
Height and spread: Up to 5m/16ft.
Habit and form: Herbaceous climber.
Leaf shape: Cordate or sagittate.
Pollinated: Insect.

Bindweeds are known as "morning glories", referring to their habit of opening early in the day, with the bloom fading by mid-afternoon. Giant bindweed has alternate leaves, and is characterized by showy, white, funnel-shaped flowers, usually appearing in spring until early autumn. The plant is very widespread, with subspecies occurring across Eurasia and North America. The genus *Calystegia* can be distinguished from the closely related *Convolvulus* genus by its floral characteristics: *Calystegia* species have a pair of large bracts that overlap the calyx, whereas *Convolvulus* species have very small bracts that are distant from the calyx.

Identification: A strong, rampant, stoloniferous, perennial climber, with stems up to 5m/16ft and alternate, heart-shaped or arrowhead-shaped leaves, up to 15cm/6in long. White, rarely pink-striped, trumpet-shaped flowers are between 6–9cm/2¼–3½in across, rarely deeply five-lobed, with bracts strongly pouched and overlapping. It may be confused with the related *C. sepium*, although its has larger flowers than that species.

Above: The tightly wrapped buds unfurl in the morning, but each flower lasts just one day.

Left: Despite its showy flowers, its vigorous smothering habit have made this plant unpopular in cultivated areas.

OTHER NIGHTSHADE AND BINDWEED SPECIES

Mandrake

Mandragora officinarum
The mandrake, the object of strange superstitions, is native to southern Europe. Its large brown, parsnip-like root runs deep into the ground. Dark green leaves spread open and lie upon the ground, among which primrose-like white, purplish or bluish flowers appear in summer or autumn, followed by yellow fruits.

Convolvulus tricolor

This annual or short-lived perennial grows up to around 60cm/2ft and has large, trumpet-shaped, sky-blue to dark blue flowers, with white-and-yellow throats, during the summer. Native to the Mediterranean region, the plant is present as a garden escapee in many other regions.

Yellow Henbane *Hyoscyamus aureus*

A biennial or occasionally perennial plant with an erect but brittle habit. It has fairly large yellow flowers that are tinged purple toward the centre. It is a common sight in old walls, dry soils and shingle, especially around the Mediterranean.

Mallow-leaved Bindweed

Convolvulus althaeoides
A low-growing, trailing perennial that produces rosy-pink or pink to purple, funnel-shaped flowers over silvery to grey-green leaves in early to midsummer. It is common on dry rocky soils in the Mediterranean and southern Europe.

Black Nightshade

Solanum nigrum

The black nightshade is an annual, one of the most common and cosmopolitan of wild plants, extending almost over the whole globe. It is frequently seen by the wayside and is often found on rubbish heaps, but also among growing crops and in damp and shady places. It is sometimes called the garden nightshade, because it so often occurs in cultivated ground. The berries contain the alkaloid solanine, which is toxic, and may be fatal if ingested in large quantities. The plant flowers and fruits freely, and in the autumn the masses of black berries are very noticeable.

Identification: A variable, hairy, much branched, annual herb. The stem is green and hollow, up to 30cm/1ft in height. Oval to lance-shaped leaves have bluntly notched or waved margins, usually untoothed. The flowers are white, with yellow anthers, approximately 6mm/¼in, in clusters of about five at the ends of stalks. The berry-like fruits are green at first and dull black when ripe.

Distribution: Worldwide.
Height and spread: Up to 30cm/1ft.
Habit and form: Annual.
Leaf shape: Ovate to lanceolate.
Pollinated: Insect.

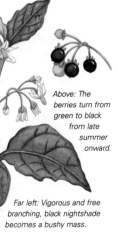

Above: The berries turn from green to black from late summer onward.

Far left: Vigorous and free branching, black nightshade becomes a bushy mass.

DOGWOOD AND PROTEA FAMILIES

The Cornaceae, or dogwoods, are woody shrubs and trees found mostly in the northern temperate zone.
The Proteaceae, or proteas, include about 80 genera and 1,500 species, with representatives in South
America, South Africa, India, Australia and New Zealand. The name is derived from the shape-shifting
Greek god Proteus, in reference to the extreme variability of leaf form in the family.

Swedish Cornel

Cornus suecica

Swedish cornel forms lovely colourful patches among
dwarf shrubs in heaths, open thickets and forests in
northern regions. The flowerheads are extremely showy
consisting of four large white bracts, surrounding small
purple flowers, which appear mainly in early
summer. These are followed later in the year by
small bunches of bright red fruit. The plant is
widely distributed in northen Europe to north Japan, and in
northern North America. The flowers are quite unusual in
that they open "explosively", possibly to help spread pollen
if there are too few insects around.

Identification: *Cornus suecica* is a low-growing, rhizomatous perennial,
with slender, freely branching creeping stems emanating from a woody
underground rootstock. A few opposite pairs of stem leaves, and egg-
shaped to lance-shaped, mid-green leaves in terminal whorls are borne
on short stems. In early summer, inconspicuous, purple-red flowers are
surrounded by four white, 12mm/½in long, elliptic bracts, in a cyme
2.5cm/1in across. They are followed by clusters of scarlet fruits. The
foliage gradually changes to bright red in the autumn.

Distribution: Circumboreal.
Height and spread: 10–15 x
30cm/4–6 x 12in.
Habit and form: Creeping
herbaceous perennial.
Leaf shape: Ovate to
lanceolate.
Pollinated: Insect.

Left: The berries are bright red
and appear in profusion on the
shrub in the autumn.

Tatarian Dogwood

Red-barked dogwood, *Cornus alba*

This suckering, deciduous, colonizing shrub, found throughout Siberia to Manchuria and
northern Korea, forms clumps of stems reaching a height of up to 3m/10ft. The young twigs
are an intense blood-red in the winter and the leaves turn many beautiful colours. The
insignificant flower cymes are followed by white to very pale blue fruits.

Identification: Most stems of this upright shrub branch little, except near the tip. It has
vivid blood-red bark in winter, which in spring reverts to nearly green. It is smooth, except
for lenticels, or leaf scars, which encircle the stems. The leaves are opposite, simple, oval
to elliptic, tapering to a point, 5–11.5cm/2–4½in long, with the major leaf veins
parallel to the curving leaf margins. They
emerge yellow-green, darkening with maturity
to medium or dark green and often reddening in
autumn. Small, yellowish-white flowers are
held in flattened cymes, 4–5cm/
1½–2in in diameter, in late spring to early
summer. The fruits, white or tinged
blue, ripen in midsummer.

Right: Cornus is often cultivated as a
garden plant, or planted on banks at the side
of busy roads for its winter foliage. The
stems of the shrub turn deep pink or
orange and remain that colour
throughout the autumn and winter.

Distribution: North Asia.
Height and spread: 3m/10ft.
Habit and form: Deciduous
shrub.
Leaf shape: Ovate to elliptic.
Pollinated: Insect.

Left: The berries.

Cornus mas
Cornelian cherry, native to
Europe and western Asia, is a
vigorous deciduous shrub
growing to 4.5m/15ft. The
yellow flowers appear
in early spring before
the dark green
leaves. The bright red
fruits produced
are edible.

Protea neriifolia
Protea neriifolia has the distinction of being the
first *Protea* ever to be mentioned in botanical
literature. It is a very widespread species and
occurs from sea-level to 4265m/1300m altitude
in the southern coastal mountain ranges from
just east of Cape Town to Port Elizabeth,
South Africa.

Leucadendron argenteum
This beautiful tree with its soft silver leaves is in
nature almost endemic to Table Mountain and
particularly to the slopes above Kirstenbosch
Botanical Gardens, South Africa, where it grows
in dense stands. The grey-green leaves are
covered with fine, silvery hairs, which reflect the
light and give the leaves a soft, velvet feel.

Peninsula Conebush *Leucadendron strobilinum*
This stout shrub is endemic to the Cape
Penninsula, and is most abundant at higher
altitudes and to the north, being especially
common on Table Mountain. It has separate
male and female plants, which grows in damp
rocky situations.

King Protea

Protea cynaroides

Probably the best-known protea, this plant
is prized worldwide as a magnificent cut
flower and in South Africa is honoured as
the national flower. The king protea has one
of the widest distribution ranges of the
genus, occurring across the south-west coast
of South Africa, except for the dry interior
ranges, at all elevations from sea level to
1,500m/4,900ft. Large, vigorous plants
produce six to ten flowerheads in one
season, although some exceptional plants
can produce up to 40 on one plant.

Identification: The king protea is a woody shrub
with thick stems. Its height and spread may vary
according to locality and habitat, but all plants have
large, dark green, rounded to elliptic, glossy leaves.
Goblet or bowl-shaped flowerheads, 12.5–30cm/
5–12in in diameter, are surrounded by large,
colourful bracts, from creamy-white to deep
crimson, produced at various
times of the year according
to location.

Distribution: South Africa.
Height and spread:
90cm–2m/3–6½ft.
Habit and form: Evergreen
shrub.
Leaf shape: Rounded to
elliptic.
Pollinated: Bird.

*Left: Each
flowerhead,
is 30cm/12in
diameter.*

*Right: King
protea is
a low-
growing bush.*

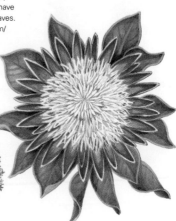

Yellow Pincushion

Leucospermum conocarpodendron

This species falls into the category of "tree pincushions" because it has a single, thick trunk.
It is locally abundant throughout the granite and sandstone soils on dry slopes in the
northern Cape Peninsula of South Africa. The flowers are bright golden-yellow and the bush
is quite spectacular when it is covered in an abundance of flowers. Flowering usually
commences as soon as the hot weather starts. The fruit is released two months after
flowering and is dispersed by ants.

Distribution: Northern Cape
Peninsula, South Africa.
Height and spread:
5 x 3m/16 x 10ft.
Habit and form:
Rounded shrub.
Leaf shape:
Lanceolate to
elliptic.
Pollinated:
Bird.

Identification: Though it is a large shrub it has a rounded, compact, neat
appearance. Large lance-shaped to elliptic, stalked, grey-silver
leaves, covered with a layer of minute hairs,
toothed at the end and tipped with red dots,
are crowded around the upright stems. The
flowers, about 8cm/3¼in in diameter,
are like large pincushions, with
numerous bright lemon-yellow, white-
tipped segments.

*Left: The shrub is laden with flowers in early
summer, and they are visited by pollinating birds.*

MILKWEEDS AND GESNERIADS

The Asclepiadaceae, or milkweeds, are mostly herbaceous perennials and shrubs with white (often poisonous) sap comprising about 250 genera and 2,000 species, many of which are vines and some of which are cactus-like succulents with reduced leaves. The Gesneriaceae (gesneriads) are herbs, shrubs, or rarely trees and include 133 genera and 3,000 species, including many well-known ornamental species.

Silk Vine

Periploca graeca

The generic name for this vine comes from the Greek *peri* (around) and *ploke* (woven), and refers to its twining habit. The glossy leaves provide a perfect foil for the interesting, if unpleasantly scented, star-shaped flowers, which are followed by curious fruits. The silk vine is usually found in woods, thickets and riverbanks throughout this range. All parts of the plant emit a milky sap when broken or cut. The sap and fruit are poisonous.

Below: The flowerhead.

Distribution: South-east Europe to western Asia.
Height and spread: 10m/33ft.
Habit and form: Woody, twining climber.
Leaf shape: Ovate to lanceolate.
Pollinated: Insect.

Identification: The silk vine is a vigorous, deciduous, woody, twining climber. The leaves are opposite, 2.5–5cm/1–2in, oval to lance-shaped, glossy, dark green, turning yellow in autumn. The flowers, up to 2.5cm/1in across with five downy, spreading lobes, are borne in long-stalked corymbs of eight to ten from early to late summer; they have a yellow-green exterior and maroon to chocolate interior. They are followed by pairs of narrowly cylindrical seedpods, up to 12.5cm/5in long.

Left: Silk vine climbs vigorously by twining around the stems of other plants.

Giant Carrion Flower

Stapelia nobilis

An interesting succulent, found intermittently from South Africa as far north as Tanzania, that has olive-green, erect branches, which give the plant a cactus-like appearance. It bears large, foul-smelling, starfish-shaped flowers that are pale yellow with reddish stripes, covered with white hairs. The flowers are said to look flesh-like and this, when combined with the rotting meat odour, attracts its main visitor, the fly, for pollinating.

Distribution: South Africa to Tanzania.
Height and spread: 15–20cm/6–8in; indefinite spread.
Habit and form: Succulent.
Leaf shape: Absent.
Pollinated: Fly.

Identification: The stems are four-sided, rigid, spineless, 15–20cm/6–8in tall and 3cm/1¼in in diameter. They are pale green and robust, and the angles are winged with small teeth. One or two flowers are borne from the base to midway up the stem, and are 25–35cm/10–14in across, flat to slightly bell-shaped, with a short dark red tube, which is densely wrinkled, and a dark purple-brown corona. The lobes are oval with elongated tapering points, pale ochre-yellow, with many tiny, wavy crimson stripes and fringed with hairs.

Left: The olive-green branches are robust, held erect and lined with small teeth, and give this plant a rather cactus-like appearance.

Pyrenean Violet

Ramonda myconi

Distribution: Pyrenees.
Height and spread: 12.5cm/5in.
Habit and form: Herbaceous perennial.
Leaf shape: Elliptic to rhomboidal.
Pollinated: Insect.

The Pyrenean violet, as its name suggests, is endemic to the Pyrenees and is found on shady rocks and in mixed woodland on rocky limestone slopes. It has a scattered distribution through its range, with populations rarely staying constant in one area. The dark green, hairy rosette of leaves may easily be missed until the pretty, five-petalled, blue-violet flowers appear in late spring or early summer. The flowers are reminiscent of the related African violet, *Saintpaulia* species, to which this plant is distantly related.

Identification: A low-growing, stemless herb, with a basal rosette of wrinkled leaves up to 6cm/2¼in long, elliptic to diamond-shaped with rounded tips and marginal teeth, covered in red-brown hairs. Between one and six flowers are borne on glandular to hairy, red-tinged leafless stalks, up to 12.5cm/5in tall, in early summer. Each five-lobed flower is 4cm/1½in across, violet to pink or white with a yellow, cone-shaped centre.

Left: The leaves are held in a tight basal rosette from where the flowers emerge.

OTHER MILKWEED AND GESNERIAD SPECIES

Hoya sussuela
This vigorous climbing vine from Indonesia has leathery, light green leaves, about 5–10cm/2–4in long, with a clear centre vein. The unusual waxy flowers are cup-shaped, dark maroon with pointed lobes arranged in a star fashion, with up to 10 flowers in an umbel. They have a strong musky odour.

Ceropegia ballyana
This robust, climbing, succulent-rooted vine from Kenya has unusual, green-white flowers with red-brown spots. The base appears triangular in profile and with the twisted tips of the lobes the whole flower looks like a fairy light.

Titanotrichum oldhamii
This pretty plant from Taiwan has a woody rootstock and produces several erect herbaceous stems with yellow, tubular flowers, which are red to maroon on the inside of the tube and borne in terminal racemes during the summer months. Although it bears a passing resemblance to a foxglove it is unrelated.

Chirita lavandulacea
This upright-growing annual species, which is native to tropical Asia, has oval, prominently veined, translucent, hairy leaves that act as a perfect foil for the pretty, five-lobed, pale blue flowers. These are borne on short stalks, singly or in pairs and groups of three to five, from the upper leaf axils.

Cape Primrose

Streptocarpus formosus

More than 100 widespread species of *Streptocarpus* are found mostly in southern Africa. This species grows in subtropical forests where the summers are humid and wet, and the winters are warm and dry. It has a scattered distribution in forests and the sandstone gorges, where it grows in pockets of well-drained soil between the rocks. Surprisingly, each leaf of the clump is an individual plant with its own roots and flowering stems.

Identification: A rosette-forming perennial with many hairy leaves, up to 45cm/18in long. Each inflorescence, up to 25cm/10in tall, bears one to four pale blue flowers up to 10cm/4in across. The flower tube is narrowly funnel-shaped, blue-mauve outside, the inside minutely spotted purple with a patch of bright yellow and purple streaks on the floor; the lobes are white or blue streaked white. The fruits, 18cm/7in long, unfold like a spiral when dry.

Right: The small perennial is clump-forming.

Distribution: Central and South Africa, Madagascar.
Height and spread: 25cm/10in.
Habit and form: Rosette-forming, evergreen perennial.
Leaf shape: Oblong.
Pollinated: Insect.

Below: The flowers appear from spring.

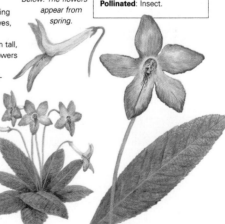

CUCURBIT FAMILY

The Cucurbitaceae are mostly prostrate or climbing herbaceous annuals. The family comprises about 90 genera and 700 species, which are characterized by five-angled stems and coiled tendrils. It is one of the most important families of food plants in the world, including crops such as squashes, gourds, melons and cucumbers. Most of the plants in this family are annual vines with fairly large, showy blossoms.

White Bryony

Common bryony, *Bryonia dioica*

This vine-like plant is common in European woods and hedges. The stems climb by means of long tendrils springing from the side of the leaf stalks, and extend among trees and shrubs, often to the length of several yards during the summer. They die away after the fruit has ripened, although the large tuber survives in the soil and new stems grow the following year.

Right: The berries often persist until after the stems have withered.

Identification: A climbing herbaceous perennial, with tendrils arising from the leaf axils. The stems are angular and brittle, branched mostly at the base, very rough, with short, prickly hairs. The leaves are held on curved stalks, shorter than the blade, and are divided into five, slightly angular lobes, of which the middle lobe is the longest. Small, greenish-white flowers, generally in small bunches of three or four, spring from the axils of the leaves in late spring, with the sexes on separate plants. The plant produces red berries, which are most noticeable after the stems and leaves have withered. The berries are filled with juice with an unpleasant, foetid odour and contain three to six large seeds, which are greyish-yellow mottled with black.

Distribution: Europe.
Height and spread: Up to 5m/16ft.
Habit and form: Herbaceous vine.
Leaf shape: Palmately lobed.
Pollinated: Insect.

Left: Long stems clamber over other plants, attaching to them by means of tendrils.

Ivy Gourd

Scarlet gourd *Coccinia grandis*

Native to Africa, Asia, Fiji, and northern (tropical) Australia, ivy gourd bears white or yellow flowers followed by scarlet fruits with white spots. It is a rapidly growing, climbing or trailing vine. In its native habitat it is a common, but not serious, weed that is kept in check by competing plants and natural enemies. In recent years, it has become an invasive weed in some tropical countries where it has been introduced.

Identification: An aggressive, fast-growing herbaceous perennial vine, with succulent, hairless stems produced annually from a tuberous rootstock, with occasional adventitious roots forming where they run along the ground. Long simple tendrils from the leaf axils wrap around the host plant. The leaves are alternate, smooth, broadly oval, five-lobed, 9cm/3½in long, with a short, pointed tip, heart-shaped base and minutely toothed margins. The white, bell-shaped flowers, 4cm/1½in long, usually solitary, are deeply divided into five oval lobes. The fruit is a smooth, egg-shaped gourd, bright red when ripe, 2.5–6cm/1–2¼in long.

Distribution: Africa, Asia, Fiji and northern Australia.
Height and spread: Up to 30m/100ft.
Habit and form: Herbaceous vine.
Leaf shape: Broadly ovate to cordate.
Pollinated: Insect.

Left: The fast-growing stems quickly smother other plants.

Above right: Bright red fruits give this vine a very distinctive appearance.

Squirting Cucumber

Touch-me-not, exploding cucumber, *Ecballium elaterium*

This member of the Cucurbitaceae is found in most of the Mediterranean region and Macronesia, growing in rich peat with some water and lots of sun. The vine has developed a unique strategy for the spreading of its seeds: while the fruit ripens, pressure develops inside. When the fruit separates from the stalk, for example if it is touched by an animal, the sticky seeds squirt out, hence the name.

Below right: The small, hairy seedpods squirt their contents out explosively when ripe.

Distribution: Mediterranean region and Atlantic islands.
Height and spread: 30 x 90cm/1 x 3ft.
Habit and form: Trailing, slightly bushy herbaceous perennial.
Leaf shape: Palmately lobed.
Pollinated: Insect.

Identification: A trailing to slightly bushy herbaceous perennial with fleshy, triangular or heart-shaped leaves, palmately lobed, with a bristly upper surface and downy underside. It has yellow funnel- or bell-shaped flowers, about 2.5cm/1in across, sometimes with deeper yellow centres. Both male and female flowers appear on one plant, the male flowers in racemes, the female flowers solitary. The egg-shaped hairy seedpods, which are blue-green and 4–5cm/1½–2in long, enclose many seeds in a watery mucilage that is ejected explosively when the fruit is ripe.

Far left: The trailing stems spread to make a low mat of leafy growth.

OTHER CUCURBIT FAMILY SPECIES
Nara Melon *Acanthosicyos horridus*
A leafless shrub native to the coastal region of the Namib Desert. It forms a densely tangled and spreading mass that can cover up to 1,500m²/1,790yd². Heavily armed with spines 2.5cm/1in long, it grows where underground water is available. Its oil-rich nuts are the staple diet of some of the indigenous Namib people.

Wax Gourd *Benincasa hispida*
The wax gourd or winter melon is a trailing, fleshy vine, grown in many warm countries for its edible fruits. Its solitary yellow flowers are followed by melon- or cucumber-shaped fruit. It probably originated in China and now exists as a garden escapee across much of Asia and beyond.

Watermelon *Citrullus lanatus*
The watermelon grows widely in Africa and Asia, and in the Kalahari Desert the wild melons have been an important source of water and food to indigenous inhabitants, as well as explorers. The history of their domestication is obscure but a wide variety of watermelons have been cultivated in Africa since antiquity.

Cretan Bryony
Bryonia cretica
Similar to white bryony, of which it is sometimes considered to be a subspecies, Cretan bryony has a more southerly distribution. The Cretan bryony has red berries.

Tatior-pot

Ma kling, *Hodgsonia heteroclita*

This large woody climbing plant, from the tropical forests of South-east Asia, is cultivated as a food plant for its large fleshy fruits, which are similar to pumpkin, and its extremely oily seeds. It is rare in the wild, and many populations are considered endangered. Flowering starts at night and continues into the following day.

Identification: Up to 30m/100ft in height or spread, this climber has leaves that are deeply three or five-lobed, almost smooth with a few small glands. Climbing tendrils have two or three branches. The male and female inflorescences are separate: males are 15–35cm/6–14in long, on a 8–15cm/3–6in stalk bearing 10–20 pale yellow, velvety, five-lobed flowers, each 3–5cm/1¼–2in long. The female flowers resemble the males but are solitary. The fruits are 15–20cm/6–8in in diameter, greenish-brown turning red-brown, smooth or shallowly grooved.

Above right: The oil-rich seeds can be eaten.

Distribution: Widely scattered in Sikkim, Bhutan, east India, south China, Burma, Indochina and Thailand.
Height and spread: Up to 30m/100ft.
Habit and form: Woody climbing plant.
Leaf shape: Palmately lobed.
Pollinated: Insect.

Below: Hodgsonia heteroclita is a vine.

CARNIVOROUS PLANTS

Strictly, carnivorous plants are those that attract, capture, kill and digest animals and absorb the nutrients from them. They are by no means common, but several plant families have become specialists in this way of life. There are various ways in which plants have adapted to do this. Most carnivorous plants are small or medium-sized herbaceous perennials; a few are woody climbers.

Round-leaved Sundew

Drosera rotundifolia

This is an unmistakable plant with a widespread distribution. It is a small, short-lived, insectivorous herbaceous perennial, most often found in acidic bogs, but also in swamps, rotting logs, mossy crevices in rocks, or damp sand along stream, lake, or pond margins. It is generally associated with sphagnum mosses, growing on floating sphagnum mats or hummocks. The plant compensates for the low level of nutrients available in its habitat by catching and digesting insects. The prey is caught on the sticky glandular leaf hairs, and the leaf then folds around it. The hairs secrete enzymes that digest the insect and enable the plant to absorb nutrients through its leaves.

Identification: The leaves form a basal rosette, with their round, depressed blades lying flat on the ground; the upper surface of each blade, 6–10mm/¼–½in long, is covered with reddish, glandular hairs, each tipped with a sticky, glutinous secretion resembling a dewdrop, which traps insects. The leaf stalk is 2–5cm/¾–2in long and covered with sticky hairs. One-sided racemes, one to seven per rosette, consist of 2–15 small white flowers on 5–15cm/2–6in stalks, which straighten out as the flowers expand in summer.

Distribution: Europe, Asia, South Africa, North and South America.
Height and spread: 5–15cm/2–6in.
Habit and form: Herbaceous perennial.
Leaf shape: Orbicular.
Pollinated: Insect.

Greater Bladderwort

Utricularia vulgaris

Bladderworts are carnivorous aquatic plants with delicate, finely divided underwater leaves and emergent, snapdragon-like yellow flowers. Their most distinctive underwater features are small, bladder-like traps – oval balloons with a double-sealed airtight door on one end. When the door is closed, the bladder expels water through its walls, creating a partial vacuum inside, which sucks in small invertebrates or even tiny fish that trigger the trap doors. Enzymes are secreted to digest the prey and provide the plant with nutrients. Bladderworts are most commonly found floating freely in shallow water, or loosely attached to sediment, and are widely distributed throughout Europe, North Africa and the USA.

Left and far right: Flowering stems rise above the water, while the rest of the foliage remains under the surface.

Above right: The tiny bladders capture small aquatic invertebrates.

Identification: This water-living, herbaceous plant has no true leaves or roots. Instead, it has a green, finely divided, underwater leaf-like stem with small, seed-like bladders. The branched stem is up to 2m/6½ft long and can be floating, submersed, or partly creeping on sediment, sometimes anchored at the base by root-like structures. It overwinters above the sediment layer. Yellow, snapdragon-like flowers, up to 2.5cm/1in wide, have a prominent spur projecting below the lower lip and faint purple-brown stripes; they are held above the water on stout stalks in late summer. The globular brown seed capsules contain many seeds. The winter bud is ovoid to ellipsoid, to 2cm/¾in long.

Distribution: Europe, North Africa and North America.
Height and spread: 15–45cm x 2m/6–18in x 6½ft.
Habit and form: Water plant.
Leaf shape: No true leaves.
Pollinated: Insect.

Great Sundew *Drosera anglica*
The great sundew is similar to the round-leaved sundew but with taller and narrower leaves, about twice as long as they are wide. It is generally found in the same habitat and range as the round-leaved sundew but is much less common.

Nepenthes rafflesiana
This pitcher plant has cream-coloured traps nearly covered in dark red botches. It is distributed throughout Borneo and is an unusually variable plant, with various forms looking like completely different species. The pitchers are often visited by ants but the plant seems not to be specialized in its prey.

Drosera cistiflora
This very striking South African sundew has long, fine leaves and an erect habit, growing to 25cm/10in or more before producing several large, typically pink, flowers. There is also a giant form up to 50cm/20in tall and forms with different flower colours are known.

Roridula gorgonias
This perennial from South Africa, which grows to around 50cm/20in, is covered with sticky glands, which capture insects much as sundews do. The plants do not assimilate the nutrients from the dead insects they catch; instead, assassin bugs in the genus *Pameridea* eat the insects and their excrement is absorbed by the leaves.

Greater Butterwort

Pinguicula grandiflora

Greater butterwort grows throughout much of the Northern Hemisphere. It is distinct in having one of the most striking flowers of the butterwort family (Lentibulariaceae) and superficially resembles a small African violet, *Saintpaulia* species, although they are unrelated. Greater butterwort is a small plant that grows in a rosette fashion, and has tiny transparent hairs that secrete sticky glue. There are also glands on the leaves, which are dry until an insect is captured. They then secrete acids and enzymes, which start to dissolve the insect before the same glands reabsorb the nutrient-rich fluid.

Distribution: Arctic Circle, Europe, Siberia and North America.
 Height and spread: 15cm/6in.
Habit and form: Herbaceous perennial.
Leaf shape: Obovate-oblong.
Pollinated: Insect.

Identification: The plant forms a rosette of oval to oblong, sticky, pale green leaves 3–5cm/1¼–2in long, with resting buds in the winter. In summer, solitary, trumpet-shaped, spurred, two-lipped, dark blue flowers, 2.5cm/1in across, with three widely spreading lobes and white throats, are borne on slender stems.

Pitcher Plant

Nepenthes ampullaria

This carnivorous plant, native to swamps in the humid tropical lowlands of South-east Asia, is a woody vine that forms rosettes of trapping leaves. In its native habitat, the rosettes may arise anywhere along the vine, although in mature plants large clumps of pitchers form at the base of the climbing stem. These fill with rainwater and insects that fall into them, and drown; their decaying bodies yield nutrients absorbed by the plant.

Distribution: Lowlands of South-east Asia.
Height and spread: Up to 20m/65ft.
Habit and form: Woody liana.
Leaf shape: Lanceolate, sometimes ending in a pitcher.
Pollinated: Insect.

Identification: A woody liana, with rounded, squat, deep red or green, sometimes mottled pitchers, up to 10cm/4in high, with round, horizontal mouths and narrow, reflexed lids that allow the broad pitchers to fill with rainwater. Wings on the front of the pitcher are broad, spreading and toothed. The basal traps are numerous and squat, with upper ones few and more cylindrical in shape, often with a dusty appearance due to a thick coating of fine hairs. Tiny, petal-less flowers with green-and-brown sepals are borne in spidery racemes. The shape and colour of the pitchers varies considerably according to location.

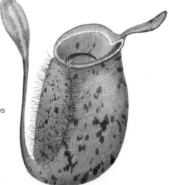

Left: Modified leaves form pitchers, which capture and digest unsuspecting insects.

PARASITIC PLANTS

When one organism "steals" all of its food from another's body, it is called a parasite. The organism that is being robbed of its food supply is known as the host. The parasitic mode of existence can be found from bacteria and fungi to insects, mites and worms. Parasitism has also evolved in many families of flowering plants, and while many of them are quite unrelated, their lifestyle brings them together here.

Rafflesia

Rafflesia manillana

Dramatic and solitary rafflesia flowers are the largest single flowers in the world, with leathery petals that in some species can reach more than 90cm/3ft across. A parasite that depends completely upon its host, the majority of the plant's tissues exist as thread-like strands entirely within vines of *Tetrastigma* species. The rafflesia plant is itself not visible until the flowers first bud through the woody vine, taking up to ten months to develop. The enormous flowers reportedly have a strong smell of rotting flesh and are believed to be pollinated by flies, although it is rarely encountered and its exact life cycle is obscure.

Identification: Only the flower ever emerges for the purposes of identification. It consists of five orange leathery petals, mottled with cream warts. There is a deep well in the centre of the flower containing a central raised disc, which supports many vertical spines. The sexual organs are located beneath the rim of the disc, and male and female flowers are separate. *R. manillana* has a flower 15–20cm/6–8in in diameter; it is the smallest of all rafflesia species.

Distribution: South-east Asia.
Height and spread: 15–20cm/6–8in (flower only).
Habit and form: Internal parasite.
Leaf shape: Absent.
Pollinated: Fly.

Cytinus hypocistis

This parasitic plant, found in Mediterranean forest and coastal scrub, lives on a shrub, the sage-leaved rock rose, *Cistus salviifolius*. Like many other parasites, it takes all its nourishment from the roots of its host and so has no need of leaves or other conventional green plant parts. It reveals itself only at flowering time, when its tight clusters of small very showy flowers erupt from the ground beneath the host plant.

Identification: Orange-and-yellow unisexual flowers are borne singly or in clusters of five to ten at the apex of the flower spike in an umbellate pattern, appearing in spring to early summer. They are subtended by (usually) two bracts and have four bright yellow petaloid sepals, up to 12mm/½in long. The short flower stem is covered with yellow, orange or bright red, densely overlapping scales, resulting from vestigial leaves. Due to their low-growing nature, the flowers can often be hidden by leaf litter.

Distribution: Mediterranean, North Africa, Turkey.
Height and spread: 4–8cm/1½–3¼in (flower only).
Habit and form: Internal parasite.
Leaf shape: Vestigial scales.
Pollinated: Insect.

Left: The tight clusters of showy flowers are the only part of this plant that may be seen above ground.

European Mistletoe

Viscum album

Distribution: Europe.
Height and spread: Up to 90cm/3ft.
Habit and form: Aerial hemi-parasite.
Leaf shape: Elliptic.
Pollinated: Possibly wind or insect.

Far right: European mistletoe lives on many deciduous tree species, particularly fruit trees such as apple, and lime, poplar and oak.

Centuries of superstition and belief are attached to mistletoe, and the tradition of "kissing under the mistletoe" has persisted for many years. It is a partial or hemi-parasite, relying on a host tree to provide it with a growing platform and some nutrients, though it does have chlorophyll in its leaves and can manufacture some food for itself through photosynthesis. The generic name *Viscum* refers to the stickiness of the seeds, a property essential to the plant's propagation method, as its seed must stick to the trunk of its host long enough to germinate and insert a root into the bark.

Identification: The leaves, borne on repeatedly forked branches, are evergreen and elliptical in shape. Male and female flowers are borne on separate plants, with the flowers of both sexes produced in the forks of the branches. Males flower between late winter and mid-spring, producing small clusters of blooms with four petals; the female plants produce sticky white berries in autumn.

OTHER PARASITIC PLANT SPECIES
Red-berried Mistletoe *Viscum cruciatum*
A native of the Mediterranean, the red-berried mistletoe, although closely allied to *V. album*, prefers a warmer and drier climate. It is very similar in shape and form to *V. album* and grows on a range of deciduous trees, especially olives.

Toothwort *Lathraea squamaria*
Also known as corpse flower, this is a perennial parasitic plant, up to 20cm/8in tall, with a pinkish-cream stem and scale-like, fleshy leaves, said to resemble pointed teeth.
Flower spikes with cylindrical, half-nodding, pink flowers on one side appear in copses and shady places in spring.

Common Dodder *Cuscuta epithymum*
This small parasitic plant, containing no chlorophyll, appears as a mass of tiny, red strings all over gorse, *Ulex* species, thyme, *Thymus* species, or other low-growing plants that act as its host. Small spherical bunches of little pale pink flowers appear in summer. Seeds sprout in the soil, but wither once it attaches to its host.

Loxanthera speciosa
This unusual, large, woody shrub, with branches to over 3m/10ft, is an aerial hemi-parasite, with large, red-and-white tubular flowers. It grows in forest in Malaysia, Sumatra, Java and Borneo, on host trees such as the tiup tiup, *Adinandra dumosa*, and several *Ficus* species, between sea level and 850m/2,800ft.

Purple Toothwort

Lathraea clandestina

This spreading perennial, found in the damp woods and streamside meadows of south-western Europe, grows as a parasite on the roots of willow, alder and poplar trees. The plant does not produce true leaves but vestigial leaves still occur in the form of fleshy scales on the rhizomes. The purple flowers, which appear in spring, are the only parts visible above ground, but colonies of the plant may have an indefinite spread. It is found widely in temperate regions, having been imported with garden trees.

Identification: A parasitic, rhizomatous perennial, with opposite, kidney-shaped, stem-clasping, scale-like white leaves, 5mm/⅛in long. Dense racemes of between four and eight hooded, tubular, two-lipped mauve flowers, to 3cm/1¼in long, are borne just above the ground in early and mid-spring.

Distribution: South-west Europe.
Height and spread: 2cm/¾in; indefinite spread.
Habit and form: Root parasite.
Leaf shape: Reniform scale.
Pollinated: Bumblebee.

Right: The mauve flowers are showy with an upper lip that has a hooded shape.

Below: The flowers that appear in spring are the only visible parts, but colonies may be quite extensive.

DUCKWEED AND ARUM FAMILIES

The duckweed family (Lemnaceae) contains mostly perennial, aquatic, floating or submersed herbs that are reduced to small green bodies. The Araceae are rhizomatous or tuberous herbaceous perennials. They are characterized by an inflorescence that is a fleshy spadix partially enveloped by a bract or spathe that is sometimes brightly coloured.

Lesser Duckweed

Lemna minor

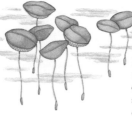

This tiny, floating, aquatic perennial, which often forms a seemingly solid cover on the water surface, is made up of many tiny individual plants. It is widespread throughout the temperate regions of the Northern Hemisphere, including North America and Eurasia, being absent only from polar areas and the tropics. It occurs chiefly in freshwater ponds, marshes, lakes and quiet streams. It is able to spread most rapidly across quiet bodies of water rich in nutrients, such as nitrogen and phosphate. Flowering duckweeds are uncommon.

Below: Lesser duckweed seems to form a blanket over water.

Identification: The tiny individual plants may be up to 15mm/⅝in across, but are usually 2–4mm/¹⁄₁₆–⅛in. Their leaves and stems are merged in a simple, three-lobed plant body, typically called a frond or "thallus", though neither term is botanically precise. The frond consists of one to several layers of conspicuous air spaces and one to several veins. It is flattened, round to elliptic-oval in outline, generally symmetrical, with a smooth upper surface. A single root hangs down in the water.

Distribution: Temperate areas worldwide.
Height and spread: Unlimited spread over suitable water habitat.
Habit and form: Floating aquatic perennial.
Leaf shape: Rounded.
Pollinated: None.

Right: The flowers are microscopic.

Left: The small fronds form a dense floating mass.

Dragon Arum

Voodoo lily, *Dracunculus vulgaris*

This rather bizarre plant, unique to the Mediterranean region, is reminiscent of an arum lily. It can be found growing in well-drained soils and full sun. It produces a spathe that, as it unfurls, reveals a slender, black central appendage, the spadix, which can reach 25–135cm/ 10–53in in length. The actual flowers, both male and female, are hidden deep inside the spathe, which features a bulbous chamber. It relies on flies and other insects for pollination and therefore emits a putrid smell, like dung and carrion, to attract them.

Identification: Unmistakable by sight or smell, this tuberous perennial with foot-shaped or spear-shaped, dark green basal leaves, 30cm/12in or more long, has a stem marked purple-brown. In spring or summer, foul-smelling, maroon-purple spathes, 60–100cm/24–39in long, with erect, almost black spadices, are borne above the leaves, attracting large numbers of beetles and flies, which become trapped in the spathe chamber.

Left: The flowering stem is a dramatic sight once the bloom opens.

Distribution: Southern Europe to Turkey.
Height and spread: Up to 1.8m/6ft.
Habit and form: Herbaceous perennial.
Leaf shape: Pedate or hastate.
Pollinated: Insect.

Left: Clusters of fruit surround the remains of the flower spike.

White Arum Lily

Calla lily, *Zantedeschia aethiopica*

This plant is neither an arum (genus *Arum*) nor a lily (genus *Lilium*). It was introduced to Europe in the 17th century, and has naturalized in almost all parts of the world. The striking flower is made up of many tiny flowers arranged in a complex spiral pattern on the central spadix, the top 7.5cm/3in of which are male flowers with the lower 2cm/¾in being female. The whiteness of the spathe is caused by an optical effect produced by numerous airspaces beneath the epidermis. Its flowering season depends upon its location; plants in the Western Cape are dormant in summer, while in the eastern summer rainfall areas the species is dormant in winter, although it remains evergreen if growing in marshy conditions that are wet all year round.

Distribution: South Africa.
Height and spread: 90cm/3ft.
Habit and form: Herbaceous perennial.
Leaf shape: Sagittate.
Pollinated: Insect.

Left: The foliage forms a clump in wet soil.

Identification: A clump-forming, rhizomatous, usually evergreen perennial, it has semi-erect, arrow-shaped, glossy bright green leaves up to 40cm/16in long. Flowers are borne in succession, and are large, pure white spathes, to 25cm/10in long, with creamy-yellow spadices. The spathe turns green after flowering and covers the ripening, succulent yellow berries.

Left: The white flowers are extremely striking.

Cobra Lily

Arisaema candidissimum

This tuberous perennial from China is found on stony slopes and in open pine forests, in full sun, on dry, rocky, south-facing slopes. Cobra lilies emerge in late spring with stalks of pink pitcher flowers, which are striped with translucent, white, vertical veins. The central flower spike is male or female, with the tip slightly bent. Alongside the flower emerges a three-lobed leaf, which can reach up to 60cm/2ft wide.

Identification: In summer the plant bears a conspicuous, sweetly scented, pink-striped white spathe, striped green on the outside, 7.5–15cm/3–6in long with a hooked, downward-curling tip. The inflorescence is up to 12.5cm/5in tall, depending upon habitat. A solitary, three-palmate, mid- to deep green leaf, very thick and leathery, with broadly oval leaflets, each 10–25cm/4–10in long and almost as broad, appears on a leaf stalk up to 35cm/14in tall, only after the spathe emerges.

Distribution: Chinese Himalayas.
Height and spread: 40cm/16in.
Habit and form: Herbaceous perennial.
Leaf shape: Palmate.
Pollinated: Insect.

Right: The greenish exterior of the flower belies the candy-striped interior.

Below: The single, large tri-lobed leaf appears only after the flower bud has emerged.

BANANA, STRELITZIA AND GINGER FAMILIES

The Musaceae, or banana family, are large, often tree-like herbaceous perennials. Closely allied to this family is Strelitziaceae, native to tropical south-eastern Africa and Madagascar. Zingiberaceae, or ginger, are herbaceous perennials, mostly with creeping horizontal or tuberous rhizomes, with a wide distribution.

Abyssinian Banana

Wild banana, red banana, *Ensete ventricosum*

Often wrongly described as trees, bananas are, in fact, giant herbaceous plants, the "trunk" (technically a pseudostem) being made up of a series of tightly wrapped leaf sheaths. Each pseudostem grows from a bud on the true stem, which is an underground rhizome. Leaves emerge through the centre of the pseudostem and expand at the top to form large, glossy, oval blades, up to 4 x 1m/ 13 x 3ft in size. *E. ventricosum*, a relative of the edible bananas, *Musa* species, is a highly variable species with a large African range. The fruit is not eaten except in times of scarcity, but the young flowers are palatable when cooked.

Identification: The plant, though herbaceous, is tall and tree-like, with a pseudostem up to 5m/16ft, often variably stained purple, with whitish latex that reddens on exposure to air. The oblong to lance-shaped leaves are borne on short stalks in a banana-like crown, erect or spreading, bright yellow-green or variably stained with red-brown, more or less glaucous beneath. The midribs are green, red or purple-brown. A drooping inflorescence bears a massive male bud. Mature fruits are banana-like but dry, bright yellow or yellow-orange with orange pulp. It seldom forms suckers from the base (as in other species) and is monocarpic.

Distribution: Africa.
Height and spread: 4–12m/13–40ft.
Habit and form: Tall herbaceous but tree-like plant.
Leaf shape: Oblong-lanceolate.
Pollinated: Insect.

Left: Flowerheads appear when plants are about eight years old.

Bird of Paradise

Crane flower, *Strelitzia reginae*

Possibly one of the best-known plants in the world, the strelitzia's fascinating blooms are sold as cut flowers by the million and this popularity has led them to be grown in gardens worldwide. *S. reginae* is, however, indigenous to South Africa, where it grows wild in the Eastern Cape, between other shrubs along the riverbanks and in clearings in the coastal bush. Mature plants can form large clumps in favourable conditions and are very floriferous, with flowers in autumn, winter and spring. When birds visit the flowers to help themselves to nectar, the petals open and cover their feet in pollen.

Identification: A large, clump-forming, nearly stemless evergreen perennial, with erect, oblong to lance-shaped stiff grey-green leaves with pointed or rounded tips, sometimes with a shallow notch at the end, to around 90cm/3ft long. The flowers, borne on long, sheathed stalks, emerge from a glaucous, horizontal spathe about 12.5cm/5in long, green flushed purple and orange; the flowers are about 10cm/4in long, with orange sepals and blue, narrowly arrow-shaped petals, with rounded basal lobes.

Distribution: South Africa.
Height and spread: Up to 2m/6½ft.
Habit and form: Stemless evergreen perennial.
Leaf shape: Oblong-lanceoleate.
Pollinated: Bird.

Left: Large clumps of leafy growth appear from the underground stems.

Dwarf Savanna Ginger Lily

Costus spectabilis

Distribution: Tropical Africa.
Height and spread:
10cm/4in.
Habit and form:
Rhizomatous perennial.
Leaf shape: Ovate-lanceolate.
Pollinated: Insect.

Costus is a large genus with more than 100 species distributed in the tropical rainforests, mainly in Africa and South America. The dwarf savanna ginger lily, found in humid or semi-humid savannas all over tropical Africa, from Senegal to the eastern coastal zones, has one of the largest blooms of all, the showy yellow flowers being highly visible during the flowering period. The plant can easily be missed when not in flower, however, as it is a low, ground-hugging species. The plants remain naturally dormant and inconspicuous during the dry season, and flowering does not occur until after the traditional burning of grassland at the beginning of the rainy season.

Identification: A rhizomatous perennial, largely stemless above the ground. The long snake-like rhizomes grow during the dry season and give rise to four-leaved spiral rosettes, that are flat on the ground. The leaves are pale green with red edges, obovate-cuneate, smooth above, downy below and cupped. Three to four bright yellow or bright orange flowers, located terminally, appear at the centre of the rosette. The fruit is a membranous capsule crowned by a persistent calyx.

OTHER BANANA, STRELITZIA AND GINGER SPECIES

Japanese Banana *Musa basjoo*
Despite its name, the Japanese banana is a medium-size species from China, growing to about 2.5m/8ft tall before flowering, though it may become considerably taller with age. The leaves are bright, light green, sometimes with a reddish flush to the underside.

Aframomum sceptrum
Generally restricted to deep forest habitats in West Africa, the Congo and Angola, the 30cm/12in inflorescences of this species arise at the base of, or independently some distance away from, the tall and leafy shoots, clothed in 25cm/10in long sheathing leaves.

Ginger *Zingiber officinale*
Ginger is a herb indigenous to South-east Asia, although it is widely cultivated in the USA, India, China, West Indies and tropical regions. The plant is a creeping perennial on a thick tuberous rhizome, with narrow, deciduous lance-shaped leaves and a long, curved spike of white or yellow flowers.

Cardamom *Elettaria cardamomum*
Common in southern India and Sri Lanka, cardamom is a perennial plant. The simple, erect stems grow to 3m/10ft from a thumb-thick, creeping rootstock. The small, yellowish flowers, which grow on prostrate stems, are followed by the capsules, which are used as a culinary spice.

Green Ripple Peacock Ginger

Kaempferia elegans

This plant is native to areas of Thailand, East Bengal, Burma and those parts of the Malay Peninsula with pronounced dry seasons, and is naturally deciduous. All *Kaempferia* species tend to be short, unlike many other plants in the Zingiberaceae. They are most notable for their foliage, which is often patterned and multicoloured, resulting in the common name of peacock ginger. The flowers, although usually inconspicuous, are a very pretty lilac. All the aerial parts die down in the dry season; the plant vegetates solely during the wet season.

Distribution: Southern Asia.
Height and spread: 15–20 x 30cm/6–8 x 12in.
Habit and form: Deciduous, rhizomatous herb.
Leaf shape: Oblong or elliptic.
Pollinated: Insect.

Identification: A low-growing, deciduous, rhizomatous herb. The smooth leaves are oblong or elliptic, broad and wavy, up to 15cm/6in long, with a pointed tip and rounded base, on short stalks. Lilac flowers with 5cm/2in green bracts appear almost daily amid the leaves during the summer months.

IRIS FAMILY

The Iridaceae are herbaceous perennials growing from rhizomes, bulbs or corms and occurring in tropical and temperate regions, particularly around the Mediterranean, in South Africa and Central America. The flowers are single and almost stemless (as in Crocus), or occur as spikes at the top of branched or unbranched stems, each with six petals in two rings of three. Many are ornamental.

Yellow Flag

Iris pseudacorus

A robust plant with beautiful, bright yellow flowers that occurs throughout much of Europe, North Africa, western Asia and the Caucasus. It has become widely naturalized outside its original range, as a garden escapee. It is common in wet habitats, including meadows, woods, fens, wet dune-slacks, and the edges of watercourses, lakes and ponds. In some areas it may also be found alongside coastal streams, on raised beaches, in saltmarsh and shingle.

Identification: An extremely vigorous, rhizomatous, beardless water iris. The 90cm/3ft leaves are ribbed, with an especially prominent midrib, grey-green, broad, flat, sword-shaped and stalkless, with several bound together into a sheath at the base. In mid- and late summer, each branched, somewhat flattened stem bears four to seven showy flowers, 7.5–10cm/3–4in across, from very large pointed buds. The petals are yellow with brown or violet markings and a darker yellow zone on each fall. The roots are thick and fleshy, brownish on the outside, reddish and spongy within, pushing through moist ground parallel to the surface, with many rootlets passing downward.

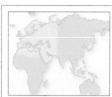

Distribution: Europe, North Africa, western Asia and the Caucasus.
Height and spread: 90cm/3ft.
Habit and form: Rhizomatous perennial.
Leaf shape: Linear-lanceolate.
Pollinated: Bee.

Left: The tall flower spikes are often seen beside water among other vegetation.

Right: The seedpod.

Crocus vernus *ssp.* albiflorus

This form of *Crocus vernus* is the smaller, high mountain plant, often seen in spring to midsummer in the Alps and the Pyrenees, although the species may be found more widely in Central and Southern Europe. It is restricted to mountain turf in areas where there is a decidedly cold winter and a short alpine summer, with snow cover persisting until well into spring, and it can often be seen flowering as the snow melts in spring or summer. The flower is commonly white but can also be purple or striped. It rarely hybridizes with the other subspecies *C. vernus* ssp. *vernus*, even when populations overlap, as both occupy different habitats.

Identification: An herbaceous corm that in time forms extensive colonies. Dull, green, semi-erect to linear-lance-shaped leaves, with pale silvery-green central stripes, appearing in spring at the same time as the flowers, can be glabrous or pubescent; elongating markedly as the flowers fade. The single white, goblet-shaped flowers, varying from pure white to being marked with purple, have a yellow style and anthers.

Left and above left: The white flowers of this subspecies are borne singly at the same time as the leaves.

Right: Flowers may be white or can be marked with purple.

Distribution: Mediterranean, Balkans and south-west Asia.
Height and spread: 7–15cm/3–6in.
Habit and form: Herbaceous corm.
Leaf shape: Linear-lanceolate.
Pollinated: Insect.

Waterfall Gladiolus

New Year Lily, *Gladiolus cardinalis*

Distribution: South Africa.
Height and spread:
40–90cm/16–36in.
Habit and form: Cormous
perennial.
Leaf shape: Linear-lanceolate.
Pollinated: Insect.

The genus *Gladiolus* comprises about 180 species of cormous perennials that originate mainly in South Africa but also in western and central Europe, central Asia, north-west and east Africa. This species from South Africa, known as the waterfall gladiolus, is often found growing under waterfalls and, as its other common name suggests, is in bloom there in December to January, although it is now thought to be virtually extinct in the wild. The plant that is grown as a cultivated form is not the true species, but the result of cross-breeding.

Identification: A cormous perennial with flattened corms and narrow to broadly sword-shaped leaves produced in fan-like tufts. In summer, arching, one-sided spikes bear up to 12 widely funnel-shaped, bright red flowers, 5cm/2in across, with white patches in the lip tepals. Each flower has six tepals: usually one central upper tepal, three smaller lower or lip tepals and two side or wing tepals. Flowers open from the base of the spike, with the older flowers dying as new ones develop and open.

Right: The plant has strap-like leaves.

Far right: The tall flower stems are clothed in large flowers that are red.

Iris lortetii
This extremely showy iris is found in Israel, Syria and northern Iraq, in areas where the rainy season is short and drought may occur for extended periods. It is 30–50cm/12–20in tall, with white flowers veined and dotted pink or maroon, deep maroon signals and mauve falls, speckled brownish-red.

Green Ixia *Ixia viridiflora*
From South Africa, the green ixia is one of the taller ixias, with upright, narrow, grass-like leaves, 40–55cm/16–22in long, surrounding a lax, many-flowered spike up to 90cm/3ft tall. Each flower is a brilliant turquoise-green with a conspicuous purple-black, circular stain or "eye" in the middle.

Table Mountain Watsonia *Watsonia tabularis*
The Table Mountain watsonia, native to the Western Cape, bears striking stalks, 1.2–1.5m/4–5ft tall, of arching, goblet-shaped blooms, in a range of colours from deep rose to salmon-orange, that appear between late spring and midsummer and are especially abundant the season after a fire.

Iris kumaonensis
Native to the western Himalayas, at altitudes between 2,400–5,500m/8,000–18,000ft, this iris has leaves 45cm/18in long and 12mm/½in broad, although at flowering time in the spring they are only 10–15cm/4–6in long around the large, pink-purple-veined flowers.

River Lily

Hesperantha coccinea

Once known as *Schizostylis coccinea*, this handsome plant from Transkei, South Africa, reaches 60–90cm/2–3ft tall, with flowers borne in profusion in autumn. The name *Hesperantha* means "evening flower", and the genus comprises 65 species, which are distributed through both the summer and winter rainfall areas of South Africa. The river lily is a species from the summer rainfall area and is widely distributed through the eastern provinces of the country, found chiefly along river edges and in water meadows, growing in full sun. The flowers are pollinated by butterflies and flies.

Identification: This vigorous, evergreen, clump-forming, rhizomatous perennial has erect, keeled, narrow sword-shaped leaves, up to 40cm/16in long, with distinct midribs. Spikes of 4–14 open, cup-shaped, scarlet flowers, 2cm/¾in across, on a one-sided, 60cm/24in spike, opening from the base upward, are produced in late summer and autumn. There are also pink and white forms.

Distribution: Transkei, South Africa.
Height and spread: 60–90 x 60cm/2–3 x 2ft.
Habit and form: Rhizomatous perennial.
Leaf shape: Linear-lanceolate.
Pollinated: *Aerpetes* butterfly and proboscid flies.

Below: The star-like, scarlet flowers are borne on tall spikes in late summer.

AMARYLLIS FAMILY

The Amaryllidaceae, or amaryllis family, are herbaceous perennials from bulbs with contractile roots,
comprising 50 genera and 870 species, which are found mainly in South Africa. Some also grow in South
America and in the Mediterranean. The flower usually consists of six distinct or fused petaloid tepals,
often with only a single flower on each stalk. Many species in this family have spectacular flowers.

Daffodil

Lenten lily, *Narcissus pseudonarcissus*

The wild daffodil is native to moist shady sites in western Europe at altitudes below 200m/650ft in light woodland. Its presence is generally considered to be a good indicator that the woodland is ancient. Cultivated daffodils are widespread in gardens and elsewhere but the distribution of wild populations is patchy, although where they do grow they tend to be abundant and make a fine display in spring.

Right: Plants produce seed but spread mainly through offsets.

Left: Older bulbs form clumps as they become established.

Identification: Thick, linear, mid-green, grass-like leaves, up to 20cm/8in high, appear at the same time as the flowers. The pale yellow flowers are usually solitary, held horizontally, and consist of six similar, yellow or white spreading perianth segments and a tubular golden-yellow corolla. Cultivated varieties of this species are widely planted and are naturalized in the wild, so distinguishing true wild populations can be difficult. The native plants always have a darker yellow flower tube and slightly twisted tepals, and the flowers are generally smaller and more nodding than in cultivated varieties.

Distribution: Western Europe.
Height and spread: 30cm/1ft.
Habit and form: Deciduous bulbous perennial.
Leaf shape: Linear.
Pollinated: Insect.

Snowdrop

Galanthus nivalis

This pretty little bulbous plant is native across much of Europe, although it is most plentiful in the eastern Mediterranean region. It is widely distributed from Spain to Russia, with several varieties and subspecies much planted in gardens outside its range and consequently found as garden escapees. Usually growing in large drifts on the banks of rivers and streams, in woodland and in damp grassland, it flowers during winter and early spring. The aptly named small flowers often push up through the snow and are white with pale green markings on their petals.

Right: The snowdrop is one of the earliest blooming bulbs, often appearing in midwinter in deciduous woodland.

Identification: Narrow, linear to strap-shaped, blue-green leaves appear at the same time as the flowers. The faintly honey-scented flowers are solitary, pendulous, to 2cm/¾in long, and appear in winter to early spring depending upon their location. The outer perianth segments are much larger than the inner ones, which do not spread on opening but form a cup containing the stamens; the inner perianth segments have a green patch towards their tip.

Distribution: Europe.
Height and spread: Up to 12.5cm/5in.
Habit and form: Deciduous bulbous perennial.
Leaf shape: Narrow linear.
Pollinated: Insect.

Left: The seedhead is a conspicuous green capsule.

Right: Snowdrops form dense clumps of foliage and flower in the late winter.

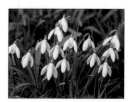

Cape Flower

Guernsey lily, Japanese spider lily, *Nerine bowdenii*

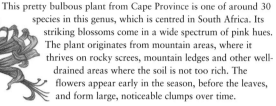

This pretty bulbous plant from Cape Province is one of around 30 species in this genus, which is centred in South Africa. Its striking blossoms come in a wide spectrum of pink hues. The plant originates from mountain areas, where it thrives on rocky screes, mountain ledges and other well-drained areas where the soil is not too rich. The flowers appear early in the season, before the leaves, and form large, noticeable clumps over time.

Distribution: Western Cape, South Africa.
Height and spread: 45cm/18in.
Habit and form: Deciduous bulbous perennial.
Leaf shape: Linear.
Pollinated: Insect.

Identification: Narrow, strap-like, glossy, mid- to dark green leaves, to 30cm/12in, develop after the flowers appear from late summer to early winter. The distinctive, musk-scented flowers are formed of six strap-like petals, candy to deep pink, rarely white, darker at the midrib, with wavy margins and usually twisted at their ends. They are borne in heads of up to eight flowers, at the end of stiff stems up to 60cm/2ft long.

Far left: The striking flowers occur in a variety of pink hues.

Right: Wild plants usually flower before the leaves appear. Those in cultivation may have both at the same time.

Hoop-petticoat Daffodil
Narcissus bulbocodium
This diminutive narcissus occurs naturally in Spain, Portugal, south-west France and Africa, and is commonly known as the hoop-petticoat daffodil because of the shape of its flowers. It is found on wet moors, meadows and marshes up to 1,000m/3,300ft, flowering in early to mid-spring.

Blood Lily *Haemanthus coccinea*
This is a very variable, summer-flowering bulbous perennial, occurring in widely varying habitats, mainly coastal scrub and rocky slopes, throughout the winter rainfall region of South Africa, from southern Namibia south. The flowerheads usually emerge before the leaves.

Amaryllis belladonna
Growing in the south-western Cape, *Amaryllis belladonna* has large clusters of up to 12 scented, trumpet-shaped, pink or white flowers, carried on a long purplish-red and green 50cm/20in stem in autumn. The strap-like leaves are deciduous and are produced after flowering.

Winter Daffodil *Sternbergia lutea*
With flowers up to 5cm/2in long and often as wide, of bright clear yellow, this species has long been a garden favourite, a fact that has contributed to its depletion in the wild. It once grew wild in Mediterranean regions from Spain to Iran and into Russia, but is now much reduced in number.

Sea Daffodil

Pancratium maritimum

An exotic member of the amaryllis family, the sea daffodil grows in coastal sand and dunes around the Mediterranean coastline and the Black Sea. Its sweetly and strongly scented, large white blooms are produced in summer and autumn, their six petals framing the corolla in the manner of a daffodil, *Narcissus* species, hence its common name. The plant reproduces vegetatively and through seeds, but despite the high number of seeds it produces, this method of reproduction is limited.

Identification: The fleshy, grey-green, strap-like leaves grow up to 50cm/20in long, and a long, partially flattened flower stem, to 40cm/16in, supports the inflorescence of five to ten florets, embraced before blooming by two large, skinny sepals. Large, white, fragrant blooms, up to 16cm/6½in across, with a slender, white perianth tube to 7.5cm/3in long, appear between late summer and mid-autumn. The fruit is a large, three-valved capsule.

Distribution: South-west Europe.
Height and spread: 40cm/16in.
Habit and form: Deciduous to semi-evergreen bulbous perennial.
Leaf shape: Linear.
Pollinated: Insect.

Right: The seed capsules still retain the remains of the flower.

Below: The clump-forming habit makes the flowers conspicuous among coastal dune grasses.

WATER LILIES, CAPE PONDWEEDS AND CATTAILS

Nymphaeaceae, or water lilies, are aquatic plants with showy flowers and are often considered the most primitive flowering plants. The Aponogetonaceae (cape pondweeds) are also primitive, occurring in the "old world". The Typhaceae, or cattail family, are widespread in the Northern Hemisphere.

Water Hawthorn

Cape pondweed, *Aponogeton distachyos*

Water hawthorn occurs naturally in the winter rainfall areas of the South African Cape region, where the edible flowers and buds, which have a strong vanilla scent, are a popular winter delicacy. It is adapted to growing in ponds and small lakes that dry up in summer. The plant flowers freely in the spring, then the tubers lie dormant in the sediment, sprouting and flowering again as soon as the pools fill in autumn. The long, oval leaves float on the water, but it is usually the sweetly scented white flowers, standing up out of the water above the leaves, that attract attention. There are several other species of *Aponogeton* in southern Africa, but *A. distachyos* is the best known.

Distribution: South Africa.
Height and spread: Variable spread.
Habit and form: Aquatic perennial.
Leaf shape: Oblong-lanceolate.
Pollinated: Bee.

Identification: Oblong to lance-shaped, bright green, sometimes brown, floating leaves, up to 20cm/8in long, on long stems, are evergreen except where water dries up seasonally. Small, scented, one-petalled white flowers, 3cm/1¼in across, with purplish-brown anthers, are enclosed in white spathes, to 2cm/¾in long, and borne in racemes with forked branches, 10cm/4in long, above the water surface.

Right: The floating leaves and sweetly scented showy white flowers make this a striking water plant.

Reedmace

Bulrush, common cattail, *Typha latifolia*

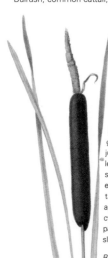

This stately water reed is well known, chiefly because of its huge distribution: it is found almost worldwide, in North and Central America, Eurasia, Africa, New Zealand, Australia and Japan. The reedmace is instantly identifiable by its tall, sword-shaped leaves and distinctive fruiting spikes. It is mainly found in shallow water up to 15cm/6in deep in ponds, lakes, ditches and slow-flowing streams, and is equally tolerant of acid or alkaline conditions.

Identification: This tall, erect semi-aquatic plant grows from stout rhizomes up to 75cm/30in long, just below the soil surface. The pale greyish-green leaves are basal, erect, linear, flat, D-shaped in cross section, 1–3m/3–10ft tall; 12–16 leaves arise from each shoot. The flower stem is erect, 1.5–3m/5–10ft tall, tapering near the flower structure, which appears in midsummer. It is a dense, dark brown, cylindrical spike on the end of the stem, with the male part positioned above the female part, continuous or slightly separated.

Right: The tall flower spikes of reedmace are a familiar sight across much of the Northern Hemisphere.

Distribution: North and Central America, Eurasia, North Africa, New Zealand, Australia and Japan.
Height and spread: 1.5–3m/5–10ft; indefinite spread.
Habit and form: Semi-aquatic or aquatic rhizomatous perennial.
Leaf shape: Linear.
Pollinated: Wind.

Right: The tight brown seedheads separate into a woolly mass of seed in late winter.

Prickly Water Lily

Foxnut, *Euryale ferox*

The prickly water lily, the only species in the genus *Euryale*, is native to east Asia and China to northern India, where it may often be found in warm water ponds and lakes in lowland regions. It is quite closely related to the Amazonian giant water lily, *Victoria amazonica*: although it is not as large as that species, its leaves can be as much as 1.5m/5ft across, with bright purple undersides, laced with large veins and covered with spines. It is day-flowering, although the flower almost always opens underwater and self-pollinates before it opens.

Distribution: East Asia.
Height and spread: Variable spread.
Habit and form: Aquatic perennial.
Leaf shape: Circular.
Pollinated: Insect.

Identification: A deep-water aquatic perennial with floating, rounded leaves, 60–150cm/2–5ft across, which are puckered, sparsely spiny, olive green above and purple beneath, with prominent, prickly veins. Shuttlecock-like flowers, up to 6cm/2¼in across, are produced in summer, with an inner row of white petals and an outer row of (usually) deep violet petals. Many-seeded, prickly berries, 5–7.5cm/2–3in across, follow the flowers. Nearly every part of the plant is covered with needle-sharp spines.

OTHER WATER LILY, CAPE PONDWEED AND CATTAIL SPECIES

Yellow Water Lily *Nuphar lutea*
Known as brandy bottle, and widely distributed across Eurasia, north Africa, the eastern USA and the West Indies. It is often found in deeper, cooler bodies of water, where it forms dense mats on the surface. The globe-shaped, unpleasant smelling flowers are fly-pollinated and followed by decorative seedheads.

European White Water Lily *Nymphaea alba*
The white water lily is widely distributed across Eurasia and North Africa, mostly in water up to 1.2m/4ft deep, in marshes, ponds, slow-moving streams, lakes and canals. It is well known for the large, semi-double, white, faintly fragrant flowers it produces in mid- to late summer.

Dwarf Reedmace *Typha minima*
This miniature bulrush is a slender aquatic perennial, relatively common across Europe and western Asia. It is smaller than its larger relatives, reaching just 75cm/2½ft, and although the flower spikes are similar to those of the other species, the plant is much less robust and invasive.

Nymphaea candida
This large, white-flowered water lily, commonly found in ponds, lakes and slow-flowing streams in Europe and parts of north Asia, flowers from mid- to late summer. The flowers last a day, opening early and beginning to close by the afternoon; they are pollinated by flies.

Cape Blue Water Lily

Nymphaea capensis

The Cape blue water lily's star-shaped, pale blue flowers are a common sight in freshwater lakes, ponds, ditches, canals, marshes and slow-moving streams across much of east and southern Africa, as well as Madagascar. This species is widely believed to be the same as the Egyptian blue lotus, *Nymphaea caerulea*, although it is in fact not a lotus but a tropical, day-blooming water lily. Wall paintings on ancient Egyptian monuments show that this flower was venerated as a symbol of life, and was used as a euphoric and aphrodisiac.

Identification: An aquatic perennial with a thick rhizome. The mid-green leaves, arising from the rhizome, are alternate and spirally arranged, simple, rounded and toothed, with a wavy margin, 25–40cm/10–16in across, with slightly overlapping lobes, usually floating. The young leaves are purple-spotted beneath. Star-shaped, solitary flowers, 20–25cm/8–10in across, on long stalks, open during the day; they are highly fragrant, with four greenish sepals, numerous blue petals and yellow stamens. The flowers grow large when in deep water.

Distribution: Africa and Madagascar.
Height and spread: Variable.
Habit and form: Aquatic perennial.
Leaf shape: Rounded.
Pollinated: Insect.

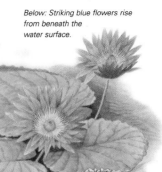

Below: Striking blue flowers rise from beneath the water surface.

GRASSES, RUSHES AND SEDGES

The Poaceae, more commonly known as the grass family, are one of the largest families of flowering plants. The Juncaceae, or rush family, is a rather small monocot-flowering plant family. Many of these slow-growing plants superficially resemble grasses, but are herbs or woody shrubs. The Cyperaceae are grass-like, herbaceous plants, collectively called sedges, found in wet or saturated conditions.

Papyrus

Cyperus papyrus

Papyrus is native to wet swamps and lake margins throughout Africa, Madagascar and the Mediterranean region, and in particular Egypt and Sudan. The most conspicuous feature of the plant is its bright green, smooth, flowering stems, known as culms, each topped by an almost spherical cluster of thin, bright green, shiny stalks. Papyrus is famed as the fibre used by the ancient Egyptians to make paper.

Identification: The stems are stout, smooth, triangular in cross-section, 4cm/1½in thick at the base, surrounded at the base by large, leathery, tapering sheaths. They are topped by umbels of numerous, needle-like rays, 10–45cm/4–18in long, each surrounded at the base with a narrow, brown, cylindrical bract, up to 3cm/1¼in long. Greenish-brown clusters of 6–16 flowers appear at the end of the rays, followed by tiny dark brown fruits, borne in the axils of tiny scales.

Distribution: Africa and Madagascar.
Height and spread: 5m/16ft.
Habit and form: Aquatic perennial.
Leaf shape: Reduced to small bracts.
Pollinated: Wind.

Far left: Papyrus is a tall, robust, almost leafless aquatic perennial, growing from stout horizontal rhizomes that creep along the substrate under water and are anchored by numerous roots.

Giant Reed

Arundo donax

This large perennial grass is native from the Mediterranean region to the lower Himalayas, although its popularity as a garden plant has led to it being introduced to many subtropical and warm temperate regions, where it often becomes naturalized as a garden escapee and can be invasive. Giant reed is found on sand dunes near seashores and does tolerate some salt, although it is most often encountered along riverbanks and in other wet places, usually on poor sandy soil and in sunny situations, where its tough, fibrous roots penetrate deeply into the soil. Reeds for musical instruments are made from its culms.

Identification: Culms up to 6m/20ft tall arise from thick, short, branched, fleshy rhizomes. The stems are 2–4cm/¾–1½in in diameter, smooth, hollow and reed-like, with many nodes and often with a white scurf. The numerous, smooth, flat leaves on the main stem are 30–70cm/12–28in long, glaucous-green, drooping, rounded at the base and tapering to a fine point; they emerge from smooth sheaths, hairy tufted at the base. The flowers appear in mid- to late autumn in large, erect feathery panicles, 30–70cm/12–28in long, light brown or yellowish-brown, with lustrous silky hairs.

Distribution: Mediterranean to lower Himalayas.
Height and spread: Up to 6m/20ft.
Habit and form: Perennial grass.
Leaf shape: Linear.
Pollinated: Wind.

Left: The architectural merits of this plant have led to its use as a garden plant

Right: The tall stems are topped with a feathery flower panicle.

Common Rush *Juncus effusus*
Common or soft rush is a long-lived perennial, wetland plant that grows in a tussock. It spreads by vigorous, underground rhizomes. It is found all over the temperate world, growing in acid or polluted soil in situations with plenty of water and sun. The bright green, hollow stems carry compact, brown or yellow flowers in summer.

Giant Feather Grass
Stipa gigantea
This grass from Spain and Portugal grows up to 1.8m/6ft tall and blooms early in summer. The flowering stems are strong and erect, and their alleged resemblance to oats, *Avena* species, gives the plant its other name of golden oats. The arching foliage is much shorter and forms a tidy clump.

Broadleaf Bamboo
Sasa palmata
This bamboo is originally native to forests in east Asia, although it has become widely naturalized in woodlands and damp hollows elsewhere. It is evergreen

and fast growing, with large leaves arranged in a fan or palm-like shape, which eventually form a dense, spreading clump.

Greater Woodrush

Luzula sylvatica

The genus name of the greater woodrush, *Luzula*, is derived from the Latin word meaning "glow worm". It probably alludes to the way that the soft, downy hairs covering the margins of each blade catch and hold dew, causing them to glisten in the morning light. It is these downy hairs that distinguish woodrushes from rushes, *Juncus* species. Woodrushes are common in temperate regions worldwide, and this Eurasian species is found in woods and shady places, as well as on open ground. The leaves remain green(ish) all winter, and in mountainous regions in western Europe they are used by most golden eagles to line their eyries. It is widely distributed in southern, western and central Europe, and south-west Asia.

Identification: Densely tufted, grass-like, tussock-forming, the greater woodrush has broadly linear, channelled, glossy, dark green leaves to 30cm/12in long, fringed with zigzagged white hairs along the margin. Groups of two to five small, chestnut-brown flowers are produced in open panicles to 7.5cm/3in long, from mid-spring to early summer.

Distribution: Europe and south-west Asia.
Height and spread: 70–80cm/28–32in.
Habit and form: Evergreen rhizomatous perennial.
Leaf shape: Broadly linear.
Pollinated: Wind.

Right: The open, feathery flower-heads emerge from mid-spring onward.

Metake

Arrow bamboo, *Pseudosasa japonica* syn. *Arundinaria japonica*

This woodland-dwelling bamboo from eastern Asia is frequently naturalized outside its range due to its popularity with gardeners. It is the most cold-tolerant bamboo, surviving temperatures as low as -24°C/-11°F. Plants often flower lightly for a number of years, although they can produce an abundance of flowers. Mass flowering severely weakens the plants, and they can take some years to recover.

Distribution: East Asia.
Height and spread: Up to 6m/20ft.
Habit and form: Rhizomatous evergreen bamboo.
Leaf shape: Lanceolate or oblong.
Pollinated: Wind.

Right: The tiny flowers are borne at the branch tips and only appear on mature plants.

Identification: An upright, spreading, bamboo up to 6m/20ft in height. The canes are erect, cylindrical, branched at each upper node, olive-green when young, maturing to pale beige. Lance-shaped or oblong, hairless, tessellated, dark green leaves, to 35cm/14in long, are silver-grey beneath and have yellow midribs. The plant usually forms a solid vertical mass of leaves, which cover and enclose it entirely from the ground to the top.

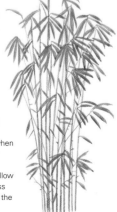

LILY FAMILY

The Liliaceae, or lily family, is a large and complex group, mostly consisting of herbaceous perennials that grow from starchy rhizomes, corms, or bulbs. The family includes a great number of ornamental flowers as well as several important agricultural crops. The plants have linear leaves, mostly with parallel veins, and flower parts in threes.

English Bluebell

Hyacinthoides non-scriptus

This bulbous perennial is restricted to northern Europe and is chiefly found in the British Isles and along the sea coasts of Scandinavia and the Low Countries, where it thrives in the cool, moist, maritime conditions. It grows in deciduous woodland, where it carpets the ground, usually on slightly acid soils, and is also common in woodland clearings, on roadsides and occasionally in open ground. The distinct species is also threatened in many areas across its range because it hybridizes freely with the Spanish bluebell, *H. hispanica*, which is a more robust species.

Left: The flowers are distinct.

Identification: The plant is vigorous and clump-forming, with spreading, linear to lance-shaped, glossy, dark green leaves, 20–45cm/8–18in long. In spring, one-sided racemes that bend over at the top bear 6–12 pendent, narrowly bell-shaped, scented, mid-blue, sometimes white, flowers, up to 2cm/¾in long, with cream anthers. Blooms appear (according to local climate and conditions) from mid- to late spring.

Right: Bluebells seed easily.

Far right: Bluebells form dense blue carpets during spring in deciduous woodlands.

Distribution: Northern Europe.
Height and spread: 20–45cm/8–18in.
Habit and form: Bulbous perennial.
Leaf shape: Linear to lanceolate.
Pollinated: Insect.

Madonna Lily

Lilium candidum

A large upright lily and one of the oldest plants recorded, being recognizable in paintings on Crete dating back 4,000 years. It has been cultivated for centuries and its original habitat (probably Turkey) is unknown, although it now occurs widely across that region. It is highly unusual in that it produces overwintering basal leaves. It grows in meadows and forests on sand and limestone, to elevations of 1,300m/4,250ft.

Identification: Broad, inversely lance-shaped, shiny, bright green basal leaves, 23cm/9in long, appear in autumn. In spring, the stiffly erect stems bear smaller, scattered or spirally arranged, often somewhat twisted, lance-shaped leaves to 7.5cm/3in long. From late spring until midsummer the plant produces a raceme of 5–20 sweetly fragrant, large, broadly trumpet-shaped, pure white flowers, 5–7.5cm/2–3in long, with yellowish bases and bright yellow anthers.

Left and right: The flower spikes sport 10–20 dazzling white, sweetly scented flowers in summer.

Distribution: Mediterranean.
Height and spread: 1–1.8m/3–6ft.
Habit and form: Bulbous perennial.
Leaf shape: Inversely lanceolate.
Pollinated: Insect.

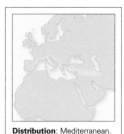

Pineapple Lily

Eucomis bicolor

These bulbous perennials, originating from wet mountain slopes and meadows in South Africa, are named pineapple lilies because of their unusual tight racemes of flowers topped by a small tuft of leafy bracts, similar to those of a pineapple, which are borne in late summer. These emerge amid a basal rosette of glossy green leaves and are borne on stout stems, giving the whole plant a highly distinctive look.

Far right: The individual flowerhead.

Left: The exotic-looking flowerheads resemble pineapples.

Identification: A large bulb, up to 7.5cm/3in in diameter, produces semi-erect to angular, strap-shaped, wavy-margined, light green leaves, growing up to 10cm/4in wide and 30–50cm/12–20in long. In late summer, maroon-flecked stems bear racemes, 15cm/6in long, of tightly packed, slightly pendent, pale green flowers up to 2.5cm/1in across, with purple-margined tepals. Each raceme is topped by a small tuft of leafy bracts, arranged in a loose rosette.

Right: The rosette of leaves gives rise to a single flower stem.

Distribution: South Africa.
Height and spread: 30–60cm/12–24in.
Habit and form: Bulbous perennial.
Leaf shape: Angular strap-shaped.
Pollinated: Insect.

OTHER LILY FAMILY SPECIES

Snakeshead Fritillary
Fritillaria meleagris
Native to north-western Europe, the snakeshead fritillary usually grows in damp meadows. The bloom, before the bud is fully opened, looks a little like a snake's head, hence the name. The nodding, tulip-shaped flowers are chequered in shades of purple or, rarely, white.

Yellow Asphodel *Asphodeline lutea*
A native of the eastern Mediterranean, yellow asphodel is a clump-forming evergreen perennial, with tightly wrapped, blade-like, narrowly triangular foliage. Tall flowering spikes, which become dense with fragrant, citron-yellow, star-shaped blooms, emerge in spring.

Toad Lily *Tricyrtis stolonifera*
The toad lily is a stoloniferous perennial from moist woodland habitats in Taiwan. It has purple-spotted, deep green leaves, borne alternately on hairy stems that grow in a zigzag pattern. In late summer, it bears white or light pink, star-shaped flowers, heavily spotted with purple.

Oriental Lily *Lilium speciosum*
This tall Japanese lily can reach 1.5m/5ft and flowers late in the summer. The large, pendent, sweetly fragrant, white flowers are borne on long racemes of 12 or more, and are covered in carmine-red spots and stripes, giving them a pink appearance.

Water Lily Tulip

Tulipa kaufmanniana

This relatively low-growing tulip, from rocky mountain slopes close to the snow edge in central Asia, has an average height of 15cm/6in, though it is a variable species in terms of height and bloom. The flower is long and white with a yellow tint on the inside and pink on the outside. The blooms, when they first open, are cup-shaped, though with pointed petals; eventually, on the sunniest days, they open flat into a characteristic hexagonal star shape from about a third of the way up the slender cup, so that when viewed from above they look almost like water lilies. The species has a scattered distribution across Kazakhstan, Uzbekistan, Tajikistan and Kyrgyzstan.

Identification: The plant has three to five lance-shaped, slightly wavy-margined, hairless, grey-green leaves, up to 25cm/10in long. Bowl-shaped flowers 3–12.5cm/1¼–5in across, are borne singly or in clusters of up to five, on slightly downy, often red-tinged stems in early and mid-spring. The flowers are cream or yellow, flushed pink or greyish-green on the outside, often with contrasting basal marks.

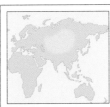

Distribution: Central Asia.
Height and spread: 15cm/6in.
Habit and form: Bulbous perennial.
Leaf shape: Lanceolate.
Pollinated: Insect.

Right: Tulips escape the extremes of summer heat and winter cold as an underground bulb.

Below: Bulbs may form dense clumps over time.

TERRESTRIAL ORCHIDS

The Orchidaceae, or orchid family, are terrestrial, epiphytic or saprophytic herbs comprising one of the two largest families of flowering plants, with about 1,000 genera and 15–20,000 species. The terrestrial species often display ingenious relationships with their pollinators, and although the flowers are generally smaller than some of the epiphytic types they are equally intricate.

Lady's Slipper

Cypripedium calceolus

This orchid, with large, solitary flowers with maroon-brown petals and a pouched, yellow lip, is found in open woodlands on calcareous soils, usually on north-facing slopes. It is widely distributed throughout Europe, and eastward across Asia to the Pacific coast and on into much of northern North America. There are several varieties across the range with different flower sizes to accommodate different pollinators. Despite this wide distribution, however, over-collection has made it rare and threatened over much of its range even though efforts have been made to protect it.

Identification: This terrestrial orchid has three to five oval to elliptic leaves, ascending, sheathing at the base, with pointed to tapered tips, sparsely hairy, 5–20cm/2–8in long. The stem is 40cm/16in tall, hairy, the hairs often glandular. Flowers are usually borne one per stem, less often two, in early to midsummer. The sepals and lateral petals are greenish-yellow to purplish-brown, 2–6cm/¾–2¼in long, the upper sepal lance-shaped to oval, the lateral sepals joined below the lip, the lateral petals narrowly lance-shaped and twisted. The lip is yellow, often purple-veined and dotted with purple around the orifice, and heavily pouched in the style of a slipper.

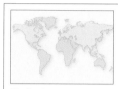

Distribution: Eurasia and North America.
Height and spread: 40cm/16in.
Habit and form: Herbaceous perennial.
Leaf shape: Ovate to elliptic.
Pollinated: Insect.

Bee Orchid

Ophrys apifera

Bee orchids, although not particularly rare across their range, are unpredictable in their appearance, often varying hugely in numbers from year to year. This is probably due to the plant's habit of overwintering as a dormant tuber. Dry years reduce the size of the orchids, resulting in the plant not flowering for a year or more after. It is a frequently encountered species of limestone grasslands, old limestone quarries, maquis and sand dunes and is typically found in areas of short, grazed turf across Europe ranging eastward into northern Asia. The flower mimics the female of a Mediterranean bee species to attract potential "suitors" who attempt to mate with it. When a male bee lands on the flower, pollen is dumped on its back and it flies off with this to cross-fertilize another flower. Despite this intricacy, many northern populations are self-pollinating as the bee is absent in their location.

Identification: An erect, perennial, terrestrial orchid, with small rosettes of oblong to egg-shaped leaves, 6cm/2¼in long, pointed at the tip, appearing early in the year. Erect racemes, up to 30cm/12in tall, of 2–11 flowers, 2.5cm/1in across, each with green or purplish-pink sepals and petals, and a brownish furry lip marked red-purple and yellow, which is supposed to resemble a bee, are borne in mid-spring and early summer.

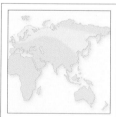

Distribution: Europe and northern Asia.
Height and spread: 30cm/12in.
Habit and form: Herbaceous perennial.
Leaf shape: Oblong-ovate.
Pollinated: Bee.

Left: The bee orchid gets its name for its ability to attract male solitary bees to its flowers.

Pride of Table Mountain

Disa uniflora

Distribution: Western Cape, South Africa.
Height and spread: Up to 60cm/2ft.
Habit and form: Herbaceous perennial.
Leaf shape: Lanceolate.
Pollinated: Butterfly (*Meneris tulbaghia*).

Far right: The bright red flowers appear in clusters.

Disa is a large African genus and, although widespread, many species are endemic to small areas. The spectacular, brilliant red flowers of *D. uniflora*, which are the emblem of the Western Cape, are borne during summer and are found in fynbos, on rock flushes, in marshes and lakes, and in montane grassland. It is always associated with water, growing on the edges of permanent mountain streams or in wet moss near waterfalls, at altitudes varying from sea level to about 1,200m/4,000ft. The butterfly, *Meneris tulbaghia*, is the only known pollinator, although the plant readily multiplies by producing stolons that develop into new plants. After flowering, the plant and its tuber die back to provide food for the production of a fresh tuber and shoot.

Identification: A deciduous terrestrial orchid, with lance-shaped leaves up to 25cm/10in long, it produces short racemes of up to three, or rarely up to ten, brilliant scarlet flowers, each 7.5–12.5cm/3–5in across, with hooded upper perianth and spreading lower perianth segments. The hood is paler with darker red striations; the lower twin petals have a green stripe on the outer surface. The bud is tightly curled and upward facing.

OTHER TERRESTRIAL ORCHID SPECIES
Man Orchid *Aceras anthropophorum*
The man orchid has a patchy distribution, ranging from the Mediterranean region to Turkey, but is much reduced over its former range due to grassland disturbance. The yellowish flowers resemble small human figures, with the upper flower parts forming a "helmet".

Pyramidal Orchid
Anacamptis pyramidalis
This orchid is so-called because of the obvious rounded-pyramid shape of the flowering spike, especially when young. The flowers are a beautiful deep pink, with a short spur; they have a faint fragrance and are moth-pollinated. The leaves are narrow and without any spots.

Satyrium princeps
This South African terrestrial orchid is a native of fynbos regions, especially in coastal districts. It has heads of scented white flowers that emerge from broad, flat basal foliage. It is extremely rare in the wild, with only scattered populations around the southern Cape.

Cypripedium himalaicum
Found from northern Europe east to northern Asia and Siberia, this orchid grows on thin, stony soils in open woodland clearings, up to and sometimes over 3,000m/9,850ft. In the late spring and early summer, waxy, brittle flowers that are pink, red and white appear on an erect, single-flowered inflorescence.

Early Purple Orchid

Orchis mascula

The early purple orchid is a widespread but local plant of woods, hedge banks, pasture and low coastal cliffs. It is very common on lime-rich or clay soils, particularly in warm, moist areas close to the coast. It is relatively common across Europe, in oak groves, undergrowth, meadows and on roadsides, up to a maximum elevation of 2,400m/8,000ft. The leaves are often marked with dark spots, and although purple is the most common colour a white variant is occasionally encountered. The production of seed often heralds the death of the plant.

Identification: A terrestrial orchid with roots consisting of roundish tubers, from which arise erect, mid-green, often purple-spotted leaves 15cm/6in long. From spring to midsummer it bears light to dark purple flowers, 2cm/¾in long, in erect racemes to 30cm/12in tall. The lowest petal is three-lobed with a stout spur, wider than the bracts. The flowers have a mild vanilla-like aroma.

Distribution: Europe except Iceland.
Height and spread: 30cm/12in.
Habit and form: Herbaceous perennial.
Leaf shape: Oblong-ovate.
Pollinated: Bee and moth.

Below: True to its name the early purple orchid flowers earlier than other orchids.

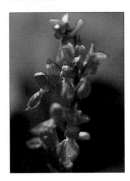

EPIPHYTIC AND LITHOPHYTIC ORCHIDS

These orchids depend upon the support of another plant, though they are not parasitic. They typically root into accumulations of plant debris in the forks of tree branches and manufacture their own food by photosynthesis. They are generally forest dwellers, many conducting their entire life cycles elevated in their host trees or on inaccessible rocky outcrops. They include some of the showiest of all flowers.

Dendrobium aphyllum

These deciduous, tropical, epiphytic orchids are widespread in South-east Asia, being found in low-altitude rainforests right up into montane forests. The large pale mauve and primrose yellow flowers have a strong violet fragrance and are borne from stem-like pseudobulbs before the new leaves appear. The foliage has a soft texture and is typically deciduous after a single season, though under some conditions leaves may last more than a single year.

Identification: Pendent to semi-erect, long, slender pseudobulbs are slightly swollen at the nodes, with new growths appearing about flowering time. Oval, fleshy leaves, 12.5cm/5in long, often wavy along the margin, are often smaller near the tips of the canes. Pale mauve-pink flowers, 5cm/2in across, with primrose-yellow lips, are borne in pairs, emerging from nodes along the previous season's leafless growth, and are so numerous that the canes appear covered with blossoms.

Above: The leaves are fleshy.

Right: The flowerhead is spectacular.

Distribution: South-east Asia from southern and eastern India to south-west China, Thailand, Laos, Vietnam, Malaysia and South Andaman Island.
Height and spread: 60–180cm/2–6ft, trailing.
Habit and form: Deciduous epiphyte.
Leaf shape: Ovate to lanceolate.
Pollinated: Insect.

Four Season Orchid

Corsage orchid, *Cymbidium ensifolium*

This lithophytic orchid is one of the most widespread and variable of the genus. It is found throughout South-east Asia, growing at elevations from 300–1,800m/1,000–5,900ft. It has many distinct recognized subtypes, which some experts believe constitute several closely related species, although most consider it a single species throughout its range.

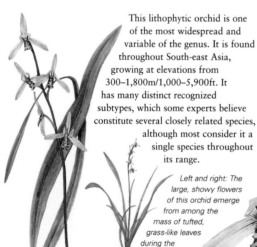

Left and right: The large, showy flowers of this orchid emerge from among the mass of tufted, grass-like leaves during the summer months.

Identification: This plant has small, ovoid pseudobulbs, often hidden from view, clumped along a short rhizome that gives rise to thick, white, branching roots. The persistent, linear, tufted, grass-like leaves are up to 30cm/12in long, sometimes with minutely serrated tips. In summer, it produces upright racemes of 3–12 waxy, greenish-yellow flowers, each 2.5–5cm/1–2in across, with spreading sepals and petals streaked with red. Green or pale yellow, rarely white, lips, with wavy margins and callus ridges converging at the apex and forming a tube at mid-lobe base, are irregularly spotted red-brown.

Distribution: Indochina, China, Japan, Borneo, New Guinea and the Philippines.
Height and spread: 30cm/12in.
Habit and form: Lithophytic orchid.
Leaf shape: Linear.
Pollinated: Insect.

Moth Orchid

Phalaenopsis amabilis

Distribution: Philippines.
Height and spread: Up to 90cm/3ft.
Habit and form: Epiphyte.
Leaf shape: Obovate-oblong.
Pollinated: Insect.

This robust epiphytic orchid from the Philippines is very variable, occurring at elevations up to 600m/2,000ft on the trunks and branches of rainforest trees, overhanging rivers, swamps and streams. The short, stem-like rhizome gives rise to long, shiny leaves, among which the spectacular, large, scented, white flowers are borne along pendent racemes and may persist for many weeks before dropping. This is one of the national flowers of Indonesia.

Identification: The short, robust stem is completely enclosed by overlapping leaf-sheaths. The long, fleshy, smooth, often branched, flexible roots are green at the end. The glossy leaves, seldom more than five, are fleshy or leathery, oval to oblong and blunt-tipped, up to 50cm/20in long. Pendent, simple or branched racemes, up to 90cm/3ft long, ascending or arched, green dotted brown-purplish, bear numerous white, often fragrant flowers, with yellow-margined lips and red throat margins, 6–10cm/2¼–4in across.

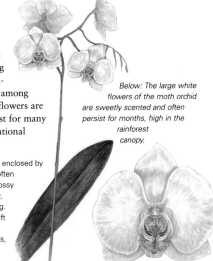

Below: The large white flowers of the moth orchid are sweetly scented and often persist for months, high in the rainforest canopy.

Scorpion Orchid

Air-flower arachnis, *Arachnis flos-aeris*

All *Arachnis* orchids are known as scorpion orchids, but the name is especially applied to this species. Mainly a lowland plant that inhabits more open areas in full sun, this is not strictly an epiphyte but a vining, monopodial orchid. It can be found scrambling over rocks and trees, usually at elevations up to 1,000m/3,300ft in wet tropical forests of South-east Asia. It is a large species, which will climb high into the treetops if given the opportunity.

Identification: It has a thick, robust stem that roots adventitiously on to supporting plants and thick, fleshy or leathery, dark green leaves, 18cm/7in long and notched at the tips. The fragrant flowers, up to 10cm/4in across with a fixed lip and four pollinia, are yellow-green horizontally striped or spotted maroon, or in shades of yellow to gold with red-brown markings. They are borne in arching, axillary panicles or racemes, pendent or ascending, up to 1.8m/6ft long, with many flowers that open over a long period.

Distribution: Thailand, western Malaysia and the Philippines.
Height and spread: 6m/20ft or more.
Habit and form: Climbing orchid.
Leaf shape: Obovate-oblong.
Pollinated: Insect.

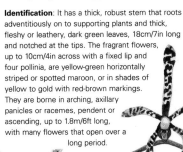

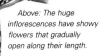

Above: The huge inflorescences have showy flowers that gradually open along their length.

WILD FLOWERS OF
THE AMERICAS

America, or the "New World" was given this name by Europeans when they "discovered" it and began settling there five centuries ago. The land is anything but new, however, and contains many plants with ancient lineages. North America has been attached to Asia for much of its recent history, and so many of the plants that grow there resemble species found across Eurasia. In contrast, South America was isolated for millions of years, having originally been part of the ancient super-continent called Gondwanaland, and its unique plants are much more closely allied to those of Africa and Australasia. When North and South America became linked, their combined flora formed some of the most diverse and spectacular plant communities on the planet.

Above from left: Chilean fire bush (Embothrium coccineum), century plant (Agave americana), and cardinal flower (Lobelia cardinalis).

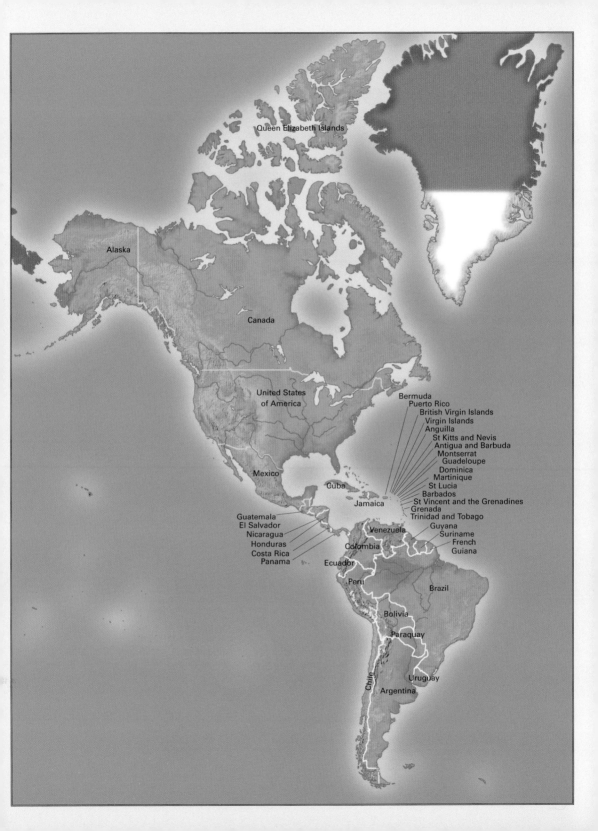

Queen Elizabeth Islands

Alaska

Canada

United States
of America

Mexico

Cuba

Jamaica

Bermuda
Puerto Rico
British Virgin Islands
Virgin Islands
Anguilla
St Kitts and Nevis
Antigua and Barbuda
Montserrat
Guadeloupe
Dominica
Martinique
St Lucia
Barbados
St Vincent and the Grenadines
Grenada
Trinidad and Tobago

Guatemala
El Salvador
Nicaragua
Honduras
Costa Rica
Panama

Venezuela

Guyana
Suriname
French
Guiana

Colombia

Ecuador

Peru

Brazil

Bolivia

Paraguay

Chile

Uruguay

Argentina

BUTTERCUP FAMILY

This large family is well represented in the New World with many colourful species to be found, some of which have become popular as garden flowers. Many species are related to similar plants in Eurasia although the variety of colour is often greater in the American species. In common with their Old World counterparts, they are mostly restricted to cooler locations.

Scarlet Clematis

Clematis texensis

This beautiful clematis is native to the Texas hill country. Unlike other clematis, this scrambler is herbaceous and dies back completely in winter, re-emerging each spring. It commences blooming in mid-spring and continues until midsummer, producing pretty, fuzzy seedpods in the autumn. The flowers do not open wide like those of many clematis species, but form a tulip-shaped red cup. There seems to be considerable variation in the shade of red from plant to plant.

Identification: Climbing subshrub or perennial with smooth, reddish-brown stems. The tough, blue-green pinnate leaves have oval to rounded leaflets, sometimes two- to three-lobed, up to 7.5cm/3in long, usually heart-shaped at the base, with small, thorny tips and a distinct network of veins; the terminal leaflet is reduced to a tendril. The solitary, pendulous, scarlet-red or carmine flowers are urn-shaped, to 2cm/¾in across, with thick, narrow, oval sepals, reflexed, on ribbed flower stalks.

Left: The pendulous, tulip-like flowers are distinctive.

Distribution: Texas, USA.
Height and spread: 2m/6½ft.
Habit and form: Subshrub.
Leaf shape: Pinnately 4–8 trifoliate.
Pollinated: Insect.

Right: The scarlet clematis has a scrambling habit.

Canadian Anemone

Meadow anemone, *Anemone canadensis*

This handsome and robust herbaceous perennial is found in Canada and the northern USA, on low-lying moist ground and in damp woods. The large white flowers and palmate leaves are striking and give the plant an almost unmistakable appearance when it is in flower from late spring to summer. The Canadian anemone typically forms large colonies along the banks of rivers and next to levees in floodplains, spreading vigorously by means of thread-like rhizomes.

Identification: A robust perennial, with deeply lobed basal leaves up to 12.5cm/5in long and upright round stems bearing a single whorl of three-lobed leaves, toothed near the tip. A single flower or loose cyme terminates each stem: the flower is buttercup-like, white, upward-facing and up to 5cm/2in across, with a lemon-yellow centre.

Left: The spreading rhizomes give rise to dense colonies of large white flowers.

Distribution: Canada and northern USA.
Height and spread: 30–60cm/1–2ft.
Habit and form: Herbaceous perennial.
Leaf shape: Palmate.
Pollinated: Insect.

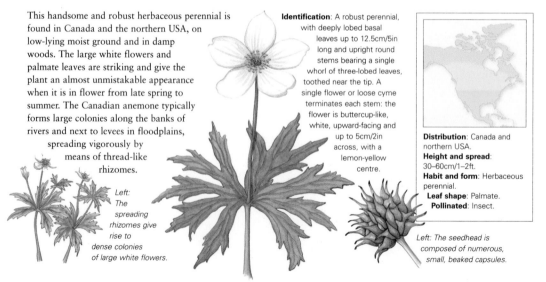

Left: The seedhead is composed of numerous, small, beaked capsules.

Monkshood

Southern blue monkshood, *Aconitum uncinatum*

This striking herbaceous perennial, native to, and with a scattered distribution across, much of North America east of the Rocky Mountains, is found in rich woods or, toward the southern part of its range, in mountainous areas. The plant has become rare, although it is probably not endangered; it is chiefly threatened by forest management practices and, to a lesser extent, by land-use conversion and habitat fragmentation. All parts of this plant are highly toxic.

Distribution: USA, east of the Rocky Mountains.
Height and spread: 60–90cm/2–3ft.
Habit and form: Herbaceous perennial.
Leaf shape: Palmately lobed.
Pollinated: Insect.

Right: The seedheads have five parallel ascending sections.

Left: The flowers appear from late summer to mid-autumn.

Identification: Tall, slender stems grow from a turnip-like root that is renewed annually, the new one being well separated from the old. The leaves are numerous, firm and deeply divided into three to nine lobes, which are lance-shaped and coarsely toothed. Short terminal racemes or panicles each bear a few violet or deep blue flowers, with unequal petaloid sepals: the upper sepal or helmet is the largest and is strongly arched or hooded, with its tip prolonged forward and downward into a short beak, covering the other two upper sepals. The lower two sepals are vestigial.

OTHER BUTTERCUP FAMILY SPECIES

Rock Clematis *Clematis columbiana*
The rock clematis, or Columbian virgin's bower, is a deciduous climber, to 3m/10ft. It is naturalized in western North America, from British Columbia to Colorado and Oregon. It inhabits dry to moist soils in woods and thickets, from valleys to mountain slopes up to 2,500m/ 8,200ft, and is in flower from early to midsummer. The flowers have four long, pointed sepals and are a vibrant pinkish-purple.

Columbian Windflower *Anemone deltoidea*
The Columbian windflower is a small, slender, rhizomatous anemone found in the Rocky Mountains. Growing to about 30cm/1ft in height, the basal, three-lobed leaves appear before the solitary white flowers in summer. The flowers are followed by fluffy seedheads.

Tall Larkspur *Delphinium exaltatum*
This tall delphinium from the eastern USA may reach 1.8m/6ft in height. In summer it produces long racemes of numerous blue or purple flowers with long spurs above large, highly dissected basal leaves.

Allegheny Crowfoot *Ranunculus allegheniensis*
The Allegheny crowfoot or mountain buttercup has tiny, pale yellow flowers, which appear in spring and summer. It is one of a group of small buttercups whose ranges overlap in the USA. They are most commonly found in moist woods, where they grow 15–60cm/6–24in tall.

Red Columbine

Canadian columbine, *Aquilegia canadensis*

Red columbine occupies open sites that are steep and rocky but moist, such as wooded bluffs of streams, wooded slopes, stream banks, the slopes of deep ravines, limestone bluffs and ledges, borders and clearings in deciduous or mixed woods or thickets from Nova Scotia to the Northwest Territories, south to Florida and Texas. The flower is adapted to long-tongued nectar-feeders. The flowering time corresponds with the spring migration movements of the ruby-throated hummingbird, which is this plant's chief pollinator.

Distribution: Eastern Canada and USA.
Height and spread: 30–80cm/12–30in.
Habit and form: Herbaceous perennial.
Leaf shape: Compound.
Pollinated: Hummingbird and hawk moth.

Identification: The fern-like, dark green basal leaves are long, stalked and divided into three lobed leaflets; the leaves on the stem are reduced upward, the uppermost sometimes simple. Nodding, bell-like red-and-yellow flowers, several per stem, have five elongated, clubbed, red spurs, up to 2.5cm/1in long and nearly straight.

Far right: Red columbine is an upright herbaceous perennial growing from a short, erect underground stem.

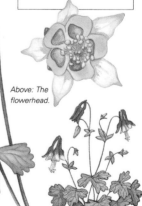

Above: The flowerhead.

ROSE FAMILY

In the Americas, Rosaceae, or the rose family, comprises a large number of trees, shrubs and herbs, many of which are similar to those found in Eurasia. The north temperate region is their centre of diversity. The family is a large and important one, especially in North America, and contains plants of economic and horticultural importance.

Swamp Rose

Rosa palustris

The densely shrubby swamp rose grows in swamps and marshes, and along stream banks in eastern North America. Growing to a height of 1.8m/6ft, it blooms in early summer and is very fragrant. It is insect-pollinated, and birds that eat the fleshy hips help spread the seed.

Identification: A many-branched, deciduous shrub with stout, curved thorns, approximately 6mm/¼in long, with a flattened base. The leaves are pinnately compound, with narrow stipules at the base of the leaf stalk, barely extending out from the stalk until they flare at the end; the leaflets (usually seven) are oval to lance-shaped, with finely toothed edges. They are smooth on the upper surface and slightly hairy along the midrib underneath. The solitary flowers are pink and very fragrant. The hips are red, up to 12mm/½in thick, and may be either smooth or covered with minute hairs.

Distribution: From Nova Scotia west to Minnesota, south to the Gulf of Mexico and east to Florida.
Height and spread: 1.8m/6ft.
Habit and form: Deciduous shrub.
Leaf shape: Pinnately compound.
Pollinated: Insect.

Right: The bright red hips appear from late summer onward.

Right: Swamp rose forms a small hummocky bush in wet areas.

Dwarf Serviceberry

Amelanchier alnifolia var. *pumila*

The dwarf serviceberry is a very variable and highly adaptable, fire-tolerant species, occurring throughout western and central North America. *Amelanchier alnifolia* is a multi-stemmed, deciduous shrub or small tree growing to 5.5m/18ft high. It is mainly found in thickets, at woodland edges and on the banks of streams in moist, well-drained soils, with the small bushy forms growing on fairly dry hillsides and the larger forms growing in more sheltered locations. The variety *pumila* is a naturally occurring dwarf alpine form native to mountainous areas of the West. The fruits are attractive to birds.

Identification: Five-petalled, white flowers, up to 2cm/¾in in diameter, appear in abundant, compact clusters in early spring before the leaves. The leaves are finely toothed, oval to rounded, pale to dark green, turning variable shades of yellow in autumn. In midsummer the flowers give way to small, round, edible berries, which ripen to dark purplish-black and are covered in a light, white bloom. They resemble blueberries in size, colour and taste.

Distribution: Western and central North America, from Saskatchewan south to Colorado and Idaho.
Height and spread: 90cm/3ft.
Habit and form: Deciduous shrub.
Leaf shape: Oval.
Pollinated: Bee.

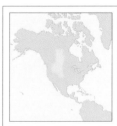

Left: White flowers appear in mid-spring, before the leaves, and are followed by edible fruits.

Prairie Rose *Rosa setigera*
This rose, which grows in open woodland in eastern and central North America, can climb to a height of 4m/13ft, and has large pink blooms that appear in late spring. The stem is usually lightly armed with curved thorns. The alternate leaves are divided into three or sometimes five-toothed leaflets. The flowers are followed by small red hips in autumn.

Meadowsweet *Spiraea alba*
This multi-stemmed woody shrub grows in damp meadows in the USA and bears white or pale pink flowers, 6mm/¼in across, in narrow upright terminal clusters 10–15cm/4–6in long from midsummer to mid-autumn. The narrow, lance-shaped leaves are green above, but paler below. The bark is smooth, greyish to reddish-brown, eventually peeling off in fine strips.

Appalachian Barren Strawberry
Waldsteinia fragarioides
The Appalachian barren strawberry is native to woods and clearings, mostly in the Appalachians, but also in scattered locations from South Carolina north to Canada and west as far as Arkansas and Minnesota. The large yellow flowers appear from mid-spring to early summer and these, along with the basal leaves on long stalks, resemble those of a strawberry, although the fruit does not.

Indian Plum

Oso berry, *Oemleria cerasiformis*

The Indian plum is a shrub or small tree with smooth, purplish-brown bark and is one of the first woody plants to bloom in the spring. The foliage emerges very early, and the fresh leaves taste of cucumber. The genus contains only this one species, which has a native range along the Pacific coast in moist to moderately dry locations, especially in white oak woodlands and open forests of Douglas fir. It is most common at elevations below 250m/800ft but occurs up to 1,700m/5,700ft in the southern part of its range. The ripening fruits are highly attractive to many birds and mammals.

Identification: An erect, loosely branched, large, deciduous shrub or small tree, it has slender twigs, green turning to reddish-brown with conspicuous orange lenticels. The leaves are simple, alternate and generally elliptic or oblong to broadly lance-shaped, 5–12.5cm/2–5in long, light green and smooth above and paler below; the margins are entire to wavy. The bell-shaped, greenish to white flowers, 12mm/½in across, appear in early to mid-spring, in small clusters. The fruits are egg-shaped drupes up to 12mm/½in long, pink to blue-purple, borne on a red stem and edible but bitter.

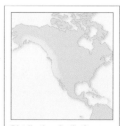

Distribution: Pacific Coast, USA.
Height and spread: 5m/16ft.
Habit and form: Deciduous shrub.
Leaf shape: Elliptical or oblong.
Pollinated: Insect.

Right: The berries attract wildlife.

Below: The bush is covered in white flowers in spring.

Arctic Bramble

Arctic blackberry, plumboy, *Rubus arcticus* subsp. *acaulis*

The arctic bramble (like many arctic species) has a circumpolar distribution, being native to northern parts of North America, Europe and Asia. Where it occurs in America it is fairly common in swamps and lakeside meadows, especially in peaty depressions rather than rocky limestone areas. The flowers appear in early summer, and are followed in late summer by sweet, shiny, red edible fruits like miniature raspberries. In full sun, the leaves often have a bronzy sheen.

Distribution: Circumboreal: northern North America, northern Europe and northern Asia.
Height and spread: 5–10cm/2–4in.
Habit and form: Dwarf shrub with herbaceous stems.
Leaf shape: Compound-trifoliate.
Pollinated: Insect.

Far right: The red berries often appear alongside the pink flowers from late summer onward.

Right: The small red fruits resemble raspberries and are sweet tasting.

Identification: Alternate, leathery, trifoliate leaves have oval leaflets, 12–35mm/½–2¼in long. The two lateral leaflets are stalkless and often deeply divided while the terminal leaflet has a short stalk; the tips are pointed to rounded, the margins smooth near the base, toothed near the tip. Solitary, bright pink to reddish-purple flowers, with five to eight petals 12–15mm/½–⅝in long and numerous stamens, appear in midsummer and are followed by deep red to dark purple, raspberry-like fruits, 12mm/½in across, in late summer.

LEGUMES

In the Americas, Papilionaceae have many similar forms to those encountered in Eurasia. Several American species are extremely important economic plants, such as the groundnut (peanut) and the lupines, which are widely used in horticulture. The group includes plants that are variously trees, shrubs, herbaceous or annual and is well represented throughout the whole of both continents.

Groundnut

Bog potato, *Apios americana*

Groundnut is a North American species, found mainly in moist areas near streams or bodies of water where it can get full sunlight at least for part of the day. The very aromatic, pink or brownish-red flowers appear in early summer, but this varies according to the location. It is a nitrogen-fixing, perennial vine, which climbs by twining up shrubs and other herbs in an anti-clockwise fashion. It is herbaceous in the north of its range, but the brown-skinned, white-fleshed tubers, on underground rhizomes, survive the winter.

Identification: A twining vine with alternate leaves, pinnately compound, usually with five to seven broadly pointed leaflets. The flowers, usually pink, maroon or brownish-red, have a typical pea-like structure, with a relatively large concave standard with a small hood at its apex into which the narrow, sickle-shaped keel is hooked; they are about 12mm/½in long, occurring in compact racemes 7.5–12.5cm/3–5in long. The fruits are pods 5–12.5cm/2–5in long, containing 6–13 wrinkled, brown seeds.

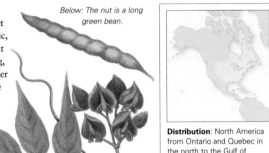

Below: The nut is a long green bean.

Distribution: North America from Ontario and Quebec in the north to the Gulf of Mexico and from the prairies to the Atlantic coast.
Height and spread: 90cm–6m/3–20ft.
Habit and form: Vine.
Pollinated: Insect.
Leaf shape: Pinnately compound.

Lady Lupine

Hairy lupine, *Lupinus villosus*

The lady lupine is a hairy plant whose lavender-blue flowers have a red-purple spot on the standard, or upper petal. The plant gets its common and botanical names from the Latin *lupus*, meaning "wolf", as it was once thought to deplete or "wolf" the mineral content of the soil. It is native to the USA and occurs in dry sandy habitats of the south-eastern states.

Identification: The plant has a soft-woody base and a shrubby appearance, with silvery, upright or spreading stems up to 90cm/3ft tall. The leaves, 2.5–7.5cm/1–3in long, are simple and lance-shaped, the lower ones clustered, the upper leaves alternate. They have a rounded base and pointed tip, and are covered with short, silver, densely shaggy hairs. The bracts at the base of each leaf are conspicuous. The flowers, which vary in colour from white, through rose to purple, are pea-like with a maroon-red spot on the upper petal and a two-lipped, silky calyx. They grow in erect clusters and are followed by woolly seedpods.

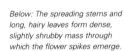

Below: The spreading stems and long, hairy leaves form dense, slightly shrubby mass through which the flower spikes emerge.

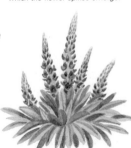

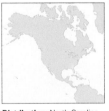

Distribution: North Carolina to Florida and west to Louisiana, USA.
Height and spread: 90cm/3ft.
Habit and form: Herbaceous perennial.
Leaf shape: Lanceolate.
Pollinated: Insect.

American Hog Peanut

Amphicarpaea bracteata

Distribution: Eastern and central North America.
Height and spread: Up to 90cm/3ft.
Habit and form: Annual vine.
Leaf shape: Trifoliate.
Pollinated: Insect.

There is only one species of *Amphicarpaea* in the Americas, although others exist in Asia and North Africa. The hog peanut is found in wet woods and thickets throughout eastern and central North America and is a twining annual, or occasionally perennial, vine. The flowers appear in late summer and early autumn and are unusual in occurring in two types. The visible flowers are violet and pea-like; flowers of the second type, which are cleistogamous (self-pollinating without opening) and without petals, are located near the base of the plant; they produce fleshy pods containing a single seed.

Identification: Thin, slightly hairy stems bear alternate leaves, each divided into three leaflets up to 7.5cm/3in long, but often much smaller, somewhat oval. The lateral leaves are asymmetrical, tending to be slightly diamond-shaped on the outer edge. The flowers are irregular in shape, up to 2cm/¾in long, tinged purple to completely creamy-white, closely spaced in drooping racemes. Cleistogamous flowers with only vestigial petals are located low on the lateral branches, resting on or under the ground. The upper flowers form flat pods with several seeds.

OTHER LEGUMES OF NOTE

Scarlet Milk Vetch *Astragalus coccineus*
Scarlet milk vetch is a low-growing perennial that bears racemes of vibrant red, pea-like flowers in late spring. It is endemic to the canyons and ridges of the desert mountains of south-west USA, being widespread and locally abundant from Colorado to California.

Blunt Lobe *Lupinus ornatus*
The blunt lobe or silvery lupine is so named because of its silvery, flattened leaves. It grows at elevations of 1,200–3,200m/4,000–10,500ft on dry flats and slopes in Washington, Idaho and California. It blooms from late spring to autumn, bearing spikes of flowers that are blue with a lilac spot at the base of the upper petal.

Campo Pea *Lathyrus splendens*
Pride of California, or campo pea, is a 60–120cm/ 2–4ft, deciduous, perennial vine or shrub with large crimson-red flowers. It climbs over chaparral shrubs and thrives in partial sun and the protection provided by other shrubs. The showy flowers attract hummingbirds and butterflies.

Goldenbanner *Thermopsis gracilis*
The slender goldenbanner has tall, erect spikes of bright yellow flowers, carried on loosely branched stems above the foliage, which is silky when young, becoming smooth with age. It is chiefly distributed in the west and north-west of North America in open, grassy places.

Canadian Milk Vetch

Astragalus canadensis

Canadian milk vetch is fairly common throughout most of eastern North America, at least as far south as Georgia. It prefers rich to moist soil and the creamy-white flowers appear in the summer. It is an important food source for birds, as it retains its seed late into the autumn and early winter. The plant is easy to identify while in flower, but vegetatively it can be mistaken for many other plants.

Distribution: Eastern North America.
Height and spread: 90cm/3ft.
Habit and form: Herbaceous perennial.
Leaf shape: Pinnate.
Pollinated: Insect.

Identification: The multiple stems are erect, branching, reddish in strong sun. The leaves are alternate and pinnate, each with 13–20 pairs of leaflets, elliptic to oblong, abruptly pointed, with smooth margins. Axillary racemes up to 15cm/6in long, bearing 30–70 flowers, appear from late spring to late summer. The flowers are pea-like but elongated, up to 2cm/¾in long, creamy-white to greenish-white or with a tinge of lilac. The fruits are inflated, to 12mm/½in long, smooth, beaked with a persistent style, containing around 10 seeds.

Above: The strong, upright flowering stems arise from underground rhizomes and are divided near their bases.

CABBAGE FAMILY

Brassicaceae, or the cabbage family, is well represented in North America but becomes more sparsely so toward the equator and down into the Southern Hemisphere. It is not as diverse on these continents as it is in Eurasia, although there are some showy examples to be found, particularly around the West Coast and montane areas.

Pennsylvania Bittercress

Cardamine pensylvanica

This perennial plant is found throughout much of North America. It is usually found in moist or wet soils, in wet woods, beside streams and along roadsides near woods. The flowering period varies according to its location, but is usually between early spring and midsummer. It can be confused with many similar species, the best way of identifying it being by its terminal leaflets, which are as large as, or larger than, the lateral leaflets.

Identification: The stems are erect, smooth or slightly hairy near the base, sometimes branched, up to 38cm/15in long, arising from a thickened rootstock. The leaves are alternate, pinnately compound with 5–13 smooth leaflets. The terminal leaflet is as large as, or larger than, the lateral leaflets, being up to 12mm/½in long and nearly as broad. All leaflets are oblong to oval, without teeth, toothed, or sometimes shallowly lobed. The tiny flowers, occurring in small groups on terminal racemes, are white, up to 6mm/¼in across, with four green, smooth sepals and four white petals, free from each other. The fruits are slender, cylindrical pods, ascending, up to 3cm/1¼in long, with a sterile beak. The seeds are pale brown.

Left: The fruit pods are short and slender.

Right: The plant is a biennial or herbaceous perennial.

Distribution: North America, from Newfoundland to Minnesota and Montana, south to Florida, Tennessee and Kansas.
Height and spread: 23–60cm/9–24in.
Habit and form: Herbaceous perennial.
Leaf shape: Pinnately compound.
Pollinated: Insect.

Waldo Rock Cress

Arabis aculeolata

Waldo rock cress is similar to the related McDonald's rock cress (*A. mcdonaldiana*), except that it is generally hairier and taller, with slightly smaller flowers. Its rosettes of glossy green, almost warty leaves send up short stems of bright pink flowers in summer. Restricted to the south-west USA, it occurs mainly on barren or shrub-covered shallow dry ridges, rocky outcrops and pine woodland at around 1,200m/4,000ft.

Right: The tall, thin flower stems are held high over the leaves.

Below: The showy flowers arise from reddish, tubular calyces.

Identification: The plant forms flattened rosettes of dark green oval-oblong to spoon-shaped leaves, with uneven to toothed margins. The basal leaves and lower parts of the stems are densely hairy, the upper parts are largely smooth. The flowers are almost 2.5cm/1in across, bright pink with spoon-shaped petals, borne in clusters at the top of 15–20cm/6–8in stems.

Distribution: South-west USA.
Height and spread: 10–20cm/4–8in.
Habit and form: Herbaceous perennial.
Leaf shape: Obovate-oblong.
Pollinated: Insect.

Beach Wallflower

Coast wallflower, *Erysimum ammophilum*

The beach wallflower is a short-lived perennial with bright yellow flowers, native to sandy coastal bluffs and old, eroded, inner dunes. It will grow only in full sun, and is found principally in Californian sagebush habitat, with a very sandy substrate seemingly a prerequisite for this species. Where it occurs it provides bright patches of colour among the sagebushes. Its habitats are increasingly threatened by development, and the flower is less common than it was.

Distribution: California, USA.
Height and spread: 5–60cm/2–24in.
Habit and form: Biennial or short-lived perennial.
Leaf shape: Narrowly oblanceolate.
Pollinated: Insect.

Far right: The flowers appear from early spring to early summer on a raceme.

Identification: The plant usually has several stems 5–60cm/2–24in long. The basal leaves are narrowly lance-shaped, smooth or slightly toothed on the edge, 4–15cm/1½–6in long; the stem leaves are wider, especially near the flowers. The yellow flowers are four-petalled, with each petal 12–25mm/½–1in long. The fruits are spreading to ascending, 2–12.5cm/¾–5in long.

Below: The leaves are linear.

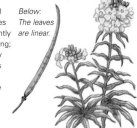

Heartleaf Twistflower

Streptanthus cordatus

The twistflower's heart-shaped, blue-green leaves, with a white, powdery film, are commonly seen in early spring in the desert mountains of western USA. The plant is wide-ranging in rocky or sandy sagebrush scrub, pinyon/juniper woodland and ponderosa pine forest between 1,200–3,100m/4,000–10,000ft. Its long, slender, leaning stalk is topped by dark purple buds; as the flower stalk elongates, the lower buds open to yellow-and-purple twisted flowers. In moist springs the flower spikes may grow especially tall, with several dozen flowers arranged evenly up the stems.

Distribution: Western USA.
Height and spread: 20cm–1m/8–40in.
Habit and form: Herbaceous perennial.
Leaf shape: Obovate.
Pollinated: Insect.

Above: An unusual twisted flower gives this plant its name.

Identification: The stem, which has a woody base, may grow from 20cm–1m/8–40in tall, and is generally smooth. The basal leaves are widely oval, with teeth, often bristly, around the upper margins. The upper leaves are lance-shaped to oblong, pointed and wrapped around the stem. The flowers are yellowish-green in bud, becoming purple in flower. The tips are generally bristly, the petals projecting to 12mm/½in long, linear, purple. They are followed by upward-curving, flattened seedpods, 5–10cm/2–4in long.

Right: The distinctive blue-grey, leaves are covered in white powdery film.

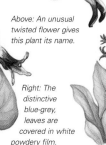

OTHER CABBAGE FAMILY SPECIES
Desert Prince's Plume
Stanleya pinnata var. *pinnata*
The desert prince's plume is a subshrub growing to 1.8m/6ft, with leathery blue-green leaves and yellow flowers. It is found in the high plains areas of the USA, from California to North Dakota, Kansas and Texas. The dense inflorescence appears in the autumn.

Smelowskia calycina
Close mats of silver fern-like foliage act as the perfect foil for the loose umbels of snowy flowers and tiny, upright, burgundy seedpods of this arctic plant. It is mostly found in high alpine or cold sites, typically those poor in nutrients such as scree and alluvial gravel, across Alaska and eastern Asia.

Gordon's Bladderpod
Lesquerella gordonii
This plant from south-western USA and northern Mexico is a cool-season annual or short-lived perennial. It is more or less prostrate, and gives rise to a dense terminal raceme of yellow to orange flowers. The seedpods that follow are smooth and rounded, typically S-shaped, though sometimes straight.

POPPY FAMILY

The poppy family (Papaveraceae) consists of annuals, herbaceous perennials and low shrubs that are mainly restricted to the Northern Hemisphere and the New World is not an exception to this. North America is especially rich in members of the poppy family, providing a concentration of species not found anywhere else in the world.

California Poppy

Eschscholzia californica

California poppy is a well-known and highly variable plant: it exists as a long-lived prostrate perennial along the coast, an erect perennial in inland valleys, and an annual in the interior. As the name suggests, it is a native of California, extending from the Columbia River valley in south-western Washington into the Baja California peninsula and sporadically on to the Cape Region, west to the Pacific Ocean, and east to western Texas. It grows in grassy and open areas to 2,000m/6,560ft.

Identification: Erect or spreading, glaucous stems arise from a heavy taproot in the perennial forms. The blue-green leaves, basal and on the stem, are deeply dissected, with blunt or pointed tips. Large cup-shaped flowers, solitary or in small clusters, open from erect buds; the four petals, 2.5–5cm/1–2in long, are yellow, usually with an orange spot at the base, although the flower colour can range from a uniform orange to various orange spots and shadings at the base of deep yellow or golden petals.

Left: The large flowers often form extensive showy drifts.

Distribution: Western USA.
Height and spread: 5–60cm/2–24in.
Habit and form: Herbaceous perennial herb or annual.
Leaf shape: Deeply dissected.
Pollinated: Insect.

Mexican Prickly Poppy

Goatweed, *Argemone mexicana*

This showy annual relative of the poppies can commonly be found in its native West Indies and Central America, and flowers throughout the summer. It has been introduced into many countries and is now a common weed in many tropical areas worldwide. It is usually found on rocky open ground, waste ground, and more occasionally on roadsides and by railways. Although it originates in a semi-tropical climate, it is remarkably well adapted to colder and drier conditions. All parts of the plant are poisonous but it is widely used as a medicinal herb.

Identification: A coarse, erect annual herb, sparsely to moderately branched and covered with prickles. The stems, 25–100cm/10–39in tall, exude a milky sap that turns yellow on exposure. The blue-green leaves are oblong to lance-shaped, irregularly pinnately lobed and serrated, the edges crisply wavy and spiny. The upper leaves are alternate, stalkless, usually clasping the stem, with thorns along the major veins, which are white and prominent. The flower buds open to solitary, bright yellow or white, showy flowers up to 6cm/2¼in across, with numerous yellow stamens.

Distribution: West Indies and Central America.
Height and spread: 25–100cm/10–40in.
Habit and form: Annual.
Leaf shape: Oblong.
Pollinated: Insect.

*Above:
The flower buds are rounded and sparsely prickly.*

Right: The yellow flowers appear at the stem tips.

Matilija Poppy

Tree poppy, *Romneya coulteri*

This beautiful perennial has large, white, yellow-centred, scented, solitary flowers, which look like fried eggs and are the largest of any plant native to California. Found in southern California and northern Mexico, this suckering perennial is a fire-follower: it may occur in areas of sage scrub, or more typically in chaparral, or along rocky watercourses away from the immediate coast, up to 1,200m/4,000ft. Open or mildly disturbed terrain is usually favoured and mature chaparral or sage scrub limits its spread. It is popular in cultivation and can be found as a localized garden escapee.

Left: The strong upright growth and large, showy flowers make this a spectacular wild flower.

Identification: This tall, leaning, heavily branched, shrubby perennial is woody at the base. The leaves are 5–20cm/2–8in long, grey-green, pinnately divided into three or five main divisions, which may have a few teeth or again be divided. The leafy, branched stems grow in patches. Each bears five to eight large, fragrant, white flowers in late spring to midsummer. The flowers are 10–18cm/4–7in across, with six fan-shaped petals; the three sepals are smooth and differentiate this plant from other *Romneya* species. Its many stamens are yellow, forming a ball in the centre with a bristle-haired ovary.

Far left: The large, fragrant, white-petalled flower with its yellow centre has become a favourite of gardeners everywhere, leading to its widespread cultivation.

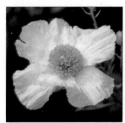

Distribution: Southern California and northern Mexico.
Height and spread: 90cm–2.5m/3–8ft.
Habit and form: Shrubby perennial.
Leaf shape: Pinnately divided.
Pollinated: Insect.

OTHER POPPY FAMILY SPECIES

Cream Cups *Platystemon californicus*
This annual native of California and the surrounding desert regions was once common in open fields, especially following fires, but in recent years it has become scarce across much of its range. The dainty, spreading, grey-green foliage is smothered with flowers of creamy-yellow to white in spring.

Wind Poppy *Stylomecon heterophylla*
This beautiful and rare, red-flowered wild poppy is native to California. Along with their striking appearance, the flowers have a fragrance like lily-of-the-valley, which is quite a rarity for a poppy. Naturally found in grasslands and mountain foothills, the flowers appear off and on throughout spring and summer.

Bloodroot *Sanguinaria canadensis*
This herbaceous perennial is found through most of the eastern USA. It can reach 25cm/10in tall, but is only about half that height at the time of flowering. The flowers are up to 5cm/2in wide, with about 12 strap-like, satiny, white petals and yellow centres. The first blooms appear in late winter and continue into early spring.

White Bearpoppy

Arctomecon merriamii

The white bearpoppy is a perennial found in flat desert scrub habitats such as the Mojave Desert. It prefers shallow, gravel, limestone soils, usually on rocky slopes between 900–1,400m/2,950–4,600ft; it is also, less frequently, encountered on valley bottoms. It is a distinctive plant, with blue-green basal leaves. From this, several long, blue-green stems arise, each bearing a single, showy white or pale yellow flower with a golden centre in the late spring.

Identification: The plant has glaucous, densely hairy stems and mainly basal leaves, which are egg- or wedge-shaped, 25–75cm/10–30in long, with rounded teeth and dense shaggy white hairs. The white or yellow flowers are solitary, terminal, opening from nodding buds, with two or three long, hairy sepals. They have four or six free, oval petals, 2.5–4cm/1–1½in long, which generally persist after pollination. The fruits are oval to oblong, opening at the tip and containing a few oblong, wrinkled, black seeds.

Distribution: Mojave Desert and southern Nevada, south-western USA.
Height and spread: 35cm/14in.
Habit and form: Herbaceous perennial.
Leaf shape: Obovate or wedge-shaped.
Pollinated: Insect.

Above: The flowers are held high above the foliage.

HONEYSUCKLE AND GERANIUM FAMILIES

Plants of the honeysuckle family, Caprifoliaceae, are mostly woody, including vines, shrubs, and small trees with a cosmopolitan distribution. The best known is the climbing garden honeysuckle, although it is a varied family with many ornamental shrubs in its ranks. The Geraniaceae family is mostly restricted to temperate habitats in both North and South America.

Hobblebush

Viburnum alnifolium

Hobblebush is a common understorey shrub from north-eastern North America. It is usually found in high elevations, and is easily seen in the early part of the year when its leaves expand earlier than those of the canopy trees, allowing them to start photosynthesizing. These very large leaves are the plant's distinguishing characteristic. The bush produces white flowers in flat-topped clusters in late spring; the large, sterile outer flowers serve to attract insects and provide a landing area for them.

Identification: The shrub has an open, straggly habit and pendulous branches. It is thicket-forming, with roots developing on branches that touch the ground. The leaves are opposite, oval, simple, dark green, 10–20cm/4–8in long, turning yellow, orange, red or maroon in autumn. The fertile flowers are white, 4mm/⅙in across, in flat clusters surrounded by 2cm/¾in sterile flowers, forming lacy heads up to 12.5cm/5in across. The berries that follow the small, fertile flowers are red, gradually maturing to purple-black in autumn. Lower branches often lie prostrate along the ground making it easy to trip over – hence the name.

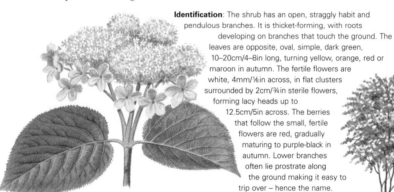

Distribution: North-eastern North America.
Height and spread: 1–3m/3–10ft.
Habit and form: Deciduous shrub.
Leaf shape: Ovate.
Pollinated: Insect.

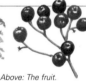

Above: The fruit.

Left The shrub has an open habit.

Bush Honeysuckle

Diervilla sessilifolia

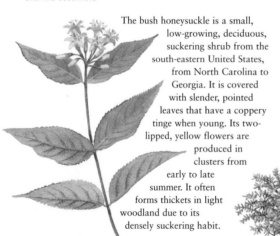

The bush honeysuckle is a small, low-growing, deciduous, suckering shrub from the south-eastern United States, from North Carolina to Georgia. It is covered with slender, pointed leaves that have a coppery tinge when young. Its two-lipped, yellow flowers are produced in clusters from early to late summer. It often forms thickets in light woodland due to its densely suckering habit.

Identification: The stems are brown and round, with striped bark. The leaves are opposite, simple and lance-shaped, up to 15cm/6in long, with a sharply serrated margin, smooth and dark green; the new growth is bronze-tinted. The tubular pale yellow flowers, 12mm/½in across, are borne in crowded 5–7.5cm/2–3in cymes, forming terminal panicles on the new growth, in early to late summer, followed by fruiting capsules.

Left: The freely suckering habit means that it forms dense thickets among other shrubs.

Distribution: South-eastern USA.
Height and spread: 60–150cm/2–5ft.
Habit and form: Deciduous shrub.
Leaf shape: Lanceolate.
Pollinated: Insect.

OTHER HONEYSUCKLE AND GERAMIUM
FAMILY SPECIES

California Stork's Bill
Erodium macrophyllum var. *californicum*
Also known as filaree, this annual, or
occasionally biennial, herb is often encountered
in valley grassland and woodlands in low
mountain reaches in western North America. It
is rare across much of its range. It has mainly
basal leaves and white flowers, sometimes
tinged with red-purple, which appear in summer.

Twinflower *Linnaea borealis*
This creeping, broadleaf,
evergreen shrub, with
rounded, opposite leaves, is
found is actually circumpolar,
occurring in northern Europe and
Asia. It inhabits dry or moist
sites in pinewoods. It bears
fragrant, pink, bell-like flowers
in pairs, from early summer
to autumn.

Fly Honeysuckle *Lonicera canadensis*
This erect, straggly shrub of open woodland in
the north of the USA and Canada, has smooth,
red branches and oval, slightly hairy leaves. The
drooping, tubular, pale orange-red flowers, which
appear in spring, are followed by characteristic
double berries later in the season.

American elder *Sambucus nigra ssp Canadensis*
This bushy, widely spreading shrub, forms
dense thickets that bear sprays of star-shaped,
white flowers in spring and summer, followed by
blue-black, edible fruits.

Ledebour's Honeysuckle

Lonicera ledebourii

This shrub is found throughout the coastal
ranges of western North America, occurring
from northern Mexico and California in the
south to British Columbia and northward
into Alaska. It forms an erect shrub that is
notable for its paired orange flowers, which
are surrounded by two broad bracts. The
flowers are later replaced by two purple-
black fruits; as they ripen, the deep red
bracts enlarge around them. The plant is
chiefly found in moist places below
2,900m/9,500ft.

Identification: A sturdy, erect, deciduous shrub with
stout, usually smooth young shoots. The leaves, up
to 12.5cm/5in long, are oval to oblong, with a
pointed or rounded base, dull dark green above,
lighter and downy beneath. The leaf margins
are hairy and leathery and the midribs
are often somewhat arched.
Funnel-shaped, paired flowers
appear in summer from the leaf
axils, heavily tinged orange or red
with yellow tips and slightly
protruding stigmas; behind them
are two to four, purple-tinged heart-
shaped bracts, which persist after
the flowers drop and
enlarge and
spread around the
fruits as they ripen
to black.

Distribution: Western North
America, from northern
Mexico to Alaska.
Height and spread:
1.5–3.5m/5–12ft.
Habit and form: Deciduous
shrub.
Leaf shape: Ovate-oblong.
Pollinated: Insect.

Woolly Geranium

Northern geranium *Geranium erianthum*

Distribution: North-west
North America and
north-east Asia.
Height and spread:
50cm/20in.
Habit and form: Herbaceous
perennial.
Leaf shape: Palmate.
Pollinated: Insect.

This herbaceous perennial from the Arctic is distributed
across north-west North America and north-east Asia, and
is most commonly found in woods and sub-alpine meadows
and scrub, from low to fairly high elevations in the
mountains, and also on grassy slopes near the sea. It is
slender-stemmed and branched, with bright blue flowers
and, although common, it is scattered in its distribution. It
is easily seen when flowering in early summer, and often
has later flushes of flowers, though the extent to which
this happens varies considerably between locations.

Identification: The basal leaves are 5–20cm/2–8in wide, with seven or nine
deeply divided, acutely lobed and freely toothed divisions; the upper leaves
are stalkless, with five or seven narrower divisions and hairy veins on the
undersides. The leaves colour in autumn. Dense, umbel-like clusters of
flowers appear in summer, occasionally with a later flush; the flowers are
flat, not nodding, 2.5cm/1in across, with almost triangular petals, pale to
dark blue-violet, with dark veins at the base and a dark centre. They are
followed by explosive seedpods.

PRIMULA AND DOGBANE FAMILIES

The primrose family (Primulaceae) is mainly restricted to the northern continent of the Americas, with only a few representatives south of the equator. They occur mainly in temperate and mountainous regions. Only one species of Primula *occurs naturally in South America.* Apocynaceae, *(dogbane) is restricted to the tropics and subtropics with a good representation in the sub-tropics.*

Dark-throat Shooting Star

Dodecatheon pulchellum

The dark-throat shooting star is commonly found in damp meadows and adjacent edges from Alaska to Mexico and eastward to the western edge of the Great Plains, mostly at elevations below 2,750m/9,000ft. It has intensely coloured flowers and a long flowering period from mid-spring to late summer, depending on location. The genus name *Dodecatheon* is translated from Greek and means 12 gods, and alludes to the usual number of flowers in the inflorescences of these plants.

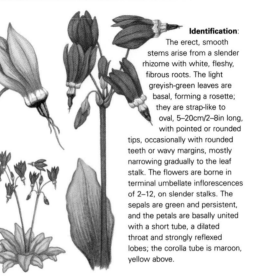

Identification: The erect, smooth stems arise from a slender rhizome with white, fleshy, fibrous roots. The light greyish-green leaves are basal, forming a rosette; they are strap-like to oval, 5–20cm/2–8in long, with pointed or rounded tips, occasionally with rounded teeth or wavy margins, mostly narrowing gradually to the leaf stalk. The flowers are borne in terminal umbellate inflorescences of 2–12, on slender stalks. The sepals are green and persistent, and the petals are basally united with a short tube, a dilated throat and strongly reflexed lobes; the corolla tube is maroon, yellow above.

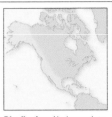

Distribution: Alaska south to Mexico.
Height and spread: 10–40cm/4–16in.
Habit and form: Herbaceous perennial.
Leaf shape: Oblanceolate.
Pollinated: Insect.

Far left: The nodding magenta or lavender flowers have strongly reflexed petals that give the plant its "shooting-star" look.

Violet Allamanda

Allamanda violacea

This evergreen vine or climbing shrub from Brazil has large, rich purple, funnel-shaped blooms, which appear throughout the year and fade to pink with age, giving a two-toned effect. The light green leaves are arranged in whorls on weak, sprawling stems. The plants exude a white, milky sap when cut or broken, and all parts are poisonous. They are naturally found growing along riverbanks and in other open, sunny areas with adequate rainfall and perpetually moist soil.

Right: The seed is released throughout the year from a spiny capsule.

Far right: Allamanda *climbs rapidly, smothering nearby vegetation.*

Identification: An erect or weakly climbing, evergreen shrub with woody stems and green, hairy leaves, 10–20cm/4–8in, in whorls, usually of four. The leaves are oblong to oval, abruptly pointed, with the secondary veins joined in a series of arches inside the margins, downy above, more densely so beneath. The funnel-shaped flowers, 7.5cm/3in long, have a narrow tube and five flared, rounded lobes; they are rose purple with a darker throat. The fruit is a round, spiny capsule.

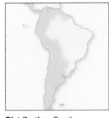

Distribution: Brazil.
Height and spread: Up to 3–6m/10–20ft in height.
Habit and form: Evergreen scrambling shrub.
Leaf shape: Oblong.
Pollinated: Insect.

White Frangipani

Plumeria alba

Frangipani is well known throughout the tropics and has long been cultivated for its intensely fragrant, lovely, spiral-shaped blooms, which appear at the branch tips from early summer to late autumn. Originating from Puerto Rico and the Lesser Antilles, the tree is unusual in appearance, with long, coarse, deciduous leaves clustered only at the tips of the rough, thick, sausage-like, grey-green branches. The branches are upright and crowded on the trunk, forming a vase or umbrella shape with age. They are soft and brittle although usually sturdy, exuding a milky sap when they are bruised or punctured.

Distribution: Puerto Rico and Lesser Antilles.
Height and spread: 6 x 4m/ 20 x 13ft.
Habit and form: Small tree.
Leaf shape: Lanceolate.
Pollinated: Insect.

Identification: The glossy, dark green leaves, 30cm/12in or more long, are alternate and lance-shaped, often blistered, with prominent feathered veining, usually finely hairy beneath. The fragrant, showy flowers are white with yellow centres, usually borne on bare branches in terminal clusters, with five spreading petals, up to 6cm/2¼in across, and a tubular base up to 2.5cm/1in long. They are followed by hard brown fruits up to 15cm/6in long.

Above: The flower is scented.

Far left: The tree has a uniform round crown.

OTHER PRIMULA AND DOGBANE SPECIES

West Indian Jasmine *Plumeria rubra*
This small tree is native to dry, rocky habitats in southern Mexico and as far south as Costa Rica. Its thick, succulent stems, clusters of leathery leaves and abundant, fragrant blooms in red, pink, yellow or white have led to its being widely planted across the tropics.

Primula magellanica
This is the only *Primula* species found south of the equator, in southern South America. It spends the winter as a resting bud; the white flowers, with a yellow eye, appear in spring.

Androsace chamaejasme
This small perennial herb has a wide Northern Hemisphere distribution along streams in poor dry soils, ranging across Canada, the USA and Eurasia. The hairy flowering stems bear umbels or, more rarely, solitary blooms that are creamy-white, yellow-centred, turning pink with age, or pink with contrasting markings.

Jewelled Shooting Star
Dodecatheon amethystinum
Found primarily in south-western Wisconsin and Minnesota, with scattered populations in Illinois, Missouri and Pennsylvania, this flower grows on north-facing cliffs and bluffs lining waterways, typically in thin alkaline soil. Its dark pink flowers are very noticeable when in bloom in late spring.

Brazilian Jasmine

Pink allamanda, *Mandevilla splendens*

This attractive, evergreen vine chiefly occurs in the wild at altitudes of around 900m/ 2,950ft in the Organ mountains near Rio de Janeiro. It is endowed with beautiful, large, deep pink, funnel-shaped blooms, which are highly visible against the large, downy, dark green, evergreen leaves. Pink allamanda has become popular as a garden plant in many countries and is sometimes found as a garden escapee in warmer climates.

Distribution: South-eastern Brazil.
Height and spread: 6m/20ft.
Habit and form: Twining, evergreen shrub.
Leaf shape: Broadly elliptic.
Pollinated: Insect.

Identification: The stems of this evergreen, twining shrub or liana are initially downy and green, later woody, and exude a milky sap when broken. The fine-textured, downy leaves, up to 20cm/8in long, are opposite, broadly elliptic with a pointed tip and heart-shaped base, with feathered veining and a wavy margin. Fragrant, trumpet-shaped, yellow-centred, rose-pink flowers, 7.5–10cm/3–4in across, appear all year round in lateral racemes of three to five; they have five spreading, abruptly pointed petals. The fruits are paired, brown, cylindrical follicles, which are inconspicuous.

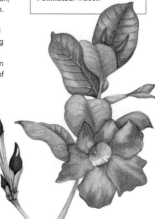

Left and right: The pink, showy flowers are produced almost all year around.

GENTIANS AND BELLFLOWERS

The gentian family (Gentianaceae) is widely distributed throughout the Americas, being found across much of the two continents including tropical and subtropical regions although without the diversity seen in Eurasia. The bellflower family (Campanulaceae) is much more northern in its distribution and found mainly in North America.

Star of Bethlehem

Hippobroma longiflora

This native of southern USA, southward to Brazil, Peru and the West Indies, is a perennial herb with an extremely poisonous milky sap. Its generic name, *Hippobroma*, translated from the Greek, means horse poison, indicating how potent it is. The plant is notable for its almost symmetrical, star-shaped flowers with very long tubes, which appear at various times of the year depending upon location.

Identification: The non-woody stem is green and smooth, with a rosette of narrow, stalkless, oval to lance-shaped, coarsely lobed leaves, with feathery veination and doubly toothed margins, mostly 10–15cm/4–6in long. The panicle usually comprises two to three white flowers on short, hairy stalks. The calyx is 2.5cm/1in long; the flowers are star-shaped with five pointed, spreading lobes, 2.5cm/1in long, on a narrow tube, usually 7.5–12cm/3–4in long. The twin-celled capsule is bell-shaped and downy, with numerous small seeds.

Distribution: Southern USA, Brazil, Peru and the West Indies.
Height and spread: 20–60cm/8–24in.
Habit and form: Herbaceous perennial.
Leaf shape: Oblanceolate.
Pollinated: Insect.

Hypsela reniformis

This unusual South American creeping plant is mainly found in Chile, but its range stretches from Ecuador to Tierra del Fuego, in mountainous regions along the Andes. It grows in moist open places, especially at the southern end of its range. The dense mats of small, rounded, shiny leaves are topped with upturned, pale pink, crimson-lipped flowers that make an eye-catching display during summer. It is a vigorous plant, spreading 30–60cm/1–2ft in a year.

Identification: This small, prostrate, creeping herb forms a dense mat of cover, with hairless stems up to 5cm/2in long. The often crowded leaves, up to 12mm/½in long, are elliptic to round or kidney-shaped. The solitary flowers, with two ascending and three descending petals, are white suffused with pink, veined carmine, yellow at the centre, and are borne throughout the summer months. They are followed in autumn by erect green berries.

Distribution: Western South America from Ecuador to Tierra del Fuego.
Height and spread: 5cm/2in; indefinite spread.
Habit and form: Prostrate, perennial herb.
Leaf shape: Reniform.
Pollinated: Insect.

Deer Meat

Centropogon cornutus

Distribution: South and Central America to the Antilles.
Height and spread: 3m/10ft if freestanding, but may reach 9m/30ft with support.
Habit and form: Shrub.
Leaf shape: Ovate.
Pollinated: Probably hummingbird.

This brightly coloured shrub is widespread from South and Central America to the Antilles. Its long tubular red flowers are designed to be pollinated by hummingbirds. Deer meat is water-tolerant and is often found growing along riverbanks, in low-lying wetland areas or in clearings in wet forest areas, particularly those where inundation is seasonal and there is a noticeable dry season. It is capable of forming a freestanding shrub but more often than not will scramble upward through other bushes and small trees to make a sizeable specimen.

Identification: An upright shrub with milky sap and oval, alternate, toothed leaves. The flowers are asymmetrical on long stalks, usually arising singly from the leaf axils near the top of the stems. Each flower is two-lipped, five-lobed, bright red or deep carmine to pale purple; the five-bearded anthers are united into a tube around the style. The corolla tube opens along the upper side, with two lobes above and three below. The fruit is a five-chambered fleshy berry, with the remains of the style persisting, giving a beaked appearance, with the five, thin pointed green sepals also persisting, giving a pome-like appearance.

OTHER GENTIAN AND BELLFLOWERS

Siphocampylus orbiginianus
This native of Bolivia is a shrub reaching 2m/6½ft in height. It has mid-green leaves arranged in threes around the green stems, which are topped with long, tubular flowers. They are red with yellow-green stripes down the tube and pointed, greenish or yellow lobes.

Lisianthus umbellatus
This shrub can reach 3.5m/12ft, with leaves clustered at the ends of its branches. It bears numerous dense clusters of sweetly scented yellow-and-green flowers. The species occurs only in Jamaica, where it and several closely related species are found in mountainous areas.

Northern Gentian *Gentiana affinis*
This decumbent or occasionally erect gentian from the western USA blooms in late summer, with sky-blue, tubular flowers, 2–3cm/¾–1¼in long, near the ends of the stems. The top edges of the flower petals have white spots on them. It is found in moist meadows and on the edges of aspen groves. It grows to 20–30cm/8–12in high.

Venus's Looking Glass
Triodanis perfoliata
This eye-catching bellflower has blue-purple flowers, each sitting above a clasping leaf on a wand-like stem. It flowers from late spring to late summer, but only a few flowers are open at any one time. It is usually found in dry fields and open woods, in infertile soil, and reaches 15–60cm/6–24in in height.

Flor de Muerto

Lisianthius nigrescens

Distribution: Veracruz, Oaxaca, and Chiapas, southern Mexico.
Height and spread: 2m/6½ft.
Habit and form: Shrub
Leaf shape: Oblong-lanceoleate.
Pollinated: Insect.

The flor de muerto, so named because it was a favoured decoration for graves in southern Mexico, is native only to the states of Veracruz, Oaxaca and Chiapas. It is an intriguing plant and one of the rarities of the plant world, as it bears a true black flower. It has been collected since it was first described in 1831, although documented collections number less than two dozen. Despite its unusual character it is virtually unknown in cultivation or for that matter outside its native range.

Identification: A large-stalked shrub, rather open and much branched, with smooth stems. The stalkless leaves are oblong to lance-shaped with pointed tips and three to five veins, nearly united at the base. The stems are crowned with tall, diffuse flower spikes, to 1m/39in long, covered with nodding flowers 5cm/2in across, with spreading lobes, recurved at the tips; the stamens do not protrude beyond the mouth of the flower. Depending on the angle at which they are viewed the flowers appear blackish-purple or inky-black, completely devoid of colour, with a satiny texture.

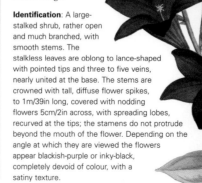

CACTUS FAMILY

The Cactaceae (cactus family) are mostly spiny succulents with photosynthetic stems. Their leaves are generally extremely reduced and ephemeral or absent altogether. The leaves are associated with highly modified axillary buds or shoots, which bear spines. With only a very few exceptions, all members of the family are native to the Americas, being found as far north as Canada and as far south as Patagonia.

Golden Stars

Lady fingers, lace cactus, *Mammillaria elongata*

The name *Mammillaria* is derived from the Latin word *mamilla*, which means "nipple", and refers to the small tubercles (fleshy lumps or "warts") on each cactus. This cactus from Mexico, where it generally occurs at altitudes of 1,350–2,400m/4,400–8,000ft, forms long finger-like branches that grow both erect and prostrate, creating club-like clusters. The many tiny, recurved spines are gold, and the small white to pale yellow 12mm/½in flowers are produced in spring.

Identification: A succulent plant forming many stemmed clusters. The stems are elongated, cylindrical and finger-like, 12–30mm/½–1¼in in diameter. The tubercles are slender and conical and the axils naked, or nearly so. The slender, needle-like radial spines are variable in number from 14–25, and are white to golden-yellow to brown, the degree of colouring varying from plant to plant. Pale yellow to pinkish 12mm/½in flowers, sometimes flushed pink or with pink midstripes, are borne in spring, followed by pink fruits, becoming red.

Right: The long finger-like stems are studded with white flowers in the early spring.

Distribution: Central Mexico.
Height and spread: 15cm/6in.
Habit and form: Spiny succulent.
Leaf shape: Absent.
Pollinated: Insect.

Texas Prickly Pear

Nopal, *Opuntia lindheimeri*

This North American cactus is a succulent shrub or subshrub that usually grows up to 1m/3ft high, although it can sometimes be more than this, with a spread of up to 3m/10ft. In the wild it is found on rocky hills and mountain slopes in Texas, New Mexico and Mexico, up to 1,400m/4,600ft. It grows only two or three "pads" high, with the pads covered with cushions of golden-brown barbed spines. In the summer, bright yellow, orange or dark red flowers are produced at the edges of the pads, and these are later followed by edible, purple fruits.

Identification: The jointed stems are flattened into green or blue-green, oval to rounded or rarely elongated pads, 15–25cm/6–10in long; the leaves are reduced to translucent yellow spines in all but the lower areoles, one to six per areole. The flowers are yellow, orange or red and showy, 5–7.5cm/2–3in across, and the fruit is purple with a white top, fleshy, egg-shaped or elongated, 2.5–7.5cm/1–3in long.

Distribution: Texas, New Mexico and Mexico.
Height and spread: 1 x 3m/ 3 x 10ft.
Habit and form: Spiny succulent.
Leaf shape: Absent.
Pollinated: Insect.

Left: The strange jointed stems form a low spreading shrub.

Far left: The showy flowers appear in summer and are followed by purple, edible fruit.

Crab Cactus

Thanksgiving cactus, *Schlumbergera truncata*

This epiphytic cactus is native to a small region north of Rio de Janeiro in South America, confined to dense virgin forest between 1,000–1,500m/3,300–4,900ft. It usually grows on forest trees, by rooting into plant debris trapped among branches, or more occasionally on decaying humus in stony, shady places. The forests where it grows have distinct wet and dry seasons, although temperatures are fairly constant all year round.

Distribution: North of Rio de Janeiro, Brazil.
Height and spread: Up to 30cm/12in.
Habit and form: Epiphytic, occasionally lithophytic, succulent subshrub.
Leaf shape: Absent.
Pollinated: Insect.

Far right: The fleshy stems form a dense mass with flowers appearing at the tips.

Identification: Erect, then pendent, flattened, jointed stems have oblong, bright green segments, 4–6cm/1½–2¼in long, with four to eight prominent, forward-projecting, tooth-like marginal notches and small areoles with a few very fine bristles. Deep pink, red or white, two-tiered, short-tubed flowers with yellowish anthers, up to 7.5cm/3in long, are borne on terminal segments, appearing at the start of the wetter season.

OTHER CACTUS FAMILY SPECIES

Plains Prickly Pear *Opuntia macrorhiza*
This low-growing cactus from the USA forms clumps up to 1.8m (6ft) in diameter in mountainous arid areas between 800 and 2200m (2600 and 7000ft) elevation. The bluish-green stems, become wrinkled under very dry or cold conditions and the large yellow flowers with a red centre appear in early summer.

Saguaro *Carnegia gigantea*
This giant, fluted cactus, is slow-growing but can reach heights up to 12m/40ft and may live up to 200 years or more. It grows in mountains, desert slopes and rocky and flat areas of southwest USA and northwest Mexico. In May and June it bears creamy-white, bell-shaped flowers with yellow centres.

Rhipsalis capilliformis
This South American cactus has pencil-like, usually spineless stems that form many branched masses, hanging from trees or rocks. The stems have small areoles that produce numerous aerial roots with which they absorb atmospheric humidity. The flowers and fruits are both white and very small, appearing at the branch ends.

Queen of the Night *Selenicereus grandiflorus*
The queen of the night is a climbing vine-type cactus from Mexico and the West Indies, usually with five to eight ribbed stems and areoles bearing 6–18 yellow spines, which gradually turn grey. The body of the plant is covered with whitish felt and hair, and it is well known for its huge yellow-and-white, night-blooming flower, 30cm/12in across, which lives for only a few hours.

Leaf Cactus

Barbados gooseberry, gooseberry shrub, *Pereskia aculeata*

This climbing, leafy cactus is now seldom found truly wild. It is frequently grown as an ornamental or occasionally for its fruit in some tropical countries. In many areas it has escaped from cultivation and become thoroughly naturalized. In 1979, its cultivation was banned in South Africa because it was invading and overwhelming natural vegetation.

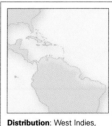

Distribution: West Indies, coastal northern South America and Panama.
Height and spread: 10m/33ft.
Habit and form: Woody shrub.
Leaf shape: Elliptic.
Pollinated: Insect.

Identification: An erect woody shrub when young, it becomes scrambling, climbing or vine-like with age, with branches up to 10m/33ft long. The spines on the trunk are long and slender, in groups; those on the branches are short, recurved, usually in pairs, borne in the leaf axils. The deciduous, alternate, short-stemmed, waxy leaves are elliptic, oblong or oval, with a short point at the tip, 3.5–10cm/1¼–4in long, sometimes fleshy. White, yellowish or pink-tinted flowers, 2.5–4.5cm/1–1¾in long, lemon-scented, with a prickly calyx, are borne profusely in panicles or corymbs. The fruit is round, oval or pear-shaped, 12–20mm/½–¾in across, lemon- or orange-yellow or reddish, with thin, smooth, rather leathery skin. It retains the sepals and a few spines until it is fully ripe.

Above left: The curious fruits are initially leafy as they develop.

AGAVES AND CRASSULAS

The Agavaceae, or agave family, are widespread in the tropical, subtropical and warm temperate regions of the world, with perhaps the most famous representatives coming from North and Central America. The Crassulaceae, or crassula family, are mostly succulents, with flowers that are very similar to those of the rose and saxifrage families. North America exhibits a fascinating array of forms within this family.

Echeveria subrigida

This plant from Mexico is extremely restricted in its range, occurring only in San Luis Potosi and Tultenango Canyon. It was originally classified as a *Cotyledon* species but was later included in *Echeveria*. This plant has been confused with *E. cante*, mainly as a result of the trade in cultivated plants, but the true species is a robust plant with smooth leaves, whose flowers have unique scarlet nectaries.

Left: The yellow-red flowers appear on a spike in summer.

Right: The red-edged leaves form a handsome rosette.

Identification: A large, solitary, evergreen, succulent rosette, 30cm/12in in diameter, with a stem up to 10cm/4in long. The oval to lance-shaped leaves, 15–20cm/6–8in long, are held closely in the rosette. They are pointed, pale blue-green with red margins, upturned and very finely toothed. The flower spike, which appears in summer, is 60–90cm/2–3ft high, bearing 6–15 flowered branches with a few bracts, 3–5cm/1¼–2in long, triangular to lance-shaped, ascending, grey-purple sepals, and flowers to 2.5cm/1in across, five-sided, not very constricted at the mouth, red, bloomed white outside, yellow-red inside.

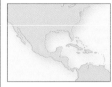

Distribution: San Luis Potosi and Tultenango Canyon, Mexico.
Height and spread: 60–90cm/2–3ft.
Habit and form: Evergreen succulent.
Leaf shape: Obovate to oblanceolate.
Pollinated: Insect.

Donkey's Tail

Burro's tail, *Sedum morganianum*

This plant, widely cultivated for its highly ornamental stems and leaves, is almost certainly a native of Mexico, although to date it has never been found in the wild. It sometimes appears as a garden escapee, although even the history of its cultivation remains a mystery. It is an attractive succulent, with spindle-shaped leaves with a silver-blue cast and pendulous branches. The deep pink flowers appear in spring but are rarely seen.

Identification: This pendulous to horizontal, trailing evergreen perennial has numerous prostrate or pendulous stems, sparsely branched and woody at the base. The leaves, to 2cm/¾in long, are very succulent, blue-green, alternate, spirally arranged, overlapping, oblong to lance-shaped, pointed, incurved and flattened. Pendent flowers, 12mm/½in across, borne terminally on long stalks, deep pink with five long-pointed, oval petals, may appear from spring onward.

Left: The dense pendulous stems have made this a garden favourite.

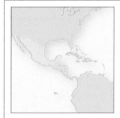

Distribution: Mexico.
Height and spread: Trailing to 60cm/2ft.
Habit and form: Succulent evergreen.
Leaf shape: Rounded, oblong-lanceolate.
Pollinated: Not known, probably insects.

Left: The flowers appear at the stem tips.

Curveleaf Yucca

Soft leaf yucca, *Yucca recurvifolia*

This spiky succulent shrub or small tree originates in the coastal regions of the south-eastern United States, where it forms a small branching plant or, with age, a colony of plants. Its large rosettes of curved leaves sit on top of a thick trunk, and once it reaches flowering size it produces large columns of white waxy flowers every year. The flowers, which are lemon-scented at night, are pollinated by *Pronuba* moths, which both pollinate and lay their eggs on the ovaries so that the caterpillars can feed on the seed. Some seeds survive this, and both moth and yucca depend upon each other for survival.

Distribution: South-eastern USA.
Height and spread: 2.5m/8ft.
Habit and form: Shrub or small tree.
Leaf shape: Strap.
Pollinated: *Pronuba* moth.

Left: The rosettes of sword-like leaves often hide the short stem on young plants.

Far right: The flower stem looks "asparagus-like."

Identification: The stems of this shrub or small tree are sometimes branched, often leaning, with new upright branches emerging from the point(s) of contact. The leaves, up to 90cm/3ft long, are green, grey-green or glaucous, nearly flat, rough on the underside, tapering to the tip, flexible, with a short brown or black spine at the leaf tip; the upper leaves are recurved. A loosely branched inflorescence appears from the centre of the leaves, usually in late spring but plants may occasionally bloom in autumn. The flowers, up to 7.5cm/3in across, are creamy, held above the leaves, with the inflorescence reaching 1.5m/5ft in height. The fruits are hard and dry at maturity, splitting open on the plant only as the *Pronuba* moths emerge.

OTHER AGAVES AND CRASSULA SPECIES
Pachyphytum bracteosum
This succulent from Mexico is found on rock escarpments on limestone cliffs, between 1,200–1,850m/4,000–6,000ft. It has upright flowering stems of 30cm/1ft or more, with white succulent bracts surrounding pink-red, five-lobed flowers with prominent yellow stamens.

Mexican Firecracker *Echeveria setosa*
A variable species, endemic to small areas of Mexico, and in danger of extinction in the wild. The stemless rosettes of densely packed, glaucous or green, hairy leaves, give rise to flower spikes of pentagonal, red-and-yellow flowers in spring and early summer.

Fox Tail Agave *Agave attenuata*
This species from central Mexico has very wide, fleshy, soft, pale blue-green leaves with a felt-like texture, and forms a leaning or creeping trunk with age. The curving flower spike grows up to 3m/10ft, and is densely covered in green-white drooping flowers, producing fruit at the base and new plantlets at the tip.

Adam's Needle *Yucca filamentosa*
Looks a little like a small palm, with evergreen, strap-like leaves up to 90cm/3ft long, taking the form of a rosette. The leaf margins are decorated with long, curly threads or "filaments" that peel back as the leaf grows. Erect flower spikes of large white flowers may reach 3.5m/12ft in summer.

Century Plant

American aloe, *Agave americana*

This is probably the *Agave* most commonly grown as an ornamental plant, and as a result, it has spread throughout the temperate and tropical areas of the world. Because it has been extensively propagated its exact origin is uncertain, although it probably originates in eastern Mexico. The flowers appear at any time after the plant has reached ten years old, so it does not live up to its common name.

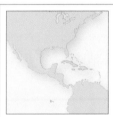

Distribution: Uncertain, probably eastern Mexico.
Height and spread: Up to 9m/30ft when flowering.
Habit and form: Evergreen succulent.
Leaf shape: Lanceolate.
Pollinated: Insect.

Identification: A rosette-forming, short-stemmed, evergreen perennial, with leaves up to 2m/6½ft long, curved or reflexed, lance-shaped, pointed, light green to grey, wavy-edged to toothed, with rounded teeth 12mm/½in long and irregularly spaced, brown to grey; the leaves have a terminal spine up to 5cm/2in long, awl-shaped to conical, brown to grey. The inflorescence grows to 9m/30ft. It is a large, asparagus-like stalk emerging from the centre of the plant, bearing 15–35 spreading horizontal branches, with pale yellow flowers.

Above: The small, individual flowers are held in dense "brush-like" umbels.

Right: The huge flower spikes appear only on plants of ten or more years.

SAXIFRAGE, CURRANT AND VIOLET FAMILIES

The saxifrage family (Saxifragaceae) and currant family (Grossulariaceae) are mainly restricted to the northern half of the Americas and are mainly represented by herbs and small shrubby plants. The violet family (Violaceae) occurs throughout the Americas and in North America are mainly herbaceous plants.

Flowering Currant

Winter currant, *Ribes sanguineum*

The flowering currant is a deciduous woody bush from North America with pink flowers in pendent bunches, which are very attractive to bees and birds, appearing in spring, followed by inedible blue berries. It is most commonly encountered in open to wooded areas, moist to dry valleys and lower mountains, and ranges from British Columbia to northern California, from the coast to the east slope of the Cascades in Washington and northern Oregon, although it is widely naturalized elsewhere.

Right: The white-bloomed, blue-black berries appear in late summer.

Identification: The branches are softly downy, glandular, and red-brown. The leaves are 5–10cm/2–4in across, rounded with three to five lobes, heart-shaped at the base, dark green and slightly downy above, white felted beneath, irregularly toothed and finely serrated, pungently aromatic; the leaf stalk is glandular and downy. Dense, erect or pendent racemes, generally with 10–20 flowers per raceme, bear small tubular red or rosy pink flowers. They are followed by slightly hairy, blue-black fruits with a white bloom, which unlike other species of this genus are rather unpalatable.

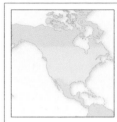

Distribution: North America.
Height and spread: Up to 4m/13ft.
Habit and form: Deciduous shrub.
Pollinated: Insect.
Leaf shape: Rounded.

Left: The bush becomes laden with pendent bunches of pink flowers in the spring.

Bog White Violet

Long leaf violet, *Viola lanceolata*

Bog white violet is found in a relatively restricted area of the USA, from the Gulf States to Texas and Florida, occurring chiefly in savanna grassland, wetlands, marshes and bogs as well as on stream sides and lake borders, usually in sandy soil. It is almost unmistakable on account of its soft, silky-haired leaves, among which the white flowers appear in spring. It readily propagates itself by sending out runners through the growing season and may form extensive patches where it occurs.

Identification: The leaves are basal, narrow or lance-shaped, 5–10cm/2–4in long, usually at least three times as long as wide, somewhat irregularly toothed along the margin, tapering to the base, pinnately veined. The flowers are few, five-petalled, irregular in shape, white or light violet with purple markings on the three lower petals, beardless. They appear in late spring and continue into early summer. Self-pollinating flowers are also produced at the same time, lower in the leaf mass. The fruit that follows is a capsule. Sometimes confused with the similar and closely related *V. primulifolia*, which has more ovate leaves, although both species vary considerably.

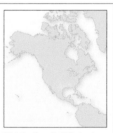

Distribution: Gulf States to Texas and Florida, USA.
Height and spread: 15–20cm/6–8in.
Habit and form: Herbaceous perennial.
Pollinated: Insect.
Leaf shape: Linear or lanceolate.

OTHER SAXIFRAGE, CURRANT AND VIOLET FAMILY SPECIES

Oregon Violet *Viola hallii*
Sometimes called Hall's violet, this rare plant from the western USA favours open woodland at altitudes of 300–1,850m/1,000–6,000ft. The dissected leaves make a graceful foil for the tricoloured flowers, which have creamy-white lower petals and two deep violet upper petals.

Brookfoam *Boykinia aconitifolia*
This pretty perennial with palmate leaves has delicate flower spikes with reddish stems and many small, white bells, each with a yellow centre. They appear in summer. A native of the Appalachian Mountains, it has mounds of bright green, leathery, kidney-shaped foliage produced in basal rosettes.

Island Alum Root *Heuchera maxima*
A perennial with a thick, fleshy rootstock and spikes of small, pinkish flowers in spring, held above rounded green leaves. It is rare, being found on canyon walls and cliffs, chaparral and coastal sage scrub below 450m/1,500ft, in only a few locations on the north Channel Islands, California.

Grass-of-Parnassus *Parnassia californica*
Circumpolar in its distribution, the American form is found in montane to subalpine stream banks and wet meadows from California to Oregon. It has solitary, conspicuous, cream flowers that look like pale buttercups. The leaves are plantain-like.

Stream Violet

Pioneer violet, *Viola glabella*

This violet occurs in woodland and near watercourses, with large colonies forming bright green carpets, starred with yellow, under the trees in early spring. It occurs from Monterey County, California, northward into Alaska, at altitudes of up to 2,500m/8,200ft, with particularly fine stands around Portland and in Oregon. The species is also present in Japan. The kidney-shaped leaves are often softly hairy all over and these emerge in spring, together with the bright yellow, neatly veined flowers.

Identification:
Knobbly green rhizomes range on, or just under, the surface, with true roots extending down into the soil. The leaves, on 5–10cm/2–4in stalks, are kidney- to heart-shaped and toothed. The flowers, up to 2cm/¾in across, are fresh yellow with purple veins, held above the leaves on leafy stems. They are followed by brownish capsules, which explode to disperse the seed.

Right: The small yellow flowers have veined petals and resemble tiny faces.

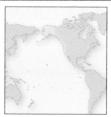

Distribution: California north to Alaska, Japan.
Height and spread: 5–30cm/2–12in.
Habit and form: Herbaceous perennial.
Leaf shape: Reniform.
Pollinated: Insect.

False Goatsbeard

Astilbe biternata

This woodland plant is the only species of *Astilbe* native to North America, found from Maryland southward to Georgia and Tennessee. Its large, bold foliage is quite distinctive, and the large, creamy-white, drooping, spike-like racemes of flowers are covered with tiny, cream-coloured blooms in midsummer. Unlike many in this genus, it is relatively rare in cultivation, and therefore hardly ever occurs outside its natural range.

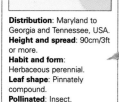

Distribution: Maryland to Georgia and Tennessee, USA.
Height and spread: 90cm/3ft or more.
Habit and form: Herbaceous perennial.
Leaf shape: Pinnately compound.
Pollinated: Insect.

Far right: The distinctive glossy green leaves are topped with large, white, feathery flowerheads in midsummer.

Identification: A clump-forming perennial with rhizomes branching below ground and leaves to 75cm/30in long, conspicuously jointed at the base and junctions of the leaf stalks, glossy, red-green, sparsely hairy. The leaf blades are compound with three to five leaflets, each up to 12.5cm/5in long, with a toothed outer margin, sometimes partially cut, oval, heart-shaped at the base. The flowers are held on large, much-branched, feathery, spike-like racemes, appearing very profusely in early summer; the individual flowers are creamy-white to yellow, generally much reduced, consisting of a small, cup-like base with 10 elongated stamens, the petals minute or absent.

ELAEOCARPUS AND MALLOW FAMILIES

The Elaeocarpaceae (elaeocarpus) are a small family of mainly tropical and subtropical shrubs and trees.
They include a few useful timber trees and some well-known ornamental plants, with a few species
producing edible fruit. The Malvaceae, or mallow family, are herbs, shrubs or trees. Members of the
family are used as sources of fibre, food and as ornamental plants.

Chile Lantern Tree

Crinodendron hookerianum

In spring and early summer distinctive,
long, lantern-shaped flowers are produced.
They hang from shoots clothed with
narrow, dark green leaves. In its
native southern Andean-Patagonic
region of Chile, it grows in open
areas or under forest canopy, chiefly in
regions with medium or high rainfall.
The exact timing of flowering depends
upon its location and altitude.

Identification: Straight, ascending branches, downy
when young, become rather sparsely furnished and
rangy with age. The leaves are opposite,
5–10cm/2–4in long, short-stalked, narrowly elliptic to oblong or
lance-shaped, with pointed tips and serrated margins, usually
curved downwards, glossy dark green above with sparse
bristly veins and pinnately veined, paler and more
downy beneath. The lantern-like scarlet flowers
hang below the branchlets on red-tinted, downy
flower stalks.

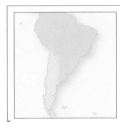

Distribution: Chile and
Argentina.
 Height and spread:
Up to 9m/30ft.
 Habit and form:
Small tree.
 Leaf shape
Narrowly elliptic.
 Pollinated: Insect.

Left: The fruits are pear-
shaped, three-winged,12mm
/½in long with an abrupt point.

Left: This is a small evergreen.

Scarlet Rose Mallow

Scarlet hibiscus, Swamp hibiscus, *Hibiscus coccineus*

The scarlet rose mallow is a narrow, upright, herbaceous
perennial with somewhat hemp-like leaves and extremely
showy, deep red flowers that appear in mid- to late
summer. Each flower lasts only a day, but new ones
continue to open over a long period. It is attractive
to many species of butterflies and hummingbirds. It
occurs naturally in swamps, marshes and
ditches, from southern Georgia and
Alabama to central Florida, and is
frequently encountered along southern
rivers and streams, where it towers
above the other aquatic plants, hence its other
common name of swamp hibiscus.

Identification: A tall, vigorous, sturdy, erect, woody-based,
herbaceous perennial, with smooth, blue-green stems. The leaves are
deep green, 7.5–12.5cm/3–5in across, palmately three-, five- or seven-parted,
or compound, the divisions narrow and sparsely toothed. The flowers are
solitary and hollyhock-like, five-petalled, with a prominent and showy
staminal column, borne on long stalks from the upper leaf axils. The deep
red petals are up to 8cm/3¼in long, horizontally spreading.

Distribution: South-eastern
USA.
 Height and spread: Up to
3m/10ft.
 Habit and form:
Herbaceous perennial.
 Leaf shape: Palmate.
 Pollinated: Insect.

Left: The tall, rangy
habit means that the
deep red flowers are
held well above the
surrounding vegetation.

OTHER ELAEOCARPUS AND MALLOW FAMILY SPECIES

White Lily Tree
Crinodendron patagua
This large shrub or small tree, with evergreen, dark green leaves, is from southern Chile. In late summer, it bears numerous white, fringed, open, bell-shaped blossoms that are lightly scented and hang below the branches. These are followed by creamy seedpods, tinted with red.

Halberdleaf Rose Mallow *Hibiscus laevis*
The halberdleaf rose mallow blooms in large colonies in marshy areas throughout the eastern USA, from midsummer to early autumn. It often grows where mud has deposited along the banks of rivers and in swamps. The large white-pink to light pink flowers are very showy.

Mountain Hollyhock *Iliamna rivularis*
Similar in appearance to *I. grandiflora*, mountain hollyhock grows to around 2m/6½ft, with a showy spike of large white or pink flowers in summer. It is widely distributed in mountains from British Columbia south to California.

Desert Globemallow *Sphaeralcea ambigua*
Also known as the desert hollyhock, this is a loose, shrubby, herbaceous perennial of dry woodland, mountains and high desert regions in the south-west USA. Its orange, pink, white or red flowers are produced for much of the year.

Wild Hollyhock

Iliamna grandiflora

This handsome plant bears large pink "mallow" flowers on tall spikes in the summer. It is a plant of damp montane meadows and stream courses, and occurs through New Mexico, Arizona, Colorado, and Utah, at altitudes between 2,200–3,350m/7,000–11,000ft. Despite its wide distribution across these states, the plant occurs in sporadic locations and where it does grow it often has very low population numbers. The reason for its scarcity remains a mystery, although changes in land management practices could be partially responsible.

Identification: The tall stems and leaves are sparsely hairy; the leaves are palmate and deeply lobed, 5–10cm/2–4in long, and coarsely toothed. The coarsely hairy flower spike appears in summer. The bell-shaped flowers, intermittently distributed up the stem and opening from round buds, have petals 2.5cm/1in long, pink drying purplish or lavender, with densely hairy margins at the base. The staminal column is basally hairy and about 15mm/⅝in long. The fruits are flattened spheres.

Distribution: New Mexico, Arizona, Colorado, and Utah, USA.
Height and spread: 1–2m/3–6½ft.
Habit and form: Herbaceous perennial.
Leaf shape: Palmate.
Pollinated: Insect.

Macqui

Aristotelia chilensis

This weedy shrub grows in damp, humus-rich soils on lower mountainsides by rivers in southern Chile. It is a colonizer that quickly invades cleared forests and waste ground and forms extensive stands. It is very abundant in areas of high rainfall, with distribution between Illapel and Chiloé, in mountain ranges, the Central Valley and the Archipelago of Juan Fernandez. The young reddish shoots bear small, white flowers in spring and early summer, followed by shiny, black, edible fruits in the autumn.

Identification: On this evergreen shrub or small tree the young shoots are reddish and the bark of older branches is smooth, peeling off in long fibrous strips. The oval leaves are 5–10cm/2–4in long, shallowly toothed, opposite and alternate, glossy dark green above, paler beneath and sparsely downy on the veins, smooth when mature; the leaf stalk is reddish. Tiny greenish-white, star-shaped flowers, usually in three-flowered axillary and terminal clusters, appear in late spring and early summer, followed by spherical black fruits, 6mm/¼in in diameter.

Distribution: Southern Chile.
Height and spread: Up to 5m/16ft.
Habit and form: Shrub or small tree.
Pollinated: Bee and other insects.
Leaf shape: Ovate.

Far left: Macqui often forms extensive stands on land cleared through logging.

Right: The black, edible fruits appear in autumn.

BORAGE AND LOBELIA FAMILIES

The Boraginaceae, or borage family, comprises about 100 genera and 2,000 species, with some showy and interesting representatives in the Americas. The lobelia family (Lobeliaceae) is widely distributed and is especially richly represented throughout the Americas particularly in the USA and southward.

Cardinal Flower

Lobelia cardinalis

This extremely showy, short-lived herbaceous perennial grows in moist meadows, bogs and along stream banks in eastern North America. In some areas it is very abundant, forming mats of floating vegetation and even clogging waterways. This is one of the most striking species of the genus found anywhere. The deep red flowers are easily noticed above the purplish leaves, and it is the only *Lobelia* species in the USA with such coloration.

Below: The flowerhead.

Identification: The dark green, lance-shaped to oblong leaves are arranged alternately, stalked below and stalkless and smaller above; they are generally smooth or sparsely hairy, serrated to toothed, up to 20cm/8in long, tapered at both ends, often with undulating margins. The flowers appear from midsummer to mid-autumn on terminal racemes around 70cm/28in in height, each subtended by a single leafy bract; they are brilliant deep red, up to 5cm/2in long, tubular, five-lobed, with the three prominent lobes joined to form a lower lip and two narrower lobes above. The five stamens, with red filaments, are united into a tube surrounding the style. The fruits are two-celled pods, opening at the top, with numerous seeds.

Distribution: Eastern North America, from New Brunswick west to Minnesota, and south to central Florida and eastern Texas.
Height and spread: 60–90 x 45cm/24–36 x 18in.
Habit and form: Herbaceous perennial.
Leaf shape: Lanceolate to oblanceolate.
Pollinated: Hummingbird.

Left: This tall, stout plant has extremely striking red flowers set above the mass of purplish leaves.

Virginia Bluebells

Virginia cowslip, *Mertensia virginica*

This eye-catching, early flowering perennial, with striking blue flowers opening from pink buds, is native to eastern North America. It is found in moist, rich woods and floodplain forests where it grows abundantly, usually on higher, dry areas, flowering in mid-spring. The plant enters a dormant phase in summer, the foliage dying to the ground until the following spring.

Identification: Erect to ascending stems, green with some purple at the base, emerge from a woody base, branching near the tips. The smooth leaves, up to 20cm/8in long, are arranged alternately, the lower leaves on winged stalks, oval, with margins smooth or slightly toothed at the tips, dull green above and silvery-green below. The upper leaves are reduced, becoming bracts at the base of the flower stalks near the top of the stem. Bell-shaped, nodding, clear blue flowers, 3cm/1¼in long, are borne in lateral cymes in spring.

Distribution: Eastern North America, from Ontario to Alabama.
Height and spread: 60cm/2ft.
Habit and form: Herbaceous perennial.
Leaf shape: Ovate.
Pollinated: Insect.

Left: The striking blue flowers open from pink buds.

Right: The abundant growth of this plant disappears during the drier summer months until the following spring.

True Forget-me-not

Water forget-me-not, *Myosotis scorpioides*

Distribution: Originated in Europe but widely naturalized across North America.
Height and spread: 90cm/3ft.
Habit and form: Herbaceous perennial.
Leaf shape: Oblong to lanceolate.
Pollinated: Insect.

Above right: The tiny blue flowers have a yellow eye in their centre.

Right: The arching sprays of flowers appear from spring.

While this plant is a doubtful native of the USA, it has been adopted as the state flower of Alaska, and is frequently found in marshy places or beside rivers, in the shallow waters of ponds and lakes, and generally in lowland habitats the further north it grows. It is occasionally invasive in woodland.
The stems are weak, often bent at the base, with alternately arranged willow-like leaves. Tiny blue flowers are located along the upper end of the stem, which unfurls in a "fiddleneck" fashion. It is in leaf all year, and in flower from late spring to autumn, with the seeds ripening from midsummer.

Identification: A rhizomatous, spreading perennial, the plant has erect to ascending, angled, smooth stems, hairy near the base, and lance-shaped to oblong leaves up to 10cm/4in long. The flowers are bright light blue, with a yellow eye, 8mm/⅜in across, tubular, with five round, flat petals slightly notched at the tip. The calyx teeth are less than half the length of the calyx when flowering, each tooth forming a more or less equilateral triangle. The ripe fruit has stalks as long or twice as long as the calyx, with ovoid nutlets, which are rimmed.

OTHER BORAGE AND LOBELIA SPECIES

Indian Tobacco *Lobelia inflata*
Also known as bladder pod, this is a native of Canada and the eastern USA. From a rosette of soft, green, finely hairy elliptic leaves, the upright flower stems, with tiny, two-lipped, pale blue flowers, appear in early summer. The seed capsules that follow look like round pouches, reflected in the species name *inflata*.

Great Blue Lobelia *Lobelia syphilitica*
This herbaceous perennial, from the eastern USA, grows along streams and in swampy areas, reaching 60–90cm/2–3ft tall. The tall leafy stems produce terminal racemes that are densely covered with blue flowers from late summer to mid-autumn.

James' Cryptantha *Cryptantha cinerea jamesii*
This variable and complex perennial species occurs in most dry habitats, from ponderosa pine forest to grasslands and desert scrub, chiefly in New Mexico. The small, yellow-eyed flowers that appear in late spring and summer are held in a much-branched inflorescence.

Seaside Heliotrope *Heliotropium curassavicum*
The seaside or salt heliotrope is an upright to spreading perennial indigenous to much of the coastal Americas. It grows from thick, creeping roots in dry or moist saline and alkaline areas. The small flowers that appear in tightly curled sprays from early summer, open white with yellow centres and gradually turn blue.

Eastwood's Fiddleneck

Amsinckia eastwoodiae

Eastwood's fiddleneck is a pretty yellow- or orange-flowered annual, found in open valleys and hills between 50–500m/165–1,650ft in central and southern California, west of the Sierra Nevada. It is named after its flower stems, which bear a large number of small flowers, and curl over at the top in a way that suggests the neck of a violin. The seeds and foliage are poisonous to livestock, particularly cattle, and the sharp hairs on the plants can cause skin irritation in humans. The species can be hard to distinguish, as it is variable and its range overlaps with others that sometimes hybridize naturally.

Distribution: Central and southern California, USA.
Height and spread: 20–100cm/8–39in.
Habit and form: Annual.
Leaf shape: Narrowly lanceolate.
Pollinated: Insect.

Identification: A variable annual covered with bristly hairs with bulbous bases. The tubular, five-lobed flowers are borne at the end of the spike-like inflorescence, which has a coiled tip. They are orange or yellow with a darker red-orange mark toward the base of each lobe, 12–20mm/½–¾in long, 8–15mm/⅜–⅝in wide at the top.

Far right: The stem is generally erect, with alternate, narrowly lance-shaped leaves growing at the base and up the stem.

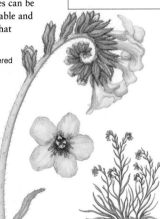

NETTLE AND DEADNETTLE FAMILIES

The nettle family (Urticaceae) is widely distributed throughout the world, although in the Americas it lacks some of the more unpleasant stinging representatives found in Eurasia. The deadnettle family (Lamiaceae) is also widespread throughout both continents, having some showy representatives among its ranks.

Bee Balm

Bergamot, Oswego tea, *Monarda didyma*

Bee balm is a native of the eastern USA. It originally occurred from New York, west to Michigan and south in the Appalachian Mountains to Tennessee and northern Georgia, though it is now much more widely distributed, probably due to its popularity as a garden ornamental, resulting in its escaping and becoming established as far north as Quebec. It occurs along wooded stream banks and in moist hardwood forests. The scarlet blooms first appear in early summer and continue into late summer. Its aromatic leaves have traditionally been used to make infusions.

Identification: A tall, upright-growing, spreading, clump-forming perennial, arising from short underground stolons in spring. The square stems carry leaves in opposite pairs. The leaves are toothed on the margins, lance-shaped to oval near the base, elongating to a pointed tip, 5–15cm/2–6in long and about a third to a half as wide, fragrant when bruised. The inflorescences are whorled clusters of scarlet-red flowers, borne singly or (rarely) in pairs. The flowers are irregular in shape and up to 4cm/1½in long, tubular, terminating in two lips; the upper lip erect and hood-like, the lower lip with three spreading lobes. Directly beneath each inflorescence is a whorl of reddish bracts, some leafy and some bristly.

Distribution: Eastern USA.
Height and spread: 120 x 60cm/4 x 2ft.
Habit and form: Herbaceous perennial.
Leaf shape: Lanceolate to ovate-acuminate.
Pollinated: Insect, especially bee.

Left: The spreading underground stems eventually result in a large clump.

Pineapple Sage

Salvia elegans

Pineapple sage grows naturally in oak and pine scrub forests at elevations from 2,400–3,100m/8,000–10,000ft in Mexico and Guatemala. It is a semi-woody, sometimes almost herbaceous, subshrub, with soft, fuzzy leaves and bright red, two-lipped flowers arranged in whorls of four at the ends of the stems. It flowers in late summer and autumn, and can occasionally be found in warmer climates as a garden escapee, due to its popularity in cultivation. The bruised foliage smells like fresh pineapple, hence its common name. It is bird-pollinated and is especially popular with ruby-throated hummingbirds.

Identification: The plant has an open-branched, airy habit, with square stems on which the leaves are opposite; the branches also originate on opposite sides of the main stem. The leaves are softly fuzzy, light green and 5–10cm/2–4in long, oval to triangular, straight or heart-shaped at the base, with serrated margins. Ruby-red, two-lipped flowers, 2.5–5cm/1–2in long, are tubular with a hood-like upper lip and spreading lower lip. They are arranged in four-flowered, terminal whorls, on 20cm/8in spikes. It rarely sets seed outside its native range due to a lack of pollinators.

Distribution: Mexico and Guatemala.
Height and spread: 1–1.5m x 60–90cm/3–5 x 2–3ft.
Habit and form: Herbaceous perennial or subshrub.
Leaf shape: Ovate to deltoid.
Pollinated: Hummingbird.

Left: The soft, felt-like leaves and bright red flowers make this a handsome specimen in late summer.

Small-leaf Giant Hyssop *Agastache parvifolia*
An erect, rhizomatous, perennial subshrub native
to the USA. Small-leaf giant hyssop is a drought-
tolerant species, reaching a height of 60cm/2ft
at maturity. It sports spikes of mauve blooms
in late spring.

Eastern Bee Balm *Monarda bradburiana*
Eastern or Bradbury bee balm can be found in
woods and on slopes in the mid-western USA.
The square, erect stems are covered with
opposite, toothed, greyish-green, aromatic
leaves, with pink to white flowers in terminal
heads in late spring and early summer.

Bog Hemp
Boehmeria cylindrica
Bog hemp or false nettle grows
in swampy meadows, along
streams and spring branches
and in low wet woods in
the eastern USA. The plant
resembles a stinging
nettle but has
opposite leaves and
no stinging hairs and is therefore harmless.
Small greenish flowers cluster around the stem
in mid- to late summer.

Wood Nettle *Laportea canadensis*
The Canada nettle or wood nettle has sharp
barbs along the stem which, when touched, can
give a painful sting to exposed skin. It is found
infrequently in wet woods in much of the
eastern USA. Tiny feathery clusters of flowers
appear from midsummer to early autumn.

Purple Giant Hyssop

Agastache scrophulariifolia

A perennial plant native to eastern North
America, naturally inhabiting the edges of
the upper limits of floodplains associated
with steep rivers and streams, and favouring
areas where competition from other plants
is limited. It is a species that is dependent on
soil disturbance and often grows in areas
close to human settlements, although it
rarely persists for long. The branching
stems bear spikes of pinkish-purple
flowers from midsummer to early
autumn, and the whole plant is
highly fragrant, smelling strongly
of anise. Historically, it ranged
from New England south to
Georgia, west to Kansas and
north into Ontario, although its
range appears to have been
shrinking in recent years.

*Below: This erect, tall, late-
flowering, mostly herbaceous
perennial is little
branched in
its lower
parts, more
so above,
with hairless
square stems,
usually
tinged with
purple.*

Distribution: Eastern North
America.
Height and spread: Up to
2m/6½ft.
Habit and form: Herbaceous
perennial.
Leaf shape: Ovate to ovate-
lanceolate.
Pollinated: Insect.

Identification: The leaves are
opposite, paired, oval to lance-
shaped, rounded to heart-shaped
at the base with pointed tips, up
to 12.5cm/5in long, conspicuously
hairy and coarsely serrated. The
inflorescence, which grows up to
15cm/6in long, is composed
of small flowers compacted
into terminal, cylindrical or
tapering whorled clusters
1.5–2cm/⅝–¾in across.
Hairless, inconspicuous bracts,
often with coloured margins,
subtend the inflorescence.
The flowers range from pale
pink to purple, projecting
significantly beyond the white or
purplish calyces.

Artillery Plant

Pilea microphylla

Distribution: Mexico to
Brazil.
Height and spread:
15–45cm/6–18in.
Habit and form: Annual or
short-lived herbaceous
perennial.
Leaf shape: Obovate.
Pollinated: Insect.

*Right: The brittle, arching stems
quickly form a large, spreading
colony of fern-like growth.*

This small, brittle succulent is usually a prostrate herb. It grows
from Mexico south as far as Brazil, in moist tropical
forest edges and glades. It has very small leaves, tiny
greenish female flowers and larger, pinkish, male
flowers. It gets its common name by virtue of its
"catapult mechanism" for dispersing pollen.
Its minute, lime-green leaves on short,
arching stems give it a fine textured, fern-like
appearance, and it quickly spreads to form
quite large colonies.

Identification: The stems are succulent and densely
branched, sometimes slightly woody at the base,
spreading or tufted, 5–50cm/2–20in long. The leaves, crowded
all along the stem on short leaf stalks, are oval to elliptic,
2–12mm/1⁄16–½in long, those of a pair very unequal in size; the
upper leaf surface is crowded with elliptic hard cysts, the lower
surface finely netted with veins, the margins smooth. Tiny green
flowers appear all year round, in stemless clusters, followed by tiny
brown fruits.

FIGWORT FAMILY

The figwort family includes about 190 genera and 4,000 predominately temperate species and is widely distributed across much of the world but well represented in the Americas. It is made up mainly of herbs with few woody representatives, and the absence of any trees in the family means that family members are often restricted to open situations such as grassland, wetland or mountainous terrain.

Shrubby Penstemon

Penstemon fruticosus

With more than 250 species, the penstemons constitute the largest genus of flowering plants endemic to North America. Shrubby penstemon inhabits rocky slopes stretching from the foothills into alpine areas, ranging from British Columbia, south through the Washington Cascades, and eastward to the Idaho panhandle. It is a low, dense shrub with abundant lavender flowers appearing between late spring and late summer.

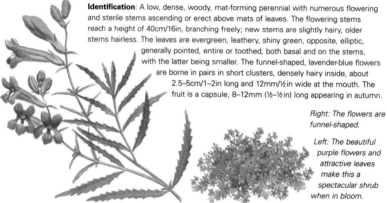

Identification: A low, dense, woody, mat-forming perennial with numerous flowering and sterile stems ascending or erect above mats of leaves. The flowering stems reach a height of 40cm/16in, branching freely; new stems are slightly hairy, older stems hairless. The leaves are evergreen, leathery, shiny green, opposite, elliptic, generally pointed, entire or toothed, both basal and on the stems, with the latter being smaller. The funnel-shaped, lavender-blue flowers are borne in pairs in short clusters, densely hairy inside, about 2.5–5cm/1–2in long and 12mm/½in wide at the mouth. The fruit is a capsule, 8–12mm (½–½in) long appearing in autumn.

Right: The flowers are funnel-shaped.

Left: The beautiful purple flowers and attractive leaves make this a spectacular shrub when in bloom.

Distribution: North-western North America.
Height and spread: 40cm/16in.
Habit and form: Woody, mat-forming perennial.
Leaf shape: Elliptic.
Pollinated: Insect.

Scarlet Monkey Flower

Mimulus cardinalis

This spreading perennial plant, native to western North America, stretches from Oregon south as far as northern Mexico. It generally inhabits shady, wet places from streamside to seepages and spreads by rhizomes, often forming good-sized colonies. Its brilliant scarlet to orange-red (sometimes yellowish) flowers are short-lived but appear prolifically from spring to autumn. While most *Mimulus* species are bee-pollinated, *M. cardinalis* is pollinated by hummingbird.

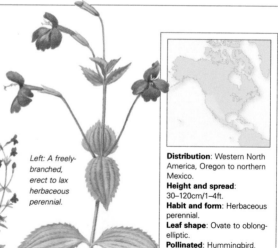

Identification: Scarlet monkey flower has hairy stems and lime-green, oval to oblong-elliptic, toothed leaves 7.5–10cm/3–4in long, with longitudinal veins. The brilliant scarlet, tubular, lipped flowers are 5cm/2in long, the upper lip arched and ascending, the lower lips flared and curved back. The narrow throat is tinged yellow; the stamens are hairy and protruding. The fruit is a capsule that opens to shed the seeds.

Left: A freely-branched, erect to lax herbaceous perennial.

Distribution: Western North America, Oregon to northern Mexico.
Height and spread: 30–120cm/1–4ft.
Habit and form: Herbaceous perennial.
Leaf shape: Ovate to oblong-elliptic.
Pollinated: Hummingbird.

Calceolaria purpurea

This striking herbaceous or occasionally woody perennial is a native of Chile, originating in the Santiago region. Its purple flowers have the balloon or sac-shaped lower lip that is characteristic of all of the species in this genus. The flowers are held on long, freely branching, leafy spikes above the foliage over a long period between summer and early autumn.

Identification: A herbaceous perennial, woody at the base, sticky to glandular, with tall, robust, branched stems. The wrinkled oval leaves, narrowing toward the leaf stalk and irregularly serrated, up to 12.5cm/5in long, form rosettes at the base. On the stem they are stalkless and opposite. The many-flowered inflorescences, freely branching, are held above the basal rosettes.

Distribution: Santiago region of Chile.
Height and spread: 60–80cm/24–32in.
Habit and form: Herbaceous perennial.
Leaf shape: Ovate.
Pollinated: Insect.

OTHER FIGWORT FAMILY SPECIES
Large Beardtongue *Penstemon bradburii*
Found over a wide range in central North America, chiefly in prairie and plain habitats. Large beardtongue has terminal clusters of slender, tubular, dark lilac flowers that bloom on open stems, which reach 60cm/2ft. The attractive, glossy, light green leaves below provide a perfect foil for the flowers.

Low Beardtongue
Penstemon humilis
This native of the Rocky Mountains is a variable species, from 15–30cm/6–12in in height. It flowers between late spring and midsummer, with erect stems ending in panicles of azure to blue-violet inflated tubular flowers, borne in three or more whorls.

Ourisia coccinea
This alpine species from the southern Andes of Chile is found in rocky soils, usually close by streams or in the vicinity of running water. Its broadly elliptic or oblong leaves are held basally, with the 30cm/1ft flower panicles crowded at the top with scarlet, drooping flowers.

Calceolaria darwinii
This tiny alpine or sub-alpine herbaceous perennial originates from Tierra del Fuego and southern Patagonia, often in very exposed, well-drained sites from sea level to 1,200m/4,000ft. It flowers in the brief southern summer, revealing large yellow flowers with ochre and blood-red streaks, and is possibly bird-pollinated.

Creeping Gloxinia

Mexican twist, *Lophospermum erubescens*

This vigorous climbing plant is a native of the mountainous areas of Mexico, Jamaica, Venezuela and Columbia, occurring at altitudes of around 1,000m/3,300ft, but it is frequently found far outside this range as a garden escapee. It is sometimes classified with *Asarina*, but differs from this exclusively European genus in having five lobes on the flower, compared with the two lobes of the other genus. It is a distinctive plant, with soft, hairy stems and leaves that give it the appearance of a creeping foxglove.

Identification: The plant is densely, softly downy and grey-green throughout, with stems are woody at the base, softer and hairy above. The leaves, up to 7.5cm/3in long and 15cm/6in across, are more or less triangular, toothed, with twining leaf stalks. The flowers also have twining stalks, and leaf-like calyces with lobes 2.5cm/1in broad. The downy, trumpet-shaped, rose pink flowers are 7.5cm/3in long with five blunt or notched lobes and a tube swollen on one side, white, marbled within. They appear in summer and autumn, followed by spherical capsules containing many winged seeds.

Distribution: Mexico, Jamaica, Venezuela and Colombia.
Height and spread: 3m/10ft.
Habit and form: Trailing vine.
Leaf shape: Deltoid.
Pollinated: Insect.

Left: The downy, rose-pink flowers are foxglove-like.

ACANTHUS FAMILY

Closely related to the figwort family, Acanthaceae, or the acanthus family, comprises about 250 genera and 2,500 species, most of which are tropical herbaceous perennials, shrubs or twining vines. Central and tropical South Americas are hotspots for their diversity, and only a few species are distributed in the temperate regions of either continent in the Americas.

Shrimp Plant

Justicia brandegeeana syn. *Belloperone guttata*

Native to central Mexico, from mountainous country at elevations of 500–1,200m/1,650–4,000ft. The drooping, arching, terminal white flowers that appear throughout the growing season have showy, overlapping red to pink-bronze bracts. Each flower spike looks like a large shrimp, hence the common name. The flowers are insignificant but their white or yellowish colour contrasts with the bracts. The plant is widely naturalized outside its original range, especially in Florida.

Identification: This evergreen, rounded, downy shrub has rather weak, twiggy stems, forming a dense, spreading clump or colony. The leaves, up to 7.5cm/3in long, are oval to elliptic, entire, soft and shiny green. The flowers are borne in arching to pendent terminal spikes, about 15cm/6in or more long, with heart-shaped, overlapping bracts of brick-red or rose; the flower, deeply double-lipped, white, the lower lip marked with red, is almost concealed by the bracts. Yellow-flowered forms occur occasionally.

Distribution: Central Mexico.
Height and spread: 90cm/3ft.
Habit and form: Evergreen shrub.
Leaf shape: Ovate.
Pollinated: Insect

Left: The shrimp plant is a sprawling, suckering, tropical, evergreen shrub.

Christmas Pride

Pink wild petunia, *Ruellia macrantha*

This dense evergreen shrub is native to Minas, São Paulo, and the Matto Grosso areas of Brazil. It is also found as far north as Mexico where suitable habitats exist. It is most commonly found on dry, gravelly slopes and rocky washes, or other well-drained soils. It has large, showy, flaring, bell-shaped flowers, which are usually rose-pink with deeper pink veining, giving the whole plant a spectacular appearance. Its popularity as a garden plant has resulted in its becoming quite widely naturalized, especially in parts of the United States.

Identification: A bushy subshrub with erect stems, it has leaves up to 15cm/6in long, opposite, lance-shaped, dull dark green, slightly hairy, with veins impressed on the upper surface. The flowers are showy, solitary, axillary, with a deeply five-cut calyx; they are funnel-shaped, lavender-rose with a paler throat with red veins, up to 7.5cm/3in long, reaching 5cm/2in across at the mouth, the five lobes rounded and spreading, the tube straight. The four unequal stamens are fused at the base in two pairs, joined to the corolla tube. The fruit is a club-shaped capsule.

Left: The bell-shaped flowers open from pink inflated buds.

Distribution: Brazil.
Height and spread: 1–2m/3–6½ft.
Habit and form: Subshrub.
Leaf shape: Lanceolate.
Pollinated: Insect.

Below: The plant is bushy with upright stems.

Golden Shrimp Plant

Pachystachys lutea

Distribution: Peru.
Height and spread: 60–180cm/2–6ft.
Habit and form: Evergreen shrub.
Leaf shape: Ovate or lanceolate.
Pollinated: Insect.

This colourful, soft-stemmed, upright perennial has dark green leaves and a showy inflorescence consisting of a congested raceme of bright yellow bracts, from among which pure white flowers emerge throughout the growing season. The name *Pachystachys* comes from the Greek for "thick spike", an obvious reference to the flowering spikes. The yellow bracts resemble the overlapping scales on a shrimp, hence the common name. The plant is quite similar in appearance to the Mexican shrimp plant, *Justicia brandegeeana*.

Identification: The stems are woody and smooth, the younger stems green, sparsely or moderately branched, with inflorescences held on terminal sections. The leaves are alternate, oval or lance-shaped to elliptic, to 15cm/6in long, tapered at the tip with a pointed or heart-shaped base. The upper surface is smooth and bright green with pinnate veination and entire to finely serrated margins. The flower spike is a cone-shaped arrangement of bracts, usually bearing four or more flowers, opposite, each located at the base of a bract; each bract is heart-shaped, 2.5cm/1in long, and golden yellow. The flowers are white and double-lipped.

Above: The white flower protrudes from the yellow bracts.

Far left: Shrubby dark green growth offsets the flowers.

OTHER ACANTHUS FAMILY SPECIES
Cardinal's Guard *Pachystachys coccinea*
This shrub from French Guiana has become naturalized in many tropical countries, particularly Jamaica and the West Indies. It is a handsome plant with large, shiny, dark green, oval leaves, which enhance the 15cm/6in spikes of bright red flowers, held well above the leaves.

Branched Foldwing *Dicliptera brachiata*
Native throughout the forests in southern states of the USA, from Texas to Florida, this shrub is known by several other common and botanical synonyms. Although not widespread, where it does occur it tends to be prolific. It is a sprawling, almost shrubby herb, producing many small pink blossoms in late summer.

Carolina Scalystem *Elytraria caroliniensis*
A North American native found in swamp forests over limestone. As a consequence it is often quite rare, being limited mainly to Florida. It flowers between early and late summer and appears to be in decline, although the reason for this is unknown.

Carolina Wild Petunia *Ruellia caroliniensis*
This wild petunia is a North American native found in dry woods throughout Florida. It is known to be a strong grower under adverse conditions. The large, showy violet flowers appear sparsely throughout the growing season and are attractive to various species of butterflies.

Mosaic Plant

Fittonia gigantea

This is one of two species in this genus. It is a native of forests, where it is noteworthy for its large colourful leaves, which appear on numerous branching, spreading stems. The small, yellowish, red-striped flowers are almost insignificant, appearing one or two at a time on each flowerhead. Despite its restricted range in the wild this plant has been popular in cultivation in many tropical countries and can occasionally be found as a garden escapee.

Identification: A low-growing, downy, evergreen herbaceous perennial. The stems are creeping, violet-red and root freely to form a dense carpet. The leaves are opposite, 10cm/4in long or more, heart-shaped toward the base, on short leaf stalks. They are colourfully veined: both leaf veins and borders are pink or carmine-red and are very elegant, with a "painted" look. The inflorescence is to 4cm/1½in long, on a short stalk. The pale green, overlapping bracts are conspicuous while the yellowish to white flowers are insignificant, emerging from the bracts one or two at a time; they are tubular, double-lipped, with the lower lip divided into three lobes, striped pink to red on the two outermost.

Distribution: Peru.
Height and spread: 60cm/2ft.
Habit and form: Herbaceous plant.
Leaf shape: Ovate.
Pollinated: Insect.

Below: The flower is a, four-angled terminal spike.

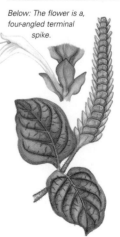

Left: The mosaic plant is a spreading, soft, freely branching herb.

DAISY FAMILY

The daisy family (Asteraceae) is one of the most widely distributed plant families. In the Americas, it is especially richly represented in Mexico, and the scrublands and grasslands of South America. The great North American plains also have many species and the family is only really absent to any extent from the dense forests of the tropical regions.

Stokes Aster

Stokesia laevis

Stokes aster is a low-growing herbaceous perennial, native to wetlands, including pine flatwoods, savannas and bogs, on the coastal plain from North Carolina to Louisiana. The rosette clump of strap-like leathery leaves may persist through the winter, and the flowers, which appear over several weeks between late spring and early autumn, have many narrow light blue or lilac petals. *Stokesia* is a monotypic genus (it has only one species), named after Jonathan Stokes, an early 19th-century British physician and botanist.

Identification: Several erect stems, with small, clasping leaves, arise from the basal leaf rosette in late spring, bearing the flowers terminally. The strap-like, pointed, leathery leaves are 15–20cm/6–8in long, dark green, with the stems and leaf veins tinged with purple. Each inflorescence comprises one to four shaggy, cornflower-like flowerheads 7.5–10cm/3–4in across. The ray florets are fringed, blue, lavender, pink or white, in two concentric rows; the disc florets are in darker shades of the same colours.

Distribution: Coastal plain from North Carolina to Louisiana, USA.
Height and spread: 30–60cm/1–2ft.
Habit and form: Herbaceous perennial.
Leaf shape: Lanceolate.
Pollinated: Insect.

Left: The strap-like leaves often form a dense rosette from which the flowers emerge.

Clasping Coneflower

Rudbeckia amplexicaulis

This annual coneflower, native to Georgia and Texas and north as far as Missouri and Kansas, gets its name because of the way that its cauline leaves clasp the stems (*amplexicaulis* means "stem-clasping"). It is typically found along roadsides, in waste areas and along streams, where it often forms dense colonies. The flowers that appear from early summer onward resemble the larger "Mexican hat", *Ratibida* species, with the yellow outer ray florets, which droop as the flowers mature, surrounding an elongated, conical, brown centre. The plant is sometimes listed in the monotypic genus *Dracopis*, chiefly due to the presence of chaff subtending the ray flowers.

Identification: The plant is erect and loosely branched, with alternate glaucous, elongated oval or oblong leaves, with margins that are smooth to wavy or toothed and a clasping, heart-shaped base. The flowerheads appear over a long period during the summer and are long-stemmed, up to 5cm/2in across, with five to ten yellow (sometimes partly orange or purple) drooping rays, which are orange or brownish at the bases, and a cone-shaped or columnar, dark brown central disc.

Distribution: South-eastern USA.
Height and spread: 30–60cm/1–2ft.
Habit and form: Annual.
Leaf shape: Ovate or oblong.
Pollinated: Insect.

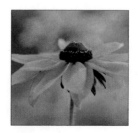

Left: The outer petals open first.

Right: The characteristic "Mexican hat" blooms are held high on branched stems.

Large-leaved Aster

Aster macrophyllus

This widespread rhizomatous perennial from north-eastern North America, from Canada to the Ohio, is common in woods except those on wetlands, favouring dry or moist sites in pine woods. It often forms dense groundcover in large colonies. It is most easily distinguished by its very large, soft, thick, heart-shaped leaves, which are much more noticeable than the sparsely borne, lavender or sometimes white flowers that appear in late summer.

Distribution: North-eastern North America.
Height and spread: 90cm/3ft or more.
Habit and form: Herbaceous perennial.
Leaf shape: Cordate.
Pollinated: Bumblebee.

Right: The flowering stems are borne sparsely among the dense mat of leaves.

Identification: A spreading herbaceous perennial that arises from creeping rhizomes, forming dense patches of one-leaved plants. The basal leaves are very large, up to 20cm/8in long, firm, thick, usually hairy, coarsely toothed, tapering to a pointed tip, heart-shaped at the base. The flowering stems are infrequent, usually hairy, with a short, woody base and staggered leaves. The sparse, daisy-like flowers are pale lavender, to 2.5cm/1in across, with 9–20 ray flowers appearing in late summer in a loose, rounded, many-flowered corymb. The fruits are small, linear seeds with fluffy hairs that form a small ball for each flowerhead; they appear in early autumn.

OTHER DAISY FAMILY SPECIES

Texas Yellow Star *Lindheimera texana*
The Texas yellow star is a hairy, upright annual with tapered leaves and yellow, star-like flowerheads consisting of five rays with two or three times as many disc flowers. It blooms in spring and can be found in full sun in the sandy or rocky soils of the Edwards Plateau region.

Peruvian Zinnia *Zinnia peruviana*
The Peruvian or redstar zinnia is a South American annual that produces bright red flowers throughout the growing season. The blooms fade with age from bright red through terracotta to a soft brick-red, perfectly illustrating its nickname of "youth and old age".

Indian Blanket *Gaillardia pulchella*
This annual or short-lived perennial is found from Virginia to Florida and westward to Colorado and New Mexico, extending south into Mexico. It is noted for its brilliant, daisy-like flowers, which appear in summer. They have large, rose-purple centres and frilly petals of yellow, orange, crimson or copper scarlet.

Dahlia coccinea
This dahlia species from Mexico is extremely multi-branching, bearing multiple, large, bright red single flowers and glossy, dark green divided leaves, through the summer and autumn. Dahlias are known to have been hybridized by the Aztecs, proving this plant's long history of popularity in cultivation.

Blazing Star

Spike gayfeather, *Liatris spicata*

This species occurs in the entire eastern half of the USA and Canada. The non-flowering plants resemble grass clumps until the flowers appear in midsummer. The bottlebrush flower spikes of fuchsia, rose and purple, which attract bees and butterflies, are unusual in opening from the top of the spike downward, continuing until late summer or early autumn.

Distribution: Eastern USA and Canada.
Height and spread: 60 x 80cm/24 x 32in.
Habit and form: Herbaceous perennial.
Leaf shape: Linear.
Pollinated: Insect.

Below: The fuzzy bottlebrush-like flowers open from the top downward.

Identification: A clump-forming, upright, hairless (or very sparsely hairy) herbaceous perennial with single or multiple stems arising from the base. The almost grass-like, mid-green basal leaves grow up to 30cm/1ft long; on the tall stems the leaves are narrow and arranged in whorls, emphasizing the plant's vertical, feathery effect. The inflorescence is a terminal spike to 60cm/2ft tall, of crowded, rose-purple, fuzzy flowerheads up to 12mm/½in broad. The lowest flowerheads are subtended by small leafy bracts.

Left: The plant resembles a grass clump when not in flower.

ERICACEOUS PLANTS

The heather family (Ericaceae) is a large family whose main centres of diversity lie in Eurasia although it is well represented throughout both continents of the Americas. The plants have characteristically bell-shaped flowers, and although they occur over a wide climatic range, they are restricted to acidic soil types and often, as a consequence, inhabit boggy or mountainous areas.

Dusty Zenobia

Honeycup, *Zenobia pulverulenta*

This distinctive, extremely slow-growing, small deciduous shrub is a native of the coastal plain of the eastern USA, where it can be found in bogs and wet areas. It is the only species in its genus, and gets its common name from the dusty appearance of the bluish-green leaves. The small white flowers appear in the spring and are much more open than the pinched bells of *Vaccinium* and other related ericaceous species found in the same areas, adding to its distinctive appearance.

Identification: An open shrub with graceful, arching branches. The leaves are oval to oblong, pale green to grey-green with a waxy bloom and serrated margin, 2.5–5cm/1–2in long; they turn yellow-orange in autumn with a purplish-red tinge. Small bell-shaped, cream flowers with pale turquoise stems appear in early summer from the old wood. The pendent, white bells are rather plump and wide open and have a light, citrus or anise scent.

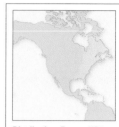

Distribution: Eastern USA.
Height and spread: 60–180cm/2–6ft.
Habit and form: Deciduous shrub.
Leaf shape: Ovate to oblong.
Pollinated: Insect.

Far left: Although it eventually forms an open shrub, it is very slow growing.

Mountain Laurel

Calico bush, spoonwood, *Kalmia latifolia*

This large spreading shrub, native to eastern North America, is typically found around woodland edges, particularly by watersides or where light filters through the forest canopy. It is an evergreen with leaves clustered at the branch tips. Its star-shaped flowers range from red to pink or white, and occur in showy clusters. It is also known as spoonwood because native Americans used to make spoons from it.

Identification: This rounded, evergreen shrub may be dense and compact or open, depending on how much light it receives, with an irregular branching habit. The brown-tan bark is lightly ridged and furrowed, the trunks gnarled and twisted. The leaves are alternate, clustered toward the shoot tips, elliptic, 5–12.5cm/2–5in long, with pointed tips and smooth margins; they are dark green and glossy above, yellow-green in full sun. The lateral buds are hidden behind the bases of the leaf stalks. The flowers are pink, fading to white, up to 2.5cm/1in across; they appear in late spring in showy clusters at the branch tips, opening from star-shaped buds. The fruits are small, upright, dry, brown-tan capsules.

Right: The star-shaped flowers can be pink or white and appear in showy clusters in late spring.

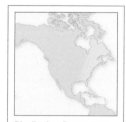

Distribution: Eastern North America.
Height and spread: 1.5–3.5m/5–12ft.
Habit and form: Evergreen shrub.
Leaf shape: Elliptic.
Pollinated: Insect.

Mayflower

Trailing arbutus, *Epigaea repens*

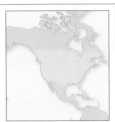

Distribution: North America.
Height and spread: 10cm/4in or more.
Habit and form: Creeping evergreen shrub.
Leaf shape: Ovate.
Pollinated: Insect.

The delicate pink flowers of this small, evergreen, flowering shrub are among the first to appear on sandy soils across many parts of North America, mostly under the shade of trees in northern or mountainous areas. It is very low-growing and forms dense, slowly spreading mats, the creeping branches rooting along their length to form a shrubby thicket. It is widespread but by no means common: its growing sites are easily destroyed when disturbed by people or livestock and seldom recover.

Identification: The yellow-orange, trailing stems of this evergreen shrub root along their length at the nodes. The leaves, on hairy stalks, are alternate and broadly oval with a short point at the tip, 2.5–4cm/ 1–1½in long, rough and leathery with wavy margins and hairy undersides; they are often spotted with dead patches. The flowers, which are very fragrant, are produced at the end of the branches in dense clusters, sometimes in late winter but mainly in spring. They are white, to 1.5cm/⅝in across, with a reddish tinge, divided at the top into five segments that spread open in the form of a star. This low creeping, evergreen shrub has numerous trailing twiggy, yellow-orange stems, all of which have a tendency to root along their length at the nodes.

OTHER ERICACEOUS PLANTS

Ground Pine Heather *Cassiope lycopodioides*
This small, low-growing, evergreen shrub is found across the upper Pacific rim, from Japan through Alaska and British Columbia, down as far as Washington State, occurring at altitude in southern locations. The small white bells, with a red calyx, grow toward the top of the branches.

Large-fruited Cranberry
Vaccinium macrocarpon
This is the familiar cranberry grown commercially and used in cooking. It occurs naturally in eastern North America in acid boggy ground, forming a low-growing, creeping mat.

Alabama Azalea
Rhododendron alabamense
The flower of the Alabama azalea is typically white with a bright yellow blotch, but can sometimes be flushed with pink. Blooms appear in mid-spring, and their attractive lemon fragrance is most distinctive. It grows naturally in north-central Alabama, western to central Georgia and South Carolina, and is widely cultivated.

Prickly Heath *Pernettya mucronata* syn.
Gaultheria mucronata
Prickly heath is a compact evergreen shrub, which spreads by underground runners and bears small, bell-shaped, white to pink flowers in early summer, followed by conspicuous, long-lasting red, pink or white berries. It is a widely distributed from Mexico to the Antarctic, New Zealand and Tasmania.

Salal

Gaultheria shallon

This evergreen plant is one of the most common understorey shrubs in some coastal forests in Alaska, British Columbia, California, Oregon and Washington. In drier coniferous forests it can form an almost continuous shrub layer. It is also common in some wet or boggy coniferous forests, and in areas near the coast the shrub layer can be impenetrable. The small, white urn-shaped flowers appear at midsummer in clusters around the branch tips.

Identification: A creeping to erect shrub of variable height, it spreads by layering or suckering, with hairy, branched stems that arch and root at the nodes. The leaves are thick and leathery, shiny, oval, 5–10cm/2–4in long and finely toothed, pointed at the tip and rounded at the base. The flowers, white to pink, pendent bells, five-lobed, are borne singly along the axis of the stem tip, in groups of 5–15, the reddish flower stalks bending so that the flowers are oriented in one direction; they appear from late spring to midsummer. They are followed by berries that mature by late summer.

Distribution: North-west North America.
Height and spread: 20cm–5m/8in–16ft.
Habit and form: Evergreen shrub.
Leaf shape: Ovate.
Pollinated: Insect.

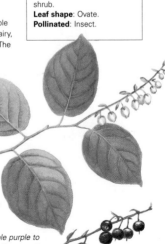

Left: Growth is largely upright.

Right: The edible purple to black berries are often sweet.

NIGHTSHADE AND BINDWEED FAMILIES

The nightshade family (Solanaceae) are herbs, shrubs or trees that are frequently vines or creepers. The family is particularly concentrated in Central and South America, where around 40 genera are endemic. The great concentration of species in this area suggests that the family may owe its origins to the region. Convolvulaceae, the bindweed family, is more widespread throughout both continents.

Blue Dawn Flower

Morning glory, *Ipomoea learii* syn. *I. acuminata, I. indica*

This fast-growing, tropical American climbing vine has large, saucer-shaped flowers borne in clusters of up to five. The flowers open bright blue-violet and fade to rose or soft red-violet, which creates an overall two-tone effect when the vine is in heavy bloom. Each flower lasts for only one day but the plant is extremely floriferous. It often occurs widely outside its native range, as it has long been admired as a garden plant and has escaped from cultivation. It usually prefers coastal habitats and moist forests. Originally native to tropical America, it is now pan-tropical and is often a troublesome weed where introduced.

Identification: A herbaceous, perennial climber, to 6m/20ft tall, often forming a woody base. The stems, which often have a woody base, are almost hairless and much branched. The leaves are oval to rounded with a tapering, pointed tip and a heart-shaped base, sometimes three-lobed, from 5–18cm/2–7in long on long stalks. The inflorescences are single to few-flowered, appearing densely on 5–20cm/2–8in stalks. The short-lived, funnel-shaped flowers are intense blue or purple, rarely white, 5–7.5cm/2–3in long and across. The rounded fruits, up to 12mm/½in in diameter, contain one to four brown seeds.

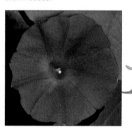

Left: A fully open flower.

Distribution: Tropical America.
Height and spread: 6m/20ft.
Habit and form: Herbaceous perennial climber.
Leaf shape: Ovate to orbicular.
Pollinated: Insect.

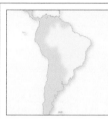

Left: The seeds are held in small fruits.

Right: The plant is a fast-growing twining vine.

Yesterday, Today and Tomorrow

Brunfelsia calycina

This bushy, evergreen or semi-deciduous shrub has fragrant, deep indigo-blue flowers that age to white over three days. It is rather slow-growing, with foliage that is normally dense and medium green, although young leaves may turn purplish in cool weather. The flowers appear in spring with indigo, lavender-blue and white flowers all present on the bush at the same time, leading to its common name. Originally a native of Brazil, it has been widely planted throughout the tropics and may sometimes be encountered as a garden escapee.

Identification: Though it may grow to 3m/10ft, this shrub is often much smaller and freely branched. The leaves, 7.5–15cm/3–6in long, are oblong to lance-shaped, pointed, glossy deep green above and paler beneath, on short stalks. The flowers appear in clusters of one to ten at the ends of shoots or from the leaf axils; they are 2.5–7.5cm/1–3in across, with five spreading, rounded, overlapping lobes and a tube up to 4cm/1½in long, purple with a conspicuous white eye at the mouth, ringed with blue.

Far left and left: The flowers emerge a deep indigo blue and fade to white over three days.

Distribution: Brazil.
Height and spread: 3m/10ft.
Habit and form: Shrub.
Leaf shape: Oblong to oblong-lanceolate.
Pollinated: Insect.

Red Angel's Trumpet

Brugmansia sanguinea syn. *Datura sanguinea*

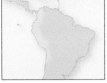

Distribution: North and central Colombia to northern Chile.
Height and spread: 11m/36ft.
Habit and form: Arborescent shrub.
Leaf shape: Ovate to oblong.
Pollinated: Hummingbird.

This small, shrubby tree, native to the Andes, is most noted for its large drooping flowers, which are brilliant orange-red at the mouth with yellow veins, fading to yellow at the base. They are produced in great profusion during the growing season. The velvety, grey-green leaves further enhance the look of this striking plant. It prefers cool, moist areas in mountains, where it is pollinated by hummingbirds. It was originally restricted to north and central Colombia to northern Chile, but it has been widely cultivated, with many cultivars now in existence, and is often encountered as a garden escapee outside its original range.

Identification: The young growth of this tree-like shrub is softly downy, and the branches are leafy near the tips. The broadly lance-shaped, wavy-edged leaves are alternate, up to 18cm/7in long. The pendent flowers are up to 25cm/10in long, emerging from a tubular, hairy, toothed calyx; the corolla is narrowly tubular, bright orange-red, yellow-green at the base, veined yellow, with backward-curving 2.5cm/1in lobes. The fruits, which are enclosed within the persistent calyx, are egg-shaped, downy and pale green to yellow.

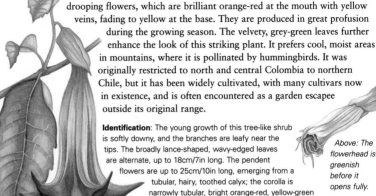

Above: The flowerhead is greenish before it opens fully.

Far left: Brugmansia *is a tree-like shrub.*

Juanulloa mexicana
This rare species has a scattered distribution in semi-deciduous and wet forest habitats from Mexico to Colombia, Ecuador and Peru. It is pollinated by hummingbirds, and occurs as a hemi-epiphyte or liana climbing tree trunks, with the tubular orange flowers often going unnoticed among the tree canopy.

Chilean Jessamine *Cestrum parqui*
This low- to medium-sized, upright shrub, native to seasonally wet forests in southern South America, bears dense panicles of greenish-yellow flowers at the branch tips. The flowers are fragrant nocturnally and are pollinated by moths. These are followed by glossy black or purplish fruits. The seed is spread by birds and floodwater.

Beach Morning Glory
Calystegia soldanella
This common but attractive seaside plant has an extremely wide global distribution, occurring on many coastlines in both temperate and tropical regions. It is usually prostrate, unlike its climbing relations, and has distinctive, kidney-shaped leaves. The bright pink flowers, with five white stripes and a yellowish centre, fade quickly through the day.

Painted Tongue

Salpiglossis sinuata

This branching annual or occasionally biennial plant is from the southern Andes. Its velvety funnel-shaped flowers, which resemble those of a petunia, are often veined and overlaid in contrasting colours. The leaves are mostly basal, and the flowers are borne on long stems above them. The plant has been widely cultivated, with many varieties raised in gardens. It may occasionally be encountered as a vagrant or escapee from cultivation where conditions are suited for its growth.

Identification: The plant has sticky, branching stems and leaves up to 10cm/4in long, alternate, elliptic to narrow oblong, wavy-edged, toothed or deeply divided, on long stalks. The flowers, which appear in summer, are solitary, long-stalked, with a tubular calyx and funnel-shaped corolla with five notched, pleated lobes, up to 7.5cm/3in long and 5cm/2in across. They are yellow to ochre, mauve-scarlet or violet-blue with darker purple veins or markings.

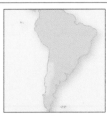

Distribution: Southern Andes, South America.
Height and spread: 60cm/2ft.
Habit and form: Annual.
Leaf shape: Elliptic to narrow oblong.
Pollinated: Insect.

Above: The long flower buds hide their true colour before they unfurl.

Below: The sticky, branched flower stems arise from a mass of basal leaves.

DOGWOOD AND PROTEA FAMILIES

The Cornaceae, or dogwood family, comprises about 15 genera, widespread in North America but largely absent from South America. The Proteaceae, or protea family, have only a few representatives in South America, where they favour areas that have a prolonged dry season, and are absent from North America.

Pacific Dogwood

Western dogwood, Cornus nuttallii

This variable, long-lived tree is found at low elevations in moist, open woods, extending from southern British Columbia to southern California, where it prefers the shade and humidity found under a canopy of conifers. The large white bracts stand out brilliantly and are often mistaken for flowers, although the true flowers are tiny and clustered in a centrally positioned head between the bracts.

Identification: The crown is rounded when growing in the open, irregular in the understorey. The bark is thin, grey, smooth when young, breaking into rectangular scales and blocks with age. The leaf buds are small and pointed, the flower buds are larger. The leaves are opposite, undivided, oval to elliptic, 7.5–12.5cm/3–5in long, with smooth to wavy margins, with distinctively curved veins, turning brilliant red in autumn. The tiny, greenish-white flowers, without petals, are borne in a dense, rounded head, surrounded by four or six large, showy, white to creamy-white bracts. The fruits are flattened, red drupes, borne in a tight cluster.

Above: The berry-lke fruit.

Right: The tree has a straight main trunk and many branches.

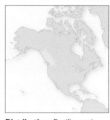

Distribution: Pacific north-west, USA.
Height and spread: 6–20m/20–65ft.
Habit and form: Deciduous flowering tree.
Leaf shape: Ovate to obovate.
Pollinated: Insect.

Bunchberry

Cornus canadensis

The bunchberry is widely distributed, stretching from southern Greenland to Alaska and Maryland to South Dakota, occurring across boreal forests in a broad range of stand types and soil/site conditions. It has a distinctive, four-petalled flower-like bract and six-leaf combination that makes it easy to distinguish from other low-growing forest plants. The white bracts attract flying insects, which pollinate the minuscule true flowers. When an insect alights, its touch induces the flowers to catapult pollen at it.

Identification: Stems 10–15cm/4–6in tall and woody at the base arise from a spreading rhizome, often forming large colonies. The evergreen leaves are opposite, with four to six leaves in a whorl at the top of the stem, often with one or two pairs of smaller, leaf-like scales on the stem below; they are elliptic or oval, 2.5–5cm/1–2in long, with margins tapering to a point at both ends and curving veins parallel to the margins. In early summer, dense clusters of small, greenish-white to purplish flowers appear above the leaf whorl, surrounded by four showy, white to purple-tinged, petal-like bracts, 1.5cm/⅝in long. The fruits are bright red, fleshy and berry-like in a terminal cluster, ripening by midsummer.

Above: The bright red berries appear in the branch tips by midsummer.

Right: The short upright stems arise from a spreading rhizome.

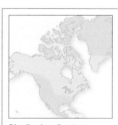

Distribution: Southern Greenland to Alaska, and Maryland to South Dakota, USA.
Height and spread: 10–15 x 30cm/4–6 x 12in.
Habit and form: Herbaceous perennial.
Pollinated: Insect.
Leaf shape: Elliptic or ovate.

Chilean Flameflower

Chilean firebush, *Embothrium coccineum*

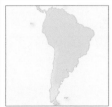

This variable shrub or small tree is the sole representative of its genus, and is endemic to southern South American forests. The flameflower grows over a wide geographic range in the temperate forests of southern Argentina and Chile, and is frequently found along the edges of forest fragments as well as in open, agricultural landscapes. Its main pollinators are birds, with two species in particular – a flycatcher, the white-crested elaenia, *Elaenia albiceps*, and a hummingbird, the green-backed firecrown, *Sephanoides sephanoides* – thought to be the principal pollinating species.

Distribution: Southern Argentina and Chile.
Height and spread: Up to 10m/33ft.
Habit and form: Shrub or small tree.
Pollinated: Bird.
Leaf shape: Elliptic or oblong.

Far right: The Chilean firebush is an evergreen and, rarely, a deciduous tree.

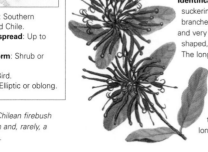

Identification: A variable shrub or tree, with ascending stems, suckering at the base in some forms, clumped and sparsely branched. The leaves, up to 12.5cm/5in long, are undivided and very variable in shape: elliptic or oblong to narrowly lance-shaped, hairless, pea-green with olive veins or dark green. The long-lasting flowers, on red-green stalks, are borne in terminal or axillary crowded racemes up to 10cm/4in long, usually appearing in spring but variable according to location. They are tubular, red or vivid scarlet, although yellow and white forms have occasionally been recorded, up to 5cm/2in long, splitting into four narrow lobes that reflex and coil; each flower carries one stamen. The style is long, slender, protruding and persistent in the fruit.

OTHER DOGWOOD AND PROTEAS

Flowering Dogwood *Cornus florida*
This large shrub or small tree from the eastern USA has a short trunk and a full, rounded crown, spreading wider than its height. It blooms in the spring, as its new leaves are unfolding, with four showy, petal-like bracts, usually snow-white or pink, surrounding a cluster of tiny, inconspicuous, yellowish flowers.

American Dogwood *Cornus stolonifera*
The American or red-stem dogwood is an elegant open shrub producing creamy-white flower clusters in spring and very attractive red stems in winter. It can be found in moist areas, in sun or shade, often along the banks of streams or slow-running water. The fruit of this dogwood is very attractive to woodland birds.

Oreocallis grandiflora
This evergreen shrub or small tree has dense terminal racemes consisting of numerous red or red-violet, tubular flowers with strongly recurved lobes. The genus comprises five species, two of which are found from the north of Peru to the centre of Ecuador.

Roughleaf Dogwood *Cornus drummondii*
This tough, thicket-forming deciduous shrub has soft, furry leaves and blooms in mid-spring, with white clusters of "true" flowers. In early autumn, the white fruit attracts forest birds, with the leaves turning to red, orange and purple.

Pagoda Dogwood

Cornus alternifolia

The species is shade-tolerant and is the dominant understorey shrub in aspen forests. It is often found along forest margins, on stream and swamp borders and near deep canyon bottoms. It is widely distributed from Newfoundland through New England to the Florida Panhandle, and west to Arkansas and Mississippi, where it often occurs alongside the commoner flowering dogwood, *C. florida*. It has tiered, horizontal branches. The light green summer foliage turns rich red and orange in autumn.

Distribution: Eastern North America.
Height and spread: Up to 9m/30ft.
Habit and form: Large shrub or small tree.
Pollinated: Insect.
Leaf shape: Elliptic to ovate-lanceolate.

Identification: The slender branches of this large shrub or small tree are often horizontal and it develops a flat-topped crown. The smooth bark is dark green, streaky, eventually developing shallow fissures. The leaves are alternate, elliptic to ovate-lanceolate, with wavy margins and often crowded at the end of the twig, appearing before the white, flat-topped or hemispheric, open flower cymes. Blue fruits ripen in late summer.

Below: Pagoda dogwood is a small tree.

Above right: Black berries appear in autumn.

GESNERIADS

The Gesneriaceae or gesneriad family are herbs, shrubs, or, rarely trees, and comprisee about 133 genera and 3,000 species, including many well-known ornamental species such as Streptocarpus *and* Gloxinia. *The family is especially well represented in the rainforests of South and Central America, where the species are often epiphytic and bird-pollinated, and their classification is the subject of considerable debate.*

Dutchmans Pipe

Bearded sinningia, *Sinningia barbata*

This small shrubby plant from Bahia, Pernambuco and Alagoas in north-east Brazil, has large leaves and differs from most other species of this genus in having no tubers. The yellow, hairy, upward-bent flowers fade to a creamy-white, and are also more pouched than other species. The leaves are bright olive-green above with reddish veins, and the whole lower surface is red.

Identification: The stems are marked with red and arise from rhizomes. The leaves, up to 15cm/6in long, are oblong to lance-shaped, tapering at both ends, opposite, crowded toward the base of the plant and the branch ends, dark olive-green above, maroon beneath. The nodding flowers, solitary or in pairs, on stalks up to 3cm/1¼in long, have leafy, triangular sepals; the corolla, up to 3cm/1¼in long, is pale greenish or creamy-yellow, fading gradually to white, downy, tubular, inflated at the base, leading to its characteristic upward bend. The lobes are spreading and short, forming a three-lobed lower and a two-lobed upper lip.

Distribution: North-east Brazil.
Height and spread: 60cm/2ft.
Habit and form: Low shrub.
Leaf shape: Oblong-lanceolate.
Pollinated: Insect.

Trichantha elegans

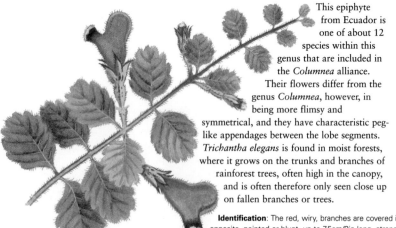

This epiphyte from Ecuador is one of about 12 species within this genus that are included in the *Columnea* alliance. Their flowers differ from the genus *Columnea*, however, in being more flimsy and symmetrical, and they have characteristic peg-like appendages between the lobe segments. *Trichantha elegans* is found in moist forests, where it grows on the trunks and branches of rainforest trees, often high in the canopy, and is often therefore only seen close up on fallen branches or trees.

Distribution: Ecuador.
Height and spread: Indefinite.
Habit and form: Epiphytic creeper.
Leaf shape: Acute to obtuse.
Pollinated: Insect, possibly bird.

Identification: The red, wiry, branches are covered in bristly red hairs. The leaves are opposite, pointed or blunt, up to 7.5cm/3in long, strongly unequal, sparsely to densely hairy with red veins, slightly red on the lower surface; the leaf stalks are short and hairy. The flowers arise in pairs or threes from the leaf axils, with fringed, orange to maroon calyces; the corolla, up to 5cm/2in long, is tubular, red-maroon, with yellow stripes on slightly raised ridges, with sparse red hairs, maroon within, spurred. Three lobes form the upper lip, two lobes the lower lip. The fruit is a fleshy mauve berry.

Miniature Pouch Flower

Goldfish plant, *Hypocyrta nummularia*, syn. *Alloplectus nummularia*, syn. *Nematanthus gregarius*

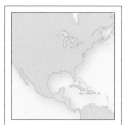

Found growing on rainforest trees in Costa Rica and Guatemala, this is the sole Central American representative of an exclusively South American genus. The brightly coloured tubular flowers, with small closed pouches, bloom profusely along the slender branching stems. The stems, set with opposite pairs of glossy green leaves, commence their growth upright, but gradually droop as they increase in length, and root as they contact the mossy surfaces of trees. After flowering, the plant often loses its leaves for a brief period, but new ones soon appear.

Identification: An epiphyte with hairy stems, climbing or pendent. The glossy green leaves are opposite, up to 3cm/1¼in long, elliptic to oval, bluntly pointed at the base and tip, fleshy, with rounded marginal teeth, on short stalks. The flowers appear one to three per cluster, on short stalks. The calyx is marked orange at the tip, with oval lobes; the corolla, up to 2.5cm/1in long, is bright orange with a purple brown stripe leading to each lobe, marked with black spots near the blunt ends of the lobes. The fruit is yellow-orange.

Distribution: Costa Rica and Guatemala.
Height and spread: Creeping to 80cm/32in.
Habit and form: Epiphyte.
Leaf shape: Elliptic to ovate.
Pollinated: Insect, possibly birds.

OTHER GESNERIADS

Sinningia pusilla
This diminutive species would fit into a thimble and is considered to be the smallest gesneriad. Its tiny rosettes of glossy leaves are comparatively dwarfed by the pale lilac flowers, and it is easily overlooked, growing high among the mossy tree branches in its native Brazil.

Kohleria bogotensis
This native of Colombia is an erect, hairy, rhizomatous plant, with olive-green leaves, which produces a profusion of extremely showy flowers. The bottom lobes of the flowers are yellow, splashed with orange dots and attached to a bright orange tube.

Sarmienta repens
This showy little native of Chile grows on the trunks of trees and rocks and has stiff, trailing, woody stems and small, succulent leaves. The bright red, pendent flowers, which are produced extremely freely, have two prominent stamens that protrude considerably from the flower tube.

Columnea argentea
This stout-stemmed, attractive species has a restricted distribution, being found in just a few localities in Jamaica. It is showy with silky-haired leaves, stems, sepals and corollas, giving it a silvered appearance. The yellow flowers arise from the leaf axils around the branch tips.

Columnea fendleri

This epiphyte, native to Venezuela, has large, showy red flowers, borne singly from the leaf axils. These asymmetrical flowers exude copious nectar and are frequently visited by hummingbirds, which are their principal pollinators. The plant is often considered to be a variety of *C. scandens*, which it resembles in every way except size: it is larger in all respects than this related Venezuelan species, and is therefore widely considered a species in its own right.

Identification: An epiphyte with erect, fleshy stems and leaves 2.5–5cm/1–2in long, dark green, upright, elliptic to oblong with rounded tips, asymmetric at the base, densely hairy beneath, with red margins. It bears one to three flowers per axil, held well away from the leaves, on 1.5cm/⅝in stalks. The calyx lobes, up to 1.5cm/⅝in long, are erect, toothed and sparsely hairy; the slender, tubular corolla is up to 6.5cm/2½in long, orange-red with yellow edges, with a wedge-shaped hood and oblong to lance-shaped lower lobe. The fruit is a fleshy white berry.

Distribution: Venezuela.
Height and spread: 60cm/2ft.
Habit and form: Epiphyte.
Leaf shape: Elliptic–oblong.
Pollinated: Hummingbird.

CUCURBIT FAMILY

The Cucurbitaceae, or cucurbit family, are a medium-sized plant family, primarily found in the warmer regions of the world. It is a major family for economically important species. The family is distinct morphologically and biochemically from other families and is therefore considered to have descended from a single ancestral line.

Buffalo Gourd

Cucurbita foetidissima

This perennial, trailing vine occurs in dry, sandy areas, beside roads and railway tracks, predominantly in disturbed soils, throughout the south-west USA and into Mexico. It is often recognizable by its foetid odour before it is even seen, but despite this disagreeable characteristic various Native American and Mexican tribes used it for at least 9,000 years as a food, cosmetic, detergent, insecticide and ritualistic rattle. The deep yellow flowers appear during spring and early summer before the fruit.

Right: The melon-like fruits have a strong, disagreeable odour.

Identification: A prostrate or trailing vine with an extremely large taproot, which may attain a weight of more than 40kg/88lb in three or four years. The grey-green leaves are stiff, leathery and rough-textured, usually triangular in outline, tending to fold upward parallel to the midvein. The large, yellow flowers, 7.5–10cm/3–4in long and 2.5–5cm/1–2in wide, open in the mornings from late spring to early autumn; male and female flowers are borne on the same plant. The fruit is gourd-like but not as hard as other wild cucurbit species, spherical to elliptic, 5–7.5cm/2–3in in diameter, green with light green or yellow stripes, the whole fruit turning yellow or tan with age.

Distribution: South-west USA and Mexico.
Height and spread: 6m/20ft.
Habit and form: Perennial low-growing vine.
Leaf shape: Deltoid.
Pollinated: Insect.

Right: Buffalo gourd is a trailing vine.

Balsam-apple

Wild cucumber, *Echinocystis lobata*

This perennial, prostrate or climbing vine is found primarily in the north-eastern United States and adjacent to Canada, although it is widespread elsewhere in forests, particularly those on floodplains or wetlands; it is occasionally found on agricultural land. It is strong-growing, with a large, tuberous root and long stems. The separate male and female blooms appear at the end of long flowering stems from early summer to mid-autumn. The spiny fruits split from the tip as they gradually dry out, revealing the seeds within.

Right: The spiny green fruit dries to a papery consistency when ripe.

Identification: This tuberous perennial herb climbs by means of double or triple corkscrew-like tendrils. The large leaves are alternate, circular or palmate, with three to five pointed lobes and serrated margins. The male flowers are borne in panicles from the leaf axils, the female flowers are solitary or paired, borne at the same axils. The calyx has six bristly lobes and the corolla is green-white with six slender petals up to 6mm/¼in long. The fruit is an oval or round, spiny pod, 5cm/2in in diameter, containing four seeds.

Distribution: North-eastern North America.
Height and spread: 6m/20ft.
Habit and form: Climbing vine.
Leaf shape: Orbicular to palmate.
Pollinated: Insect.

Right: The plant spreads quickly from an underground tuber.

Globe Berry

Ibervillea lindheimeri

This native of North America is fairly limited in its range, which includes the south-west states of Texas, Oklahoma, New Mexico, Arizona and California. The small, elegant leaves can be unlobed or deeply three- or five-lobed and range from narrowly triangular to fan-shaped. The species is dioecious with flowers carried on slender branching stems, and the most ornamental aspect of this plant is the round fruit. The plants are usually found in open dry woodlands and open areas with rocky soil.

Distribution: South-west USA.
Height and spread: 2–4m/6–13ft.
Habit and form: Climbing or trailing herbaceous perennial.
Leaf shape: Cuneate to rhombic-ovate.
Pollinated: Insect.

Right: The stems climb by means of long, corkscrew-like tendrils.

Identification: The leaves, up to 12.5cm/5in long on 4cm/1½in stalks, have three to five wedge- to diamond-shaped segments, with 12mm/½in teeth or lobes. The male flowers, borne five to eight per raceme, are yellow and tubular, with three stamens and five yellow or greenish-yellow petals that are not ornate; the solitary female flowers have three stigmas. The calyx is cylindrical and slightly downy. The globular fruits, 2.5–3cm/1–1¼in in diameter, are pale green, turning orange and then vibrant red, and containing around ten swollen, round seeds.

Below: The fruit turns vibrant red when ripe.

OTHER CUCURBIT FAMILY SPECIES
Star Cucumber *Sicyos angulatus*
The star or burr cucumber is a vine that produces white flowers in summer, in small clusters at the end of long flowering stalks. It is found in thickets and along the banks of streams and rivers throughout eastern and central North America. The flowers are followed by clusters of small, red, spiny, oval fruits.

Cucamonga Manroot *Marah macrocarpus*
This manroot is a common plant of dry areas of chaparral, washes, roadsides, coastal sage scrub and foothill woodland in south-west North America. It is most notable for its large, fleshy root, which may weigh as much as 45kg/100lb. The greenish-white flowers that appear in winter are quite insignificant, and the fruit that follows is egg-shaped and densely covered with stiff, flattened prickles.

Creeping Cucumber *Melothria pendula*
This perennial vine has a very scattered distribution, from the southern United States down as far as Bolivia, being most commonly found in thin woods, thickets and at swamp edges, and often occurring in large numbers on disturbed ground. The yellow flowers appear in late spring and are followed by fruits that resemble tiny watermelons.

California Manroot

Marah fabaceus

This perennial climbing or creeping vine can be found beside streams and washes, in shrubby and open areas up to around 1,600m/5,200ft. It is limited to California, principally the Mojave Desert and Baja California. Its common name refers to its surprisingly large tubers, which some claim look like a dead body when dug up, but which help it to survive the dry Californian summers. The prickly fruits look like cucumbers, although they are not edible. The plant dies to the ground after fruiting.

Distribution: California, USA.
Height and spread: 5–6m/16–20ft.
Habit and form: Trailing or climbing herbaceous perennial.
Leaf shape: Cordate.
Pollinated: Insect.

Identification: A large perennial with branched, coiling tendrils, the plant usually winds over and through other vegetation. The leaves are round or heart-shaped, with five to seven lobes. The male flowers appear in racemes or panicles while the female flowers are solitary, usually borne in the same leaf axil; the flowers are cup-shaped, up to 1.5cm/⅝in across, yellowish green, cream or white, appearing in spring. The fruit is a spiny, round capsule containing four seeds.

Above: A quite variable, mounding, sprawling perennial.

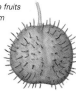

Below: The fruits appear from late spring onward.

CARNIVOROUS PLANTS

The ways in which plants have adapted to attract, capture, kill and digest animals varies, and carnivorous plants have evolved into some of the best-known and most spectacular forms in the Americas. Among the familiar sticky traps of the Americas are some ingenious mechanisms including the trumpet pitchers and the unique, and universally famous, Venus flytrap, which is now a common houseplant.

Venus Flytrap

Dionaea muscipula

This is possibly the best known of all carnivorous plants. It famously traps insects with its specially adapted leaves. As soon as an insect, or anything else, touches any of the three sensitive hairs on the surface of a trap, it rapidly closes and then extracts nutrients from the unfortunate victim. This added nutrition enables the plant to survive in poor soils that few other plants could tolerate. Despite its being so well known, the Venus flytrap is actually endangered in the wild, being restricted to wet sandy areas, bogs and savannas mainly on the coastal plain of North and South Carolina.

Identification: The basal leaves are semi-erect or held close to the ground in a rosette, each consisting of two hinged, round, glandular lobes, which become glossy red with exposure to sunlight, with spines on their margins and three sensitive hairs on the upper surface that cause the leaf to fold when stimulated twice in quick succession. Once folded the spines mesh, trapping insects. Each leaf is on a winged, flat, spatula-shaped stalk that looks more leaf-like than the trap itself. The flowers are white shot with green veins, five-petalled, up to 2.5cm/1in across, widening from the base; they are clustered at the end of leafless stalks in umbel-like cymes, appearing in mid-spring into early summer.

Distribution: North and South Carolina, USA.
Height and spread: 30–45cm/12–18in.
Habit and form: Low-growing herbaceous perennial.
Leaf shape: Two-hinged, orbicular traps.
Pollinated: Insect.

Yellow Pitcher Plant

Huntsman's horn, *Sarracenia flava*

This carnivorous plant traps wasps, bees and flies in long, upright modified leaves. The leaves form tubes, which fill with water and drown the victims inside. It is found along the south-eastern coastal plain of the USA, from Alabama to a few sites in Virginia, and like many carnivorous plants it is threatened, primarily by habitat destruction. Its flowers are yellow, borne on stalks that clear the foliage and appear in spring before the pitchers, to prevent the trapping of pollinating species. The species is quite variable and is usually divided into seven varieties, distinguished mostly by pitcher pigmentation.

Identification: This large, carnivorous plant is rhizomatous, with thin wiry roots. The pitcher, 30–120cm/1–4ft tall with a rounded lid raised above the wide mouth, is yellow-green, often heavily veined red on the lid, especially at the base, sometimes totally red or maroon externally. The winter leaves are straight or slightly curved, and glaucous. The flowers, borne on leafless, unbranched stems up to 60cm/2ft tall, are up to 10cm/4in across, yellow and pendulous, with oval- to lance-shaped petals slightly constricted at the middle; the calyx, subtended by persistent bracts, has five overlapping, persistent sepals; the style is dilated at the end into an umbrella-like structure, with five ribs ending in hook-like stigmas.

Right: The yellowish, red-veined pitchers are topped with a heart-shaped lid.

Distribution: South-eastern USA coastal plain, from Alabama to Virginia.
Height and spread: 30–120cm/1–4ft.
Habit and form: Herbaceous perennial.
Leaf shape: Pitcher-shaped traps.
Pollinated: Insect.

Pinguicula macrophylla

Distribution: Mexico.
Height and spread:
12.5–18cm/5–7in.
Habit and form: Herbaceous
perennial.
Leaf shape: Round-ovate.
Pollinated: Insect.

This Mexican species grows on moist banks and ledges in oak and pine forests of the western mountains and is arguably one of the handsomest of all butterworts. It is quite variable in form. The leaves, which are sticky on the surface, trap small insects and then curl inward from the edges to secrete the digestive juices by which the insects' bodies are broken down prior to absorption. The large, pink-purple, spurred flowers are produced singly on long stems in late spring or summer. In winter the carnivorous leaves are replaced by a smaller, succulent rosette that is not carnivorous.

Identification: The leaves of this stemless plant grow from the root in rosettes, with distinct winter and summer forms. The winter leaves, in a cushion-like rosette of 25–40, are up to 2.5cm/1in long; the summer rosette contains six to nine round to oval leaves 5–12cm/2–5in long, covered by glands that secrete sticky mucilage and digestive enzymes, with a rolled or flat margin. The flowers, produced singly on three to five 12.5–18cm/5–7in stalks from the leaf axils, are 4–5cm/1½–2in across, with five lobes and a long spur, violet-purple to pink with a white throat, with contrasting darker purple or crimson markings at the base of the lobes.

OTHER CARNIVOROUS PLANTS

Huntsman's Cap *Sarracenia purpurea*
This low-growing carnivorous species is widespread in the eastern USA and Canada, extending from New Jersey to the Arctic. The pitchers are slender at the basal rosette, rapidly becoming swollen higher up. They are usually green with purple tints and the lids stand erect. The flowers, which appear in spring, are purple or greenish.

White-topped Pitcher Plant
Sarracenia leucophylla
This plant has pitchers up to around 90cm/3ft tall, and sports large red flowers in the spring. The lower part of the pitcher is green while around the mouth and lid it is white with red or sometimes green veining. It is native to boggy and marshy areas in the south-eastern USA.

Swollen Bladderwort *Utricularia inflata*
This common aquatic bladderwort is found over much of the south-eastern USA and is identified by its large radial floats on the flowering stems, which keep the showy yellow flowers erect and above water. Looking something like green wagon wheels floating on the water, they can reach up to 23cm/9in in diameter.

Cobra Lily *Darlingtonia californica*
This plant looks like a snake ready to strike, and is closely related to the genus *Sarracenia*. The trap is a twisted upright tube with nectar glands that attract insects toward the mouth or opening, which is under the dome. It grows in the north-eastern states of California and Oregon on ground permeated by running water.

Utricularia nelumbifolia

This highly unusual aquatic carnivorous plant inhabits the water caught in the leaf axils of epiphytic bromeliads, *Vriesia* species, which grow high in the canopy of the moist tropical forests of Brazil. The large blue-violet flowers are consequently the most obvious visible sign of the plant, although the rigid unbranched stolons by which it seeks out new water are another visible clue. The presence of the plant may ultimately prove beneficial to the host, with some of the by-products of the digested insects being absorbed by the bromeliad itself.

Distribution: Brazil.
Height and spread: 1.2m/4ft.
Habit and form: Perennial,
aquatic.
Leaf shape: Circular.
Pollinated: Insect.

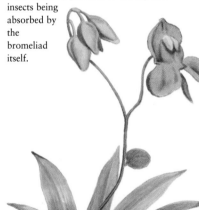

Identification: The submerged stolons are fleshy, long and much branched, the aerial stolons, to 90cm/3ft or more long, are rigid and unbranched. The leathery, circular leaves, attached near the centre to 45cm/18in stalks, are 2.5–10cm/1–4in in diameter. Numerous oval bladder traps are borne on the submerged stolons. The inflorescence, which grows to 1.2m/4ft, is erect and solitary; four to nine pouched, blue-violet flowers, 2.5–4cm/1–1½in long with a lower lip to 5cm/2in across, are borne in a lax raceme.

Left: The flowers may be seen emerging from bromeliad rosettes.

PARASITIC PLANTS

Parasitic plants are always a curiosity and in the New World the range of types is dazzling.
Many unique forms can be found, especially concentrated in the vast forests of Northern and Central
America. Despite their diversity though, many are unassuming plants and often go
unnoticed by observers unless in flower.

Western Dwarf Mistletoe

Arceuthobium campylopodum

This small parasitic plant occurs from northern Washington and eastern Idaho, south through Oregon to California and Mexico, growing at higher altitudes in more southerly locations. It parasitizes pine trees throughout its range. The plant consists of a mass of small cylindrical stems, which have no central vascular cylinder, variously coloured from green to orange-red and black, depending in part upon the host species. The tiny single-sex flowers occur in spring on young shoots and are followed by small single-seeded berries.

Right: The plant forms a small, fan-shaped bush with stems of varying colours.

Left: The flowers, which appear at the end of young shoots are up to 4mm/⅛in across.

Identification: The fan-shaped branches have hairless stems, variously coloured from greenish-yellow to orange, reddish and black, with leaves reduced to minute scales. The flowers, found on the young shoots, are generally arranged in alternating, opposite pairs or rarely whorled The fruit is an oval, one-seeded, sticky, explosive, green berry.

Distribution: Western North America.
Height and spread: 7.5–12.5cm/3–5in.
Habit and form: Partial epiparasite.
Leaf shape: Reduced to minute scales.
Pollinated: Insect.

Saltmarsh Dodder

Cuscuta salina var. *salina*

This small parasitic plant is unusual in being found in a saltwater habitat. It occurs in salt marshes, flats and ponds, mostly below 100m/330ft, often on glasswort, *Salicornia* species. It is fairly common where it occurs, with a wide range from British Columbia south to Utah, Arizona and California. The plant shows the typical leafless, twining stems of most dodders and the tiny, bell-shaped flowers appear throughout the summer. The stems, while easily discerned from the host, may be overlooked when not in flower.

Identification: This small parasitic annual attaches itself to its host with a mass orange, twining stems. The inflorescence is spike-like with short flower stems; the star-shaped tubular white flowers, up to 5mm/⅛in across, have five pointed, spreading petals.

Distribution: Western North America, from British Columbia south to Utah, Arizona, and California.
Height and spread: Variable.
Habit and form: Epiparasite.
Leaf shape: Absent.
Pollinated: Insect.

Left: Saltmarsh dodder has attached itself to a colourful host, Salicornia pacifica.

Groundcone

Boschniakia strobilacea

Distribution: California and southern Oregon, USA.
Height and spread: 7.5–18cm/3–7in only when in flower.
Habit and form: Subterranean epiparasite.
Leaf shape: Absent.
Pollinated: Insect.

This rather unusual parasitic plant is found in open woods and chaparral, on the roots of bearberry, *Arctostaphylos* species, or strawberry trees, *Arbutus* species, at elevations below 3,000m/9,850ft in California and southern Oregon. It is widely scattered, and most common in north-western California, especially in the Transverse Ranges. The plant gets its name from the cone-shaped, reddish-brown to dark purplish inflorescence, which consists of densely overlapping bracts and is the only part of the plant that appears above the soil surface. Like many parasites, it is easily missed unless you actively look for it.

Identification: The spike-like inflorescence is generally 7.5–18cm/3–7in tall, 2.5–6cm/1–2½in across, reddish-brown to dark purplish; the lower bracts, 1.5–2cm/⅝–¾in, are widely oval with a pale margin and blunt to rounded tip, densely overlapping; very short flower stalks carry up to three narrow bractlets. The calyx is cup-shaped, variably toothed, with a pointed or tapered tip; the corolla is 1.5–2cm/⅝–¾in long, purplish, with a ring of hairs in the upper tube at the base of the stamens, the upper lip entire or indented and the lower lip three-lobed; the upper filament and anther are hairy. The fruit is two- to four-valved. The whole plant is almost undetectable when not in flower.

OTHER PARASITIC PLANTS
Chaparral Broomrape *Orobanche bulbosa*
This broomrape from the south-west USA consists of a dark purplish stem arising from a round, coral-like root attachment, which is stout and thickened at the base, appearing almost bulb-like, with over-lapping scales. The flower is somewhat pyramid-shaped with tiny yellowish to purplish flowers. It is found in chaparral.

Squawroot *Conopholis mexicana*
This is a parasitic plant closely related to the broomrapes and is occasionally grouped with them. It parasitizes oaks and other woody plants in dry mountainous areas of the south-east USA and northern Mexico. All that shows above the ground is a group of yellow-brown flower spikes, resembling a small bunch of fallen pine cones.

Corynea crassa
This fleshy root parasite grows in the tropical rainforests of Central America. The bizarre flowers are the only part of the plant seen and these resemble the fruiting body of a soil fungus. In Costa Rica this remarkable fly-pollinated species is known to parasitize palms and bamboos simultaneously.

Cassythia filiformis
This species of dodder from the Caribbean belongs to the laurel family and is from an entirely different plant family to other dodders, which are in the genus *Cuscuta*. It is a good example of convergent evolution, by which a single genus from each family has independently developed a parasitic mode of life.

Thurber's Pilostyles

Pilostyles thurberi

This plant is extremely hard to see until it flowers, and even then the flower is the only part of the plant that can be seen. It is an example of a stem parasite, completing almost the whole of its life cycle inside the stem of another plant. It is found in open desert scrub, at altitudes up to 300m/1,000ft in the south Sonoran Desert, Nevada, Arizona, Texas and Mexico. The flowers appear on the stems of parasitized plants in the genus *Psorothamnus*, especially dyeweed, *P. emoryi*, in winter.

Identification: A stem parasite, the plant is largely hidden until the flower parts appear. The leaves are reduced to bracts subtending the minute, fleshy, brown or maroon flowers, less than 2mm/¹⁄₁₆in across, with four to five round or oval sepals and four to seven overlapping bracts. When the flowers fall they leave a small crater-like depression in the host stem. The fruit is a fleshy capsule.

Distribution: South Sonoran Desert, Nevada, Arizona, Texas, USA and Mexico.
Height and spread: Only flowers emerge, direct from host stem.
Habit and form: Endoparasite.
Pollinated: Insect.
Leaf shape: Absent.

Below: The only visible sign that this parasitic plant is present is when the flowers appear.

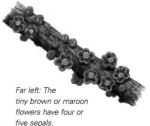

Far left: The tiny brown or maroon flowers have four or five sepals.

DUCKWEED AND ARUM FAMILIES

The duckweed family (Lemnaceae) is as widely distributed in the Americas as in Eurasia. Their familiar small green flattened stems covering waterways on both continents. The arum family (Araceae) is especially well represented in the tropical regions, with many familiar houseplants having their origins there, and although temperate areas have fewer species, some of these are very showy plants.

Giant Duckweed

Spirodela polyrrhiza

This is the largest of all North American duckweeds, with a large (compared with other duckweed species), rounded plant body. Its reddish-purple lower surface and multiple roots make it easy to distinguish from all *Lemna* species. New plants are produced in a budding pouch at the base or along the margin of the plant body; these may overwinter in the sediment as dense, rootless, starch-filled daughter plants (winter buds). Giant duckweed is found throughout the USA from sea level to 2,500m/8,200ft, in freshwater ponds, marshes and quiet streams. It is also widespread in Central America, Europe, Africa, Asia and northern Australia. It is largely absent from South America, where it is mostly replaced by *S. intermedia.*

Right: The flowers are microscopic and rarely seen.

Right: The rounded plant bodies soon form dense colonies on the water surface.

Identification: This small, clonal, floating aquatic generally occurs in clusters of two to five, in dense populations. Clusters of slender fibrous roots hang down from the lower surface. The plant body is 2–10mm/1⁄16–1⁄2in long, oblong to round, flat; the upper surface is shiny dark green, the lower surface generally red-purple, with 3–12 veins visible in backlight; the flowers, rarely seen, are minute, appearing in two lateral budding pouches, sheathed by minute membranes. The fruit is balloon-like, sometimes winged, containing a ribbed seed.

Distribution: USA, Central America, Europe, Africa, Asia and northern Australia.
Height and spread: Unlimited spread.
Habit and form: Floating aquatic.
Leaf shape: Leaves absent.
Pollinated: Water.

Skunk Cabbage

Symplocarpus foetidus

This North American plant of wet woodland, marshes and stream banks is one of the first to bloom in spring, although its flowers are often partly or wholly hidden beneath the previous year's fallen leaves. Like many other dark-coloured flowers, skunk cabbage is pollinated mostly by flies. The flowers actually produce heat, which is, of course, a benefit to any early flies out in cold weather. The leaves emerge after the flowers and smell unpleasant if they are crushed.

Identification: The large leaves, 30cm/12in or more across, are oval, heart-shaped at the base, bright waxy green, appearing after the flowers have bloomed; they are highly malodorous when crushed. The flowers appear from late winter to mid-spring: the actual flowers are tiny, located on the ball-like spadix inside the hooded, purplish-brown and green spathe, which is 7.5–15cm/3–6in tall.

Above: The flowers often appear as soon as the winter snows melt.

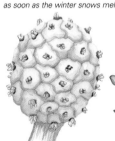

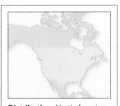

Distribution: North America.
Height and spread: 30–60cm/1–2ft.
Habit and form: Herbaceous perennial.
Leaf shape: Ovate.
Pollinated: Insect.

Below: The unpleasant-smelling leaves give this plant its common name.

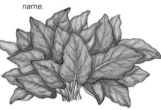

Jack in the Pulpit

Indian turnip, *Arisaema triphyllum*

Distribution: Eastern North America, Canada to Florida and westward to Kansas and Minnesota.
Height and spread: 65cm/26in.
Habit and form: Herbaceous perennial.
Leaf shape: Trifoliate.
Pollinated: Insect.

Right: The leaves are prominent.

Far right: A cluster of bright red, shiny berries appears from late summer.

This common perennial has a wide distribution, stretching from Canada to Florida and westward to Kansas and Minnesota, where it can almost always be found near waterfalls or where water is running or splashing. Its large leaves, divided into three, radiate out from the top of the stalk and are usually the most noticeable feature, with the flowers mostly hidden beneath them. The flowers are enclosed in a green-and-purplish spathe and appear through the spring and into the summer. Later in the summer, the flowers are replaced by a black seed cluster that ripens to red.

Identification: The underground portion, usually referred to as the root but botanically known as a corm, is shaped like a turnip. The lower part is flat and wrinkled, while the upper part is surrounded by coarse, wavy rootlets. The leaves are basal, usually two, but sometimes one, each divided into three almost equal parts, 7.5–15cm/ 3–6in long. The flowering structure is irregular in shape, with a spathe up to 7.5cm/3in long, green with purple or brownish stripes, and a spadix covered with tiny male and female flowers.

OTHER DUCKWEED AND ARUM
FAMILY SPECIES

Green Dragon *Arisaema dracontium*
A herbaceous perennial reaching 90cm/3ft, with one basal leaf, which is divided into 7–15 leaflets. The yellowish-green flowers are irregular in shape, first appearing in late spring and continuing into early summer. A very long, slender spadix extends far above the top of the sheathed spathe.

Flamingo Flower *Anthurium scherzerianum*
Extremely well known in cultivation, the wild plant is restricted to moist forest areas of Costa Rica. Spotted green foliage gives rise to orange-red flower spikes, held out above the highly ornamental, bright red, waxy spathes. The plant may grow terrestrially in open areas or as an epiphyte in thick forest.

Arrow Arum *Peltandra virginica*
An immersed plant that is found in swamps and marshes, most commonly along the Atlantic coastal plain. Its range appears to be actively expanding. Its leaves are arrow-shaped, clustered on long, succulent stems. Small, light yellow flowers, surrounded by a yellowish-green spathe, appear in spring and early summer.

Golden Club *Orontium aquaticum*
A herbaceous perennial found in swamp areas on the Atlantic coast of North America. It has bluish-green leaves covered in a powdery bloom that causes the water to bead. In spring, tiny yellow flowers are borne on a spadix at the end of a white cylindrical stalk.

Swamp Lantern

Yellow skunk cabbage, *Lysichiton americanus*

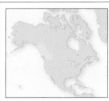

Distribution: Pacific north-west.
Height and spread: 40cm/16in or more.
Habit and form: Herbaceous perennial.
Leaf shape: Ovate-oblong.
Pollinated: Insect.

This common perennial plant is ubiquitous in the wetlands of the Pacific north-west. The large yellow spathes emerge very early in spring from a thick dormant bud and are extremely noticeable. The plants grow to 40cm/16in tall or more, with enormous, net-veined leaves. The pungent, skunk-like odour attracts various insect pollinators and is responsible for the plant's other common name, skunk cabbage.

Identification: The leaves are bold, oval to oblong, heart-shaped or straight at the base with wavy margins, smooth, green, soft-textured and prominently veined below. They are produced in loose rosettes, three to six per head, shortly after the flowers, ultimately appearing rather wilted, with a musky smell when bruised. The leaf stalks are short, pale, grooved above and winged. The bright yellow spathe is oval to lance-shaped, arising in late winter or early spring. The cylindrical spadix is short at first, lengthening in the fruiting stage. The fruits are green.

Left, right and above right: The yellow flowers of the swamp lantern are soon obscured by the large, cabbage-like leaves.

BANANA AND GINGER FAMILIES

The banana family (Musaceae) has only one genus and about 50 species. It is represented in the Americas by the genus Heliconia, *although this is sometimes considered as a separate family (Heliconiaceae) or with the Strelitziaceae. Zingiberaceae, the ginger family, comprises 47 genera and about 1,000 species with a wide distribution, mainly in the tropics.*

Parrot's Beak

Popokaytongo, *Heliconia psittacorum*

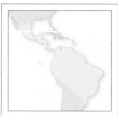

This herbaceous, upright, small *Heliconia*, native to Central and South America, is highly variable. It is found in forests, although it is also common in meadows and some savannas, like buttercups in cooler regions, usually forming dense clonal colonies with erect, leafy shoots in groups of 50 or more. It generally grows to no more than 60cm/2ft tall. Parrot's beaks are exotic flowers, consisting of orange-red bracts with a dark spot at the end, arising from a central point on the stem. They are abundantly produced all year round.

Distribution: Central and north South America.
Height and spread: 60cm/2ft.
Habit and form: Herbaceous perennial.
Leaf shape: Obovate.
Pollinated: Hummingbird.

Identification: A rhizomatous herbaceous plant with pseudostems composed of overlapping, sheathing leaf bases. The large leaves, in two vertical ranks with smooth margins, resemble those of bananas. The flowers, in erect or pendent inflorescences, consist of brightly coloured, leaf-like bracts, arranged on two sides or spirally, each subtending a coiled cyme of flowers, each flower in turn subtended by a membranous floral bract; the true flower consists of two whorls joined at the base with varying degrees of fusion within and between the whorls. The fruit is a one to three-seeded drupe, blue or red to orange at maturity.

Right: The bright orange flowers have a dark spot at the end and are produced abundantly throughout the year.

Wild Plantain

Balisier, *Heliconia caribaea*

The tree-like *Heliconia caribaea* is actually a herbaceous plant, the stems being made up of leaf bases. It is native to Jamaica, east Cuba and St Vincent, although it has been widely planted outside this range and, along with its numerous cultivars, has become naturalized across tropical America and beyond. The flowers can be held high on tall stems with the red spathes contrasting vividly with the white flowers. The blue fruit that follows is also eye-catching.

Distribution: Jamaica, East Cuba and St Vincent, West Indies.
Height and spread: 2.5–5m/8–16ft.
Habit and form: Tree-like herbaceous plant.
Pollinated: Hummingbird.
Leaf shape: Oblong.

Identification: Large pseudostems arise from a thick underground rhizome. The leaves are up to 1.2m/4ft long, oblong, with an abruptly pointed tip and rounded base, on leaf stalks up to 60cm/2ft long, often glaucous or thickly waxy. The inflorescence is 20–40cm/8–16in long, erect and straight, with 6–15 bracts up to 25cm/10in long arranged in two overlapping rows; they are broadly triangular, red or yellow, sometimes with green or yellow keels and tips. Each bract bears 9–22 flowers with straight or slightly curved sepals up to 6cm/2½in long, white with green tips; the upper sepals curve upward, the lower sepals are spreading. The fruits are up to 15mm/⅝in long.

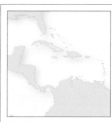

Left: The tree-like growth resembles a banana plant and gives rise to the common name.

Expanded Lobster Claw

Heliconia latispatha

This tree-like herbaceous plant is native to Mexico, and Central and South America, although it is very widely cultivated and has become naturalized far outside this range. It is frequently found along forest edges growing in full sun to half shade. There is some colour variation in the bracts, ranging from orange to red. The erect inflorescences of spirally arranged bracts appear all year round, but more abundantly from late spring through summer, with each inflorescence lasting for several weeks on the plant.

Distribution: Mexico, Central and South America.
Height and spread: 3m/10ft.
Habit and form: Tree-like herbaceous plant.
Pollinated: Hummingbird.
Leaf shape: Broadly oblong to ovate.

Right: The inflorescence stem curls in alternating arcs between each of the claw-shaped flower bracts.

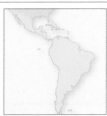

Identification: Pseudostems arise from a thick underground rhizome. The leaves are up to 1.5m/5ft long, broadly oblong oval, sometimes edged red. The inflorescence is 30–50cm/12–20in long, erect, held above the leaves; it consists of 20–30 slender, spreading keeled bracts, spirally arranged, not overlapping, dark red or orange to green-yellow; the flowers are yellow, edged and tipped with green.

OTHER BANANA AND GINGER
FAMILY SPECIES

Spiral Ginger *Costus malortieanus*
A familiar sight in the rainforests of Costa Rica down as far as Brazil. Spiral ginger is most noteworthy for its spiralling stems, which are thought to be an adaptation to make the best of available light. The pyramidal flower spikes are held at the end of leafy stems, with one small, tubular, yellow flower arising from each bract.

Shining Bird of Paradise *Heliconia metallica*
Native from Honduras to Bolivia, this *Heliconia* is more noteworthy for its handsome foliage than its pretty but comparatively less significant inflorescences. The leaves are a satiny dark green with a light midrib and often a wine-purple underside. The pink or red flowers and greenish bracts are held on long stalks away from the leaves.

Hanging Heliconia
Heliconia rostrata
This native of Colombia, Venezuela, Ecuador, Peru and Bolivia is frequently found at relatively low elevations, along seasonally flooded Amazon tributaries. Its popularity in cultivation has led to its spread throughout the tropical world. Pendent inflorescences of red and yellow bracts last for several weeks on the plant.

Monkada

Renealmia Cernua

Monkada is a tall and showy ginger plant, with hard and waxy orange and yellow bracts held terminally and reminiscent of a pineapple. The light green foliage is wavy on the edges and notable for its "ginger" scent when crushed. It is most commonly encountered in humid areas and on slopes beneath trees, being widely distributed in forested tropical regions from Mexico to South America.

Identification: An aromatic perennial herb, 90cm–5m/3–16ft tall with leafy stems, leaves two ranked. The leaves are 10–45cm/4–18in long, narrowly elliptic, acuminate, glabrous. Inflorescence racemose, terminal on long stems, to 25cm/10in long, ovoid, bracts red to yellow, sometimes tinged green, triangular, acute. Calyx to 12mm/½in long, tubular, three-lobed, same colour as bracts; corolla to 2.5cm/1in long, yellow to white; petals to 8mm/⅜in long, lip erect, not spreading, three lobed, to 8mm/⅜in long, yellow to white, ovate, base and margin pubescent. The fruit is a fleshy capsule.

Distribution: Central and South America.
Height and spread: 90cm–5m/3–16ft tall.
Habit and form: Herbaceous.
Leaf shape: Elliptic.
Pollinated: Birds and probably insects.

Below: The waxy orange and yellow bracts are somewhat pineapple-like.

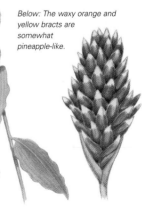

IRIS FAMILY

*There are about 80 genera and 1,500 species in the Iridaceae, or the iris family. The flowers of most
New World Iridaceae occur as spikes at the top of branched or unbranched stems, each with six petals in
two rings of three. Many of the American family members are extremely showy and it is in Central and
South America that an especial richness of species is encountered.*

Tough-leaf Iris

Oregon iris, *Iris tenax*

This deciduous perennial from north-western USA is found in pastures, fields
and open oak woodlands, although it is unusual in coniferous
forests unless they have been logged. It has a wide colour range
from purple and lavender to white, cream and yellow. Where
they occur, the handsome flowers often provide brilliant colour
displays along highways. The species name *tenax* is from the
Latin for "tenacious", referring to the tough leaves, which
were once used by Native Americans to make
strong, pliable rope and cord.

Identification: The
leaves are green and
linear, tinged pink at the base,
growing as tall as or taller than
the numerous flower stalks.
The flowers, 7.5–10cm/3–4in
across, appear in early
summer, one to two at the top
of short stalks 30cm/12in tall; they
are palest yellow to lavender or red
purple, with lance-shaped falls
2.5cm/1in wide, reflexed, with a white
or yellow central patch, suffused with
purple veins, and lance-shaped standards
1cm/½in wide.

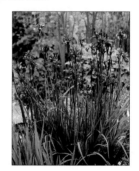

Distribution: North-western
North America.
Height and spread:
30cm/12in.
Habit and form: Herbaceous
perennial.
Leaf shape: Linear.
Pollinated: Insect.

*Left: Tough-leaf iris is an attractive
plant that is often cultivated in
gardens for its showy blooms.*

Prairie Blue-eyed Grass

Sisyrinchium campestre

This herbaceous perennial is found throughout the tall-
grass prairie regions of North America, on the sandy soils of
open areas. It is especially attractive after a controlled burn,
when it is more noticeable. When not in bloom, it easily can be
mistaken for a grass because of its grass-like leaves. It sports
lavender to violet blossoms in early summer: as with many small
prairie plants, it blooms relatively early in the year to take better
advantage of the sun. The small, pea-like seedheads contain
several small seeds.

Identification: This fibrous-rooted, often tufted, herbaceous perennial is covered with
a fine bloom. It is sometimes purplish at the base with mostly basal, linear, grass-like
leaves up to 3mm/⅛in wide. The flower stems are narrowly to broadly winged, with one
or several flowers borne terminally, subtended by a two-bracted spathe: the outer bract
is up to three times longer than the inner bract, and its margins are united above the
base. The flower is blue-violet with a yellow centre and six regular petals with broadly
pointed or rounded tips, 15mm/⅝in long. The three stamens are united by their filaments
around the three-branched style. The fruit is a rounded, straw-coloured capsule containing
numerous black seeds.

Distribution: North America.
Height and spread:
10–45cm/4–18in.
Habit and form: Herbaceous
perennial.
Leaf shape: Linear.
Pollinated: Insect.

Tiger Flower

Tigridia pringlei

This bulbous perennial plant is native to Mexico and is most noteworthy for its large and brilliantly coloured iris-like flowers. The flowers are short-lived but flower in succession, one at a time on each inflorescence. The flower colours are quite variable and the ease of producing cultivars has led to this plant being widely cultivated both in the tropics and temperate regions. Consequently, it occasionally occurs outside its natural range as a garden escapee.

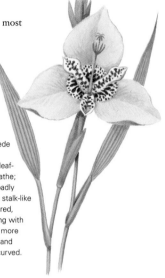

Distribution: Mexico.
Height and spread: 80–125cm/32–50in.
Habit and form: Herbaceous perennial.
Leaf shape: Lanceolate.
Pollinated: Insect.

Identification: The basal leaves of this bulbous plant, which precede the flowers, are up to 50cm/20in long, lance-shaped, pleated and ranked alternately in a fan shape; the stem leaves are reduced to leaf-like bracts. On the flowering stem a few flowers are borne per spathe; they are large, showy, and shallowly cupped, with three outer, broadly oval, pointed, spreading segments 5–10cm/2–4in long, with broad stalk-like bases, orange, bright pink, red, yellow or white, variously spotted red, brown or maroon at the base; the three inner segments, alternating with the outer ones, are one-third as long, of similar ground colour but more distinctly marked. The staminal tube, 5–7.5cm/2–3in long, is erect and protrudes far beyond the flower cup; the anthers are erect and incurved.

OTHER IRIS FAMILY SPECIES

Copper Iris *Iris fulva*
From the south-eastern USA, this iris grows in moist areas in wetlands and along bayous. The beardless, crestless, deep copper flowers bloom in late spring, and the bright green, sword-shaped leaves remain attractive all through the growing season. The flowers attract hummingbirds.

Yellow Star Grass *Hypoxis curtissii*
A herbaceous perennial growing in glades and open woods throughout the eastern and mid-western USA, mainly on the coastal plain in alluvial soil or wooded swamps. The yellow blooms, with six parts, first appear in mid-spring and continue into mid-autumn. There may be two to nine flowers, usually there are three.

Western Blue Flag *Iris missouriensis*

The western blue flag or Rocky Mountain iris is indigenous from south Dakota to southern California, reaching north to British Columbia. It is a perennial with pale lavender flowers that often emerges through snow in spring. It grows in sunny, open, moist areas such as meadows surrounded by forests, and is most often found in extensive, dense patches in moist meadows from the foothills to the mountains.

Pinewood Lily

Propeller flower, *Alophia drummondii*

This lovely and interesting member of the iris family is native to the southern USA and Mexico. The plants grow from small, shallow bulbs and form loose colonies in sandy soils in lightly wooded areas. The velvety purple to red-purple flowers resemble those of *Tigridia* but they face to one side, unlike *Tigridia* flowers, which face upward. Each flower lasts only one day but the blooms open in succession. The plants are dormant in winter and flower from late spring until autumn.

Distribution: Southern USA and Mexico.
Height and spread: 15–40cm/6–16in.
Habit and form: Herbaceous perennial.
Leaf shape: Narrowly to broadly lanceolate.
Pollinated: Insect.

Identification: The leaves, rising from the oval truncated corm, are 15–30cm/6–12in long, narrowly to broadly lance-shaped and strongly pleated. The flowering stem, simple or forked, appears in spring, bearing a few-flowered terminal raceme subtended by two spathes. Each flower has three rounded outer segments, up to 2.5cm/1in long, and three narrow inner ones, 15mm/⅝in long; they are red-purple to indigo or violet, fading to white, spotted brown at the centre and on the claws, with margins inrolled to a central band of hairs.

WATER LILIES

Nymphaeaceae, the water lily family, are aquatic plants of five genera and 50 species. They have showy flowers on long stalks, and are often considered the most "primitive" of the flowering plants. In the New World there are some truly remarkable examples of these plants: the family reaches its zenith in the gargantuan plants of the Victoria *genus, with their giant leaf pads and curious, night-blooming flowers.*

Spatterdock

Yellow cow lily, yellow pond lily, *Nuphar polysepala*

This perennial, water-lily-like plant from western North America can form extensive stands in the shallow waters of lakes, ponds, sluggish streams and canals. Mature plants have large "elephant's ear" leaves and yellow flowers. Unlike the showy, many-petalled fragrant water lily flowers, spatterdock blossoms are simple yellow globes that partially open to reveal reddish poppy-like centres from early to late summer, standing just above the water surface. The leaves float on, or stand above, the water, on thick, fleshy stalks.

Identification: Fibrous roots anchor the scaly, log-like rhizomes to the sediment; the rhizomes are up to 20cm/8in in diameter and 5m/16ft long. The leaves are 10–45cm/4–18in long and 7.5–30cm/3–12in wide, green, heart-shaped, with a notched base, a blunt tip, a prominent mid-vein and a leathery surface; they rise directly from the rhizome, floating on or extending above the water. In early summer, large, delicate underwater leaves resembling lettuce precede the floating leaves. The flowers arise directly from the rhizome in summer. They are waxy, bright yellow, cup-shaped globes, 5–10cm/2–4in across, rising above the water; they usually have nine sepals, but can have up to 17; the stamens are reddish. The flowers are sweetly scented on the first day after opening, malodorous later.

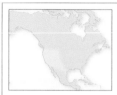

Distribution: Western North America.
Height and spread: 5m/16ft or more.
Habit and form: Floating, aquatic perennial.
Leaf shape: Cordate.
Pollinated: Insect, especially flies.

Left: The fruits are urn-shaped. *Below: The leaves float.*

American Lotus

Yellow lotus, water chinquapin, *Nelumbo lutea* syn. *N. pentapetala*

This deciduous, perennial water plant occurs in quiet waters in ponds, lakes and the edges of slow-moving streams and rivers of eastern North America, the West Indies, Central America and south to Colombia. Its large, spongy rhizomes penetrate the mud beneath the water by as much as 2.5m/8ft, and the showy pale yellow flowers appear in late spring and summer. They are as magnificent as those of its Asian relative, *N. nucifera*, but it is less cultivated for ornament. It was probably originally confined to the floodplains of major rivers and their tributaries in the east-central United States, and was carried northward and eastward by Native Americans.

Identification: The stems arise directly from the rhizomes, reaching 2m/6½ft or more. The leaves may be 60cm/2ft or more across, with the stalk attached to the underside of the leaf at its centre, without the cleft seen in *Nymphaea* species. The leaves float on the surface, flattened, in deep water, or stand above it in shallow pools; the margins tend to rise above the centre, creating a "funnel" effect. The leaves are dull-satiny blue-green on top and pale green with prominent veins underneath. The large flowers, 25cm/10in across, have numerous pale yellow tepals, and anthers to 2cm/¾in long. Each bloom is borne singly on a long, stiff stalk, standing above the leaves. The woody rounded seedpods have a distinctive, flattened, pierced top like a showerhead.

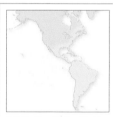

Distribution: Eastern North America, West Indies, Central and South America.
Height and spread: Forms extensive colonies.
Habit and form: Aquatic perennial.
Leaf shape: Orbicular.
Pollinated: Insects.

Above left: Native Americans used the seeds and tubers for food.

Left: The blooms are held on long stems.

Royal Water Lily

Amazonian giant water lily, *Victoria amazonica*

Distribution: Equatorial Brazil.
Height and spread: Forms extensive colonies.
Habit and form: Aquatic perennial.
Leaf shape: Orbicular, extremely large.
Pollinated: Beetle.

This giant water lily was "discovered" in 1801 and caused a stir when it was introduced to Europe in the mid-1800s. It is native to equatorial Brazil, where it grows from large, tuberous rhizomes in the calm waters of oxbow lakes and flooded grasslands along the Amazon River. Its gargantuan, glossy green leaves grow to 2.1m/7ft in diameter, with a pronounced maroon lip around the circumference. The lush, 30cm/12in flowers are variously white or pink on the same plant. They open at night, and have a pineapple fragrance.

Identification: The floating leaves, on long stalks, are 1.2–1.8m/4–6ft across, oval with a deep narrow cleft at one end, becoming almost circular when full grown, with the margin turned up all round, green above, deep purple below, with prominent flattened, spiny ribs, united by cross ribs. Round, prickly stalks bear solitary flowers 25–38cm/10–15in across, pear-shaped in bud, fragrant, with numerous petals; they open white on the first night, becoming pink later.

Below: Although this plant is famed for its leaves, the night blooming flowers are also spectacular.

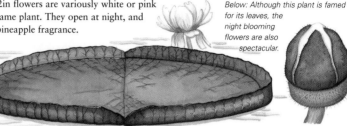

Banana Water Lily

Yellow water lily, Mexican water lily, *Nymphaea mexicana*

This aquatic perennial was identified from specimens collected in Mexico, although it is also found in east and south Texas and in Florida. It grows in standing water, where its round floating foliage acts as a foil for the showy, fragrant, multi-petalled yellow flowers. It grows from a stout, tuberous rhizome and spreads by runners, typically inhabiting water 45cm/18in deep. It was abundant throughout Florida until the introduction of *Eichhornia crassipes*, which has crowded it out from former strongholds.

Identification: Stems arising directly from the submerged rhizome bear oval to circular leaves, floating or emergent, with smooth to toothed or wavy margins; they are shiny deep green, blotched brown above, reddish-purple below, 10–20cm/4–8in across, split from one edge to the stalk, with pointed or rounded lobes, sometimes overlapping. The flowers appear from spring to autumn, with a musty fragrance.

Distribution: South-east USA and Mexico.
Height and spread: Forms extensive colonies.
Habit and form: Deciduous or evergreen aquatic perennial.
Leaf shape: Ovate to orbicular.
Pollinated: Insect, probably beetles.

Below: The leaves and flowers can stand above the water.

Right: The flowers are fragrant.

GRASSES, RUSHES AND SEDGES

The grasses and their allies are an important element of the vegetation of North and South America,
where they can be found almost everywhere except for dense forest cover. Many of the species found in
the Americas have wide distributions across both continents. It has been estimated that the grass family
(Poaceae) is the principal constituent of around 20 per cent of the world's terrestrial habitats.

Giant Bamboo

Canebrake, rivercane, *Arundinaria gigantea*

Occurring widely along rivers and streams in the southern
USA, in well-drained floodplain forests, this bamboo has a
broad tolerance for weather and soil. It grows from sea level
to 600m/2,000ft and can withstand extreme
temperatures of -20–40°C/-4–104°F. It spreads by large
fast-growing rhizomes to make extensive colonies,
and once formed large dense stands called
canebrakes in the floodplains of
south-eastern rivers.

Identification: Woody perennial and
semi-evergreen smooth stems,
3cm/1¼in in diameter, emerge
from the axils of strong, rapidly
spreading rhizomes, forming dense
stands. The leaves, borne on two-
year old stems, are 7.5–20cm/3–8in
long and 2.5cm/1in wide, with parallel
venation, crowded at the tips. The flowers
appear in early spring at irregular intervals of
several years; panicles form on the branches on
older portions of stem or directly from the rhizomes,
consisting of a few racemes of large many-flowered
spikelets. The fruit is a furrowed grain enclosed in
the flattened spikelets.

Above: Giant bamboo's tree-like
stems are a familiar sight in flood
plain areas of the southern USA.

Left: Despite its giant
proportions, the flower
spikes reveal that this
is a grass.

Right: The spreading
rhizomes enable the
development of dense,
extensive colonies.

Distribution: Southern USA.
Height and spread:
60cm–4m/2–13ft or more.
Habit and form: Woody
grass (bamboo).
Leaf shape: Linear.
Pollinated: Wind.

Oreobolus pectinatus

This grass-like herbaceous perennial is
common in the Pacific coastal regions of
temperate America, with a wide distribution
from the coast up to montane meadows at
altitudes of 3,700m/12,000ft or more.
It ranges from Washington
State, east to Colorado
and south to Texas in
the USA, and grows
widely in South
America. It forms a
tight, hummocky mass,
flowering between late
spring and late summer
depending on latitude and
altitude and in cooler climates it
is more likely to be an annual.

Identification: This annual or herbaceous perennial
grows with or without rhizomes, which are generally
heavy with scale-like leaves where present. The
slender stems are cylindrical or flat, erect or
generally spirally twisted. The leaves are basal in
loose sheaths, the upper sheaths
generally bearing
5–20cm/2–8in blades that
resemble the stem,
well developed,
cylindrical or flat, or
reduced to a small
point; short, firm
appendages are often
present at the blade-
sheath junction. The flowers
are generally terminal, although
often appearing lateral, with three or
six stamens and one pistil; the seeds
are numerous.

Distribution: Washington
State, Colorado and Texas,
USA, and South America.
Height and spread:
10–60cm/4in–2ft.
Habit and form: Grass-like
herbaceous perennial.
Leaf shape: Linear.
Pollinated: Wind.

OTHER GRASSES, RUSHES AND
SEDGES OF NOTE
Abrupt-beaked Sedge *Carex abrupta*
A grass-like herb found in coastal prairie, forests,
meadows, slopes and wetlands of the USA to
elevations of 3,500m/11,500ft. The separate
male and female plants have sharply three-
angled, solid stems, with spikelets generally
arrayed in a raceme, panicle, or head-like cluster.

Globe Flatsedge *Cyperus echinatus*
Occurring chiefly in upland prairies, sand prairies,
glades, dry upland forests, pastures and
disturbed sites, in the east and south USA, this
species can be identified by its spherical flower
clusters, red base, and short, knotty rhizomes,
and by the long bracts that subtend the
inflorescence, which appears in summer.

Fragrant Flatsedge *Cyperus odoratus*
An annual sedge with oval flower spikes and
elliptic to oval, light brown flower bracts,
6–24 per spikelet, which are splotched reddish
with a conspicuous mid-vein, appearing from
midsummer to autumn. It is found in wet,
disturbed soils in tropical and warm temperate
parts of south-west North America.

Shore Rush *Juncus biflorus*
The shore rush is unusual in possessing leaf
blades. It is usually encountered along sandy,
wet shores and ditches as single clumpy plants
or abundant colonies, throughout the deep south
and extending into the south-west of North
America. The dense, dark-flowered
inflorescences occur at the stem tips in summer.

Big-leaf Sedge

Ample-leaved sedge, *Carex amplifolia*

This grass-like perennial has one or more
sharply triangular stems, which arise from
long, stout, creeping rhizomes. The smooth,
flat leaves are distributed evenly along the
stems. A single spike of male flowers
appears at the tip of the stem, and
several female spikes appear on short
stalks below, in summer. It is found in
swamps, bogs and other wet places,
from lowlands to moderate
elevations in the mountains, from
British Columbia to
California, being
frequent and locally
plentiful in the western
portion of its range.

Identification: The stems are
coarse and stout, sharply triangular,
usually tinged dark red toward the
base, with some bladeless leaf sheaths,
and with the dry leaves of the previous
year present. The leaves are light to blue-
green, 8–20mm/⅜–¾in wide. The leafy
bracts are slightly sheathing, the lowest
usually surpassing the inflorescence of several
elongated, well-separated, greenish-brown
flower spikes, of which the male is narrow
and terminal, and the females lateral,
narrowly cylindrical, closely flowered,
short-stemmed or stalkless.

Distribution: British
Columbia to California.
Height and spread:
50–100cm/20–39in.
Habit and form: Grass-like
herbaceous perennial.
Leaf shape: Linear.
Pollinated: Wind.

*Below: The tall flowering stems
often form dense stands in
marshy areas along its range.*

Saltmarsh Bulrush

Bolboschoenus maritimus syn. *Schoenoplectus robustus*

Distribution: Cosmopolitan
in Northern Hemisphere,
South America and Africa.
Height and spread: Variable
to 50cm/20in or more.
Habit and form: Grass-like
herbaceous perennial.
Leaf shape: Linear.
Pollinated: Wind.

This grass-like perennial is one of the most
widely distributed plants of the
Northern Hemisphere, being
more or less circumpolar in boreal
and temperate regions. It occupies a
wide range of habitats up to at
least 3,000m/10,000ft and from
just inside the Arctic Circle to
Mediterranean regions. It has a
scattered occurrence in South
America and Africa and is
encountered in various other
warm parts of Eurasia. It is
remarkable in its range of
tolerances, from coastal marsh to
dry rangeland, and is quite variable
as a consequence, leading to its having
been classified and re-classified by
botanists under several synonyms.

Identification: A grass-like herb with
creeping, branching, scaly rhizomes. The
stems are solitary, tuberous, and swollen at
the base, arising from rhizomes, three-
angled, leafy below. The tapered leaves,
to 35cm/14in long, exceed the stems;
the sheaths are often membranous, the
lower ones often lacking blades. A
terminal inflorescence appears in summer,
subtended by leaf-like, rough bracts, twice
its length; it bears between
one and ten pointed
brown spikelets, up to
3cm/1¼in long, stalkless
or on arching stalks.

*Right: The grass-like flowering
stems of this herbaceous
perennial are a common sight
across much of the world,
especially on wet soils.*

AMARYLLIS FAMILY

The amaryllis family (Amaryllidaceae) is chiefly restricted to the southern half of North America but is widely distributed across Central and South America. Many of the plants in the family have large, showy flowers, and a number of these have found their way into cultivation as a consequence of this and may become naturalized away from their original range.

Empress of Brazil

Blue amaryllis, *Worsleya rayneri* syn. *Hippeastrum procerum*

This plant is the only species in the genus. It is restricted to certain cliffs in the Organ Mountains in southern Brazil. The arching evergreen leaves and umbels of large and beautiful lilac-blue flowers are a magnificent sight, although rarely seen except in cultivated specimens. The bulb has an unusually long neck, which projects horizontally or hangs from moist cliffs.

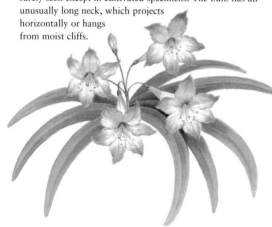

Identification: An evergreen, bulbous perennial, growing from pear-shaped bulbs up to 15cm/6in in diameter at the base, usually with several clumped together. They appear stem-like due to their thick, tapering, aerial necks, up to 90cm/3ft long, formed from sheathing leaf bases. The 12–14 leaves, up to 90cm/3ft long, are strap-shaped, thick, smooth, pale green to blue-green, two-ranked and usually arching. A terminal umbel on a stout, leafless stem bears 4–14 tubular flowers on 7.5cm/3in stalks. The flowers are lilac to heliotrope or opalescent-blue, speckled mauve within and white at the base, with six curving, pointed lobes up to 15cm/6in long. The stamens are much shorter than the lobes, and the style is longer than the stamens.

Distribution: Organ Mountains, southern Brazil.
Height and spread: 2m/6½ft.
Habit and form: Evergreen bulbous perennial.
Leaf shape: Strap-shaped.
Pollinated: Insect.

Urceolina urceolata

Confined to the Peruvian Andes, this bulbous perennial has curiously shaped flowers that hang down on slender stalks. The lower part of the stalk-like flower tube swells abruptly into an urn-like upper part, giving rise to the generic name, which means "little pitcher". The stalked leaves usually develop later than the flowers, which are normally yellow with green-and-white tips.

Left: The yellow flowers with green tips appear in spring and are up to 8cm/2¾in long.

Identification: Four hairless, oval to oblong, pointed leaves, up to 50cm/20in long and 15cm/6in wide, bright green above, paler below, on 10cm/4in stalks, appear simultaneously with the flowers. In spring and summer, a leafless, solitary stem bears a small umbel of four to six nodding, tubular flowers up to 10cm/4in long, the upper two thirds urn-shaped, usually yellow, more rarely cinnabar-red, orange or white, with green tips and sometimes with white margins. The fruit that follows is a capsule.

Distribution: Peruvian Andes.
Height and spread: 30cm/12in.
Habit and form: Herbaceous, bulbous perennial.
Leaf shape: Ovate to oblong.
Pollinated: Insect.

Glory of the Sun

Leucocoryne ixioides

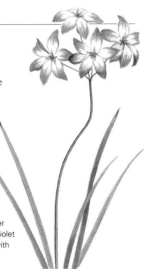

This South American bulbous plant is distantly related to the onions, *Allium* species, differing in having three fertile stamens instead of six. The plant's name is derived from the Greek words *leukos* meaning "white" and *koryne* meaning "club" referring to the prominent, infertile anthers. The flowers appear in spring and can be white, pink or pale lilac, with the plant being very variable in its wild setting. Ranging from Colombia to Valparaiso, it is especially abundant between the region of Coquimbo and the river Bío Bío in Chile.

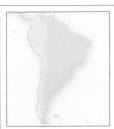

Distribution: Colombia to Chile.
Height and spread: 45cm/18in.
Habit and form: Herbaceous bulbous perennial.
Leaf shape: Linear.
Pollinated: Insect.

Identification: The leaves are basal, slender and grass-like, withering before the flowers appear. Six to nine fragrant flowers in a loose umbel appear in spring on stalks up to 6.5cm/2½in long; they have six tepals, with the lower parts fused into a white basal tube and the upper parts free and spreading, white or more usually deeply edged lilac to violet blue. Three slender, cylindrical yellow-white staminodes, sometimes with dark tips, are joined to the perianth at the mouth of the basal tube.

OTHER AMARYLLIS SPECIES OF NOTE

Barbados Lily
Hippeastrum puniceum
This is the most widespread species in this genus, common in open situations and ranging across Central America, the West Indies and much of tropical South America. Its tall stems bear between two and four large, elegant, bright red, orange or pink flowers, and as a consequence it has become popular in cultivation.

Coicopihue *Philesia magellanica*
This small, low-growing shrub has deep rose, waxy flowers. It is a fairly common evergreen plant in the cold, wet, swampy rainforests of southern Chile. It has a "box-like" habit of growth, spreading by subterranean stolons that can grow up to 1.2m/4ft. The leaves are small, leathery and glossy green.

Quamash *Camassia quamash*
A bulbous perennial from western North America. It ranges from British Columbia and Alberta to California and Wyoming. It can be found in moist meadows and on grassy slopes and flowers in early to mid-spring. It has linear basal leaves and racemes of light to deep violet-blue, star-shaped flowers on tall green stems.

Pinebarren Deathcamas *Zigadenus leimanthoides*
The deathcamas is a bulbous perennial from western North America, ranging from Canada to Utah and New Mexico. The long, narrow leaves grow from the base of the plant, and the small, creamy-white, star-like flowers are held on a long, single or branched raceme on a tall smooth stem.

Narrow-leaved Onion

Allium amplectens

This perennial North American onion is found in yellow pine forest, foothill woodlands, grassy summits or slopes and more occasionally fields, streamsides or creek beds up to 1850m/6000ft, ranging from British Columbia to southern California. It thrives in clay soils and is common where it occurs. The four narrow leaves are grass-like and easily missed until the open umbels of peach, rose or white florets appear in late spring or early summer. These become papery once they have opened and persist in this state until the seedpod develops. It has a strong onion smell.

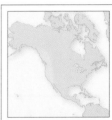

Distribution: British Columbia to southern California.
Height and spread: 20–50cm/8–20in.
Habit and form: Herbaceous, bulbous perennial.
Leaf shape: Linear.
Pollinated: Insect.

Identification: The bulbs, up to 2cm/¾in across, are solitary or on rhizomes, reforming each year, dividing at the base into daughter bulbs. Two to four narrow, flat, basal leaves, shorter than the stem, become twisted with age. The numerous flowers are borne in a spherical umbel on slender stalks up to 15mm/⅝in long; they have pointed, white to pink tepals, which become papery after opening, with shorter stamens, filaments broad at the base and yellow or purple anthers.

LILIES AND ALSTROMERIAS

The lily family (Liliaceae) is a very large and complex family, comprising about 280 genera and 4,000 species and is well represented throughout the Americas. The family has been revised recently and a number of its members moved into other families. The alstroemeria family (Alstroemeriaceae) is an offshoot of the amaryllis family and is centred on the Neotropics of Central and South America.

Large-flowered Bellwort

Fairy bells, *Uvularia grandiflora*

This clump-forming, erect herbaceous plant of moist woods in mountain regions, is found throughout most of eastern North America except the extreme north, and is usually confined to calcareous or limestone soils, although it is relatively common where it does occur. The yellow, bell-shaped flowers with six, partially twisted tepals, are held singly at the end of branched stems that appear to pass through the somewhat twisted, bright green leaves. It has the peculiar habit of drooping while in flower only to stand upright once fertilization has taken place.

Right: The drooping flower stems can often form large clumps. The plant may occur in extensive drifts under the right conditions.

Identification: The bright green leaves are alternate and perfoliate, up to 12.5cm/5in long, smooth above and hairy below. There are seldom more than two leaves below the first fork in the stem, often none. The flowers have six lance-shaped to oval tepals up to 5cm/2in long, slightly twisted, free, pale yellow, sometimes yellow-green; the stamens are longer than the style. The flowers first appear in late spring, continuing into early summer, drooping limply until fertilized. The fruit is a bluntly three-lobed capsule.

Distribution: Eastern North America (except extreme north).
Height and spread: 75cm/30in.
Habit and form: Herbaceous perennial.
Leaf shape: Perfoliate.
Pollinated: Insect.

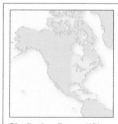

Left: The drooping flowers are the most significant feature.

Yellow Adder's Tongue

Trout lily, *Erythronium americanum*

This distinctive plant is one of the earliest spring wild flowers in the eastern USA, ranging from New Brunswick to Florida and westward to Ontario and Arkansas, where it sometimes forms large colonies in damp, open woodlands. The leaves are distinctively mottled, with flowering plants always having two basal leaves. The solitary yellow flowers are often marked purple or brown, with six reflexed, petal-like segments.

Left: Yellow adder's tongue forms dense eye-catching colonies in damp woodlands.

Identification: The membranous, yellow-white bulb is tooth-like in appearance. The shiny leaves are basal, up to 20cm/8in long, in pairs, mottled brown and white, minutely wrinkled, with parallel, longitudinal veins. Yellow, nodding, bell-shaped flowers, up to 2.5cm/1in across, are borne singly, terminally, on a naked stem, from mid- to late spring. The six perianth segments, consisting of three petals and three sepals, are strongly reflexed, often brushed with purple on the outside and finely dotted within at the base; they have six stamens, shorter than the petals, yellow to brown anthers and a short-lobed stigma. The fruit is capsular, with a rounded or flat tip.

Distribution: Eastern USA.
Height and spread: 25cm/10in.
Habit and form: Herbaceous perennial.
Leaf shape: Lanceolate.
Pollinated: Insect.

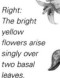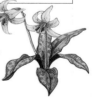

Right: The bright yellow flowers arise singly over two basal leaves.

Wake Robin

Trillium erectum

This highly variable upland plant of wet woodlands in eastern North America is one of the commonest eastern trilliums, being unique in this region by virtue of its diamond-shaped leaves, whorled in sets of three, which have a network of veins instead of the parallel ones typical of most members of this family. A solitary maroon or white flower rises above the leaves, and is notable for its foul smell, which attracts the carrion flies that act as pollinators.

Distribution: Eastern North America.
Height and spread: 60cm/24in.
Habit and form: Herbaceous perennial.
Leaf shape: Ovate to rhomboid.
Pollinated: Insect, chiefly flies.

Right: Each individual flower has a distinctive arrangement of three petals over three light green sepals.

Right: The underground rhizomes form loose colonies over time.

Identification: The erect stem arises from a stout subterranean rhizome. The three leaves, up to 20cm/8in long, are whorled, stalkless, broadly oval to diamond-shaped and dark green. A single flower with three regular parts, borne upright or obliquely on a 10cm/4in flower stalk, appears in spring or early summer. The sepals, up to 5cm/2in long, are light green suffused red-purple, particularly at the margins; the petals, up to 7.5cm/3in long, are elliptic and pointed, spreading from the base or incurved, dark garnet to white or greenish-yellow. There are six stamens and a maroon ovary. The fruit is an oval reddish berry.

OTHER LILY AND ALSTROMERIA SPECIES
Erythronium multiscapoideum
A native of shady wooded slopes in the foothills of the Sierra Nevada of California, this plant has become a popular garden plant and is one of the first western species to bloom, possessing white flowers with a yellow centre.

Painted Trillium *Trillium undulatum*
Distributed in north-eastern North America in hemlock or spruce fir forests at high elevations in the mountains. The distinctive red basal markings on the white or pale pink petals make identification of the flowers easy when they appear in late spring.

Beavertail Grass *Calochortus coeruleus*
A common sight in gravelly openings in woodlands between 600–2,500m/ 2,000–8,200ft, from Oregon to north-western California, especially in the Cascade Range and High Sierra Nevada. It has one long, persistent basal leaf and white or cream, blue-tinged flowers, held on an unbranched stem.

Alstroemeria aurea
This spreading, tuberous perennial, native to Chile and Brazil, has become a very popular garden plant. The stems carry lance-shaped, twisted leaves, which are topped during the summer by loose heads of yellow or orange flowers, tipped with green and streaked with dark red, usually in clusters at the end of thin leafy stems.

Mount Diablo Fairy Lantern

Calochortus pulchellus

This plant from the western USA is found on wooded slopes and chaparral at altitudes of 200–800m/650–2,600ft, and is almost entirely restricted to the San Francisco Bay Area. It grows in woodland and thicket vegetation, and the beautiful, nodding, conspicuously fringed, yellow flowers appear in late spring. The plant has one large basal leaf, longer than the stem, which withers around flowering time.

Identification: The erect stem is rather stout and usually branched. The basal leaf, 20–50cm/8–20in long, usually exceeds the stem. The two or three green leaves on the stem are up to 20cm/8in long, gradually smaller upwards, lance-shaped to narrow. The inflorescence is umbel-like, with one to many, nodding, globular to bell-shape, deep yellow flowers. The sepals, not exceeding the petals, are oval to lance-shaped and pointed; the petals, up to 2cm/¾in long, are triangular, narrow at the base and sharply rounded at the tip, fringed, almost hairless outside, hairy within. The gland is deeply depressed, arched, bordered above by slender hairs; the filaments are flat, the anthers generally attached at the base. The fruit is an oblong, three-winged, nodding capsule.

Distribution: San Francisco Bay Area, California.
Height and spread: 10–30cm/4–12in.
Habit and form: Herbaceous perennial.
Leaf shape: Lanceolate to linear.
Pollinated: Insect.

Above: The showy yellow flowers are conspicuously fringed and are borne singly or in bunches.

Left: Restricted to woody thickets near San Francisco, the beautiful, globe-shaped, yellow flowers are very distinctive when they appear in the springtime.

ORCHIDS

The orchid family (Orchidaceae) is widespread and spectacular in respect of its diversity in the Americas. The Northern continent shares many genera with Eurasia, and even where species have been separated by geographic isolation for long periods, such as those found in South America, they often show a striking similarity to species found in similar habitats elsewhere on the planet.

Masdevallia tricallosa

This epiphytic orchid occurs in Peru, in wet montane forests at altitudes of around 2,000m/6,500ft, and is distinguished by its white flower, which appears in the rainy season, singly on a short stalk. It often goes unnoticed in the canopy, partly because it is out of view but also because the small rhizomatous growth is easily overlooked when not in flower.

Identification: Spreading epiphyte, growing from a short, creeping rhizome from which (unusually for the genus) appear minute pseudobulbs. The blackish, erect, slender ramicauls, are enveloped basally by two to three tubular sheaths, carrying a single, apical, erect, leathery, yet pliable, ovate to elliptical or lanceolate leaf. The inflorescence is erect and slender, 5cm/2in long; single flowered, arising from low on the ramicaul, with a bract below the middle and a tubular floral bract carrying the flower at or just below leaf height. The flowers are triangular, white, with a small labellum partly hidden deep inside the flower and three large sepals fused along their edges each with a long tail. It is distinguished by three conspicuous, dark purple calli at the apex of the lip in the centre of the flower.

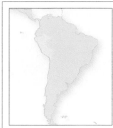

Distribution: Peru.
Height and spread: Low creeper.
Habit and form: Epiphyte.
Leaf shape: Ovate to elliptical.
Pollinated: Insect.

Scarlet Maxillaria

Ornithidium coccineum syn. *Maxillaria coccinea*

This epiphytic orchid species is found in montane forests in the Greater and Lesser Antilles. The flowers, which are usually red, are held in dense clusters, often tucked under the foliage, and are characterized by three fleshy sepals arranged in a triangular fashion. The style and stamens are fused together and curved over in jaw-like fashion over the lip.

Identification: Robust, epiphytic orchid with a rhizome covered in overlapping, papery sheaths; the pseudobulbs, to 4cm/1½in long, are oval, compressed and one-leaved. The leaves, up to 35cm/14in long by 2.5cm/1in wide, are narrow, oblong, pointed or blunt-tipped, folded at the base. The flowers, in clusters on wiry 5cm/2in stalks, are bright rose-pink, carmine or vermillion; the sepals, to 12mm/½in, are spreading, fleshy, oval to lance-shaped, tapering, concave; the petals, to 8mm/⅜in, are oval to lance-shaped, tapering or pointed; the lip, to 8mm/⅜in, is fleshy and three-lobed, the column short. The capsule is beaked.

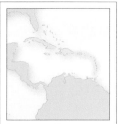

Distribution: Greater and Lesser Antilles.
Height and spread: 50cm/20in.
Habit and form: Epiphyte.
Leaf shape: Linear oblong.
Pollinated: Insect.

Right: The red flowers of scarlet maxillaria can be seen from quite a distance.

Fringed Star Orchid

Epidendrum ciliare

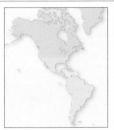

Distribution: Southern North America, Mexico, Caribbean and South America.
Height and spread: Creeping, not exceeding 15cm/6in.
Habit and form: Epiphyte.
Leaf shape: Oblong-ligulate.
Pollinated: Insect.

This is a very widespread species of epiphytic orchid, ranging from the southern part of North America, Mexico, throughout the Caribbean and parts of South America. The pseudobulbs are oblong and compressed, with one or two leathery leaves. The erect clusters of waxy flowers, which can be extremely variable in size, are strongly fragrant at night. They appear all year round, with the best flushes of flowers in spring and early summer.

Identification: The pseudobulbs are tufted, cylindrical, up to 15cm/6in long, with one to three leaves at the tip of each. The leaves are up to 28cm/11in long, lance-shaped, leathery and glossy. The erect raceme, up to 30cm/1ft tall, bears a few or several flowers, with their stalks concealed by large, overlapping, purple-spotted sheaths. The flowers are large and very fragrant, with thin, tapering tepals up to 7.5cm/3in long, white to green or pale yellow. The white lip, joined to the basal half of the column and up to 5cm/2in long, is deeply three-lobed: the lateral lobes are flared and fringed and the mid-lobe is long and straight.

OTHER ORCHIDS OF NOTE

Laelia anceps
This native of Mexico and possibly Honduras grows on rocks and trees at the fringes of dense forests, and is extremely popular in cultivation. The large, 10cm/4in flowers are generally light lavender with a darker lip and throat and are borne in a cluster of between two and six blooms on the end of a long spike, lasting for three weeks.

Zygopetalum intermedium
Found in the states of Santa Catarina to Espiritu Santo, Brazil, at elevations of 600–1,200m/ 2,000–4,000ft, this medium-sized, terrestrial or epiphytic orchid has long, erect, racemes with three to ten showy, fragrant, waxy, long-lived flowers, with a pale blue lip set against maroon-spotted green sepals, occurring in the dry season.

Dragon's Mouth *Arethusa bulbosa*
The dragon's mouth or swamp pink is a terrestrial orchid found in peat bogs, swamps and wet meadows in the north-east of North America. The pink or white flowers, appearing in early summer, offer no nectar to pollinators, despite being attractively coloured and sweetly scented, apparently deceiving inexperienced queen bumblebees early in the season.

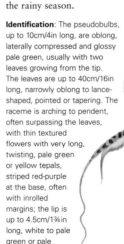

Spider Orchid

Brassia longissima

This epiphytic orchid is found in the rainforests of Costa Rica and is considered to be a variety of *B. lawrenciana* by some authorities. However, it differs from that species principally in its longer, tail-like sepals. The flowers are very striking and strangely scented, and appear on pendent racemes of six or more, borne at the start of the rainy season.

Identification: The pseudobulbs, up to 10cm/4in long, are oblong, laterally compressed and glossy pale green, usually with two leaves growing from the tip. The leaves are up to 40cm/16in long, narrowly oblong to lance-shaped, pointed or tapering. The raceme is arching to pendent, often surpassing the leaves, with thin textured flowers with very long, twisting, pale green or yellow tepals, striped red-purple at the base, often with inrolled margins; the lip is up to 4.5cm/1¾in long, white to pale green or pale yellow, fiddle-shaped with a long, tapering tip.

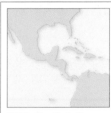

Distribution: Costa Rica.
Height and spread: Creeping, not exceeding 10cm/4in.
Habit and form: Epiphyte.
Leaf shape: Narrowly oblong.
Pollinated: Insect.

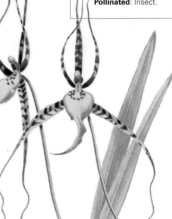

WILD FLOWERS OF AUSTRALIA AND OCEANIA

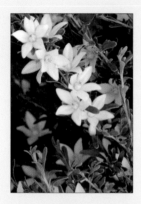

Australia is an ancient continent, with a continuous history
of 200 million years above sea level and is home to a great many
species of flowering plants, more than two-thirds of which are not
found anywhere else on Earth. The Pacific Ocean covers nearly one-third
of the globe, and is the largest, deepest and probably the most violent of
all oceans. Its vast central and southern expanse – known as Oceania –
is dotted with many thousands of islands. Many of these islands are
home to unusual and interesting plants, all of which originally reached
them from across the ocean, although many have since evolved into
unique forms. The region does not include any continental land mass,
although Australia and New Zealand are sometimes included on
its westernmost edge.

Above from left: Willow-leaved crowea (Crowea saligna), ivory curl (Buckinghamia celsissima), and lesser bottlebrush (Callistemon phoeniceus).

BUTTERCUP AND DILLENIA FAMILIES

The Ranunculaceae, or buttercup family, is better represented in the Northern Hemisphere than in Australasia or Oceania, but those that do occur are often striking examples within the family. The Dilleniaceae, or dillenia family, is closely related, mainly from tropical and warm regions, especially Australia. It includes trees, shrubs and occasionally vines, comprising 10 genera and about 350 species.

Gold Guinea Plant

Snake vine, climbing guinea flower, *Hibbertia scandens*

This climbing shrub is restricted to eastern Australia, occurring in Queensland and New South Wales. It climbs by twining its way up other shrubs and may occur as a more procumbent shrub in the absence of a suitable support plant. Its large golden-yellow flowers are borne at the end of short side branches and appear in early spring among the evergreen leaves, often providing an eye-catching display among the shrubby vegetation.

Below: Berries cluster on old sepals.

Identification: The trailing stems of this vigorous climber are initially hairy. The leaves are alternate, 5–10cm/2–4in long, glossy above and hairy beneath, and tend to clasp the stems. The golden-yellow flowers, which have an unpleasant smell, are up to 5cm/2in across and are borne at the tips of downy, lateral branchlets; they have five notched petals with slightly wavy edges, and numerous stamens. The round fruits, about 2cm/¾in across, contain several shiny red seeds.

Distribution: Eastern Australia.
Height and spread: 1.8m/6ft.
Habit and form: Evergreen shrub.
Leaf shape: Obovate to lanceolate.
Pollinated: Insect.

Far left: The short side branches are laden with flowers in early spring.

Korikori

Hairy alpine buttercup, *Ranunculus insignis*

This yellow-flowered New Zealand buttercup is found at higher altitudes of around 1,050–2,000m/3,500–6,500ft on North and South Islands. It is a widespread species but generally tends to favour habitats that are sheltered from the drying sun: in areas with a greater number of cloudy days it can be found in more exposed positions, but always prefers moist soils.

Right: The large leathery leaves can easily be spotted in high rocky places when the plant is not in flower.

Identification: The stems range in height from 10–90cm/4–36in. The dark green, leathery, basal leaves, up to 15cm/6in across, are oval to heart-shaped, with toothed, hairy margins; the stem leaves have three lobes. Each branched stem carries numerous yellow flowers up to 5cm/2in across, with five to seven oval, notched or rounded petals.

Below right: The yellow flowers are borne abundantly above the large leaves (below).

Distribution: New Zealand.
Height and spread: 10–90cm/4–36in.
Habit and form: Herbaceous perennial.
Leaf shape: Ovate-cordate.
Pollinated: Insect.

Mount Cook Lily

Mountain buttercup, *Ranunculus lyallii*

This magnificent buttercup, from the Southern Alps of New Zealand's South Island, has large, waxy white flowers held above huge glossy leaves shaped like saucers. It prefers a sheltered site, usually in the shade of rocks or other plants, and flourishes in stony soils near torrents at altitudes of 450–1,500m/1,500–5,000ft. It is an extremely robust plant in ideal conditions and can be very striking when encountered in the wild.

Distribution: South Island, New Zealand.
Height and spread: Up to 1.5m/5ft.
Habit and form: Herbaceous perennial.
Leaf shape: Peltate.
Pollinated: Insect.

Far right: The large distinctive, saucer-shaped leaves stand out among rocks and other mountain plants.

Identification: The stout, branched stems may grow up to 1.5m/5ft tall. The saucer-shaped leaves are dark green and leathery, borne on long stalks attached to the centre of the leaves; the basal leaves are up to 40cm/16in across, progressively reducing in size up the stems. The white flowers are borne in panicles of 5–15; they are 5–7.5cm/2–3in across with 10–16 oval, rounded or notched petals and a green centre surrounded by numerous yellow stamens.

OTHER BUTTERCUP AND DILLENIA SPECIES OF NOTE

Twining Guinea Flower
Hibbertia dentata
This trailing or twining shrub found in New South Wales, has large, deep yellow flowers with oval pointed petals, alternating with shortened calyx lobes, which appear on the branch ends. The dark green leaves are prickle-toothed.

Trailing Guinea Flower *Hibbertia empetrifolia*
This small shrub occurs naturally in a wide variety of habitats in south-east Australia, from south-east Queensland around the coast to South Australia and Tasmania. The yellow flowers appear in spring, and at their peak the plants resemble bright yellow mounds, with the foliage scarcely visible between the flowers.

Ranunculus pinguis
This New Zealand native, found only on the Auckland Islands and Campbell Island is now restricted to a few, rather inaccessible ledges, due to intensive grazing. The multi-petalled yellow flowers appear in the spring above the basal leaves, which resemble pelargonium leaves.

Old Man's Beard *Clematis aristata*
This Australian climber flowers in early summer in panicle-like inflorescences arising from leaf axils near the branch tips. The showy flowers consist of four or five white or ivory sepals. These are followed later in the season by feathery, fluffy seedheads.

Small-leaved Clematis

Traveller's joy, *Clematis microphylla*

This vigorous, sprawling climber is widespread in Australia, and is found in all states except the Northern Territory. It is especially common in coastal regions or near rivers, in moist gullies and on tablelands. The species is dioecious, with male and female flowers carried on separate plants. The greenish-white flowers, which appear in early summer, are produced in the leaf axils, giving the branch tips an inflorescence-like appearance when the plant is in full bloom.

Distribution: Australia.
Height and spread: 3m/10ft.
Habit and form: Woody, sprawling climber.
Leaf shape: Trifoliate, lanceolate.
Pollinated: Insect.

Identification: The leaves are opposite, on long leaf stalks, often twisted; each consists of two or three narrow or lance-shaped leaflets about 15mm/⅝in long and 3mm/⅛in wide. The star-like flowers, carried in short panicles, consist of four narrow, creamy-white sepals tinged green, up to 2.5cm/1in long, surrounding a central mass of numerous yellow stamens. They are followed by attractive, feathery seedheads on the female plants.

Above and below: The seedheads appear in late summer and autumn.

ROSE, PITTOSPORUM AND TREMANDRA FAMILIES

The rose family, Rosaceae, has a worldwide distribution. In contrast, the Pittosporaceae, or pittosporum family, with nine genera and 240 species from the tropical world, is centred on Australasia, and the Tremandaceae (Tremenda family), with three genera and 43 species, are found in temperate Australia.

Creeping Lawyer

Snow raspberry, *Rubus parvus*

This scrambling, thorny, shrubby perennial is restricted to the north-west of New Zealand's South Island. It is most commonly found in lowland forest and river flats, where its thorny stems and bronzed foliage form tangled masses over the ground. The white flowers appear in the summer and are followed by juicy, edible, red "blackberry" fruits. It is one of only a few evergreen shrubs in New Zealand that develop an autumn tint to the foliage. Hikers know it as a plant that is "easy to get involved with, but difficult to shake off".

Identification: The smooth stems, rooting at the nodes, are usually without prickles when mature. The leathery leaves are narrow to lance-shaped, up to 16mm/⅝in long, dark green turning bronze in the autumn, shiny above, dull below, densely and regularly serrated, with small sharp teeth on the underside of the midrib; they are borne on prickly leaf stalks up to 2.5cm/1in long. White flowers, up to 2.5cm/1in across, appear in summer in small panicles; they have five oval, spreading petals and numerous stamens. The red fruits are up to 2.5cm/1in long.

Distribution: South Island, New Zealand.
Height and spread: Variable.
Habit and form: Prostrate, scrambling, evergreen shrub.
Leaf shape: Lanceolate.
Pollinated: Insect.

Left: The thorny stems form a tangled mass that spreads over the ground.

Above left: The fruits are edible.

White Marianthus

Marianthus candidus

This twining shrub is endemic to western Australia, on limestone plains, particularly in coastal heaths, south from Perth to Cape Leeuwin. The dense white flower clusters appear mainly in the spring and are very attractive. The sharply pointed white petals become pink with age, especially on the lower side, and the narrow, erect, claw-like anthers are covered in bright blue pollen.

Below White marianthus thrives in sandy soil.

Right: This plant is a twining shrub or vine that grows to 5m/16ft.

Identification: The erect, eventually twining stems are warty with lenticels. The mature leaves are narrow, up to 7cm/2¾in long, on 7.5cm/3in stalks. Panicles of 10–30 irregular flower clusters, each of around six tubular flowers, appear in spring; the sepals are pink and white with slightly hairy margins, and the spoon-shaped, pointed petals are up to 2.5cm/1in long, white becoming fawn or pink. The arrow-shaped anthers are white, eventually becoming blue, and the pollen is noticeably blue.

Distribution: Western Australia.
Height and spread: Variable.
Habit and form: Twining shrub.
Leaf shape: Elliptic.
Pollinated: Insect.

Sweet Pittosporum

Native daphne, *Pittosporum undulatum*

The moist gullies in the forests of south-east Queensland to eastern Victoria are home to this tree with coarse, grey bark and glossy, green, elliptical, wavy-edged leaves. The small, white fragrant flowers appear abundantly at the branch tips in spring and early summer and in the autumn are followed by orange-tan berries, which persist for several months. Despite being native to Australia, this species has become an environmental weed in Tasmania, western Australia, western Victoria and South Australia, as well as in bushland around Sydney, chiefly because it has been favoured by habitat changes created by urban development.

Distribution: Eastern Australia.
Height and spread: 9–14m/30–45ft.
Habit and form: Evergreen tree.
Leaf shape: Ovate.
Pollinated: Insect.

Right: This tree forms an evergreen "mop" of foliage.

Far right: The brown woody seed capsules appear quite berry-like.

Identification: The laurel-like leaves, alternate to whorled, are 7.5–15cm/3–6in long, with pointed tips and distinctive wavy margins. The sweetly fragrant, tubular flowers are borne in terminal clusters from late spring to early summer; they are 12–20mm/½–¾in across with five creamy-white reflexed petals. The fruit is a dry, woody capsule, up to 12mm/½in in diameter, yellow, brown or orange, containing brown seeds with a sticky, resinous coating.

OTHER ROSE, PITTOSPORUM AND TREMANDRA SPECIES OF NOTE

Karo *Pittosporum crassifolium*
The karo or stiffleaf cheesewood is a small tree found along the edges of forests and streams in New Zealand's North Island and Kermadec Island in the south-west Pacific. It has a dense, almost columnar crown, and the undersides of the leathery leaves are covered with velvety felt. Umbels of deep red blooms make a striking display.

Finger Flower *Cheiranthera cyanea*
Found in the scrubby woodlands of south-east Australia, finger flower is named after the five stamens, which are positioned in a row. It has dense, linear foliage and despite being a small shrub has very large, striking blue flowers, which are specially adapted for pollination by bees.

Bluebell Creeper *Sollya fusiformis*
From western Australia, this low shrub or vine has slender stems set with narrow, mid-green, glossy leaves. In summer and autumn it displays clusters of little bell-shaped, pale mid-blue blossoms, followed by small, blue berries.

Rubus queenslandicus
This pinnate-leaved species of native Australian bramble is endemic to coastal ranges of north Queensland. The white, hairy, five-petalled flowers are followed by characteristic, red, conical, bramble fruits, which are dry in texture.

Pink Bells

Pink eye, *Tetratheca ciliata*

This widespread but uncommon Australian species, found in south Australia, Victoria and Tasmania, is restricted to coastal heaths and heathy woodland. It flowers in spring, when numerous, erect, slender stems sport a profusion of pink, four-petalled flowers with a darker central eye.

Identification: An understorey shrub with slender erect or spreading branches arising from a woody basal stock. The younger stems are clothed in fine short hairs, the older ones largely smooth. The rough-textured oval leaves, up to 12mm/½in long, grow in scattered groups of three or four, alternate to opposite or whorled. The flowers are four-parted, solitary, terminal or in the leaf axils, with purple or lilac petals up to 12mm/½in long. The fruit is a two-celled, flattened capsule.

Right: The erect or spreading branches arise from a woody base.

Distribution: Southern Australia.
Height and spread: 90cm/3ft.
Habit and form: Shrub.
Leaf shape: Ovate.
Pollinated: Insect.

Below: The four-petalled flowers are pink with a darker eye.

LEGUMES

Legumes form a significant component of nearly all terrestrial habitats, on all continents (except Antarctica) and are well represented in Australasia and the oceanic islands. They range from dwarf herbaceous perennials of alpine vegetation to massive trees in tropical forests with Australia being an especially rich source of these showy plants.

Yellow Kowhai

Sophora tetraptera

This small tree occurs naturally only on North Island, New Zealand, but is now widely cultivated throughout that country and can also be found in Chile. It is most commonly found growing along streams and forest margins, from East Cape to the Ruahine Range and from sea level up to 450m/1,500ft. It can reach 12m/40ft in height depending upon the altitude. In spring, birds feed on the nectar-rich flowers, which are followed by fruits that resemble strings of corky beads.

Top: the leaves are pinnate.

Above: The seedpod.

Distribution: North Island, New Zealand.
Height and spread: 4.5–12m/15–40ft.
Habit and form: Deciduous tree.
Leaf shape: Pinnate.
Pollinated: Bird.

Left: This small, open-crowned tree varies considerably in height depending upon the altitude within which it grows.

Identification: A small to medium-size tree, occasionally shrubby, with spreading branches. The pinnate, mid-green leaves, 7.5–15cm/3–6in long, are much divided, with 20–40 oval to oblong leaflets. Racemes of four to ten greenish or golden-yellow, tubular, pendulous flowers, up to 6cm/2¼in long, appear in spring to summer. The brown pods of four-winged seeds are 6–7.5cm/2¼–3in long.

Cockies' Tongue

Templetonia retusa

This fast-growing, evergreen shrub, native to South and Western Australia, gets its common name from its flowers, which allegedly resemble a cockatoo's tongue. It is frequently found growing on limestone, or sand or loam over limestone, mostly in coastal areas. The flowers appear in late summer, continuing until well into the winter, hence its popularity with birds at a time when other nectar sources are scarce.

Distribution: South and Western Australia.
Height and spread: 30cm–3m/1–10ft.
Habit and form: Evergreen shrub.
Leaf shape: Obovate.
Pollinated: Bird.

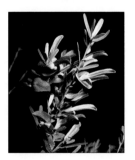

Identification: A spreading, much-branched shrub of variable height, it is frequently somewhat glaucous, with smooth, angled and grooved branches. The rounded, leathery leaves are grey-green, up to 4cm/1½in long, oval to wedge-shaped with a notched or blunt tip. Large red pea-like flowers are borne terminally or in the leaf axils in winter and spring, singly or in groups. They are up to 4cm/1½in long, with scale-like bracts and petals that are often darker at the tips. The oblong fruit may be up to 8cm/3¼in long, pale to dark brown.

Left: The pea-like flowers have a keel (the two lower petals) that allegedly resemble a cockatoo's tongue.

Left: This evergreen shrub varies in height and in some cases resembles a small tree

Rusty Pods

Hovea longifolia

Distribution: Eastern Australia.
Height and spread: 3m/10ft.
Habit and form: Shrub.
Leaf shape: Linear.
Pollinated: Insect.

Right: Hovea longifolia is not well-known in cultivation, but when seen in the wild, forms an eye-catching specimen.

The most widespread and variable species in this genus is found in dry open forests in eastern Australia, extending from north Queensland to Victoria, especially on sandy soils. It is an erect understorey shrub with elongated, coarse-textured leaves, closely spaced on erect stems from where the rich violet flowers appear in small clusters in the leaf axils. They eventually give rise to short, inflated pods, covered with short rusty hairs: these split rapidly and shoot out the seeds for some distance upon ripening.

Identification: An upright shrub with erect, felted stems. The narrow leaves are glossy and leathery, dark green above and paler beneath, up to 7cm/2¾in long. In spring, bluish-purple pea flowers appear in clusters of two or three along the branchlets, with dark blue veins and a central yellow blotch; the calyx is covered with grey or red hairs. The globular or egg-shaped pod, covered with rust-coloured hairs, contains two hard-coated seeds.

Left: This upright shrub is quite variable across its range and is most noticeable when the flowers appear in spring.

OTHER LEGUMES OF NOTE

Holly Flame Pea *Chorizema ilicifolium*
Belonging to an endemic Australian genus of about 18 species, this is a small, spreading shrub with deeply lobed leaves with prickly teeth. The large pea flowers are bright red and orange, usually appearing in late winter and spring.

Climbing Wedge Pea
Gompholobium polymorphum
This variable plant from western Australia may occur as a slender, twining climber or a loose dwarf shrub. Its linear to oval leaves are variable in form and are a foil to the equally variable, large pinkish-red pea flowers that bloom in spring.

Coral Pea *Hardenbergia violacea*
Known as Australian sarsaparilla or native wisteria, this evergreen twining plant is a woody-stemmed species occurring in Victoria, Queensland, New South Wales, Tasmania and south Australia, in a variety of habitats from coast to mountains, usually in open forest or woodland and sometimes in heath. The flowers, which appear in winter and spring, are usually violet, but other colours are found.

Cape Arid Climber *Kennedia beckxiana*
This moderate to vigorous Australian climber has large trifoliate leaves and prominent scarlet, pea-shaped flowers with greenish-yellow blotches in spring to early summer.

Sturt's Desert Pea

Clianthus formosus

This short-lived species was adopted as the floral emblem of South Australia in 1961, although it mainly occurs in the dry central part of Australia and is named after Charles Sturt, who explored inland Australia in the 19th century. It is found in arid woodlands and on open plains, often as an ephemeral following heavy rain. It is one of Australia's most spectacular wild flowers: its large flag-shaped blooms are generally bright red but may be pure white to deep purple in some specimens.

Identification: A slow-growing, creeping plant, sometimes with a woody base, it may be annual or perennial. Most parts have a fine covering of silky hairs. The prostrate stems are long and thick, and the leaves, up to 18cm/7in long, are pinnate, with 9–21 oval, grey-green leaflets. The flowers are up to 7.5cm/3in long, with five or six held horizontally (appearing pendulous), on erect, thick-stalked racemes up to 30cm/12in tall. The scarlet flowers are up to 7.5cm/3in long, with five or six held horizontally on erect, thick-stalked racemes.

Distribution: Australia.
Height and spread: Variable.
Habit and form: Variable subshrub.
Leaf shape: Pinnate.
Pollinated: Insect.

Left: The red flowers have a deep red to black standard that protrudes and appears boss-like.

CABBAGE AND CAPER FAMILIES

The Brassicaceae, or cabbage family, are herbs or rarely subshrubs mostly found in temperate regions. Australasia has only around 160 species, although New Zealand and other southern oceanic islands have some rare and interesting species. Capparidaceae, the caper family, includes 45 genera and 675 species of shrubs, herbs and trees, chiefly from warmer climates, many of which produce mustard oils.

Bush Passionfruit

Australian caper bush, *Capparis spinosa* var. *nummularia*

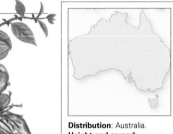

This small shrub is extremely widespread, and although the species is apparently of Mediterranean origin, a history of aboriginal use of the *nummularia* variety would indicate that this variety is indigenous to the Australian mainland. The plants grow spontaneously in rock crevices, thriving best in nutrient-poor, sharply drained, gravelly soils. The roots penetrate deeply into the earth and their salt-tolerance allows them to flourish along shores within sea-spray zones.

Distribution: Australia.
Height and spread: 90cm–2m x 3m/3–6 x 10ft.
Habit and form: Shrub.
Leaf shape: Elliptic.
Pollinated: Insect.

Identification: A sprawling, mounding shrub with arching red stems and dark green, semi-succulent oval or round leaves on short leaf stalks. Large, solitary flowers appear at almost any time of the year, often at night, disappearing in the heat of the day; they are borne from the leaf axils on stalks up to 7.5cm/3in long, and have pure white petals and numerous feathery white stamens. The green fruit ripens to yellow, usually off the bush and is an edible, elongated berry.

Far left and below left: The fruit is an elongated pod.

Right: This sprawling shrub commonly forms a mound in poor dry soils.

Kerguelen Island Cabbage

Pringlea antiscorbutica

This plant's common name is derived from its appearance and from the island of its discovery. Although most plants in the cabbage family are insect-pollinated, the Kerguelen Island cabbage has adapted to wind pollination (in the absence of winged insects on subantarctic islands) to exploit the almost continual winds in this region. The large, cabbage-like leaves contain a pale yellow, highly pungent essential oil that is rich in vitamin C, rendering the plant a useful dietary supplement against scurvy for early sailors. Despite its name it is also found elsewhere in the Southern Ocean, on the Crozet Archipelago and Marion Island.

Distribution: Subantarctic, centred on Kerguelen Island.
Height and spread: Up to 45cm/18in across.
Habit and form: Herbaceous plant.
Leaf shape: Spathulate.
Pollinated: Wind.

Identification: A large rosette-forming, evergreen, herbaceous plant with smooth, spoon-shaped leaves with strong parallel veins, arising from stout, overground rhizomes extending 1.2m/4ft or more from the roots. The flowers are arranged on dense spikes, appearing axially from each rosette; they usually lack petals – although between one and four white, sometimes pink, petals may develop – and the stamens and thread-like stigma project from tiny sepals.

Right: The large cabbage-like rosettes give the plant its common name.

Long-style Bittercress

Rorippa gigantea

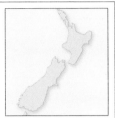

This large cress-like plant grows in coastal regions mostly in New Zealand's North Island but is also known from an isolated population in the northeastern part of South Island. It is perfectly at home in salt spray on clifftops and coastal slopes, sometimes within active petrel colonies, around their burrow entrances but is rare in many places now due to grazing and exotic insect pests (particularly cabbage white butterfly). The large inflorescences support a multitude of tiny white flowers in spring and early summer.

Distribution: New Zealand.
Height and spread: 30–200cm/1–6½m.
Habit and form: Annual to perennial herb.
Leaf shape: Pinnatifid.
Pollinated: Insect.

Identification: This annual to perennial herb (depending on local growing conditions), grows 30–200cm/1–6½ft tall, arising from a stout taproot and one or more basal stems. The stems are erect to decumbent, slightly woody, purple-red when mature and angled. The leaves vary between yellow-green, dark green or purple-green, with margins that are entire or toothed and pinnatifid. The inflorescence is a complex, heavily branched raceme, appearing in spring to early summer. Each individual flower is tiny with white petals, 2–3mm/⅟₁₆–⅛in long. Fruits appear in summer, consisting of dark green to purple-green siliquae (specialized seedpods), with orange to red-brown seed, that is extremely sticky when fresh.

OTHER CABBAGE AND CAPER SPECIES OF NOTE

Notothlaspi australe
This species of penwiper, from New Zealand, can be found across a restricted range in mountain screes in the Torlesse Range of central South Island. It is similar to the other species from the island but sometimes forms dense colonies and has more rounded flowerheads.

Coastal Cress *Lepidium flexicaule*
This small, flat, creeping cress was once widespread in New Zealand, on bluffs, outcrops and among coastal turfs, but is now largely restricted to west and north-west South Island. The many racemes of small, white flowers, often hidden among foliage, appear in early summer.

Cook's Scurvy Grass *Lepidium oleraceum*
A bushy, aromatic, white-flowered herb, found in coastal areas and some offshore islands of New Zealand's South Island. It was abundant during the voyages of James Cook in the 18th century, and eaten to prevent scurvy. It is now scarce and endangered across its former range.

New Zealand Bitter Cress
Cardamine corymbosa
This tiny species of cress flowers all year but is mainly seen in autumn and winter. The tiny white flowers, which are self-pollinated, are followed by tiny explosive seedpods. The exceptional seeding ability of the plant has led to it becoming a troublesome weed in certain horticultural situations well outside its native range.

Penwiper Plant

Notothlaspi rosulatum

This curious little alpine herbaceous perennial, one of only two in this genus, is widespread on mountain screes at altitudes of around 800–1,800m/2,600–5,850ft in the Southern Alpine area of New Zealand's South Island. Its common name is derived from the structure of the plant, which allegedly looks like a 19th-century penwiper. The flat rosette of grey leaves is well camouflaged among the rocks, but when the large, conical flowerhead of fragrant, white flowers appears in summer it becomes quite conspicuous.

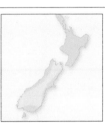

Distribution: South Island, New Zealand.
Height and spread: 7–25cm/2¾–10in.
Habit and form: Alpine herb.
Leaf shape: Spathulate.
Pollinated: Insect.

Identification: An erect, pyramidal, alpine herbaceous perennial with a long, central taproot. The fleshy, toothed, spoon-shaped leaves form a dense basal rosette or cushion, and are very numerous, overlapping, hairy at first, becoming more or less smooth. The large, white, four-petalled, fragrant flowers appear in summer, borne on a crowded pyramidal raceme.

GENTIAN, BELLFLOWER, TRIGGER PLANT AND GOODENIA FAMILIES

The Gentianaceae, or gentians, and the Campanulaceae, or bellflowers, are scarce in Australasia, though the gentians include some remarkable island endemics. Stylidiaceae, the trigger plant family, are small herbs, and Goodeniaceae, or goodenia, comprises sappy shrubs, herbs and trees; both thrive in Australia.

'Oha wai

Clermontia parviflora

This Hawaiian endemic is restricted to the wet forests of the Kohala Mountains and windward Mauna Kea and Mauna Loa, at heights of 120–1,450m/400–4750ft, where it can be found growing as a terrestrial shrub and as an epiphyte. It is one of the smaller-flowered *Clermontia* species, and is susceptible to browsing and habitat alteration by wild goats and pigs. If only epiphytic plants are found in a given area, it usually indicates that pigs are eating the vegetation there. This is one of 100 species of lobeliods, which make up about 10 per cent of Hawaii's native flora.

Identification: The bark is green when young, turning grey with age. The leaves, which are mainly clustered around the branch tips, are dark green above, paler below, with a purple midrib and stalk whose colour becomes less pronounced with age; developing leaves are often purple. The leaves are 6–18cm/2¼–7in long and 2–5cm/¾–2in wide, with finely toothed margins and elongated, pointed tips. The small flowers are green, purple or white on the outside, white or pale purple inside, tubular at the base, with narrow reflexed petals and projecting reproductive parts.

Distribution: Hawaii.
Height and spread: 3.5m/12ft.
Habit and form: Epiphytic or terrestrial shrub.
Leaf shape: Oblanceolate.
Pollinated: Bird.

Left: The plant has a candelabra-like habit, with branches usually arising from a single basal stem.

Far left: The yellow or orange berries have small ribs.

Pua'ala

Alula, Haha, *Brighamia rockii*

One of the most unusual plants of Hawaii, this plant, found only on the tall sea cliffs of the island Molokai, formerly grew on sunny, well-drained hillsides on all the four main islands. It is extremely rare today, however, with fewer than 100 plants growing in the wild. A strange plant that looks like a cabbage on a stick, it is a long-lived succulent, with a swollen base tapering toward a crowning rosette of fleshy leaves and yellow or white, trumpet-shaped flowers. It is presumed to be moth-pollinated although the moth is thought to have become extinct, so seed is not produced on wild plants.

Identification: The thickened, succulent stem, usually branching, tapers from the base and is distinctly purple during its juvenile stage. The shiny, leathery leaves are arranged in a rosette at the top of each branch; they are bright to dark green, 6–23cm/2¼–9in long and 5–15cm/2–6in across. The fragrant, trumpet-shaped, five-petalled, white flowers are clustered in groups of three to eight in the leaf axils, forming a dense rosette at the top of the stem in autumn.

Distribution: Molokai, Hawaii.
Height and spread: 5m/16ft.
Habit and form: Shrub.
Leaf shape: Obovate or spathulate.
Pollinated: Probably a moth (now extinct).

Far left: This strange plant looks a little like a cabbage on a stick.

Left: The large, white, trumpet-shaped flowers are fragrant and appear in the autumn.

Trigger Plant

Stylidium spathulatum

Distribution: Western Australia.
Height and spread: 25cm/10in.
Habit and form: Herbaceous perennial.
Leaf shape: Obovate.
Pollinated: Insect.

The curious trigger plants are so named because of the rapid flick of the column when touched by a visiting insect. This column protrudes from the flower and bears the stamens and stigma. In the "cocked" position it is kinked at the base and sticks out to one side between two of the petals. When an insect attempts to take nectar from the flower, the sensitive base, irritated by its touch, straightens instantaneously and swings the stamens and stigma through an arc, hitting the animal and showering it with pollen. As the flower ages the stamens shrivel, but the stigma protrudes from the end of the column, ready to be brushed by insects already covered in pollen.

Identification: Oblong to spoon-shaped leaves, covered with green, yellow or brown glandular hairs, form a basal rosette. The flowers are pale yellow, borne in loose, unbranched racemes on a leafless stem 15–50cm/6–20in tall. The calyx has five lobes, more or less united into two lips; the corolla lobes are irregular, with four arranged in two pairs and the labellum much smaller and turned, or nearly as long and curved upward; the column is elongated and bent down, elastic.

Left: The flower is the easiest means of identifying trigger plants.

Right: All Stylidium *species have four petals.*

OTHER GENTIAN, BELLFLOWER AND TRIGGER PLANTS OF NOTE

'Oha Wai Nui *Clermontia arborescens*
'Oha wai nui is endemic to Maui, where it occurs in mesic (moist) to wet forest from 520–1,850m/1,700–6,000ft. Its fleshy, claw-shaped, strongly arched flowers are among the largest of the genus and are pale green with purple columns.

Thick-leaved Trigger Plant
Stylidium crassifolium
The fleshy leaves that cluster about the base of the flower stem give rise to this plant's common name. It grows to 60cm/2ft. It comes from western Australia, where it is found near wet flushes and drying creek beds, especially following bushfires.

Cunningham's Snow-gentian
Chionogentias cunninghamii
Naturally found in swamps and wet heath in New South Wales, this tall gentian has white flowers. Australian gentians of this genus mostly occur in the alpine or subalpine zone, although this species mainly occurs at lower altitudes.

Boomerang Trigger Plant
Stylidium breviscapum
This creeping herbaceous perennial from western Australia grows to 20cm/8in high and is curiously elevated up to 7cm/2¾in above the soil by wiry, black, stilt roots. The flowers are white with red markings, appearing from early spring to summer.

Blue Leschenaultia

Leschenaultia biloba

Aboriginal people are said to have called blue leschenaultia, which is native to the sand hills of western Australia, "the floor of the sky", because the ground where it grows is carpeted with its blue flowers. In many areas the plant adopts a suckering habit, enabling it to spread over a wide area and resulting in massed spring displays. Arguably one of the most beautiful Australian species, its flower is designed to attract bees. It has a blue "landing platform" with a white centre that helps guide the bee to the nectar at the base of the tubular petals. To reach the nectar the bee must either pick up or deposit pollen.

Distribution: Western Australia.
Height and spread: 50cm/20in; indefinite spread.
Habit and form: Evergreen perennial.
Leaf shape: Narrow.
Pollinated: Insect.

Right: The bright blue flowers open from greenish buds.

Below: The plant commonly forms a heath-like sprawling shrub.

Identification: A diffuse, small, sprawling to climbing, semi-woody, evergreen perennial or subshrub. It has tiny, narrow, heath-like, soft grey-green leaves 12mm/½in long. The flowers, up to 2.5cm/1in across, appear from late winter to late spring, with five pointed lobes with distinctive large corolla wings, veined with parallel, transverse lines. They range from deep purplish-blue through sky-blue to pale blue.

GERANIUM, PORTULACA AND AMARANTH FAMILIES

The Geraniaceae, or geraniums, are a varied family usually featuring five-petalled flowers and a beaked fruit that often disperses the seed explosively. The Portulacaceae (portulacas) comprise mainly herbaceous perennials; the Amaranthaceae (amaranths) are mostly herbs but also rarely shrubs or small trees.

Broad-leaf Parakeelya

Rock purslane, *Calandrinia balonensis*

This fleshy herb, with flowers that open quickly in response to sunshine, belongs to a genus of around 150 species, which occur in Australia and from Canada to Chile. *C. balonensis* is named after the Balonne River in Queensland, where it was first collected, and is one of approximately 30 Australian species. It grows as an annual or perennial in arid areas of southern Australia and the Northern Territory, often around salt lakes, and its bright, shiny, red flowers, amid flattened, succulent, finger-length leaves, often carpet large areas in spring.

Right: This low-growing, fleshy herb spreads from woody branches near the base.

Identification: A low-growing, spreading or trailing herbaceous perennial, with the older branches becoming woody near the base. The leaves are alternate, fleshy and narrow, with a very pronounced, somewhat flattened midrib. The long-lasting, five-petalled flowers, up to 2.5cm/1in across, are borne from the leaf axils. They have two persistent sepals, vibrant pinky-red petals with paler, often white, bases and yellow centres with numerous filaments.

Distribution: Australia.
Height and spread: 15–40cm/6–16in.
Habit and form: Herbaceous perennial.
Leaf shape: Narrow.
Pollinated: Insect.

Pink Mulla Mulla

Lamb's tail, *Ptilotus exaltatus*

This ephemeral plant inhabits a wide range of habitats stretching across the mainland from the north-west of Australia. The flowers are borne on candelabra-like branches, and the time of year in which they appear depends largely upon seasonal rainfall patterns: in arid areas they are usually most abundant following good rains. It is a common and widespread plant, with specimens from the westernmost regions being generally taller with longer inflorescences and less hairy than their eastern counterparts.

Far left: The stems are stout and erect.

Identification: A stout, erect, perennial with hairless stems, branched or unbranched, growing from woody rhizomes. The thick, wavy-edged leaves, up to 10cm/4in long, are bright blue-green tinged red, forming a rosette at the base of the plant. The pink, fluffy flowers appear on tall stems in conical spikes, becoming cylindrical with age, up to 15cm/6in long and 5cm/2in wide.

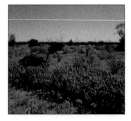

Distribution: North-west Australia.
Height and spread: 90cm/3ft.
Habit and form: Erect perennial.
Leaf shape: Oblong-lanceolate.
Pollinated: Insect.

Left: The flowers of pink mulla mulla often form striking displays following rains.

Southern Stork's Bill

Pelargonium australe

This is a widespread and variable plant that is generally found growing in sand dunes near the coast, between rocky outcrops, and inland, sometimes at higher elevations in subalpine regions. It often flowers over a long period, and the leaves may take on orange or even darker tones in the autumn. Plants collected in Tasmania are smaller in all parts, with dark green leaves and red leaf stalks and although they resemble the mainland species in most other respects some botanists recognize some populations to be separate subspecies.

Distribution: South-eastern Australia, Tasmania, and New Zealand.
Height and spread: 30cm/1ft.
Habit and form: Subshrub.
Leaf shape: Rounded.
Pollinated: Insect.

Left: This straggling shrubby plant varies considerably in height and colour across its native range.

Identification: A straggling, short-stemmed, softly hairy, shrubby, erect, low-growing perennial shrub. The heart-shaped, faintly aromatic leaves are up to 10cm/4in in diameter, rounded and shallowly lobed, and are very soft, being covered with thick, soft hairs. Each flowering stem bears a compact umbel of 5–25 flowers, which vary in colour from white to pale blush to pink, with dark red spots and feathering, appearing in spring or summer.

OTHER GERANIUM, PORTULACA AND AMARANTH SPECIES OF NOTE

Pussy Tails *Ptilotus spathulatus*
This low-growing Australian perennial has numerous stems arising from a stout rhizome. The rounded or spoon-shaped, fleshy leaves are held basally, and the cylindrical flower spikes emerge over a long period between winter and summer, bearing yellow, green or golden flowers, either solitary or clustered.

Rose-tipped Mulla Mulla *Ptilotus manglesii* This Australian perennial sometimes lasts only as an annual, with stems that trail along the ground a little before ascending at the tips. The long, rounded leaves have stems near the base of the plant, becoming stalkless near the top. The round flower spikes are covered with shaggy white hairs, among which the pink to violet-purple flowers nestle in summer.

Geranium homeanum
This widespread plant is found in Java, Timor, Samoa, New Zealand and the east coastal states of Australia. It is commonly found in grassland, thin forests and on roadsides. The prostrate, often hairy stems support lobed leaves with large teeth, and the small, white to pale pink flowers appear from late spring to late summer.

Small storksbill *Erodium angustilobum*
Found from Queensland to south Australia, this annual has narrow, basal leaves, which are deeply seven-lobed. In summer it sports numerous blue to pinkish flowers on ascending stems that reach 30cm/12in.

Purslane

Pigweed, *Portulaca oleracea*

Purslane is a species that grows worldwide and, although generally regarded as a weed in many parts of Australia, it is a native of that continent. It is found throughout Australia except in Tasmania. In inland areas dense colonies of the plant appear after rain. It is edible and has long been used as a vegetable, as a substitute for spinach, or as a salad leaf.

Identification: A succulent, prostrate annual herb with smooth, reddish-brown stems and alternate, oval, succulent leaves, 2.5cm/1in long, clustered at the stem joints and ends. The yellow flowers, 6mm/¼in across with five two- or three-lobed petals, occur in the leaf axils; they appear in late spring and continue into mid-autumn, each opening singly at the centre of a leaf cluster for only a few hours on sunny mornings. The seeds are contained in a pod.

Distribution: Cosmopolitan in warm areas.
Height and spread: 40cm/16in.
Habit and form: Succulent herb.
Leaf shape: Obovate.
Pollinated: Insect.

Right: The tiny, black seeds are contained in a pod, the top of which falls off once the seeds are ripe.

OLEANDER AND BRAZIL NUT FAMILIES

The Apocynaceae (oleanders or dogbane family) are distributed mainly in the tropics and subtropics, though some perennial herbs thrive in temperate regions. Plants of this family may have milky sap and are often poisonous. The Lecythidaceae (Brazil nuts) are woody plants native to tropical climates. The Brazil nut is the most well known and important species from this family.

Indian Oak

Freshwater mangrove, *Barringtonia acutangula*

Indian oak grows in coastal areas in the tropics, or on seasonally inundated land by lagoons, creeks and riverbanks. In areas prone to seasonal dry periods, it may be partially deciduous. In Australia it is found mainly in the Northern Territory and is striking when in flower due to its handsome foliage and large pendulous sprays of pink or white, fluffy, scented flowers, which open in the evening and fall the following morning.

Identification: The leaves, crowded at the ends of the branches, are up to 15cm/6in long, lance-shaped to oval, smooth, finely toothed, with a midrib prominent on both sides. Terminal, pendulous racemes bear up to 75 flowers, ranging in colour from dark red to white, with four petals, stamens in three whorls fused at the base, and filaments protruding to 2cm/¾in. The fruit is single-seeded, fleshy, tapering at either end, up to 6cm/2¼in long.

Far right: Indian oak is a small flowering tree.

Distribution: Indo-Pacific region.
Height and spread: 13m/42ft.
Habit and form: Shrub or small tree.
Leaf shape: Oblanceolate.
Pollinated: Uncertain, possibly bat or moth.

Bloodhorn

Mangrove ochrosia, *Ochrosia elliptica*

This large shrub or small spreading tree can be found along northern and central coastal Queensland, on Lord Howe Island and parts of Melanesia in fore-dune vine thickets immediately behind the mangroves. The small, yellow or white flowers are sweetly fragrant and occur in small clusters between mid-spring and late summer and are followed by pairs of striking, red fruits, which resemble red horns or elongated tomatoes. These often persist on the tree for a considerable time. Unfortunately, despite their appearance, the fruit are poisonous, and plants also bleed copious amounts of poisonous white sap when wounded, making it best to avoid contact with this tree.

Identification: A large evergreen shrub or small, spreading tree with stout, green young branches. The leaves are glossy, leathery, dark green, elliptic to oblong or oval, with smooth, wavy edges, up to 20cm/8in long and 8cm/3¼in wide, occurring in whorls of three or four. The flowers appear in axillary clusters and are fragrant, small and yellow or white. The showy, oval fruits, 5cm/2in long, are borne in pairs and are persistent on the tree.

Distribution: Australia, Melanesia.
Height and spread: 5–9m/16–30ft.
Habit and form: Large shrub or small tree.
Leaf shape: Elliptic to oblong.
Pollinated: Insect.

Left: This evergreen tree has a dense, spreading crown and is most noticeable when the bright red fruits ripen.

OTHER OLEANDER, BRAZIL NUT AND EUCALYPTUS SPECIES

Kalalau *Pteralyxia kauaiensis*
This long-lived small tree has shiny, dark green leaves that hide the small, greenish, tubular flowers. It is one of just two members of an endemic Hawaiian genus within Apocynaceae, growing in the Wahiawa Mountains in the southern portion of Kauai.

Kaulu *Pteralyxia macrocarpa*
The kaulu is the only other member of this rare Hawaiian genus and is a small tree found in valleys and slopes in diverse mesic forest on the island of Oahu. Its shiny, green leaves almost hide the yellowish, tubular flowers. It is rare, with 500 or so in the wild.

Water Gum *Tristania neriifolia*
A large shrub that may become a small tree, the water gum is found along the central coast and adjacent ranges of New South Wales, along the banks of streams. It has narrow leaves with conspicuous oil glands. The yellow, star-shaped flowers occur in summer, usually in groups of three to six. It is the only species in the genus.

Scarlet Kunzea *Kunzea baxteri*
This erect shrub from the south coastal areas of Western Australia has grey-green, oblong leaves and large, crimson flower clusters, which are arranged in bottlebrush form and are very profuse and conspicuous in spring and early summer. The plant is related to the bottlebrushes, *Callistemon* species, and also bears a similarity to *Melaleuca* and *Leptospermum* species.

Falaga

Barringtonia samoensis

This shrub or small tree occurs in coastal areas or on seasonally inundated land by lagoons, creeks and riverbanks, from south-east Celebes to Micronesia, New Guinea and Polynesia. It bears spectacular pendulous spikes at the branch tips that may contain 150 or more individual, scented flowers of red or white, each with numerous long golden-yellow anthers and a single, persistent, red stigma.

Identification: The leaves, up to 90cm/3ft long with smooth margins or rounded teeth, are crowded at the ends of the branches, spirally arranged, with a midrib prominent on both sides. The flowers are borne in pendulous racemes up to 55cm/22in long, which may be terminal or sprout directly from the branches. They have four convex, white or red petals and numerous protruding yellow stamens, fused at the base in three to eight whorls. The ribbed fruit is single-seeded and fleshy, up to 7cm/2¾in long with a tapering base.

Distribution: Micronesia, New Guinea and Polynesia.
Height and spread: 12m/40ft.
Habit and form: Shrub or small tree.
Leaf shape: Obovate.
Pollinated: Insect.

Left: The spectacular flower spikes are borne at the branch tips and may contain 150 flowers.

Cocky Apple

Billy goat plum, *Planchonia careya*

Distribution: Tropical northern Australia.
Height and spread: 4–10m/13–33ft.
Habit and form: Small tree or spreading shrub.
Leaf shape: Ovate or spathulate.
Pollinated: Bat.

Above: Each of the large, fleshy flowers persists for just one night.

Far right: The fruit is green, egg-shaped and smooth.

This is a common, widespread small tree or spreading shrub found across much of northern tropical Australia and down the east coast to Fraser Island, most commonly in open forests and woodlands. It prefers moist places, such as the edges of floodplains and coastal monsoon forests, and flowers from spring to mid-autumn. It is related to the freshwater mangroves, *Barringtonia* species. It is night-flowering: the flowers open at dusk and persist only until the sun shines the following day.

Identification: The species is briefly deciduous in the dry season. The bark is grey, rough, slightly corky and fissured. The leaves are oval or spoon-shaped with rounded teeth on the margins, tapering to the base and up to 10cm/4in long. They are softly leathery, shiny, light green above, dull beneath, turning rusty-orange before falling. The large, fleshy flowers are white, grading to pink inside towards the base, with numerous pink-and-white stamens, 5cm/2in long, fused together into a tube at their bases. The flowers are borne only at night, the whole staminal bundle falling off as a single unit in the morning.

MYRTLE, EVENING PRIMROSE AND DAPHNE FAMILIES

The Myrtaceae, myrtle family, are trees and shrubs found in the warm-temperate regions of Australia.
The family dominates the hardwood forests across the continent. The evening primrose family, Onagraceae,
has a restricted distribution although the Daphne family, Thymelaeaceae, is much more widespread.

Shining Copper Cups

Pileanthus rubronitidus

This small shrub is one species in a small genus restricted to Western Australia. Shining copper cups is found only between Kalbarri and west of Northampton, growing on grey sand over sandstone, or white sand, in heath or shrubland colonized by the sceptre banksia, *Banksia sceptum*, although isolated colonies have been reported from Mount Magnet. The orange-red flowers appear between early and late spring, although it is the conspicuous, cup-like calyces, persisting long after flowering, that give rise to the plant's common name.

Identification: A small, branching evergreen shrub with very narrow, three-sided, smooth leaves, up to 12mm/½in long, with prominent oil glands. The flowers appear in clusters around the upper leaf axils in spring, initially enclosed in a one-leaf bract; they are very distinctively red-orange, with ten sepals and five rounded petals, on a slender stem 12–25mm/½–1in long.

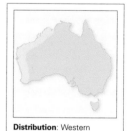

Distribution: Western Australia.
Height and spread: 90cm/3ft.
Habit and form: Shrub.
Leaf shape: Linear.
Pollinated: Insect.

Left: Shining copper cups forms a small open bush.

New Zealand Tea Tree

Manuka, *Leptospermum scoparium*

This shrub occurs widely throughout lowland to subalpine areas and in many habitats, chiefly in New Zealand, where it is considered to be endemic, although some botanists claim that it is also a native species of Tasmania, New South Wales and Victoria, Australia. It is by far the commonest shrubland constituent and has increased greatly under the influence of human settlement. The English common name is derived from the fact that early white settlers made infusions of tea from the leaves, which are aromatic. The white blooms appear in spring and early summer, often so profusely that it resembles snow.

Identification: A bushy, evergreen shrub ranging in size from a creeping plant to a small tree, although it is seldom more than 4m/13ft high. It is adaptable and extremely variable in leaf size and shape, flower and leaf colour, branching habit and foliage density, as well as oil content and aroma. Differences occur in individual plants, within and among populations, genetically and with season, soil and other variables. The bark sheds in long papery strips. The thick leaves are narrow and less than 15mm/⅝in long, with sharp pointed tips, hard and leathery, with aromatic scent glands beneath, variable in colour from very pale green to dark brown; younger shrubs have softer, paler leaves. Showy, mostly white, sometimes pink or reddish flowers, 1.5cm/⅝in across, are borne profusely in spring.

Distribution: New Zealand, eastern Australia.
Height and spread: 4–6m/13–20ft.
Habit and form: Shrub or small tree.
Leaf shape: Narrow.
Pollinated: Insect.

Above left: The fruits are woody capsules containing numerous small, thin seeds.

Left: This variable shrub can have a creeping habit or be almost tree-like.

Mottlecah

Rose of the west, *Eucalyptus macrocarpa* subsp. *macrocarpa*

Distribution: Western Australia.
Height and spread: Up to 5m/16ft.
Habit and form: Mallee shrub.
Leaf shape: Ovate.
Pollinated: Insect.

This species of eucalyptus is distinctive in having a growth habit in which several woody stems arise separately from a lignotuber, or starchy swelling on underground stems or roots – a form known as a "mallee". It is chiefly found on open sandy heath in Western Australia. It is quite variable in form, with two subspecies often reported: the subspecies *elachantha* is restricted in occurrence and differs from the common form in having smaller leaves and lower stature.

Right: The large gumnuts contain many tiny seeds.

Identification: A spreading or sprawling mallee with smooth bark throughout, grey over salmon-pink. The glaucous, silvery grey-green leaves are opposite, 5–12.5cm/2–5in long, stalkless and oval, while the young leaves are almost circular. Spectacular large flowers, up to 10cm/4in across, appear from early spring to midsummer, with a mass of stamens that are usually red, occasionally pinky-red or cream. The very large, shallowly hemispherical "gumnuts" that follow them have a powdery grey covering.

Far left: This medium to large shrub grows from an underground stem that protects it from fires.

OTHER MYRTLE FAMILY SPECIES OF NOTE

Tree Manuka *Leptospermum ericoides*
This large shrub or small tree can reach 15m/50ft high. It has loose, peeling bark and small, pointed, aromatic leaves. The small, white, five-petalled flowers cover mature specimens in spring and early summer with a mass of blossom. It is abundant in lowland and mountain forests throughout New Zealand.

Lutulutu *Eugenia gracilipes*
This graceful tree possesses delicate foliage and drooping branches, which bear terminal slender racemes of three to seven pale yellow or pink-tinged flowers. It is found only in the Fiji islands. Related species include *Sygyzium malaccensis*, the malay apple, which has deep purple, crimson or even white flowers and reddish fruits, much valued locally for eating.

Pohutukawa *Metrosideros excelsa*
The New Zealand Christmas tree gains its name from its time of flowering and forms a wide-spreading tree with round, leathery, dark green leaves and large flowers most noted for their spectacular sprays of red stamens. Its natural distribution is restricted to the coastal forest in the North Island.

Rata *Metrosideros robusta*
The rata is an inhabitant of the forests of New Zealand's North Island but can also be found on Three Knights Island and western South Island. It forms a large tree, with dull red flowers appearing in summer. The plant often begins life as an epiphyte, perching in another tree. In time, roots are sent down to the ground, and the *Metrosideros* takes over.

Copper Cups

Pileanthus peduncularis

Distribution: South-western Australia.
Height and spread: 90cm/3ft.
Habit and form: Shrub.
Leaf shape: Linear.
Pollinated: Insect.

This small rounded shrub, found only on the south-western Australian sand plains, is probably the best-known member of the genus. It is often encountered among sand dunes north of Perth, although its distribution is scattered. It is a spectacular sight in spring with its unusual, large, copper-orange flowers, which occur towards the ends of the branches and from the leaf axils in a massed display. The conspicuous, cup-like calyces often persist for a long time after flowering.

Identification: Small, branching evergreen shrub with very narrow, three-sided, smooth leaves up to 4mm/⅛in long, with prominent oil glands. The flowers appear in clusters toward the ends of the branches and from the leaf axils, initially enclosed in a one-leaf bract; they are up to 2.5cm/1in across, copper-orange, sometimes red, with ten sepals and five rounded petals, on a slender stem 12–25mm/½–1in long.

Above: The cup-like calyces often persist well after flowering.

Below: The plant forms a low, branching, rounded shrub on sandy soils.

Bottlebrush

Callistemon brachyandrus

This large bushy shrub is found growing naturally in western New South Wales, Victoria and South Australia. It is one of the later flowering bottlebrushes and flowers during the summer, often after others of the genus have finished. Like so many of Australia's attractive native plants, the inflorescences of *Callistemon* are composed of a large number of small flowers grouped together. The flower arrangement closely resembles a bottle-cleaning brush, hence the common name. The small red brushes cover the branches, and the masses of stamens are dark red with yellow anthers, giving the flowers the appearance of being dusted with gold.

Above and below right: The bush forms a dense shrub with flowers appearing at the branch tips.

Distribution: South-eastern Australia.
Height and spread: 4m/13ft.
Habit and form: Shrub.
Leaf shape: Linear.
Pollinated: Insect.

Identification: A dense, small to tall shrub. The prolific young shoots are grey, silky, soft and hairy, distinct from the mature needle-like leaves, which are up to 4cm/1½in long, stiff and sharp-pointed, pungent, with undersides typically dotted with oil glands. The flowers are borne in loose spikes up to 8cm/3¼in long, appearing in mid- to late summer; the five small, green petals and sepals, together with the pistils, are barely noticeable among the showy, orange-red stamens, with gold anthers.

Lesser Bottlebrush

Fiery bottlebrush, Callistemon phoeniceus

Despite its common name, this plant is actually a medium-sized shrub that is widespread in south-west Western Australia. It is one of only two species that occur there. It naturally grows in depressions and along watercourses extending from the Swan River to the Murchison River, with its eastern limits in the Norseman area.

Below right: This medium-sized shrub often resembles a small pendulous tree.

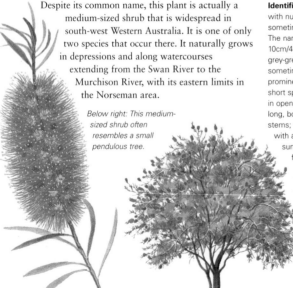

Identification: A medium shrub with numerous branches, sometimes slightly pendulous. The narrow leaves are up to 10cm/4in long, blue-green to grey-green, thick, rigid, sometimes twisted, with a prominent midrib, tipped with a short spine. The flowers grow in open spikes 10–15cm/4–6in long, borne terminally on slender stems; they appear in late spring, with a second flowering in late summer if conditions are favourable. The stamens are a bright rich red, usually with darker anthers.

Right: The fluffy red flowerheads resemble bottle-cleaning brushes and give rise to the common name.

Distribution: Western Australia.
Height and spread: 3m/10ft.
Habit and form: Shrub.
Leaf shape: Linear-lanceolate.
Pollinated: Insect.

Arakura

Scarlet rata, *Metrosideros fulgens*

This plant is one of a number of rata vines found in New Zealand. Unlike *M. robusta* however, which begins as a vine and often grows into a tree, the scarlet rata needs support throughout its life. It commonly flowers from late summer into autumn, when it can be seen scrambling and twining over logs and up trees, and is considered an early sign that winter is approaching.

Distribution: New Zealand.
Height and spread: 10m/33ft or more.
Habit and form: Liana.
 Leaf shape: Elliptic-oblong.
 Pollinated: Insect.

Left: The plant is a liana and needs the support of another tree to reach its full height.

Identification:
A liana with aromatic bark, separating in flakes, and smooth leaves up to 7.5cm/3in long, opposite, simple, pinnately veined and dotted with glands, on stout leaf stalks. The flowers are in terminal clusters, with oblong sepals, round orange-red petals and a mass of scarlet stamens up to 2.5cm/1in long. The fruit is a leathery capsule.

Right: The small flowers are given added prominence by the mass of scarlet stamens.

OTHER MYRTLE FAMILY SPECIES OF NOTE
Alpine Bottlebrush *Callistemon pityoides*
The alpine bottlebrush forms dense thickets at altitudes of 2,000m/6,500ft or more, being found most commonly in and around sphagnum bogs and swamps, and along watercourses in eastern Australia. The colourful bracts that surround the developing buds first become evident in early spring, opening to reveal yellow flowers.

Crimson Bottlebrush *Callistemon citrinus*
From the east coast of Australia, this is an upright shrub with narrow, lance-shaped, leathery leaves with a distinctly citrus aroma (hence the specific name). The plump, bright red, bottlebrush-shaped flowers, composed mostly of stamens, bloom throughout the hot weather. The bark is rough and light brown.

Regelia cymbifolia
Occurring in a restricted area in south-west Western Australia in sandplain or woodland, this is a bushy, erect, many-branched shrub up to 1.8m/6ft tall. It has oval leaves and deep pink to purple flowers produced in small, terminal clusters in spring. The seeds are retained within the capsules until a fire prompts their release.

Gillham's Bell *Darwinia oxylepis*
This is a small shrub that may reach 1.5m/5ft, with narrow, recurved leaves. The small flowers are enclosed within large, deep red bracts with a characteristic bell shape, on the branch tips in spring.

Cranbrook Bell

Darwinia meeboldii

One of several species of *Darwinia* from south-western Australia, known collectively as "mountain bells", this plant is found in moist, peaty soils in the Stirling Ranges, although it is now rare. It is an erect, spindly, small to medium-sized shrub that bears clusters of around eight small flowers enclosed within large bracts. These give the inflorescence its characteristic bell shape.

Identification: The narrow, aromatic leaves are alternately paired, triangular in section, up to 1cm/⅜in long with prominent oil glands. Flowers appear from early to late spring, prominently displayed on the ends of the branches: small, white to red tubular flowers appear in groups of about eight enclosed within leafy, bell-shaped bracts, usually white with bright red tips, more rarely red or green.

Far right: The plant forms an erect, spindly, medium-sized shrub that is clothed with flowers in the spring.

Distribution: South-western Australia.
Height and spread: Variable.
Habit and form: Dwarf to medium shrub.
 Leaf shape: Linear.
 Pollinated: Insect.

Chenille Honey Myrtle

Melaleuca huegelii subsp. *huegelii*

This flowering shrub, native to south-western coastal districts of Western Australia, is unusual in that it flowers during the summer. Two subspecies are currently recognized, *huegelii* and *pristicensis*, the latter distinguished by its mauve to pink flowers held in narrow spikes. Both are medium to large shrubs, found on limestone cliffs, coastal plains and dunes. The leaves are very small and crowded against the stems in a scale-like manner, and these are covered with small oil glands. The long whip-like branches make this a highly distinctive plant.

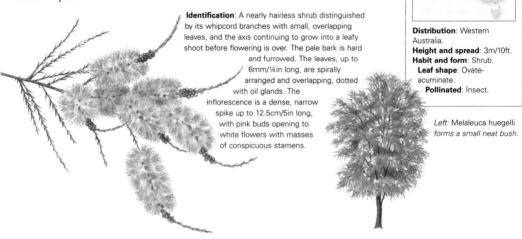

Identification: A nearly hairless shrub distinguished by its whipcord branches with small, overlapping leaves, and the axis continuing to grow into a leafy shoot before flowering is over. The pale bark is hard and furrowed. The leaves, up to 6mm/¼in long, are spirally arranged and overlapping, dotted with oil glands. The inflorescence is a dense, narrow spike up to 12.5cm/5in long, with pink buds opening to white flowers with masses of conspicuous stamens.

Distribution: Western Australia.
Height and spread: 3m/10ft.
Habit and form: Shrub.
Leaf shape: Ovate-acuminate.
Pollinated: Insect.

Left: Melaleuca huegelii forms a small neat bush.

Scarlet Honey Myrtle

Melaleuca fulgens

This well-known plant, from south-west Western Australia, north-west South Australia and the south-west of the Northern Territory, is common in cultivation in both its usual red-flowered form and in several other colours. The leaves and branches emit an aromatic fragrance when bruised. It occurs in various habitats, most commonly in rocky granite areas, and blooms in spring, with a typical bottlebrush form to the flowers. Birds, particularly honeyeaters searching for nectar, are attracted to the shrub when it is in flower.

Identification: The branches are smooth except for the young felted shoots, and the narrow, grey-green leaves, up to 3cm/1¼in long, are borne in alternate pairs on very short or no stalks. The inflorescence is a spike of 6–20 flowers, usually with the axis growing on into a leafy shoot; the numerous, conspicuous stamens, much longer than the petals, are scarlet or deep pink (rarely white). The urn-shaped fruit has a rough, wrinkled, almost papery texture.

Distribution: Western Australia.
Height and spread: 2.5m/8ft.
Habit and form: Shrub.
Leaf shape: Elliptic.
Pollinated: Bird.

Left: Scarlet honey myrtle forms a loose spreading shrub that is highly visible when in flower.

Fuchsia procumbens

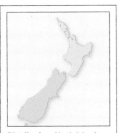

Originating in North Island, New Zealand, this small shrubby plant grows in rocky, sandy or gravelly places near the sea, in areas that can occasionally be flooded by exceptionally high tides, where it may cover substantial areas. Due to the destruction of its natural habit, it is now an endangered species in the wild. It is prostrate in growth, with slender, trailing stems, small, heart-shaped leaves and distinctive, though rather diminutive, erect flowers.

Distribution: North Island, New Zealand.
Height and spread: Variable.
Habit and form: Prostrate shrub.
Leaf shape: Suborbicular.
Pollinated: Insect.

Identification: Slender, branched, prostrate shrub with long, trailing shoots and alternate, round or heart-shaped leaves, 6–20mm/ ¼–¾in across, borne on thin stalks. The erect flowers, up to 20mm/¾in long, have a greenish-yellow tube that is red at the base, and purple-tipped, sharply reflexed green sepals and no true petals; the stamens bear bright blue pollen. The attractive seedpods are about 2cm/¾in long. They ripen from green to bright crimson, covered with a light bloom, and are long-lasting.

Above: The tiny orange flowers have strongly reflexed sepals and no true petals.

Kotukutuku *Fuchsia excorticata*
The largest fuchsia in the world, growing in Central South America and New Zealand, particularly on North Island, where it is common in lowland to lower montane forest, especially along margins and in damp valleys. The solitary, red, pendulous flowers have blue pollen and the dark, egg-shaped fruit is relished by the Maoris and known as konini.

New Zealand Daphne *Pimelia prostrata*
This variable, low shrub is found in dry places in New Zealand where it may variously adopt a wide-spreading or tufted habit. The small, silky-downy white flowers are fragrant and appear in small crowded heads of between three and ten, on short side shoots near the ends of the branches, usually in spring or early summer.

Rosy Paperbark *Melaleuca diosmatifolia*
The rosy paperbark of eastern Australia is most commonly found in woodland and open forest, often in areas subject to inundation. It is a small shrub with narrow leaves ending in a small point. The pale to deep mauve flowers are usually seen in spring and early summer and occur in bottlebrush-type spikes on short branches.

Scarlet Feathers *Verticordia grandis*
A showy small shrub, found in woodlands and sandy heaths in south-western Australia. It has small, stem-clasping, rounded, grey-green leaves. Throughout the year it bears bright red, five-petalled flowers, each with a long, protruding style. The popularity of this species for floral arrangements has resulted in over-picking from the wild in some areas across its range.

Rice Flower

Pimelia ferruginea

This small to medium-sized, evergreen, woody shrub is one of around 80 species of so-called rice flowers, found throughout Australia and New Zealand, which are related to the European and Asian genus *Daphne*. The flowers are produced mainly in spring but can appear at any time, in dense heads borne at the tips of the branches.

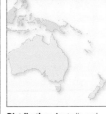

Distribution: Australia and New Zealand.
Height and spread: 1.8m/6ft.
Habit and form: Evergreen shrub.
Leaf shape: Ovate or oblong.
Pollinated: Insect.

Identification: An erect, evergreen shrub with opposite, crowded leaves up to 12mm/½in long, shiny and smooth above, often hairy beneath, with rolled margins. Almost spherical flowerheads, up to 4cm/1½in across, appear in late spring to early summer, held at the ends of branchlets and surrounded by leaf-like pink or red bracts. The tubular, four-petalled flowers are rose-pink with a paler centre.

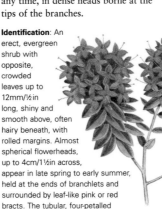

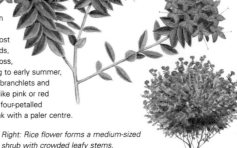

Right: Rice flower forms a medium-sized shrub with crowded leafy stems.

PASSIONFLOWER, VIOLET AND SAXIFRAGE FAMILIES

The Passifloraceae (passionflowers) are tropical climbers and woody shrubs. Members of the Violaceae, the violet family, are widely distributed with species being herbaceous trees or shrubs. The Saxifragaceae, or saxifrage family, includes herbaceous perennials and deciduous shrubs typically in cooler climes.

Slender Violet

Hybanthus monopetalus

This delicate, erect, herb-like shrub is common in sheltered spots in scrub and dry grassland in mountainous areas throughout much of eastern Australia and Tasmania. The leaves are narrow and soft, with the upper leaves held opposite, while the lower ones are mostly alternate. The striking blue flowers have five petals, but four of these are so tiny they are inconspicuous. The fifth is greatly elongated and its appearance gives rise to the botanical species name: *monopetalus* is Latin for single-petalled, and this feature gives the plant a highly distinctive appearance.

Identification: An erect, herb-like shrub, reaching 50cm/20in tall where ungrazed. The soft, narrow leaves are mid-green with a strongly defined midrib, 1–6cm/⅖–5¼in long. Large, solitary, prominent blue flowers are borne on slender stalks; they have five more or less equal sepals and five petals, four of which are inconspicuous. The fifth is 6–20mm/¼–¾in long, oval, pale blue with darker veins, with a pale spot toward the base and a broad, dilated concavity or claw in the base.

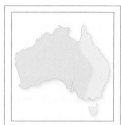

Distribution: Eastern Australia and Tasmania.
Height and spread: 50cm/20in.
Habit and form: Herb-like shrub.
Leaf shape: Linear-lanceolate.
Pollinated: Insect.

Above left: The fruit is divided into three parts that split to reveal the seed.

Left: While herb-like in appearance, slender violet is actually a shrub.

Australian Violet

Trailing violet, ivy violet, *Viola hederacea*

Known as the ivy violet because of its trailing habit, this creeping herbaceous plant is a native of shady and moist spots among the mountains of eastern and southern Australia, including Tasmania. It is a fairly variable species, with dark green leaves and, during the summer, short stems of fragrant, purple or white flowers that have a squashed appearance and are borne fairly abundantly above the foliage.

Identification: A stemless, tufted or creeping, mat-forming perennial. The leaves are rounded or kidney-shaped, up to 4cm/1½in wide, sometimes toothed, dark green with paler veination, often forming dense cover. The flowers are blue-violet to white, usually with a blue-purple centre and white edges, and are flattened in appearance, with bearded lateral petals and inconspicuous spurs. They are held 7.5cm/3in above the leaves and are sometimes scented.

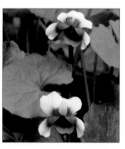

Above: The flowers have a squashed appearance when they open.

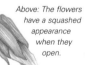

Left: The flowerheads are pale and nodding before they open.

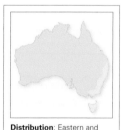

Distribution: Eastern and southern Australia.
Height and spread: 7.5cm/3in.
Habit and form: Mat-forming herb.
Leaf shape: Spathulate to reniform.
Pollinated: Insect.

Left: The flattened flowers are held on thin stalks above the foliage.

Red Passion Flower

Passiflora aurantia

This climbing vine is naturally found in eastern Queensland and also occurs in New Guinea and on some Pacific islands. *Passiflora* is a well-known genus because it includes the commercial passion fruit, *P. edulis*. While the genus is mostly restricted to areas of tropical America and Asia, this is one of three Australian species. It has tri-lobed leaves and red or salmon flowers, borne mainly in winter and spring, although a few can usually be seen all year round. The flowers deepen in colour as they age and are followed by egg-shaped, green fruits, which, although edible, are unpalatable.

Distribution: North-east Australia, New Guinea, Pacific islands.
Height and spread: Variable.
Habit and form: Liana.
Leaf shape: Lobed.
Pollinated: Insect.

Right: This vigorous climbing plant clings by means of coiling tendrils and flowers over a long period.

Identification: A vigorous, woody liana with hairless, angular stems, producing long, coiling tendrils by which it supports upward growth. The leaves, up to 7.5cm/3in long, usually have three shallow oval lobes. The flowers, up to 10cm/4in in diameter, have narrow, pale pink sepals deepening to orange-red, orange to brick-red petals and deep red filaments. The egg-shaped green fruit, 4cm/1½in long, contains greyish pulp and numerous black seeds.

OTHER PASSIONFLOWER, VIOLET AND SAXIFRAGE SPECIES OF NOTE

Mahoe Wao *Melicytus lanceolatus*
This large shrub or small tree from New Zealand has grey-brown bark and long, deep green leaves. The purple-tinged flowers are held in clusters of six around the leaf axils, although they sometimes appear to emerge directly from the branches. They are followed by small, dark purple fruits.

Whiteywood *Melicytus ramiflorus*
This is a fast-growing, spreading tree with a short, branched trunk and whitish-grey peeling bark. Found naturally all over New Zealand, Fiji, Norfolk Island and the Solomon Islands, it occurs from sea level to 900m/2950ft. The small yellow flowers are followed by blue or purple berries.

Mountain Violet *Viola cunninghamii*
This stemless, hairless perennial with rounded or triangular leaves is a native of New Zealand, where it is found in North, South, Stewart, and Chatham Islands, in moist or shady sites in river valleys. The short-spurred flowers appear in spring, and are white to pale violet, with greenish or yellowish throats and a number of purple lines on the petals.

Aupaka *Isodendrion hosakae*
This endemic Hawaiian shrub occurs on volcanic cinder or ash soils in the Waikoloa region. It is a branched, upright, evergreen with long, white, five-petalled, tubular flowers, which are produced from the axils of shiny leaves near the stem tips.

Wire Netting Bush

Corokia cotoneaster

This much-branched shrub with stiff interlacing branches is common throughout New Zealand, in dry rocky places from North Cape to Stewart Island. Its star-like yellow flowers are followed by red berries in autumn and, although the plant is an evergreen, the leaves are so small and scattered that even in full growth the plant has a sparse, metallic appearance. It is thought that the cage-like tangle of branches evolved to protect the tender young shoots from being eaten by the moa, New Zealand's giant bird, now extinct.

Distribution: New Zealand.
Height and spread: 2m/6½ft.
Habit and form: Shrub.
Leaf shape: Rounded.
Pollinated: Insect.

Identification: The slender, tortuous branches of this shrub are covered in silvery hairs, later becoming hairless, dark grey or black, often spiralling or tangled or zigzagging. The sparse, round leaves, up to 2cm/¾in across, are maroon-green or bronze, often flushed maroon above, silvery beneath. The solitary yellow flowers appear in the leaf axils or in a terminal panicle in late spring; they are star-like, with five narrow petals and five prominent stamens. The fruit is a small, vermilion, fleshy drupe with a persistent calyx.

Left: The stiff interlacing branches give rise to the common name of this shrub.

Left: Bright red berries appear in the autumn.

CARROT FAMILY

The Apiaceae, or carrot family, are poorly represented across much of Oceania although those that do occur there tend to be interesting examples, having become isolated from their counterparts in the Northern Hemisphere. A greater diversity of species is found in Australia and some of these have also evolved into interesting forms.

Sydney Flannel Flower

Actinotus helianthi

This herbaceous or shrubby plant, found in open forest and woodland and on dry hillsides, coastal dunes and heaths, usually on sand or sandstone, is a native of the coast and mountains of New South Wales and southern Queensland. The deeply lobed, grey leaves have a velvety texture, giving rise to the common name. The small flowers occur in clusters surrounded by velvety, petal-like bracts, giving each flowerhead an appearance similar to that of a daisy. The flowers appear in spring and continue into early summer, though some are usually present throughout the year.

Identification: An erect, branching, herbaceous or shrubby perennial. The pinnate leaves have narrow, toothed, felted segments and the daisy-like flowerheads consist of numerous tiny, white flowers in dense umbels surrounded by large cream bracts, often tipped green, with a dense covering of silvery, woolly hairs. They are followed by fluffy seeds in a globular head, readily dispersed by the breeze.

Distribution: Eastern Australia.
Height and spread: 60cm/2ft.
Habit and form: Herbaceous perennial or subshrub.
Leaf shape: Compound.
Pollinated: Insect.

Gingidia montana

This small, aromatic herbaceous plant is found in moist open sites in both the North and South Islands of New Zealand and is also endemic to New South Wales. It occurs in *Eucalyptus paucifolia* woodland, or more commonly at the edge of forests of southern beech, *Nothofagus* species, growing within the crevices of basalt or trachyte rocks, mostly on cliff faces.

Identification: A stout, hairless, erect herb or small shrub, up to 50cm/20in high, strongly aromatic with divided leaves up to 60cm (2ft) long, composed of seven to nine ovate to almost circular leaflets with obtusely toothed margins. The white flowers are borne on umbel-like inflorescences with 8–12 rays, up to 2.5cm/1in long, on 15cm/6in flowering stems. The fruits are egg-shaped. Plants occasionally hybridize with the related *Aciphilla squarrosa* and the exact details of its classification remain the subject of some debate.

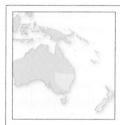

Distribution: New Zealand and New South Wales.
Height and spread: 50cm/20in.
Habit and form: Herbaceous perennial or subshrub.
Leaf shape: Pinnate.
Pollinated: Insect.

Far left: Gingida *forms dense masses of aromatic green foliage that resembles cress but is topped in summer by white umbels of flowers.*

Golden Speargrass

Bayonet plant, golden Spaniard, *Aciphylla aurea*

This common perennial, from the subalpine grasslands of New Zealand's South Island, forms a large, clumped rosette of stiff, rigid, yellowish-green leaves with golden-yellow margins, which can deliver a painful stab if not approached with care, hence the common name for this species. The spiny, golden flower spike that appears in summer is rather showy and contains many flowers. Individual plants are either male or female (dioecious) and this gives the species a slight variability. Its ability to survive fire has led to it colonizing extensive areas.

Distribution: South Island, New Zealand.
Height and spread: Evergreen herbaceous perennial.
Habit and form: Up to 90cm/3ft.
Leaf shape: Hastate.
Pollinated: Insect.

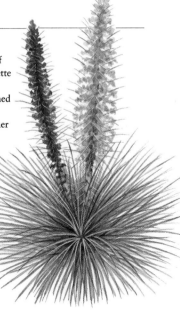

Identification: A coarse, evergreen perennial with rosettes up to 90cm/3ft across. The grey-green, spear-shaped leaves, up to 70cm/28in long, have thick sheaths and yellow margins and midribs. The flowers appear on a massive terminal panicle up to 90cm/3ft tall, usually long-stemmed and candelabra-like, composed of compound umbels. Those of the male plants are strictly unisexual, while the female flowers are interspersed with sporadic males. The small flowers are white to pale yellow and crowded, though the male umbels are more loosely arranged than the female's.

OTHER CARROT FAMILY SPECIES OF NOTE

Flannel Flower
Actinotus leucocephalus
This species from Western Australia has white, fuzzy or hairy bracts, making it look almost like an edelweiss when it flowers. Flowering is erratic, however: the best time to see flowers is in spring following a bushfire, when they sometimes cover the ground profusely.

Actinotus bellidioides
This rare species is restricted to peaty soils, chiefly in upland bogs in south-eastern Australia and Tasmania. It has a small, flat rosette of circular dark green leaves, which although not as hairy as other species are typical of the genus, and is identifiable chiefly by its buttercup-like, golden-yellow bracts.

Anisotome flexuosa
This large perennial has narrow, two-pinnate, leathery leaflets, and like others in the genus it is dioecious. It is found in montane and subalpine habitats of New Zealand's South Island, where it may be seen growing among rock crevices. The creamy-white umbels are loosely scattered across the hummocky mass of foliage in the early summer.

Aciphylla montana
This tufted, small perennial of South Island, New Zealand, has sharp-pointed, yellowish-green leaves, with two to four pairs of segments, which are strongly pungent when crushed. The male inflorescences are shorter than those of the female. The yellowish umbels rarely exceed the leaf height.

Aromatic Aniseed

Anisotome aromatica

This perennial herb, native to the South Island of New Zealand, is found chiefly in the grassland of the montane subalpine zones. The fragrant flowers are held in clusters in small umbels, which appear above the carpeting foliage. The male and female flowers appear on separate plants, both arranged in umbels on slender, sparingly divided stems.

Distribution: South Island, New Zealand.
Height and spread: 50cm/20in.
Habit and form: Herbaceous perennial.
Leaf shape: Pinnate.
Pollinated: Insect.

Identification: A dioecious herbaceous perennial with basal, pinnate leaves, 5–12cm/2–5in long, with 6–12 pairs of leathery, toothed, deeply divided leaflets, the segments of which are sessile and deeply divided with hairs at their apex. The flowers appear in clusters in a small umbel reaching 10–15cm/4–6in across and are white and fragrant. The male umbels are large and many flowered and the female umbels are much smaller, contracted and fewer flowered, often looking a little like a different species. Several sub-species occur across its range, making it a variable plant and one that can cause confusion when identifying it.

BELLFLOWER, PINCUSHION AND AND MADDER FAMILIES

Bellflowers (Campanulaceae) are highly ornamental and have become familiar plants in cultivation. The Australian family Brunoniaceae (pincushion family) has only one genus and species, whereas the Rubiaceae, the madder family, mostly occurs in the tropics.

Royal Bluebell

Wahlenbergia gloriosa

The royal bluebell occurs mainly in subalpine woodland above 1,300m/4,250ft in the Australian Capital Territory, south-eastern New South Wales and Victoria. It grows in the most uninviting dry, stony habitats, often exposed to full sun and strong winds. The vivid blue or violet-blue flowers are easily recognized; they are held above the foliage on long slender stems and may be erect or nodding. It has become scarce in recent times and is now legally protected throughout its natural range.

Distribution: South-eastern Australia.
Height and spread: Variable.
Habit and form: Creeping herbaceous perennial.
Leaf shape: Obovate.
Pollinated: Insect.

Identification: A small, slender, creeping to semi-erect herbaceous perennial with spreading rhizomes and erect stems, sometimes branching, rising above the oval, wavy-edged leaves. The flowers, 2.5cm/1in across, are deep blue to purple, bell-shaped, erect or nodding, on long slender stems with a few distant, narrow bracts; there are usually five petals, joined in a short tube, with spreading lobes with light blue bases and a purple style ending in two white stigmas. The fruit is a small capsule, prominently ribbed and surmounted by the five erect sepals.

Left: The small creeping stems of this herb give rise to vivid blue or violet-blue, star-shaped flowers.

Blue Pincushion

Brunonia australis

This silky or hairy herb is locally frequent in all Australian states in dry forests, being most often encountered following bushfires. Each inflorescence has a large number of crowded flowers, with the reproductive parts raised above the petals so that they resemble pins in a pincushion. The flowers appear in late spring to summer, held on leafless stems above the rosettes of silky, hairy, spoon-shaped leaves, giving the plant a decorative appearance. *Brunonia* is a monotypic genus although it is variable in habit as a result of its widespread distribution.

Identification: A rather variable, densely hairy herbaceous perennial, growing to 30cm/1ft tall and with grey-green, spoon-shaped leaves up to 5cm (2in) long, forming a basal rosette. The vivid cornflower-blue flowers, tubular at the base and with spreading, star-like petals, appear in crowded, terminal, pincushion-like heads up to 2.5cm/1in across, atop a base of hairy calyces and borne on erect, leafless stems that reach 45cm/18in tall, usually in spring but sporadically extending through to autumn.

Distribution: Australia.
Height and spread: 30cm/1ft.
Habit and form: Herbaceous perennial.
Leaf shape: Obovate.
Pollinated: Insect.

Beach Gardenia

Guettarda speciosa

Beach gardenia can be found in coastal northern Australia, from Western Australia to central Queensland, and also on many Pacific Islands, typically in beach strand communities in coastal regions, almost all the way to the high tide level in places. It has large rounded leaves, above which the large, white, fragrant, tubular flowers occur from spring to autumn, although they may also be seen at other times. The fragrance is similar to that of true gardenia, though weaker.

Identification: The leaves, up to 20cm/8in long, are opposite or in whorls of three, broadly oval with blunt or pointed tips, smooth above and hairy beneath, with a prominent midrib and 7–10 pairs of lateral nerves. White, fragrant, tubular flowers up to 4cm/1½in long, with seven spreading lobes, appear in dense axillary cymes, and are followed by small, hard, globular, white to brown fruits.

Distribution: North Australia, Pacific Islands.
Height and spread: 5m/16ft.
Habit and form: Shrub or small tree.
Leaf shape: Obovate.
Pollinated: Insect, probably moths.

Far right: Beach gardenia is a large, spreading shrub or small tree. It is very sensitive to too much sun and its flowers are most fragrant at night or just before dawn.

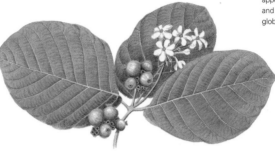

OTHER BELLFLOWER, PINCUSHION AND GARDENIA FAMILY SPECIES OF NOTE
Australian Bluebell *Wahlenbergia stricta*
This Australian flower is probably the most commonly encountered of the genus, being found everywhere except the Northern Territory and is often seen on roadsides. It forms clumps up to 40cm/16in high, and its masses of light blue or white flowers are easily seen, in spring and summer.

Indian Mulberry *Morinda citrifolia*
This large shrub to medium tree has oval leaves and white flowers that occur in the leaf axils in clusters, mainly in summer and autumn. These are followed by succulent fruits, which fuse into a large compound structure as they ripen. The fruits are edible but are very pungent when ripe, apparently to attract fruit bats.

Coprosma pumila
This small, mat-forming alpine shrub from Australia and New Zealand hugs the rocks among which it grows to form a tight cushion. The bases of the leaf stems are fused, giving a fleshy appearance. The lemon-yellow, star-shaped flowers are followed by yellow-red fleshy fruits.

Delissea rytidosperma
This unusual and rare flower is an Hawaiian endemic. Each tall upright stem is topped with a whorl of greyish-green, serrated leaves, sometimes tinged purple. The long, claw-shaped, pale green to purple flowers emerge from close to the growing point, in loose inflorescences.

Sweet Suzie

Canthium odoratum syn. *Psydrax odorata*

Sweet Suzie is a large shrub, with a range from Hawaii, Micronesia and parts of the South Pacific to the rainforest in northern Australia and more occasionally open forest on the continent. It is a common species in the Whitsunday area of north Queensland. It is a very handsome plant, with white bark that contrasts well with its dark, shiny leaves, but it is the clusters of attractive, sweetly fragrant flowers that arise from the leaf axils over a long season that earn this plant its common name.

Identification: A medium to large shrub, sometimes a small tree, with white bark and green young twigs. The oval leaves, up to 8cm/3¼in long, are glossy deep green on the top surface, duller below, with paler green veins and slightly wavy edges. The small, highly fragrant, tubular white flowers are borne in clusters arising from the leaf axils, appearing prolifically in spring and autumn. They are followed by fleshy, juicy, black fruits about 5mm/³⁄₁₆in in diameter, containing two seeds.

Distribution: Hawaii, Micronesia, South Pacific, northern Australia.
Height and spread: Variable.
Habit and form: Shrub or tree.
Leaf shape: Ovate.
Pollinated: Insect.

Below: Sweet suzie grows into a small tree or large shrub.

NETTLE, DEADNETTLE AND VERBENA FAMILIES

The nettle family, Urticaceae, contains about 45 genera and 700 species, many of which have stinging hairs on their stems and leaves. The Lamiaceae, or deadnettle family, comprise 200 genera. Verbenaceae, the verbena family, has 75 genera and 3000 species, mostly tropical or subtropical herbs or trees.

Stinging Tree

Gympie-gympie, *Dendrocnide moroides*

This tropical member of the nettle family ranks as one of the most painful plant encounters should you ever be unlucky enough to touch it. In Australia it is officially classed as a dangerous plant. The stems and leaves are coated with fine hairs which, when embedded in the skin, cause severe pain and irritation. Apparently the plants have killed dogs and horses that have bumped into them. There is no effective antidote known for the stinging tree. These plants are mostly found along Australia's eastern coast, especially in the rainforest of the north-east and, like other nettles, they tend to grow in disturbed areas, especially more open and sunny parts, such as forest clearings and riverbanks.

Identification: A single-stemmed herbaceous perennial or sparingly branched shrub, with stems up to 5cm/2in wide. The leaves are large and broad, oval or heart-shaped, up to 30cm/1ft long and 22cm/9in wide, on 5–15cm/2–6in leaf stalks. The small male and female flowers are borne on separate plants, in panicles in the forks of leaves.

Distribution: Queensland, Australia.
Height and spread: 90cm–5m/3–16ft.
Habit and form: Shrub.
Leaf shape: Ovate or cordate.
Pollinated: Wind.

Left: The single stem supports the large stinging leaves.

Far left: The fruits appear on female trees.

Victorian Christmas Bush

Victoria dogwood, mint bush, *Prostanthera lasianthos*

This spectacular summer-flowering tall shrub, or small tree, has white or pink flowers and is commonly seen growing along the banks of streams or gullies in south-east Australia and Tasmania. It flowers profusely around December, hence the common name. It emits a strong scent similar to eucalyptus or peppermint when brushed. In favourable conditions the Christmas bush flowers so heavily that the fallen flowers form a carpet on the ground beneath.

Identification: A variable woody species with long, smooth, upright shoots and lance-shaped, soft, slightly fleshy, opposite leaves 5–7.5cm/2–3in long with toothed edges, paler below. The fragrant flowers, appearing in summer, are paired in short leafless racemes, forming branched terminal panicles up to 15cm/6in long. The flowers are funnel-shaped with five lobes, two forming the upper lip and three the spreading lower lip. They are white or cream, or may be tinted violet or lilac, spotted brown or yellow in the wide throat and covered inside and out with fine hairs.

Distribution: Eastern Australia.
Height and spread: 8m/26ft.
Habit and form: Tall shrub or small tree.
Leaf shape: Lanceolate.
Pollinated: Insect.

Right: The Christmas bush can be a shrub or small tree.

Above and right: The white flowers are peppermint-scented.

Honohono

Haplostachys haplostachya

Distribution: Hawaii.
Height and spread:
30–60cm/1–2ft.
Habit and form: Subshrub.
Leaf shape: Variable/ovate.
Pollinated: Insect.

This extremely rare plant, formerly from Kauai, Maui and Hawaii, is now known only from a single population in Kipukakalawamauna on Hawaii. The genus is endemic to the islands and comprises five species, all extinct except for a few remaining plants of this species. It is found on dry shrublands and forests on old lava flows and cinder cones. Though a member of the mint family, it lacks the characteristic aromatic oils, probably because they had no natural pests on the island. The woolly leaves help to reflect sunlight away from the plant, and the beautiful spikes of sweet-smelling, white flowers appear at the branch tips.

Left: The plant forms an erect hairy sub-shrub.

Right: The flowerhead.

Identification: Erect, herbaceous perennial or subshrub with four-angled stems. The opposite, lance-shaped or oval to triangular leaves are extremely soft, covered with dense, tangled or matted woolly hairs, light green on top and silvery-white underneath. The irregular, funnel-shaped flowers are large, white and fragrant, up to 5cm/2in long, borne on terminal racemes up to 45cm/18in tall, each bearing several flowers, arranged spirally around the stem. Four black, hard nutlets are produced per flower.

Left: The striking, white, fragrant flowers appear at the branch tips.

OTHER NETTLE, DEADNETTLE AND VERBENA FAMILY SPECIES OF NOTE

Snakebush *Hemiandra pungens*
This native of the coastal sands and woodlands of south-western Australia is a small shrub, sometimes prostrate or trailing. Tubular mauve to red flowers, with a two-lobed upper lip and a three-lobed lower lip, open in spring.

Austral Bugle *Ajuga australis*
This widespread native of Southern and Eastern Australia can be found in a range of soils and habitats. It is a small, herbaceous perennial with a basal rosette of velvety leaves and soft, erect stems. The flowers, usually deep blue or purple are seen mainly in spring and summer.

Lambstails *Lachnostachys verbascifolia*
Native to the deserts of Western Australia, lambstails is recognizable by its fluffy texture and white to grey colouring. Found in sandy places, especially the sand plains, its hairy covering protects it from the heat, although this almost entirely hides the tiny, pinkish flowers.

Mintplant *Chloanthes parviflora*
A small, erect, shrubby perennial, superficially resembling rosemary and found in Queensland and New South Wales, Australia. It reaches 60cm/2ft tall, and the pale mauve, hairy, tubular flowers are borne close to the axils of the stems through winter and spring.

Snowy Oxera

Royal creeper, *Oxera pulchella*

This evergreen, woody vine, like the rest of the genus, is found only in the dense, moist tropical forests of the Pacific island of New Caledonia. It has thick, deep green, rounded leaves on twining stems, which in turn sport large clusters of white, azalea-shaped, pendent bells with a hint of cream-yellow. It tends to scramble over smaller bushes, rather than climb taller trees.

Identification: A climbing, evergreen, twining shrub, with rough bark and prominent lenticels, and smooth stems to 5cm/2in thick. The leathery, dark green, oblong to lance-shaped leaves, opposite and up to 12.5cm/5in long, have smooth or toothed margins. The flowers appear in great abundance in axillary, forked cymes, in early spring; 5cm/2in or more long, they are pendent, brilliant white or yellow-white.

Distribution: New Caledonia.
Height and spread: Variable.
Habit and form: Vining shrub.
Leaf shape: Oblong.
Pollinated: Insect.

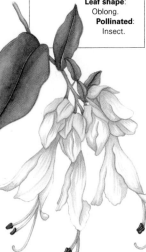

Above: The buds are conspicuous.

Left: Oxera forms a climbing evergreen vine.

FIGWORT AND MYOPORUM FAMILIES

The Scrophulariaceae (figwort family) comprise mostly herbs but also a few small shrubs, with about 190 genera and 4,000 predominately temperate species, with a cosmopolitan distribution. The majority are found in temperate areas and tropical mountains. The Myoporaceae (myoporum family) comprise four genera and 150 species, mostly trees and shrubs, and found in Australia and the South Pacific.

Spotted Emu Bush

Eremophila maculata

This shrub is one of the most widespread and variable of the emu bushes, a large genus of 214 species, all endemic to Australia. It can be found in inland areas of all mainland states, mostly on clay soils in the more arid regions. It is a variable plant with tubular, nectar-filled flowers, which occur in the leaf axils and are seen in a wide range of colours from pink and mauve to red, orange and yellow. They often have a pale, spotted throat. Flowering occurs mainly through winter and spring but some flowers may also be seen at other times.

Identification: An evergreen shrub with downy twigs and alternate, narrow leaves. Abundant tubular flowers in a wide range of colours are borne in the axils: they are about 2.5cm/1in long, constricted at the base, with protruding stamens and spotted, hairy throats; the upper lip consists of four erect lobes, the lower lip is reflexed and deeply divided. The fruit is a drupe with four chambers, each containing one or more seeds, subtended by the persistent five-lobed calyx.

Distribution: Australia.
Height and spread: 1–2.5m/3–8ft.
Habit and form: Shrub.
Leaf shape: Linear.
Pollinated: Insect.

Left: The emu bush is variable in habit, and often forms a small tree-like bush.

Slender Myoporum

Myoporum floribundum

This spectacular but uncommon myoporum occurs naturally on the coastal ranges of southern New South Wales and Victoria, Australia, rising up to gullies of the upper Snowy River and parts of the Southern Tablelands. It is a slender, fragrant shrub, and has long, arching branches with pendulous, narrow, sticky leaves and small, scented, white flowers that cluster along the branches on fine hair-like stalks, giving a feathery appearance to the massed inflorescences in spring and early summer.

Identification: A spindly shrub with an arching or weeping habit. The very narrow leaves, up to 9cm/3½in long, alternate, are smooth and dark green, and hang down from the horizontal or arching branches, giving the plant a wilted look. Small, scented, white to cream, five-petalled flowers, with prominent stamens, are borne on fine stalks in the axil of each leaf, and are clustered along the upper parts of the branches, which often arch under the weight. The fruits are numerous, small, succulent and brown when mature.

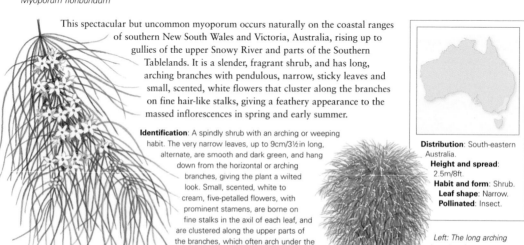

Distribution: South-eastern Australia.
Height and spread: 2.5m/8ft.
Habit and form: Shrub.
Leaf shape: Narrow.
Pollinated: Insect.

Left: The long arching branches form a slender, weeping shrub in time.

Snowy Mountain Foxglove

Ourisia macrocarpa

Distribution: New Zealand.
Height and spread: Up to 60cm/2ft.
Habit and form: Alpine herb.
Leaf shape: Rounded.
Pollinated: Insect, probably flies.

This New Zealand alpine flower is found chiefly in the southern mountains of the South Island and is a low-growing, rhizomatous perennial that flowers during spring or early summer according to location. It spreads to form a loose mat of dark leathery leaves from which the whorled inflorescences emerge on long stalks. Like many alpine species in New Zealand, the flowers are white and relatively unspecialized, reflecting the limited range of native insects available to pollinate them.

Identification: A low-growing, alpine perennial herb with robust, erect stems up to 60cm/2ft long, though usually shorter, rising from a creeping rhizome. The oval to circular leaves are thick and leathery, dark green above, hairless except on the margins, which have rounded teeth. The tubular, white flowers appear in sequentially blooming whorls on the stout stems; they are up to 2.5cm/1in in diameter, with a broad, short tube and five spreading lobes, sometimes with a yellow throat, minutely hairy within.

OTHER FIGWORT AND MYOPORUM FAMILY SPECIES OF NOTE

New Zealand Mousehole Tree
Myoporum laetum
A small tree with alternate, glossy green, finely toothed leaves, covered with translucent glands that give them an attractive appearance. The flowers appear in summer from the leaf axils and are white spotted with purple; while attractive, they are easily overlooked. The fruits that follow are oblong and reddish.

Ourisia integrifolia
This small herb of alpine wet areas appears to be closely related to the New Zealand *Ourisia* species and is the only representative of the genus in Australia. It is restricted to Tasmania, where it can be found in thickets and woods. The shiny leaves are very small in comparison to the large white or pale blue, five-petalled flowers, which appear in summer.

Parahebe lyallii
This variable plant can be found in many parts of New Zealand. The flowers are most commonly white or white with pink, held over the reddish-green leaves in spring. As its name suggests, the genus is closely allied to hebes, but in appearance it resembles a small, slightly shrubby *Veronica* species.

Hebe elliptica
This bushy shrub has fleshy, green, oval leaves with light edges. The flowers, which open in the spring, are white to pale mauve and relatively large. It has a variable habit, and is found on the west coasts of the South and North Islands of New Zealand and also in the Falkland Islands.

New Zealand Hebe

Hebe speciosa

This bushy, rounded shrub is highly popular with gardeners, but in the wild is found only in a few localities in the Marlborough Sounds and on the west coast of North Island on exposed sea cliffs. It is a highly variable species, giving rise to many cultivars and hybrids, some of which may have become naturalized outside its native range. Its large, magenta inflorescences make it one of the more spectacular hebes when flowering commences in summer and extends over a long season.

Distribution: North Island, New Zealand.
Height and spread: 2m/6½ft.
Habit and form: Shrub.
Leaf shape: Ovate.
Pollinated: Insect.

Identification: A strong-growing shrub with stout, angular branches and thick fleshy, glossy, leaves up to l0cm/4in long. The stems and margins of the young leaves are purple, and this colour persists on the backs of the leaves when they mature. The flowers are dark red to magenta, crowded in terminal conical to cylindrical racemes up to 7cm/2¾in long.

Left: Hebe forms a small-to medium-sized rounded bush that is often found in cultivation.

AGAVE, GRASS TREE, BLOODWORT AND LILY FAMILIES

The agave (Agavaceae), grass tree (Xanthorrhoeaceae), and bloodwort families (Haemodoraceae) are all loosely allied to the lily family (Liliaceae). They generally prefer hot warm dry habitats and are well represented in Australia and New Zealand.

New Zealand Cabbage Tree

Cabbage palm, *Cordyline australis*

This unusual-looking tree typically occurs on forest margins and coastal cliffs, in swamps and other wet areas, and is a familiar sight throughout New Zealand. It is also widely planted in gardens and is known to many who have never visited its native islands. The species is often naturalized outside its range and there are many cultivars. The crown is made up of long, bare branches carrying bushy heads of large, grass-like leaves, from which large panicles of small, white, sweet-scented flowers emerge. Flowering is erratic, with the best displays usually following dry summers.

Identification: The trunk is generally sparingly or not at all branched below, copiously branched above, and ultimately massive, up to 1.5m/5ft in diameter, with rough, fissured bark. The leaves 30–90cm/1–3ft long and 5cm/2in wide, are narrow and arching, light green with indistinct veins. Small, sweetly fragrant flowers, creamy-white with yellow anthers, appear in a much-branched panicle up to 1.8m/6ft long and 60cm/2ft wide, with well-spaced branches more or less at right angles and almost hidden by the flowers. The small, spherical fruits are white or very pale blue.

Distribution: New Zealand.
Height and spread: Up to 20m/65ft x 4m/13ft.
Habit and form: Tree.
Leaf shape: Linear-lanceolate.
Pollinated: Insect.

Left: The small flowers are fragrant and held in dense panicles.

Right: The palm-like trunks are distinctive.

New Zealand Flax

Phormium tenax

This robust, evergreen, New Zealand perennial gets its common name because the Maori people used the leaf fibres for making clothing, fishing nets and ropes. It is abundant, especially in lowland swamps and intermittently flooded land, and is also found on Norfolk Island. It has attractive foliage and, while not renowned for its flowers, the tubular, orange-red flowers that appear in tall, upright panicles are very striking.

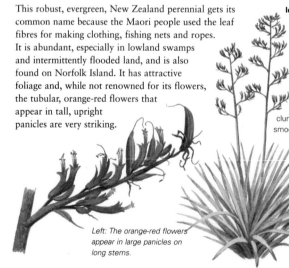

Identification: A perennial rhizomatous herb with short, stout stems and strap-like, deep green leaves that are bright orange towards the base. They are stiff and erect, at least in the lower part, 90cm–3m/3–10ft long and 5–12.5cm/2–5in wide, usually splitting at the tip, clump-forming and fibrous. The smooth, dark brown flowering stems may reach a height of 5m/16ft. The flowers have dull red tepals, 2.5–5cm/1–2in long, with slightly recurved, orange tips to the inner tepals. The fruit is a long, three-sided capsule.

Distribution: New Zealand, Norfolk Island.
Height and spread: 2m/6½ft.
Habit and form: Rhizomatous herb.
Leaf shape: Linear-lanceolate.
Pollinated: Insect.

Left: The orange-red flowers appear in large panicles on long stems.

Tall Kangaroo Paw

Evergreen kangaroo paw, *Anigozanthos flavidus*

Distribution: South-west Australia.
Height and spread: 90cm/3ft.
Habit and form: Clump-forming perennial.
Leaf shape: Linear-lanceolate.
Pollinated: Insect.

This unusual plant, which is native to moist areas in open forests of the far south-west of Australia, has a vigorous clumping growth habit with long, dull green leaves. The tall flowering stems, which emerge from the bases of the leaves from late spring to midsummer, carry unusual furry flowers, which are mostly green, although they can also contain yellow or soft red tones. It is very attractive to birds, the prime pollinators.

Identification: A robust perennial with narrow olive to mid-green leaves 30–45cm/12–18in long and up to 4cm/1¾in wide. The reddish flowering stems are 90cm–3m/3–10ft long, smooth at the base becoming downy on the branches; the flowers, borne in panicles, have forward-pointing lobes that are usually sulphur-yellow to lime-green, though sometimes red, orange, pink or multi-coloured, and are densely covered with yellow-green or red-brown hairs.

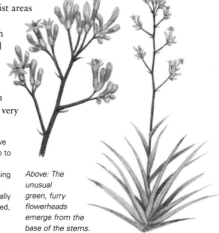

Above: The unusual green, furry flowerheads emerge from the base of the stems.

OTHER AGAVE, GRASS TREE AND BLOODWORT SPECIES OF NOTE

Narrow-leaved Palm Lily *Cordyline stricta*
This shrubby, palm-like plant is found in wet forest and rainforest in Australia. It forms a multi-caned, fountain-shaped bush 2–3m/6½–10ft tall, with narrow, purplish dark green leaves. The showy, lavender to bluish flowers, in drooping panicles, appear in the spring and are followed by round, blue-black, fleshy fruits.

Mountain Flax *Phormium colensoi*
The mountain flax, while similar to *P. tenax*, is smaller, with thinner leaves that are arching rather than erect. The flowers are greenish-yellow and the seedpods are twisted and hang down from the flowering stalks.

Grass Tree *Xanthorrhoea australis*

This very slow-growing plant develops a rough trunk with age, coloured black as the result of surviving many bushfires. The long, narrow leaves are crowded at the tops of the trunks, and small, individual, white or cream flowers are clustered together in a spear-like spike, which can tower 2m/6½ft or more above the top of the trunk.

Western Australian Grass Tree *Kingia australis*
This unusual species is not related to true grasses. The sole species in this genus is found between Perth and Albany. It flowers irregularly, usually after a fire, with yellow, green and brown flowers appearing in early spring, amid the mass of grass-like leaves.

Blue Tinsel Lily

Calectasia cyanea

This plant takes its name from its shiny blue flowers, which really do have the look and feel of tinsel and appear mainly in late spring. Native to Western and South Australia, the bush is adapted to very dry conditions and resembles a small paperbark or tea tree, *Melaleuca* species, when not in flower. Despite its appearance, however, this monotypic genus is actually most closely related to the grass trees, *Xanthorrhoea* species.

Identification: A small rhizomatous shrub with upright slender stems clothed with small, needle-like sheathed leaves, spirally arranged. The solitary, bright blue flowers are borne terminally on short branchlets. They are star-like, with six pointed, glossy, metallic tepals and yellow anthers that turn red as they mature. The fruit is a one-seeded nut.

Below: The shiny, blue, star-like flowers give rise to this plant's common name.

Distribution: Southern Australia.
Height and spread: 25cm/10in.
Habit and form: Shrub.
Leaf shape: Linear-lanceolate.
Pollinated: Insect.

DAISY FAMILY

Australia and New Zealand support many species in the Asteraceae, or daisy family, many of which form impressive displays in summer or following rains in arid areas. It is on some of the islands in the vast southern oceans where plants have become isolated from their continental ancestors that the most interesting forms are encountered though.

Bachelor's Buttons

Billy buttons, *Craspedia uniflora*

This rosette-forming annual or sometimes perennial plant is found over a wide range of habitats in southern Australia, Tasmania and New Zealand, preferring dry, stony grassland, from lowland to moderate altitudes. The round pompom flowerheads that appear in the summer give rise to its common name; they are yellow in this species, although most other species in the genus have white flowers.

Above and left: The plant forms a low rosette of leaves.

Above: The seedhead has tightly packed oval, silky seeds, each one bearing a feathery plume.

Identification: The erect flowering stems rise above basal rosettes of oval to narrowly spoon-shaped leaves up to 12.5cm/5in long. The yellow flowerheads are spherical, about 15mm/⅝in across, on very thin stems.

Distribution: Southern Australia, Tasmania and New Zealand.
Height and spread: 40cm/16in.
Habit and form: Rosette-forming annual.
Leaf shape: Oblong-ovate to spathulate.
Pollinated: Insect.

Swan River Daisy

Brachycome iberidifolia

This wiry annual plant has dainty, dark-eyed, bright blue, daisy-like, fragrant flowers, borne above and among the feathery leaves. It flowers predominantly in the cooler wetter months of the year. The plant is bushy or spreading in habit, and has downy, grey-green leaves that are deeply lobed.

Identification: An annual herb with slender, branched, glandular-hairy stems and finely divided, fern-like leaves up to 10cm/4in long. The daisy-like flowers, on slender stalks about 7.5cm/3in long, are white, blue or violet with yellow central discs. The fruit is tiny and club shaped with tiny bristles on the uppermost part.

Distribution: South and Western Australia.
Height and spread: 45cm/18in.
Habit and form: Annual herb.
Leaf shape: Pinnatifid.
Pollinated: Insect.

Below: The plant forms a low, spreading, wiry mass of feathery-leaved stems.

Left: A massed flowering of this plant is a spectacular sight.

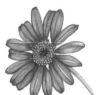

Above: Pink flowerheads are rare or absent from wild populations but often selected in cultivated stock.

Winged Everlasting

Sandflower, *Ammobium alatum*

A native of sandy habitats in New South Wales and as far north as Queensland, Australia, the common name of this grey-leaved, perennial herb refers in part to the curious, membranous wings on its stems. In addition, the small flowerheads are surrounded by rows of papery bracts, giving the spent flowers an "everlasting" effect. The flowers are often dried for commercial use, being cut for drying just as they open.

Distribution:
Eastern Australia.
Height and spread:
50–90cm/20–36in.
Habit and form: Erect perennial.
Leaf shape: Lanceolate.
Pollinated: Insect.

Above: The papery bracts are tightly folded and enclose the yellow flowerhead in the bud.

Left: This grey-leaved herb has tall flower stems that emerge from a basal rosette.

Identification: The stems of this erect, branched perennial herb have wings formed from decurrent leaf bases. The pointed leaves, up to 18cm/7in long in the basal rosette, becoming smaller up the stem, are covered in white down. The flowerheads, with silvery-white, pointed, papery bracts and yellow centres, are about 2cm/¾in in diameter, borne singly at the ends of the flower stalks.

OTHER DAISY FAMILY SPECIES OF NOTE

Strawflower *Helichrysum bracteatum*
Also known as the yellow paper daisy, this coarse, erect perennial is relatively common across much of Australia, growing in open scrub and grassland areas. It gets its name from the papery texture of the bright yellow flowers, which close in the evening or on overcast days.

Celmisia hookeri
This large, tufted plant inhabits mountain grassland scrub and is confined to north-east Otago on the South Island of New Zealand. The broad green leaves are dark and leathery and large, white daisy flowers with yellow centres appear in the spring and summer.

Wilkesia gymnoxiphium
Endemic to Kauai in the Hawaiian Islands on dry volcanic soils, with rosettes elevated on woody stems up to 5m/16ft tall, the plant flowers once in its variable lifespan and then dies. The tall flower spike is composed of many nodding yellow flowers.

Mountain Daisy *Celmisia angustifolia*
This small subshrub, woody at its base, is found in the montane tussock grasslands of New Zealand. Its branches are clothed in old leaf remains. It has long, spoon-shaped leaves, with felted undersides, in rosettes at the branch tips. The white flowerheads are produced on solitary stalks during the summer.

Hawaiian Silversword

Ahinahina, *Argyroxiphium sandwicense*

This rosette-forming shrub is restricted to habitats in the cinders of volcanoes, at altitudes of up to 3,700m/12,000ft on the islands of Hawaii and Maui. It is a spectacular species, with tall maroon flowers surmounting the rounded rosette of silvery, sword-like leaves and making it one of the wonders of the Pacific plant world. The flowers develop erratically, usually between early summer and autumn. The grey hairy leaves are an indication of the harshness of the dry environment that this plant occupies.

Identification: A rosette-forming shrub that is usually solitary, with a short vegetative stem and a flowering stem up to 2.5m/8ft tall and 90cm/3ft wide. The pointed leaves, up to 40cm/16in long, are rigid, succulent, and covered with silvery hairs. They are spirally arranged, together forming a silver sphere. The showy inflorescence may contain between 50 and 600 compound flowerheads, pink or red in colour with yellow central disc florets.

Distribution: Hawaii and Maui.
Height and spread: 3m x 90cm/10 x 3ft.
Habit and form: Rosette-forming shrub.
Leaf shape: Lanceolate.
Pollinated: Probably insect.

Below: The tall showy inflorescence appears erratically between summer and autumn.

HEATH FAMILIES

The Ericaceae, or heath family, are a large family, mostly shrubby in character, comprising about 125 genera and 3,500 species. Mostly lime-hating and restricted to acid soils, the family is cosmopolitan in distribution, except in deserts. It is almost absent from Australasia, where it is largely replaced by Epacridaceae, a family almost exclusively centred upon the Australian continent and nearby islands.

Giant Grass Tree

Tree heath, pandani, *Richea pandanifolia*

The wet mountain forests of Tasmania are home to this unusual plant, one of about ten species in the genus, all but one of which are endemic to the island. It is a tall, palm-like species, which usually grows on a single stem but may occasionally be branched. Its tapering leaves, with bases that wrap completely around the stem, are densely crowded towards the top of the trunk. The white or deep pink flower panicles arise from the leaf axils, often hidden among the leaves.

Identification: A gaunt evergreen tree or shrub with erect, slender branches with annual scars. The narrow, arching leaves, up to 90cm/3ft long, are crowded at the branch tips. They are smooth and waxy, with a concave upper surface and smooth or serrated margins tapering to a fine point, ultimately very slender and frayed. The white or pink flowers are inconspicuous, in erect axillary panicles crowded at the branch tips. The individual flowers are covered by large bracts, which fall as the flowers develop. The fruit is a capsule.

Distribution: Tasmania.
Height and spread: 10m/33ft.
Habit and form: Tree or shrub.
Leaf shape: Lanceolate.
Pollinated: Insect or bird.

Left: The flower panicles often go unnoticed as they are hidden among the leaves.

Pink Heath

Common heath, *Epacris impressa*

Found throughout the heaths and open forests of southern New South Wales, Victoria, Tasmania and eastern South Australia, the deep pink-flowered form of *E. impressa* is the floral emblem of Victoria. Usually a small shrub, its stiff branches have small leaves with a sharp point at the end and the narrow, tubular flowers occur in clusters along their tips. They contain copious nectar and are frequented by honey-eating birds. Their colour ranges from white through various shades of pink to bright red. Flowering occurs from autumn through to spring, reaching a peak in winter. A form from the Grampian Ranges in western Victoria known as *E. impressa* var. *grandiflora*, has larger flowers and leaves than the typical form and some plants have double flowers.

Identification: An often spindly, upright shrub, with stiff branches, russet when old, with stringy bark. The small, alternate leaves are narrow and sharply pointed. The flowers are snow-white to rose-pink or purple-red, short-stalked and nodding, borne in clusters in an elongated, slender, erect terminal raceme; the corolla tube, up to 2cm/¾in long, has five small indentations near the base, alternating with the stamens.

Distribution: South-east Australia.
Height and spread: 90cm/3ft.
Habit and form: Shrub.
Leaf shape: Linear-lanceolate.
Pollinated: Bird.

Left: The small pointed branches of this plant give it a rather spindly appearance.

Red Five Corners

Styphelia tubiflora

Distribution: Australia (except Northern Territory).
Height and spread: 1.5m/5ft.
Habit and form: Shrub.
Leaf shape: Oblong-linear.
Pollinated: Insect or bird.

Far right: The bright red flowers appear toward the branch tips in groups of twos or threes.

This genus, closely related to *Epacris*, contains 14 species, all of which occur naturally only in Australia and in all states except the Northern Territory. The fruit, a greenish-red berry with distinct ribs, gives rise to the common name. This species is found in dry forest or heath on the coast and mountains and has bright red flowers, emerging from greenish-yellow bases in autumn and spring.

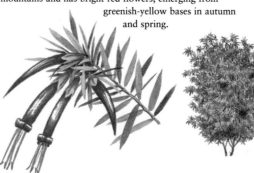

Identification: A small straggly plant with stiff stems and small, narrow leaves with margins curved under, ending in a sharp point. The flowers, which appear from autumn to spring, are solitary or in loose groups of two or three, borne along the upper reaches of the branches in an apparent raceme; they are usually bright red, although white, pink and yellow forms are sometimes seen, with a greenish-yellow calyx. The corolla tube is narrow and about 2.5cm/1in long, conspicuously five-angled, with short lobes strongly rolled back to expose the long, protruding stamens. The fruit is a ribbed drupe with up to five seeds.

OTHER HEATH FAMILY SPECIES OF NOTE

Blunt-leaf Heath *Epacris obtusifolia*
This uncommon small Australian shrub is found in sandy heathland along the coast from Queensland to Tasmania and has very small leaves, pressed to the stem. The large, bell-shaped white flowers appear in late winter and spring, in a massed display along the branches from the leaf axils, and are frequented by honey-eating birds.

Coral Heath *Epacris microphylla*
This shrub has tiny, pointed leaves, held erect against the wiry stems and angular branches. Common on damp rocky heath on the eastern coast of Australia, it is spectacular when in flower with masses of white, cup-shaped blooms toward the ends of the branches.

Richea dracophylla
This erect, small, evergreen shrub from Tasmania has sharp, pointed leaves arranged in a crowded spiral at the end of the stem. The dense spikes of white flowers appear at the ends of branches in autumn. When the flowers open the petals fall, giving the spike a bristly appearance.

Snow Bush *Leucopogon melaleucoides*
This very small shrub from east coast Australia is covered in tiny, hairy, tubular, white flowers, with pinkish calyces and a musty scent. The flowers appear in late winter to early spring. The plant resembles a small *Melaleuca* when not in flower.

Kerosene Bush

Richea scoparia

The kerosene bush provides brilliant splashes of colour throughout the alpine areas of Tasmania during the summer. While endemic to this island, it is a very common alpine and subalpine shrub of high rainfall areas. Its sharp leaves are persistent for a long time on old growth, making it unpopular with bushwalkers because it forms dense, prickly thickets. In summer, the terminal spikes of red, pink, white or orange flowers attract small lizards that feed on the nectar, and expose the plants reproductive organs to pollinating insects.

Identification: A bushy, erect, evergreen treelet or shrub. The semi-rigid, sharp-pointed, glossy leaves are up to 5cm/2in long, alternate, parallel-veined, on a sheathing stem with overlapping bases, persisting for several seasons. The flowers grow in dense, cylindrical terminal racemes up to 30cm/1ft long, and may be white, pink or orange. The corolla, up to 1.5cm/⅝in long, is closed at the tip except for a small opening, not separated into lobes.

Right: This prickly bush is often covered in brilliantly coloured flowers in the summer months.

Distribution: Tasmania.
Height and spread: 150 x 90cm/5 x 3ft.
Habit and form: Tree or shrub.
Leaf shape: Lanceolate.
Pollinated: Insect.

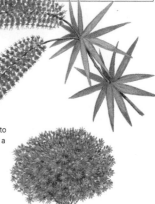

MALLOW AND ELAEOCARPUS FAMILIES

The Malvaceae, or mallow family, are not particularly well represented in Australia and Oceania, but those that do grow there include some strikingly beautiful flowers and some very rare plants among their numbers. The Elaeocarpaceae, or elaeocarpus family, are sparsely represented in Australia, mostly restricted to the eastern coast, but better represented on New Zealand.

Blue Hibiscus

Lilac hibiscus, *Alyogyne huegelii* syn. *Hibiscus huegelii*

The blue hibiscus is native to sandy and sandy-gravel soils in south and western Australia. Despite its common name, it is only distantly related to the true *Hibiscus*, and the flower colour ranges from pink or lilac to purple, usually with a contrasting basal spot. White and yellow forms also occur with the white form reported to have a more sprawling growth habit and brighter green leaves. Numerous varieties exist. The hibiscus-like flowers are borne singly in the leaf axils, appearing from spring through summer to autumn, and although individual flowers are short-blooming, only lasting a day or two; new flowers continue to open over a long period, generally in summer and autumn.

Identification: A fast-growing, medium-sized shrub with bright green, wrinkled, complexly five-lobed leaves and woolly younger stems. The conspicuous, short-lived but profusely borne flowers are about 7.5cm/3in across, with spreading, triangular to round, spirally overlapping petals and a staminal column with numerous filaments in whorls. They are usually lilac with reddish-purple-spotted throats, but may also be pink, blue, white or yellow.

Distribution: South and Western Australia.
Height and spread: 2.5m/8ft.
Habit and form: Shrub.
Leaf shape: Ovate-palmate lobed.
Pollinated: Insect.

Lily of the Valley Tree

Blueberry ash, *Elaeocarpus reticulatus*

Elaeocarpus is a genus of about 200 species occurring in eastern Australia and in nearby tropical areas, but the blueberry ash is unique among these in extending south into temperate areas. It can be found as far south as Flinders Island and Tasmania, where it grows in forest gullies and wooded ranges, usually near the coast. Flowering occurs in summer, when masses of small, bell-shaped flowers with an unusual, liquorice scent are produced. The flowers are followed by globular, blue fruits, which are retained on the plant for a long time, attracting many bird species.

Identification: A small tree with a dense crown of foliage and an approximately conical form. The branchlets and leaf stalks are often reddish, with distinct leaf scars. The leaves are alternate, 10–15cm/4–6in long, oval or lance-shaped with pointed tips, dark green above with prominent veins, paler below. Lax axillary racemes appear from mid-spring to midsummer; the fragrant flowers are small, cup-shaped, ivory-white, with three to five fringed petals and numerous stamens. The fruit is a tough, blue, globular drupe, about 12mm/½in in diameter, with a thin layer of edible flesh and one seed encased in a hard, rough stone.

Distribution: Eastern Australia.
Height and spread: 3–15 x 5m/10–50 x 16ft.
Habit and form: Tree.
Leaf shape: Oblong-elliptic.
Pollinated: Bird.

Far left: The globular fruits are popular with birds.

Left: This small tree has a dense crown.

Mountain Ribbonwood

Lacebark, *Hoheria lyallii*

This large shrub or small tree is found by
forest edges and streams in the drier,
eastern, reaches of the Southern Alps
of New Zealand, at altitudes
between 600–1,050m/2,000–3,500ft,
where it forms scrub-like groves on the
upper margins of the forests. Large quantities
of flowers are borne in the leaf axils in summer or
autumn, when they can be so profuse as to bend
the flexible branches.

Distribution: South Island,
New Zealand.
Height and spread: 6m/20ft.
Habit and form: Tree.
Leaf shape: Cordate.
Pollinated: Insect.

*Right: Mountain ribbonwood is
mostly restricted to high water-
courses and damp forest margins.*

*Far right: Ribbonwood forms a
large shrub or small tree that
flowers profusely in late summer.*

Identification: A deciduous tree with
alternate, heart-shaped, grey-green, deeply
toothed leaves 5–10cm/2–4in long and up to
5cm/2in wide. Mature leaves are covered in
white down, especially on the undersides, while
the juvenile foliage is smooth. The five-petalled,
snow-white flowers are 2.5cm/1in in diameter, on
slender stalks with densely hairy calyces, yellow
filaments and purple anthers. The round fruit breaks up
into 10–15, compressed, downy, slightly winged carpels.

OTHER MALLOW AND ELAEOCARPUS FAMILY SPECIES OF NOTE

New Zealand Damson *Elaeocarpus dentatus*
This tall forest tree with grey bark is found in
lowland forests on both the North and South
Islands. The leaves are quite tough and leathery,
and have wavy to serrated margins. Clusters of
white, bell-shaped flowers appear in summer,
followed by purple drupes in the autumn.

Sturt's Desert Rose *Gossypium sturtianum*
This wild cotton species is widely distributed in
the interior of Australia and is the floral emblem
of the Northern Territory. It is a shrub with large
oval leaves and showy,
hibiscus-like, pink to mauve
flowers with a dark red
centre. The flowers can be
seen for most of the year,
with a peak in late winter.

Native Rosella
Abelmoschus moschatus subsp. *tuberosus*
Found in northern Australia, this plant dies back
to an underground tuber in the dry season,
emerging again following the first substantial
rains. The dark-centred, pink-white or cream,
hibiscus-like blooms, last for one day only but
are prolific between October and April.

Hawaiian White Hibiscus *Hibiscus waimeae*
This rare Hawaiian endemic species, found only
on Kauai, occurs in two distinct and isolated
populations on opposite sides of the island. The
single white flowers last only one day, opening in
the morning and fading to pink in the afternoon.

Phillip Island Hibiscus

Hibiscus insularis

This island endemic is confined to just two
patches on Phillip Island. Remarkably, these
have survived despite the grazing pigs, goats
and rabbits, which destroyed most of the
island's other vegetation, although the
removal of these introduced animals is
allowing new seedlings to regenerate near
the original bushes. The plant is very
attractive and produces creamy flowers,
which fade to a beautiful wine colour for
about 10 months of the year. It has tiny,
neat leaves and a densely branching
characteristic, that are adaptations to the
strong coastal winds of its native habitat
and this has made it popular with gardeners
in recent years.

Distribution: Phillip Island.
Height and spread:
3.5m/12ft.
Habit and form: Evergreen
shrub.
Leaf shape: Ovate when
young more cordate
with age.
Pollinated:
Insect.

Identification: A dense, bushy, many-
branched shrub, growing up to 3.5m/
12ft in tall, with a spread of 1.8m/6ft.
There is a marked difference between the
juvenile and adult foliage, with the tiny round leaves
that are characteristic of seedling and young plants
gradually changing over ten years or more
to the larger more triangular, slightly
lobed leaves more characteristic
of *Hibiscus*. The small, single,
five-petalled flowers are held
upward on the stems, and
are borne profusely for much
of the year.

*Above: The creamy flowers of
this rare hibiscus are borne
profusely and gradually turn
reddish with age.*

DOGWOOD AND PROTEA FAMILIES

The dogwoods, Cornaceae, are absent from Australia, and only two genera, Griselinia *and* Corokia,
*occur in New Zealand, with the latter often considered to be part of the wider Saxifragaceae group. The
proteas (Protaeceae) on the other hand are at their most diverse in Australia, with 42 genera and 860
species, and include flowers of outstanding beauty.*

Drummond's Dryandra

Dryandra drummondii

The dryandras are a large group, closely related to *Banksia*, which show a
tremendous variation in form and foliage. This species is restricted to the
Swan River area of south-western Australia, where it usually occurs in
shallow, poor and clay soils. The leaves form a rosette, in the
middle of which is a large flattened, yellow flowerhead,
made up of many hundreds of individual flowers. It appears
towards the end of the winter.

Identification: A stemless plant with alternate, leathery leaves, 30cm/1ft
long and up to 7.5cm/3in broad, incised to the midrib with triangular lobes
and densely covered with white down on the underside. The flowerhead is
produced at ground level, surrounded by a persistent circle of bracts; the
flowers open in succession from the outside in, with the
gingery perianths curling
back to reveal the yellow
styles and stigmas.

Distribution: South-western
Australia.
Height and spread:
50–70cm/20–28in.
Habit and form: Rosette-
forming shrub.
Leaf shape:
Pinnatisect.
Pollinated: Insect
or possibly mammal.

*Left: Many hundreds
of individual flowerheads
make up the inflorescence.*

Left: All Dryandras
*are yellow in colour,
though the shade of
yellow varies considerably.*

Saw Banksia

Old man banksia, *Banksia serrata*

This widespread species from eastern Australia is common
in sandstone woodland and open forests or sandy soils. It
ranges from southern Queensland along the coast to
Victoria, with a small population in northern Tasmania,
and stretches west as far as the Great Dividing Range.
Normally a tree in favourable conditions, its
blackened rough bark is a result of surviving many
bushfires. The leaves are large and stiff with saw-
toothed edges, hence its common name.

Identification: A small tree with knobbly grey bark and
leathery, narrowly oval, serrated leaves, 15cm/6in long, glossy dark green
above and paler beneath. The flowerheads are dense, terminal,
cylindrical spikes, 15cm/6in long, usually greenish-cream,
surrounded by a circle of bracts. They appear from
summer to autumn and are
followed by seed cones with
large, protruding follicles.

Distribution: Eastern
Australia.
Height and spread:
2–15m/6½–50ft.
Habit and form: Small tree.
Leaf shape: Saw-like.
Pollinated: Birds
and possibly insects.

*Left: Seed is usually only released from the
cone-like fruits following bush fires.*

*Left: The saw
banksia
often forms
a gnarled,
fire-blackened
small tree.*

Mountain Grevillea

Cat's claw, *Grevillea alpina*

Despite its specific name, this plant from south-eastern Australia is a widespread and variable species, occurring at both low and high elevations. It is usually a small shrub with simple rounded leaves, but some forms have much larger leaves with some plants being distinctly hairy. The flowers appear in clusters at the ends of the branches in winter and spring; these too are variable in colour. The species hybridizes naturally with the lavender grevillea, *G. lavandulacea*, and the woolly grevillea, *G. lanigera*, adding to the difficulty of identification.

Distribution: South-eastern Australia.
Height and spread: Variable, to 2m/6½ft.
Habit and form: Shrub.
Leaf shape: Linear.
Pollinated: Bird.

Identification: A variable, spreading shrub with both prostrate and erect forms. The leaves, up to 2.5cm/1in long, are alternate, narrow to rounded, downy or smooth. The obliquely tubular flowers are borne in short, crowded racemes, paired, in groups of five or seven. Their colours range from greenish-yellow to white, pink-orange and red, and they may be a single colour or a combination.

Below: The tubular flowers have a long, claw-like style.

Far left: The plant usually forms a small shrub.

Waratah

Telopea speciosissima

The waratah ranges along the central east coast of Australia from sea level to above 1,000m/3,300ft in the Blue Mountains. It grows mainly in the shrub understorey in open forest that has developed on sandstone and adjoining volcanic formations, often on slopes or in gullies. A truly spectacular plant, it is the floral emblem of New South Wales. Its bright red flowers appear in spring and attract the nectar-seeking birds that act as its pollinators.

Distribution: Central and south-eastern Australia.
Height and spread: 3m/10ft.
Habit and form: Shrub.
Leaf shape: Narrow-obovate.
Pollinated: Bird.

Identification: A tall, straggling shrub with narrow, leathery, sometimes toothed leaves up to 25cm/10in long. The red flowers are grouped in densely packed, domed terminal racemes up to 15cm/6in wide, surrounded by a circle of large, smooth crimson bracts.

Right: It forms a tall, straggling shrub in time.

Below: The fruits that develop from mid to late summer contain numerous winged seeds.

OTHER DOGWOOD AND PROTEA FAMILY SPECIES OF NOTE

Red Spider Flower *Grevillea punicea*
A native of New South Wales that grows on sandy soils, in heath, open forest or scrubland, often just away from the coast. It is a highly variable species, with bright red flowers from late winter to summer.

Tasmanian Waratah *Telopea truncata*
This upright shrub or small tree grows on moist, acidic soils in wet forest or subalpine scrubland. The young branches and unopened flowerheads are often covered with brownish hairs, the blooms occurring in a loose cluster of red flowers at the ends of the erect stems from late spring to late summer.

Gippsland Waratah *Telopea oreades*
This upright shrub or small tree grows on moist, acidic soils, often alongside creek beds, in wet forest or cool rainforest of southern Victoria, Australia. The red flowers appear in summer. A white form, from the Errinundra Plateau in east Gippsland, is sometimes seen.

New Zealand Privet *Griselinia littoralis*
This fast-growing, evergreen, upright shrub of dense habit bears oval, leathery, bright apple-green leaves, among which the tiny, inconspicuous, yellow-green flowers appear. It is a common hardwood tree throughout the mixed and beech forests of the North, South, and Stewart Islands, from lowland altitudes to subalpine scrub.

Ivory Curl

Buckinghamia celsissima

The rainforests of northern Queensland are the home of this Australian tree, which although rare in the wild, has been widely used as a street tree in Brisbane. It has attractive foliage: the juvenile leaves are often lobed while the new growth is an attractive bronze colour. Its long, pendent, curling flowers are white to cream and occur in summer in large racemes that are well displayed at the ends of the branches and are reminiscent of those of grevilleas, as are its fruits.

Identification: A tall, robust, evergreen tree. The juvenile leaves are variable, sometimes lobed; the adult leaves are elliptical, 10–20cm/4–8in long, glossy dark green with conspicuous veins, silver beneath, alternate. The small, creamy-white, scented, tubular flowers have long, slender, curling styles and appear in semi-pendulous, 20cm/8in terminal racemes from summer to late autumn.

Left: The fruits contain four seeds.

Right: The long, pendent flower spikes appear at the branch tips.

Far right: Ivory curl forms a very attractive tall tree in its native habitat.

Distribution: North-east Australia.
Height and spread: 30m/100ft.
Habit and form: Tree.
Leaf shape: Elliptic.
Pollinated: Bird.

Long-leaf Lomatia

River lomatia, *Lomatia myricoides*

This Australian species inhabits open forests of eastern New South Wales and Victoria, usually in moist locations such as watercourses, at altitudes up to 1,000m/3,300ft. It is a medium shrub or small tree, with very attractive bark, usually growing tallest in favourable conditions. The scented flowers occur in racemes in the leaf axils or at the ends of branches in summer, and are usually white or cream, although pink forms are known.

Identification: A broadly spreading shrub with ridged young growth, brown and covered in fine hairs, maturing to smooth, grey-brown with branches that are broadly divergent. The narrow leaves are up to 12.5cm/5in long, smooth, tough, mid-green, with margins that may be entire to coarsely toothed at the top half, stalked or stalkless, and variable even on the same plant. Lax racemes up to 15cm/6in long, terminal or axillary at the ends of the branches, appear from spring to summer, produced regularly except during drought; the paired, obliquely tubular flowers are ivory to yellow-green, fragrant and profuse. The flowers are followed by dry fruits containing a number of winged seeds.

Left: The lax racemes of flowers appear at the branch tips during the summer months.

Distribution: South-east Australia.
Height and spread: 2.5m/8ft.
Habit and form: Shrub.
Leaf shape: Linear.
Pollinated: Bird or insect.

Right: The scented flowers occur in racemes.

Right: Lomatia is really a large shrub but in time it can come to resemble a small tree.

Firewheel Tree

White beefwood, *Stenocarpus sinuatus*

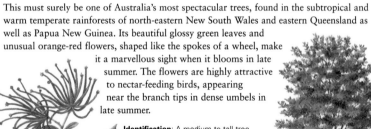

This must surely be one of Australia's most spectacular trees, found in the subtropical and warm temperate rainforests of north-eastern New South Wales and eastern Queensland as well as Papua New Guinea. Its beautiful glossy green leaves and unusual orange-red flowers, shaped like the spokes of a wheel, make it a marvellous sight when it blooms in late summer. The flowers are highly attractive to nectar-feeding birds, appearing near the branch tips in dense umbels in late summer.

Distribution: North-east Australia, Papua New Guinea.
Height and spread: 30m/100ft.
Habit and form: Tree.
Leaf shape: Obovate, lobed.
Pollinated: Bird.

Far right: The firewheel tree is a spectacular sight when in full bloom.

Identification: A medium to tall tree with alternate, variable, glossy, dark green leaves, sometimes lobed, or oval to lance-shaped with wavy edges. Terminal, wheel-like umbels 5–7.5cm/2–3in across, consisting of 12–20 narrow red flowers, are produced in the upper leaf axils from summer to autumn. The flowers are followed by woolly grey capsules, containing winged seeds.

OTHER DOGWOOD AND PROTEA FAMILY SPECIES OF NOTE

Tree Waratah *Alloxylon flammeum*
Native to the rainforest in Queensland, this is a tall tree with glossy green, elliptical leaves, although juvenile leaves may be much larger and lobed. The conspicuous bright red flowers are displayed in the leaf axils towards the ends of the branches in spring and early summer.

Strangea linearis
This small Australian shrub is found in the coastal heaths of north-eastern New South Wales and south-eastern Queensland. It has narrow leaves and small cream flowers, which occur in clusters of two or three in the leaf axils in spring.

Rewarewa *Knightia excelsa*
An upright tree with a slender crown, endemic to New Zealand and found in lowland to montane forest. The small, bright red flowers crowd together to form a bottlebrush-like inflorescence 10cm/4in long.

Guitar Plant
Lomatia tinctoria
An endemic species of open forests and woods of Tasmania, from sea level to 1000m/3,300ft. It is a small shrub with cream or white flowers appearing in summer, in racemes, in the leaf axils, or at the ends of branches. Dry fruits follow, containing winged seeds. Its common name is derived from the shape of the opened fruits.

Grass-leaved Hakea

Hakea multilineata

The gravelly heaths of south-western Australia are home to this large shrub or small tree, whose pink flowers occur in racemes in the leaf axils in winter and spring. Although the flowers occur within the foliage, the plant's open habit means that they are well displayed, never failing to attract attention. The seeds are shed only when stimulated to do so by the occurrence of a bushfire, thereby allowing the seedlings to grow rapidly without competition from other plants.

Distribution: South-western Australia.
Height and spread: 5m/16ft.
Habit and form: Tall shrub or small tree.
Leaf shape: Linear.
Pollinated: Bird, possibly insect.

Identification: A tall shrub or small tree with alternate, grey-green leaves 10–12.5cm/4–5in long, which are rigid to leathery, erect, with 11–15 fine parallel veins. Small, pink-purple, tubular flowers with long, protruding styles appear from midwinter to spring in dense 2.5–7.5cm/2–3in axillary spikes, and are followed by woody seedpods containing two winged seeds.

Right: While it is generally regarded as a large shrub, in time grass-leaved hakea often forms a small, upright tree.

GESNERIAD, ACANTHUS AND JACARANDA FAMILIES

The Gesneriaceae (gesneriads) are mostly tropical herbs and shrubs including well-known ornamental species such as Streptocarpus *and* Gloxinia. *The Acanthaceae (acanthus) are tropical herbs, shrubs or twining vines. The Bignoniaceae (jacarandas) are lianas restricted to eastern part of Australasia.*

Fieldia

Fieldia australis

This attractive, slightly woody perennial, found in shady spots in the mountains and coastal areas of New South Wales and Victoria, Australia, is actually the sole species in this genus. It forms a tall, climbing shrublet, which clings to mossy bark, especially that of tree ferns, by means of roots that it can put out at need. The large, pure white, tubular flowers arise from spring to summer. When fertilized they eventually turn into large, hanging berries that are white when ripe.

Identification: A tall, climbing subshrub or shrublet often found climbing on tree ferns. The stems, which root as they climb, are red and downy when young, becoming smooth with silvery bark with age. The oval leaves are opposite, of unequal length in each pair, 1.5cm/⅝in or more long, shiny deep green above, paler to silvery below, with downy, reddish midribs, veins and stalks. The large, softly hairy, pure white, pendent, tubular flowers, with a pale green calyx, five petals and white, slightly protruding stamens and stigma, appear singly in the leaf axils. The fruits are large hanging berries, white when ripe, with tiny seeds contained in a fleshy pulp.

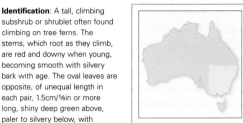

Distribution: South-eastern Australia.
Height and spread: 1.8–2.5m/6–8ft.
Habit and form: Climbing subshrub.
Leaf shape: Ovate.
Pollinated: Insect.

New Zealand Gloxinia

Taurepo, waiu-atua, *Rhabdothamnus solandri*

The only African violet genus from New Zealand, this loose, twiggy shrub is found in the coastal forest of North Island, where it favours stream banks. It has rough, hairy leaves that arise from decorative snake-bark stems. The single orange to dark red flowers are carried in succession almost throughout the year, making this one of the prettiest of all New Zealand's forest flowers. The colour of the flowers often pales during the winter.

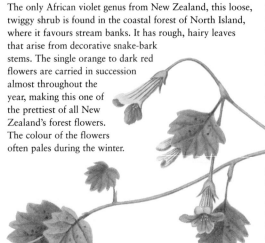

Identification: A loose, evergreen shrub with purplish young stems and older bark with a snakeskin pattern. The hairy leaves are opposite, oval to elliptical, up to 1cm/⅜in long and coarsely toothed. They are mid- to silvery green with purple veins and spots, on short, purple stalks. The flowers are red-orange with darker stripes or, more rarely, yellow and up to 15mm/⅝in long, arising from the leaf axils. The calyx of five sepals, somewhat reflexed, is purple outside, pale green within and sparsely hairy; the flower is tubular with flared, round lobes; the style and stamens protrude slightly.

Distribution: New Zealand.
Height and spread: 90–180cm/3–6ft.
Habit and form: Shrub.
Leaf shape: Ovate-elliptical.
Pollinated: Bird.

Cyrtandra pritchardii
This shrub or small tree from Fiji has oval,
toothed leaves and bears white flowers in
axillary cymes throughout most of the year. The
slightly downy flowers are two-lipped, with the
lower lip larger than the upper.

Caricature Plant *Graptophyllum pictum*
This erect, loosely branched shrub, of obscure
origin, has been widely planted in tropical
gardens and now often exists as an escapee. It
most probably originates from New Guinea, and
is most noted for its glossy, dark green leaves
that are irregularly blotched or marbled.

Bower of Beauty *Pandorea jasminoides*
This robust, Australian climbing vine reaches up

to the forest canopy in
rainforest from eastern
Victoria to south-east
Queensland. The funnel-
shaped flowers are pale to
deep pink and appear in
terminal clusters from
September to March.

Holly-leaved Fuchsia *Graptophyllum ilicifolium*
This is a medium shrub with shiny, sharply
toothed leaves. It is native to the lowland rain-
forests around the Mackay area of Queensland,
Australia. Dense racemes of beautiful, deep red,
tubular flowers are born on short stalks in the
leaf axils in late spring over a short season.

Wonga Wonga Vine

Pandorea pandorana

This vigorous, evergreen climber is found in
habitats from fern gullies to open forest in
Australia, New Guinea and several other
Pacific Islands. It becomes very large over
time as it ascends into the rainforest canopy,
hiding most of its blooms from view. In
spring the vine bears large clusters of small
flowers, variable in hue from white with
purple markings to light red, depending
upon its location.

Distribution: Australia, New
Guinea, Pacific Islands.
Height and spread: Up to
30m/100ft.
Habit and form: Liana.
Leaf shape: Pinnate.
Pollinated: Insect.

Identification: An evergreen liana, with a slender
stem and pinnate leaves with six opposite pairs of
glossy, dark
green, lance-
shaped leaflets
up to 10cm/4in
long and 5cm/2in
wide. The leaves
are sparsely glandular
below, entire and
hairless on the upper
surface. The flowers are in
terminal or lateral clusters, up to 20cm/8in long,
often on old wood. They are funnel to bell
shaped, creamy-yellow, and around
2.5cm/1in across, with five short lobes
reflexed to reveal the throats of the flower
that are streaked and splashed red or purple. The
tube is twice the length of the lobes. The beaked,
cylindrical capsule contains winged seeds.

Scarlet Fuchsia

Graptophyllum excelsum

Distribution: North-east
Australia.
Height and spread:
1.5–8m/5–26ft.
Habit and form: Shrub.
Leaf shape: Spathulate.
Pollinated: Bird.

Found in dry vine thickets, usually on soils
derived from limestone, on the eastern coast
and ranges of Queensland,
Australia, this shrub or
small tree flowers in
spring and early
summer, sporting
many deep red,
tubular blooms
that are borne singly or in pairs
in the leaf axils. In a good
flowering season flowers are borne
in almost every axil, and the
plant becomes a mass of
brilliant scarlet red, which
attracts honeyeaters, probably its
main pollinator. The plants sucker readily
and new clumps appear beside established
plants that can lead to it developing into a
dense thicket in time.

Identification: An erect, evergreen shrub with
multiple stems, often forming large colonies. The
spoon-shaped leaves, 3cm/1¼in long and borne in
opposite pairs, are shiny dark green, with margins
that are mostly smooth, though sometimes toothed,
painted or spotted. The waxy, deep red flowers are
borne on short stalks, often in
great profusion, singly or in
pairs in the leaf axils. They
are tubular, two-lipped and
up to 2.5cm/1in long. The
seed capsules that
follow are club-
shaped, containing
two seeds.

CITRUS FAMILY

There are around 150 genera and 900 species in Rutaceae (the citrus family). They are mostly found in warm to tropical regions and are usually sweet-smelling shrubs or trees. The family produces many edible fruits, some of which, such as oranges, grapefruits and lemons, are important food crops. It displays particular diversity of species in Australasia.

Coastal Correa

Native fuchsia, *Correa backhousiana*

This is a rare plant in the wild, growing only in a limited area in Tasmania and a restricted area of Victoria, Australia. It forms a compact bush, with tubular, pale greenish-yellow flowers from late summer to spring. The leaves have rust-coloured undersides, as do the stems and flower calyces, caused by a woolly covering of small, brown hairy scales, giving the whole plant a very decorative appearance. The plant has become popular in cultivation and may occasionally be encountered far from its native range as a garden escapee.

Identification: A dense, spreading, evergreen shrub with felted, orange-brown stems. The oval, leathery leaves are up to 3cm/1¼in long, with felted brown undersides. The flowers are funnel-shaped, about 2.5cm/1in long, with four lobes, cream to pale green or sometimes orange-brown, axillary or terminal, solitary or in small clusters.

Left: The flowers are a creamy-green colour with calyces covered in a rusty-brown felt.

Right: Correa forms a compact, slow-spreading, evergreen shrub.

Distribution: South-east Australia.
Height and spread: 2m/6½ft.
Habit and form: Shrub.
Leaf shape: Ovate.
Pollinated: Insect.

Willow-leaved Crowea

Crowea saligna

The sheltered open forests of the central coastal area of New South Wales are home to this small, pink-flowered shrub. The star-like flowers emerge singly from the leaf axils and are seen over a long season stretching from late summer through to midwinter. The long, thin, willow-like leaves are aromatic. The seeds are naturally dispersed by ants.

Identification: A small shrub, with angular branches and aromatic, lance-shaped leaves up to 8cm/3¼in long, alternately arranged. The star-shaped, five-petalled, pale to mid-pink flowers are produced from the leaf axils or terminally, singly or sometimes paired. They are quite large, with some forms having flowers up to 4.5cm/1¾in in diameter.

Above: The star-like flowers can be variable and are seen here in a rarer white form.

Distribution: Central eastern Australia.
Height and spread: 90cm/3ft.
Habit and form: Shrub.
Leaf shape: Elliptic.
Pollinated: Insect.

Above and left: The angular branches and aromatic lance-shaped leaves are quite distinctive on this small shrub.

Granite Boronia

Boronia granitica

Distribution: Central eastern Australia.
Height and spread: 90cm/3ft.
Habit and form: Shrub.
Leaf shape: Pinnate.
Pollinated: Insect.

This medium-sized, compact shrub with pinnate foliage and pink flowers grows in heathy vegetation among granite boulders. It can be found in only a few locations on the north-western side of the New England Tablelands of New South Wales, and the Stanthorpe district of southern Queensland, Australia. It grows either among boulders in the skeletal soils found in narrow rock crevices and fissures, or in adjacent areas on granite scree and shallow soils, in areas of predominantly summer rainfall and cool winters. The flowering season is long, from midwinter to early summer, with the greatest concentration over the spring.

Identification: An evergreen shrub with opposite, pinnate, aromatic leaves, dotted with glands and covered with hairs. The fragrant flowers are also downy and are pale to bright pink, or occasionally white, with four oval, pointed petals, borne singly from the leaf axils over an extended flowering season from winter to summer.

Far right and right: Granite boronia forms a compact evergreen shrub that bears pretty pink flowers over a long period from winter until the early summer.

Right: The flowers are followed in late summer and autumn by capsules containing small, black seed that is dispersed by ants.

OTHER CITRUS FAMILY SPECIES OF NOTE

Native Fuchsia *Correa reflexa* var. *cardinalis*
This plant from south-eastern Australia occurs in a variety of habitats, from mountain forests to dry mallee scrub. Its flowers are downy, tubular and yellow-green to crimson, with two or three held together on axillary stalks, appearing mostly between late autumn and late spring.

Phebalium rotundifolium
syn. *Leionema rotundifolium*
This small shrub from open woodland and shrub-land in New South Wales has the clustered, star-shaped, five-petalled, yellow flowers that are typical of the genus, but does not possess the scales on the leaves or stems that are found on many other species.

Diplolaena grandiflora
This striking shrub has oval woolly leaves and pendent red flowers in hairy, green bracts that appear in spring and summer. It is restricted to the south of Western Australia. Although the individual flowers are very small, they are grouped together into large clusters, which may be up to 4cm/1½in across.

White Star *Philotheca myoporoides*
The white star or native daphne comes from open forests and woodlands of Victoria, New South Wales and Queensland, Australia. Its branches are warty and the glossy, deep green leaves have a strong aroma when crushed. From late winter to late spring it is smothered with waxy, white, star-shaped flowers, opening from deep pink buds.

Forest Phebalium

Phebalium squamulosum

This small shrub occurs naturally in open woodland or heath on sandy soils in south-east and north-east Queensland, eastern New South Wales and eastern Victoria, Australia. It is an extremely variable species, with several subspecies and varieties, all of which possess very aromatic foliage and clusters of small, star-like flowers in cream to bright yellow. They appear in early spring. Plants in new leaf have a highly decorative silvery appearance.

Identification: A variable species ranging from slender, small trees to prostrate shrubs. The buds and flowering stalks are covered in small brown scales. The elliptical leaves are bright to grey-green, up to 3cm/1¼in long, sometimes irregularly toothed, and the new growth and undersides of older leaves are covered with silvery scales. The five-petalled flowers appear in early spring and last about four weeks. Though small, they are very conspicuous, occurring in clusters of 12 or more, with cream to yellow pointed petals, bright yellow anthers and long cream stamens.

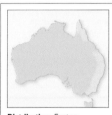

Distribution: Eastern Australia.
Height and spread: Up to 7m/23ft.
Habit and form: Variable (woody).
Leaf shape: Elliptical.
Pollinated: Insect.

Right: Forest phebalium is immensely variable, ranging from a small tree to a prostrate shrub.

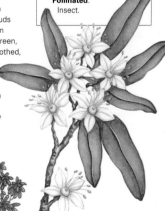

CARNIVOROUS PLANTS

Carnivorous plants have one thing in common; namely that they have evolved the ability to capture and/or digest animals. Over time they have evolved into many forms and often come from diverse ancestry. While some are found in the islands of Oceania, the greatest concentration of species is found in Australia.

Rainbow Plant

Byblis gigantea

This carnivorous plant grows in fire-prone, acid, sandy soils in south-western Australia. It is a close relative of the butterworts, *Punguicula* species, and sundews, *Drosera* species, and its tentacles, much like those of sundews, cover the whole plant, including the stem, leaves and even the flowerheads and buds. Insects are lured to the plants by the sticky mucilage secreted by the stalked glands, which appears to them as dew or nectar. Unlike those of the sundews, the rainbow plant's glands and leaves do not move or curl around their prey.

Identification: A sticky, erect, glandular-hairy, carnivorous herbaceous perennial. The leaves are 10–30cm/4–12in long, narrow and often channelled above, densely sticky and hairy beneath; they have glands with a stem (for trapping insects) and without (for digestion). Flowers up to 4cm/1¾in across appear in summer, growing singly from the axils on hairy stems. They have five overlapping, triangular petals, 2cm/¾in long, and are iridescent blue, pink or purple, with a yellow centre and long, slender style.

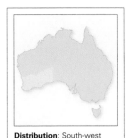

Distribution: South-west Australia.
Height and spread: 60cm/2ft.
Habit and form: Perennial herb.
Leaf shape: Linear.
Pollinated: Insect.

Albany Pitcher Plant

Cephalotus follicularis

Found in a small corner of Western Australia, in a 400km/250mile strip from Albany to Eusselton, this curious little plant is the only representative of both its genus and its family, and has no close relatives in the plant kingdom. A variable species in the wild, it produces passive pitcher traps that are mostly used to attract crawling insects: once ensnared they are unable to crawl out of the cleverly designed pods. The traps are produced from spring to autumn and in winter the plant produces small, flat, green leaves. The white flowers are produced on tall, branching stems over the summer.

Identification: A carnivorous herbaceous perennial growing from a short, thick, branched rhizome. The leaves grow in a rosette and are of two kinds: the leaves are 5–7.5cm/2–3in long, oval, rounded, glossy green, often with a red margin; the trapping leaves, which form pitchers up to 5 x 2.5cm/2 x 1in long, are sparsely hairy, green, heavily marked red-brown, with a hinged, ribbed, oval lid attached on the stalk side and three external longitudinal raised nerves swollen into narrow, leaf-like double wings with fringed margins. Small white flowers are borne in terminal panicles on stems up to 60cm/2ft long.

Distribution: Western Australia.
Height and spread: Variable.
Habit and form: Perennial herb.
Leaf shape: Ovate, trapping leaves jug-like.
Pollinated: Insect.

Fairy Aprons

Utricularia dichotoma

Distribution: Australia.
Height and spread: Variable.
Habit and form: Herbaceous perennial.
Leaf shape: Elliptic.
Pollinated: Insect.

This small, Australian, carnivorous herb of permanently wet or seasonally waterlogged soils is only ever likely to be seen when the large, paired, purple flowers appear on long, slender stems. The flower gives the impression of a small skirt, which accounts for the plant's common name. It occurs in all areas of the continent except the Northern Territory, growing from sea level to 1,500m/4,900ft, and flowers year-round, though most commonly in the warmer months.

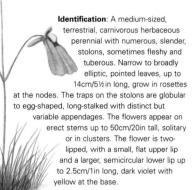

Identification: A medium-sized, terrestrial, carnivorous herbaceous perennial with numerous, slender, stolons, sometimes fleshy and tuberous. Narrow to broadly elliptic, pointed leaves, up to 14cm/5½in long, grow in rosettes at the nodes. The traps on the stolons are globular to egg-shaped, long-stalked with distinct but variable appendages. The flowers appear on erect stems up to 50cm/20in tall, solitary or in clusters. The flower is two-lipped, with a small, flat upper lip and a larger, semicircular lower lip up to 2.5cm/1in long, dark violet with yellow at the base.

OTHER CARNIVOROUS PLANTS OF NOTE

Utricularia protrusa
This aquatic bladderwort, normally found in slow-moving or still water throughout New Zealand, floats on the surface of the water, with submerged leaves and traps emerging from a long central stem. During winter, resting buds sink, re-emerging in spring. Sulphur-yellow flowers appear from spring to late summer.

Pitcher Plant *Nepenthes mirabilis*
The most widespread species in the genus, this carnivorous pitcher plant, found in northern Australia and much of South-east Asia, occupies a wide range of forest habitats, although always preferring those with a relatively high humidity for much of the year. The plants produce pitchers in various colours, depending upon their place of origin.

Waterwheel Plant *Aldrovanda vesiculosa*
The waterwheel plant is a widespread and curious aquatic, carnivorous herb. It occurs sporadically along the coasts of Queensland, the Northern Territory and far northern Western Australia, as well as in South-east Asia, southern Africa and Europe. It is the only aquatic carnivorous plant with visible trap movement.

Byblis liniflora
This variable, annual carnivorous herb, found in northern Australia and Papua New Guinea, has long, slender leaves with many long-stemmed glands covering much of the plant. The flowers are pink or blue and are produced on long stalks from the leaf axils.

Fork-leaved Sundew

Drosera binata

This robust and variable species is normally found in bogs and swamps, or, in many cases, in roadside drainage ditches. It is very widespread, occurring across Victoria, South Australia, Tasmania, in a small area of south-west Western Australia, and throughout New Zealand. The sticky leaves characteristically divide into two and produce a "tuning fork" shape, and the white (or occasionally pink), sweet-scented blooms are produced between spring and autumn, with the plants usually being dormant from late autumn to early winter.

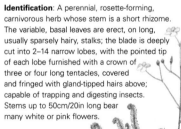

Distribution: South-eastern Australia, New Zealand.
Height and spread: 50cm/20in.
Habit and form: Perennial herb.
Leaf shape: Forked.
Pollinated: Insect.

Identification: A perennial, rosette-forming, carnivorous herb whose stem is a short rhizome. The variable, basal leaves are erect, on long, usually sparsely hairy, stalks; the blade is deeply cut into 2–14 narrow lobes, with the pointed tip of each lobe furnished with a crown of three or four long tentacles, covered and fringed with gland-tipped hairs above; capable of trapping and digesting insects. Stems up to 50cm/20in long bear many white or pink flowers.

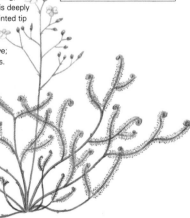

PARASITIC PLANTS

Parasitic plants are found on all continents except Antarctica and the southern oceans are no exception to this. Oceania is the home to an extremely diverse range of parasites, most of which can be gathered together under the general term mistletoes. Mistletoes are only partial parasites, and have green leaves.

Western Australian Christmas Tree

Moodjar, *Nuytsia floribunda*

This bush is a native of sandy or granite soil in open forest, woodland and heath in Western Australia. It is related to the mistletoe and is, at least in the early stages of its life, dependent on a host plant. When its roots encounter those of another plant, they form a collar-like "haustorium", a structure that cuts into the host root to extract nutrients and moisture. The species famously flowers at around Christmas time, when its bright yellow flowers, borne in clusters at the end of the branches, make the whole plant a spectacular, seasonal highlight.

Right:
The bright yellow flowers appear on branch tips around Christmas time.

Identification: An evergreen shrub or small tree with rough, grey-brown bark, which parasitizes the roots of grasses as much as 50m/160ft away. The leaves are 2.5–10cm/1–4in long, opposite, subopposite or occasionally whorled, lance-shaped with pointed or rounded tips, narrowing at the base. The brilliant orange-yellow flowers appear in large, crowded terminal clusters over several months. The fruit is brown, dry and three-winged, with sticky seeds.

Distribution: Western Australia.
Height and spread: 7m/23ft.
Habit and form: Shrub or small tree.
Leaf shape: Lanceolate.
Pollinated: Insect.

Rosewood Mistletoe

Amyema scandens

This showy mistletoe species is native to the moist tropical forests of Papua New Guinea, New Caledonia and Borneo, with a few isolated occurrences on the Australian east coast, where it is a parasite of the rosewood tree, *Dalbergia sissoo*. The species grows at elevations from sea level to 1,600m/5,200ft in both primary and secondary rainforest and in open humid forests, on a wide range of hosts. It is a variable species, with red or pink tubular flowers appearing close to the branches of the host.

Identification: A semi-parasitic shrub, with external runners and robust stems, with distinct lenticels, enlarged at the nodes. The elliptic to circular leathery leaves are mostly in whorls of five to eight, or rarely four; they are very variable, lance-shaped to oval, up to 20cm/8in long, sometimes with wavy margins. The clusters of slender, stemless red or pink flowers appear at the nodes and on the runners.

Distribution: Papua New Guinea, New Caledonia, Borneo.
Height and spread: Variable.
Habit and form: Semi-parasitic shrub.
Leaf shape: Lanceolate to ovate.
Pollinated: Insect.

Left: Amyema scandens is an endangered species of parasite.

New Zealand Red Mistletoe

Peraxilla tetrapetala

Distribution: New Zealand.
Height and spread:
90cm/3ft.
Habit and form: Semi-parasitic shrub.
Leaf shape: Rhombic.
Pollinated: Insect.

Right: The fruit of the New Zealand red mistletoe are dull green.

This mistletoe, endemic to New Zealand, has showy, bright red flowers, and is most commonly seen on mountain beech, *Nothofagus* species, and tawheowheo trees, *Quintinia* species, in the forests of North Island and also on silver beech, *N. menziesii*, on South Island. It is most frequently found on the inner branches and the host trunk, where the flowers provide a dazzling display in early summer. It has the distinction of being the only plant in the world with bird-pollinated explosive flowers, which are also opened by insects.

Identification: Semi-parasitic, bushy shrub, joined to its host by several haustoria (attachments). The rhombic leaves are oppositely arranged on short stalks and are thick and fleshy, usually with some blisters on the surface caused by gall-forming insects. The flowers are tubular in bud, with a clubbed tip, and have four petals, red or yellow at the base shading gradually to crimson at the reflexed tips, and protruding stamens and stigma. The fruit is a greenish-yellow, semi-translucent drupe, appearing in autumn.

OTHER PARASITIC PLANT SPECIES
OF NOTE

Dendrophthoe acacioides
This aerial stem-parasite from the Northern Territory and Western Australia has conspicuous orange flowers, held on axillary spikes, which adorn the sparsely leafed runners. The mature bud is usually inflated and curved with the open, star-like flower.

Decaisnina signata
This mistletoe is found mainly on *Barringtonia*, *Planchonia* and *Ficus* trees in the monsoon forest of the Northern Territory. It has showy, orange, tubular flowers with yellow-and-black lobes, arranged in terminal spikes.

Yellow Beech Mistletoe *Alepis flavida*
The yellow beech mistletoe is a native of both North Island and South Island of New Zealand, where it mostly occupies mountain or black beech, *Nothofagus* species, as a host. It has small, orange-yellow to yellow flowers in summer, followed by shiny, golden-yellow berries.

Daenikera corallina
This monotypic genus occurs only in the dense wet forests of New Caledonia, where it is parasitic on the roots or trunk bases of forest trees. The new growth is bright red, becoming brown with age. Tiny burgundy flowers are followed by red fruits that turn blue with age.

Galapagos Dwarf Mistletoe

Phoradendron henslowii

This mistletoe, seen on trees on Santa Cruz and Isabella Island, Galapagos, is an endemic species that grows in the elevated cloud forest vegetation of those islands. It is related to other dwarf mistletoes, whose principal centre of diversity is in Mexico and the western United States, and in some respects it resembles the Ecuadorian species *P. nervosum*. The oval, leathery leaves are paired and joined at their bases, and the small, greenish flowers on thin red spikes give rise to small, pinky-white berries.

Distribution: Santa Cruz and Isabella Island, Galapagos.
Height and spread: Variable.
Habit and form: Semi-parasitic shrub.
Leaf shape: Obovate.
Pollinated: Insect.

Identification: A semi-parasitic shrub, with green stems and reddish buds and nodes, with a dense or sparse growth habit, often forming an extensive colony within the host canopy. The variable, waxy, oval leaves are smooth, pale green, often with darker margins, becoming mottled darker and with red spots with age. The small, greenish flowers and greyish, sticky berries are held terminally on the branchlets, subtended by paired leaves.

Left: Dwarf mistletoe grows only on trees in cloud forest regions.

Below: The small, greyish berries appear on the branch tips on red stems.

DUCKWEED, ARUM AND GINGER FAMILIES

Lemnaceae, the duckweed family, is widespread across Australia. The Araceae, arum family, are rhizomatous or tuberous herbs characterized by an inflorescence that is a fleshy spadix partially enveloped by a bract or spathe. The Zingiberaceae (ginger family) are perennial herbs, mostly with creeping horizontal or tuberous rhizomes. They have a wide distribution, mainly in the tropics.

Taro

Coco yam, *Colocasia esculenta*

This plant is grown as a crop for its edible corms and leaves throughout the humid tropics and is used in Africa, Asia, the West Indies and South America. Its origins are very obscure: it is probably a selection of an ancestral wild food. It was extremely important to the Polynesian, Melanesian and Micronesian peoples, who transported it across the Pacific Ocean, where it occurs as an introduced vagrant on many islands. It is most recognizable for its large, arrow-shaped leaves, the flowers being rather insignificant and rarely setting viable seed.

Distribution: Pan-tropical.
Height and spread: 1.5m/5ft.
Habit and form: Herbaceous perennial.
Leaf shape: Sagittate.
Pollinated: Unclear, rarely sets seed.

Identification: A perennial herb with thick shoots from a large corm; slender stolons are also often produced, along with offshoot corms. The leaf blades, up to 60cm/24in long and 50cm/20in wide, are arrow-shaped, with a dark green, velvety upper surface; the leaf stalks, which join the middle of the leaf, are succulent and often purplish near the top. The inflorescence is a yellow spathe 20–40cm/ 8–16in long, surrounding a spadix 5–15cm/2–6in, on a stout stem; the flowers are tiny and densely crowded on the upper stalk, female flowers below, male flowers above. The fruits are small berries in clusters on the stalk, producing few seeds, which are rarely viable.

Above: The corm is an important food crop.

Right: The leaves are quite distinctive.

Star Duckweed

Ivy leaf duckweed, *Lemna trisulca*

This diminutive, floating, aquatic perennial is found throughout the world's temperate zones in both hemispheres, where it often forms tangled masses just under the water surface. The leaves and stems are merged in a common structure that usually has a single root below. It is distinguished from other *Lemna* species by the stalked fronds that aggregate into chains. The tiny flowers, although uncommon, occur on small fronds with toothed margins, which rise to float on the surface.

Identification: A minute, aquatic herb, floating just below the water surface, consisting of a leaf-like frond and a single root. Fronds 3–15mm/⅛–⅝in long and up to 5mm/⅛in wide, submerged except when flowering, narrow at the base to form a 3–20mm/⅛–¾in-long stalk, cohering and often forming branched chains with margins toothed at the base. The roots (sometimes not developed) are up to 2.5cm/1in long, with pointed rootcaps. Flowers and fruits are rare.

Distribution: Cosmopolitan.
Height and spread: Spread indefinite.
Habit and form: Aquatic herb.
Leaf shape: N/A.
Pollinated: Water.

Above and right: The tiny leaf-like stems of this floating, aquatic plant, reproduce rapidly and can form a dense "carpet" across the surface in favourable conditions.

Right: The microscopic flowers of this unusual plant are hardly ever seen.

Pinecone Ginger

Shampoo ginger, *Zingiber zerumbet*

This widespread plant, believed to originate from India and the Malaysian Peninsula, is an example of a species so long under cultivation in so many places throughout the Pacific and Oceania that it is uncertain where it originated, although it was widely introduced by Polynesian settlers. It develops conical bracts, resembling pinecones, which produce creamy-yellow flowers. The bracts contain a clear soapy liquid that has been used by Polynesians to wash the hair and skin, and all its parts are spicily fragrant.

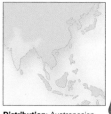

Distribution: Austronesian and Pacific regions.
Height and spread: 2m/6½ft.
Habit and form: Herbaceous perennial.
Leaf shape: Lanceolate.
Pollinated: Insect or bird.

Right: The tall stems arise from an underground rhizome, with flower and leaf stems borne separately.

Far right: The creamy-yellow flowers appear from the tight flower cones.

Identification: A tall, perennial herb with branching, thick, aromatic rhizomes and leafy, reed-like stems. The leaves, which are arranged in two ranks, are lance-shaped, up to 35cm/14in long, closely set, smooth above and hairy beneath. Separate flower stalks 20–45cm/8–18in tall arise in mid- to late summer, bearing pale green, cone-shaped bracts, which gradually turn red. Creamy-yellow, three-petalled, tubular flowers, about 3cm/1¼in long, appear on the cones.

OTHER DUCKWEED, ARUM AND GINGER FAMILY SPECIES OF NOTE

Chinese Evergreen *Aglaonema commutatum*
The inappropriately named Chinese evergreen is actually a native of the Philippines and north-east Celebes. It has been widely planted as an ornamental elsewhere and often persists as an escapee. It is an evergreen perennial with elliptical, dark green, silver mottled leaves and creamy-white axillary flowers enclosed by a pale green spathe.

Stinky Lily *Typhonium brownii*
The aptly named stinky lily grows on rainforest margins, in sheltered gullies and along creek banks from coastal New South Wales and up into Queensland, Australia. It gains its name by virtue of the smell of the newly opened flowers, which, when they open on summer evenings, smell strongly of excrement.

Red Ginger *Guillainia purpurata*
Commonly grown in tropical gardens and possibly a native of South-east Asia, although it has been widely cultivated, red ginger is now naturalized in many tropical islands. The attractive, brilliant red inflorescences consist of large, waxy bracts with small, white, inconspicuous flowers inside.

Amorphophallus galbra
From New Guinea and tropical northern Australia, where it grows principally in lowland forest areas, this plant has a cylindrical, green spathe enclosing a green spadix, held on top of a long scape above the foliage.

White Ginger Lily

Hedychium coronarium

This showy plant, probably a native of eastern India, was transported around the Pacific by Polynesian settlers and is frequently cultivated and naturalized in tropical island forests. The stalks are topped with long clusters of wonderfully fragrant white flowers that look like butterflies. The flowers are popular in Hawaii and the Pacific Islands, where they are used in leis or worn singly in the hair or behind the ear.

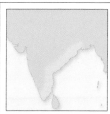

Distribution: Eastern India and Pacific regions.
Height and spread: Up to 3m/10ft.
Habit and form: Perennial herb.
Leaf shape: Lanceolate.
Pollinated: Insect or bird.

Identification: An erect, perennial herb with stout rhizomes and numerous reed-like stems. The lance-shaped, pointed leaves, 60cm/24in long and 10cm/4in wide, are arranged in two ranks, stemless or on short stems. The very fragrant flowers are borne in summer in dense spikes 15–30cm/6–12in long, with two to six flowers per bract. They have three petals and are white with a yellow-green centre. They eventually give way to showy seedpods full of bright red seeds.

Above: The large, flowers appear at the branch tips.

Left: The leafy stems arise from underground rhizomes.

IRIS AND AMARYLLIS FAMILIES

Iridaceae, the iris family, are mostly perennial herbs from rhizomes, bulbs or corms which occur in both tropical and temperate regiosn. The flowers commonly occur at the top of a branched or unbranched stem, each with sex petals in two rings of three. Amaryllicaceae, the amaryllis family, are perennial herbs from a bulb with contractile roots. The flower usually consists of six distinct or fused petaloid tepals.

Darling Lily

Crinum flaccidum, Macquarie lily, Murray lily

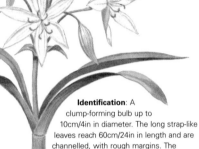

This yellow-flowered bulb emerges after deep soaking rains, and is quite variable in form with a number of geographical variants ranging over a large area from Queensland and New South Wales and to south and west Australia. It favours sandy floodplains, where it can sometimes be found in abundance. Its large, flat, green leaves often emerge within several days of rain. The flowers usually emerge from summer to autumn, some time after the first leaves. They are strongly scented, emitting an unpleasant fragrance, particularly in the evenings.

Identification: A clump-forming bulb up to 10cm/4in in diameter. The long strap-like leaves reach 60cm/24in in length and are channelled, with rough margins. The flowering reaches 60cm/24in in height and is green, with between five and eight white, fragrant flowers, that are tubular at the base, slightly curved, and up to 8cm/3¼in diameter. The six lobes are elliptic, broad, spreading, and tipped with green. The anthers are yellow and the style is green.

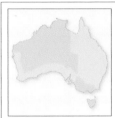

Distribution: Australia.
Height and spread: 60cm/24in.
Habit and form: Bulb
Leaf shape: Linear.
Pollinated: Insect.

Silky Purple Flag

Patersonia sericea

This iris-like perennial herb is widespread from north-eastern Victoria to south-eastern Queensland. It thrives in grassland, woodland and open forest, and is one of the most commonly encountered species of the genus. The three-petalled flowers occur mostly in the spring, on grey woolly stems, which are shorter than the leaves. The flowers are deep purple-blue, often closing before noon in hot, sunny weather. Before opening, the flowers are enclosed in two large, papery bracts and although each flower only opens for a single day, new flowers are produced over an extended period.

Identification: A perennial herb ascending from a short rhizome with stems to 30cm /12in, which are covered with silky, woolly hairs. The leaves are linear, erect, stiff, woolly at the base when young, clustered at the base of the stem, evenly and oppositely arranged, usually forming a fan. The inflorescence consists of a few- to several-flowered, sessile spikes enclosed in spathes: each spikelet being several-flowered. The flowers are regular, short-lived, deep violet-blue, with a slender perianth tube. The outer tepals are broadly ovate, woolly when young, while the inner tepals are lanceolate or ovate and rather small by comparison.

Distribution: Eastern Australia.
Height and spread: 30cm/1ft.
Habit and form: Perennial herb.
Leaf shape: Linear.
Pollinated: Insect.

Swamp Iris

Patersonia fragilis

Distribution: Eastern Australia.
Height and spread: 30cm/1ft.
Habit and form: Perennial herb.
Leaf shape: Linear.
Pollinated: Insect.

Found in the eastern states of Australia, from Queensland down to Tasmania and across to South Australia, this tussock-forming plant is often found associated with tea tree heath, particularly on moist ground. It flowers from September to January and looks like an iris, with purple flowers and a rhizomatous root system. The greyish-green twisted leaves are often longer than the flower stem and obscures the blooms from view until seen from almost above, making this an easy plant to miss when among other vegetation.

Identification: A herbaceous perennial with a short rhizome from which stems grow to 30cm/1ft or more. The leaves, to 45cm/18in long, are often longer than the flower stem. They are greyish-green, twisted, clustered at the base of the stem, linear and usually forming a fan or tussocky mass. The inflorescence is a several-flowered sessile spike, enclosed in a spathe; the bracts are scarious; the flowers are regular, short-lived and purple. The outer three tepals are broad and spreading; the inner three are erect and small, forming an enclosing sheath around the stamens and style.

Orange Libertia

Mikoikoi, *Libertia peregrinans*

This flower is found in moist grassy areas and scrub on the west coast of New Zealand's North Island, between Kawhia and Wellington, and from a few locations on South Island and nearby coastal islands. It has strap-like, tufted, veined leaves that turn an attractive orange colour in cool weather. The flowers, which resemble a small iris, are white, star-shaped with yellow anthers, and are produced in spring. Burnt-orange, marble-sized seedpods follow the flowers.

Distribution: New Zealand.
Height and spread: To 70cm/28in.
Habit and form: Herbaceous perennial .
Leaf shape: Linear.
Pollinated: Insect.

Identification: This plant consists of leafy fans, which emerge at intervals from horizontal stolons. The leaves are 13–70cm/5–28in long, 1cm/⅜in wide, and are copper-coloured. They are many-veined with the median ones crowded and coloured red or orange. The flowers and fruits are carried below the leaves. The panicles of flowers are narrow, closely branched, with long lower bracts and shorter upper bracts. Each has one to seven flowers per branch. The flowers are to 2.5cm/1in in diameter; with bright white tepals that are oblong-elliptical or oblong. The anthers are dark yellow-brown. The seedpod is an ovoid-barrel-shape.

WATER LILIES, BUCK BEANS, LOTUS LILIES, PICKERELWEEDS AND APONOGETON

Aquatic plants often have immensely showy flowers, and include among their number species considered as the most basally "primitive" of the flowering plants. They all live in a challenging environment and show a variety of ingenious solutions to the problem of survival.

Giant Water Lily

Nymphaea gigantea

This waterlily, native to north Australia and New Guinea is quite scarce, occurring in lagoons and slow-flowing creeks, in deep soft mud. It is a magnificent species with large blooms held high above the water, which emerge and are best seen in the day. Their abundant yellow stamens are very striking and both white- and pink-petalled variants can be found as well as the more common blue form.

Identification: An aquatic herbaceous perennial with tuberous roots. The leaves are to 60cm/2ft in diameter, ovate to orbicular, glabrous, green above, green tinged pink to purple beneath. The base of each is deeply cleft into two-lobes, with the lobes often overlapping. The margins are finely dentate. The petioles are usually elongate, glabrous. The flowers, to 30cm/1ft diameter, are sky-blue to blue-purple, scentless, opening in the day and closing at night. The sepals are ovate to elliptic, green, with the margins and exterior surface often blue. The 18–50 petals are obovate enclosing 350–750 stamens, which are bright yellow. The fruit is berry-like, maturing under water. The seeds have a floating aril.

Distribution: North Australia and south New Guinea.
Height and spread: Variable.
Habit and form: Aquatic, perennial herb.
Leaf shape: Rounded.
Pollinated: Insect, usually beetles.

Left: The large blooms are held high above the water and rounded, green leaves.

Water Snowflake

Nymphoides indica

This pretty, fast-growing, perennial water plant, has an extremely wide tropical distribution, inhabiting pools, pans, marshes and rivers throughout Australia and New Zealand, as well as southern and tropical Africa, India and Asia. Although it bears some resemblance to water lilies, it is not related. It has flat, rounded, floating leaves, and floating stems that form tufted plantlets along their lengths. The delicate, white flowers with yellow centres, have unusual, feathery-edged petals and mostly appear between October and May.

Identification: An aquatic perennial herb with creeping rhizomes and elongated stems that form tufted plantlets along their length. Roots form at the nodes, particularly in seasons of drought. The floating leaves, to 15cm/6in in diameter, but usually far smaller, are orbicular, pale glossy green, long-stalked, deeply cordate at the base, with margins that are entire or undulate. The flowers are borne in profusion from October until May, emerging ephemeral, on slender stalks arising from petioles. The petals to 1cm/⅜in, are white, stained deep yellow at the centre, and are covered in white glandular hairs or are densely papillose. Petal margins are fringed. Each flower has five stamens inserted at the base of the corolla. The stigma is bifid and the ovary is single-celled. The fruit is a capsule.

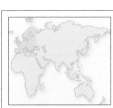

Distribution: Australia, New Zealand, Africa, India, Asia.
Height and spread: Variable.
Habit and form: Aquatic, perennial herb.
Leaf shape: Rounded.
Pollinator: Insect.

Below: The unusual feathery flowers appear around the leaves.

Sacred Bean

Nelumbo nucifera

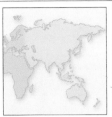

Distribution: Australia, Asia.
Height and spread: Variable.
Habit and form: Aquatic, herbaceous perennial.
Leaf shape: Rounded.
Pollinated: Insect.

This striking Australian native perennial can be found across much of Asia. Its floating and emergent, blue-green leaves can be found in stationary or slow-moving water in lagoons and floodplain watercourses, mostly in tropical zones. It is a spectacular sight when in bloom. The soft pink blossom opens on top of a stiff stalk, which emerges from below the water. The easily recognized, large fruit structure develops as the flower opens and turns brown when the flower fades and the petals fall into the water. It is prized by florists for use in dried arrangements.

Left: The soft pink blooms appear above the water on long stems.

Identification: A perennial aquatic herb with a spongy, horizontal and wide-spreading rhizome. The leaves are long-petiolate, to 2m/6½ft above the surface, to 80cm/32in across. They are glaucous, with a margin that is undulate peltate and veins that radiate. The flowers are solitary, emerging from the water, large and showy, pink or white, very fragrant, to 30cm/1ft diameter. Each has four or five green sepals and numerous petals that are arranged spirally. A mass of 200–400 stamens, to 12.5 x 7.5cm/5 x 3in, each have yellow anthers. The 2cm/¾in fruits provide ellipsoid seeds, which can survive for hundreds of years in river mud.

OTHER SPECIES OF NOTE
Yellow Water Snowflake *Nymphoides crenata*
This pretty perennial water plant has yellow flowers with five characteristically fringed petals, held above the heart-shaped leaves. The leaves arise from a stoloniferous base, floating on the water surface, and the floating runners produce new plants along their length.

Blue Lily *Nymphaea violacea*
The blue lily is a showy aquatic plant from northern Australia, which can be seen along the margins of billabongs. It has large, round, floating leaves and bears violet-tipped, white flowers that appear between January and July, on long stalks up to 30cm/12in above the water surface.

Queensland Lace Plant *Aponogeton elongatus*
This pondweed, native to north and eastern Australia, is found in the shallow turnings of slow-flowing rivers. It has long, wavy-edged, mostly submerged or occasionally floating leaves, and a yellow, usually simple flower spike that emerges in the summer.

Cobooree *Aponogeton queenslandicus*
This rare water plant, occurs in Queensland, the Northern Territory and the far west of New South Wales, Australia. It is threatened by invasive introduced grass species. It has lance shaped floating leaves and bright lemon-yellow floating spikes of flowers.

Bog Hyacinth

Monochoria cyanea

Distribution: North Australia.
Height and spread: Variable.
Habit and form: Aquatic, annual or perennial herb.
Leaf shape: Ovate.
Pollinated: Insect.

The billabongs, swamps and, small watercourses of northern Australia are the home of this attractive plant, which generally likes to grow rooted in soft muddy sediments. It begins life as a floating-leaved plant, which in time changes to the adult form with a loose rosette of rounded leaves. The short flower stems appear to emerge from the leaf stalk, and each one produces several pretty blue to purple flowers in the summer.

Identification: An annual or perennial aquatic herb with a short, creeping rhizome and short erect stems. The leaves emerge on long petioles, basal or alternate on the stem. They are cordate-ovate to lanceolate in shape. The inflorescence has a solitary, terminal, sheathing leaf enclosing a membranous spathe at the base of stalk. The spathe shape is variable, sometimes with the lower spathe enclosing the upper. The flowers appear in elongated racemes. The outer flower appears in six sections. It is tubular to oblong, blue, often spotted red, with six stamens, with oblong anthers; one large and blue, the other five smaller and yellow. The fruit capsule has numerous seeds.

GRASSES AND SEDGES

The Poaceae, more commonly known as grasses, are mostly herbaceous perennials, comprising one of the largest and, from the point of view of human and grazing animals, most important families of flowering plants with about 500 genera and 8,000 species. The Cyperaceae (sedges) are grass-like, herbaceous plants comprising about 70 genera and 4,000 species, commonly found in wet or saturated conditions.

Rice Sedge

Cyperus exaltatus, Dirty Dora

This tussock-forming, grass-like plant is a common sight in the freshwater wetlands of much of Australia, where it thrives on riverbanks, creekbanks, frequently inundated alluvial floodplains, drainage channels, lagoons and shallow dams. Superficially. the plant resembles grasses, but its green stems are a distinctive triangular shape. The reddish-brown spikes of flowers appear in summer, autumn or winter, depending upon the location they are found in.

Far left The stems of rice sedge are three-sided making them quite distinctive and easy to identify.

Identification: Rice sedge is a robust, tussock-forming, aquatic perennial, to 2m/6½ft tall. The leaves are 5–15mm/³⁄₁₆–⅝in wide. The culms are triangular and smooth, 1–1.8m (39–72in) high, to 8mm (⅜in) diameter. The inflorescence is compound or decompound, with five to ten primary branches to 18cm/7in long. The spikes are narrow-cylindrical, 2–5cm/⅘–5in long, and 5–15mm/³⁄₁₆–⅝in diameter. The four to six bracts surrounding the inflorescence are leaf-like, to 90cm/3ft long. The flattened spikelets, which are numerous per spike, to 2cm/¾in long, with 6–44 flowers appear in spring and summer. The fruit is a yellow-brown, ellipsoid nut.

Distribution: Widespread in tropics and warm climates.
Height and spread: 2m/6½ft.
Habit and form: Tussock-forming aquatic perennial.
Leaf shape: Linear.
Pollinated: Wind.

Left: The seeds, held tightly in the spikelets are small nuts that are easily borne by water.

River Club Rush

Schoenoplectus tabernaemontani (syn. *Schoenoplectus validus*)

This stout, grass-like perennial species occurs across a very wide range, including the Americas, Eurasia, Africa, many Pacific Islands as well as Australia and New Zealand. It grows in both fresh and brackish marshes, tidal shores, shallow margins of ponds, quiet waters and on some riverbanks. It is an extremely variable plant that is probably really a cluster of very closely related subspecies, all of which hybridize freely. The erect, soft, circular flowering stems have only small leaves and are topped by small clusters of drooping flowers covered by red-brown spiral, scales.

Identification: An erect perennial standing 90cm–3m/3–10ft tall. It is semi-aquatic, and often forms large colonies. It has spongy cylindrical, bluish-green stems with big air chambers. The roots develop from a shallow rhizome, to 1cm/⅖in diameter. Each stem produces three or four, basal leaves that are often pinnate-fibrillose; margins often scabridulous. The inflorescences is branched, each with two to four branches to 20cm/8in long. The 15–200 spikelets are solitary or in clusters of two to four, but most commonly all are solitary. Each scale is uniformly dark to pale orange-brown, sometimes straw-coloured. The fruiting time is variable according to location, but is usually in spring to summer.

Distribution: Widespread across the world.
Height and spread: 90–300cm/3–10ft.
Habit and form: Erect, semi-aquatic perennial.
Leaf shape: Linear.
Pollinator: Wind.

Left: The small clusters of drooping flowers can be variable according to where the plant grows.

Salt Couch

Sporobolus virginicus, Sand couch

This rhizomatous, perennial grass species occurs widely from Australia and New Zealand to the Pacific Islands, West Indies, Africa, India, China and Indonesia; mostly inhabiting salt marshes and sand hills. Its long thin, paired, spine-tipped and wiry leaf-blades emerge in erect clusters from the underground rhizomes looking like individual plants from which the dense pale flower spikes emerge.

Right: The small pale flowers emerge when it is warm.

Far right: In time the spreading habit of the plant results in dense wiry clumps.

Identification: This prostrate or almost erect perennial grass grows up to 40cm/16in high. The underground parts consist of stout creeping horizontal stems with scales. It produces vegetative and flowering shoots that arise singly from the underground stems and branching above. The lower leaves remain undeveloped, arising as shining pale sheaths. The upper leaves are arranged in two opposite rows. They are finely grooved, with blades to 7cm/2¾in long, inrolled, and rigid. The plant's stems are circular in cross-section, smooth and branched. The seedhead, to 6cm/2¼in long, projects from or is enclosed in the uppermost leaf sheath. It is lead-coloured. Spikelets of flowers, to 2.5mm/¹⁄₁₆in long, appear in the warmer months in more temperate regions, but the plant is able to produce seed several times a year in tropical regions.

Distribution: Australia, New Zealand, Pacific Islands, West Indies, Africa, Asia.
Height and spread: 40cm/16in.
Habit and form: Perennial grass.
Leaf shape: Linear.
Pollinator: Wind.

OTHER SPECIES OF NOTE

Variable Flatsedge *Cyperus difformis*
Also known as small-flower umbrella plant, this is a fast-growing, erect, annual sedge, wide-spread across much of Australia and Oceani,a and a common weed of rice fields. It is well adapted to moist lowland soils or flooded areas. The small, rounded flowerheads appear near the top of the stems.

Spike Rush *Eleocharis equisetina*
Grown in parts of Asia for its edible corms and native down as far south as northeastern Australia in marshy land and the edges of seasonal swamps. The tube-shaped, leafless, brittle, sharply pointed, erect, green stems, have flowers in spikelets near their tops.

Kangaroo Grass *Themeda triandra* (syn. *Themeda australis*),
An easily recognized, tussock-forming grass, with unusual flower and seedheads, found in all warm and tropical regions of the Old World. Once the dominant grass in much of Australia, introduced livestock has reduced the populations.

Weeping Grass *Microlaena stipoides*
Arguably Australia's most important native grass, with a widespread distribution stretching beyond the continent, mostly in high rainfall areas. It has slender, weeping seedheads, and a variable, growth habit from prostrate to erect, according to its location.

Oryza australiensis

This species of rice is found in the tropical regions of northern Australia where it naturally inhabits undulating plains of *Eucalyptus* and grasslands or in box woodland; mostly in wet places such as swamps, the edges of freshwater lagoons, seasonally dry pools, alluvial streams, or behind river levees. The loose, open, wispy flowerheads, are initially pale green, turning a straw colour as the dry season progresses, yielding a small rice grain upon ripening.

Identification: A perennial, rhizomatous grass, to 2m/6½ft or more in height, which stands erect and is robust. The leaves are strap-shaped to linear, and flat. They have a papery quality and are grey-green or dark-green. The inflorescence is a panicle that is loose and open. The spikelets are pear-shaped 8mm/⅝in long and 2.5mm/¹⁄₁₀in wide, laterally compressed and three-flowered.

Right: The loose open flowerhead contains numerous rounded seeds that are similar to cultivated rice grains.

Distribution: North Australia.
Height and spread: 2m/78in.
Habit and form: Perennial grass.
Leaf shape: Linear.
Pollinator: Wind.

Below: The wispy flowerheads arre drooping and green when young.

LILIES, ANTHERIAS, ASPARAGES, AND ASPHODELS

Lilies (Liliaceae), asphodels (Asphodelaceae), antherias (Anthericaceae) and asparages (Asparagaceae)
were all formerly classed together and share many similarities. Most of them have extremely showy
flowers and they are well represented across the whole of Australasia and Oceania.

Fringe Lily

Thysanotus multiflorus

This very striking plant from the southern tip of western Australia is found in a range of mostly dry habitats from forest to coastal plain sands. It has a clump of grass-like leaves that are rarely noticed among other grasses until the delicate mauve flowers appear in summer. Each of the three petals has frilly edges and while the individual flowers only last a day, the plant continues to produce flowers over several months, making this one of the most noticeable flowers at this time.

Identification: A rhizomatous perennial with simple, naked stems. The leaves are linear, grass-like and expanded into papery, sheathing wings at the base. Each plant produces 3–30 linear to narrowly lanceolate leaves, 20–30cm/8–12in long, sometimes channelled, glabrous with margins entire. The scapes are erect, glabrous, 15–30cm/ 6–12in. The inflorescence is a solitary umbel containing 4–20 or more blue-violet flowers. The six perianth segments are 6–20mm/¼–¾in long, with outer segments linear to narrowly oblanceolate, to 2.5mm/⅒in wide, inner segments to 8mm/⅜in wide. Each has three stamens, with twisted filaments, and purple to yellow anthers.

Distribution: Western Australia.
Height and spread: 20–30cm/8–12in.
Habit and form: Rhizomatous perennial.
Leaf shape: Linear (grass-like).
Pollinated: Insect.

Poor Knights Lily

Xeronema callistemon

This unusual, but highly decorative, plant found only on inaccessible inland cliff areas of the Poor Knights Islands is situated off the northeast coast of New Zealand. It forms a clump of sword-shaped, green leaves and has unusual bottlebrush flower clusters that grow horizontally, like a giant, red toothbrush. The stunning red flowers emerge straight up from the stalk and have bright orange pollen. Another species (*Xeronema moorei*) is found in New Caledonia.

Identification: A herbaceous perennial resembling the *Asphodelus* species. The rhizomes are short and the roots fibrous. The basal leaves are narrow, erect to arching, to 1m x 5cm/39 x 2in, tips and margins thickened, carried in tight clumps, glabrous and leathery. The stem leaves are fewer and smaller. The flowering stem is held erect, to 90cm/3ft unbranched, bearing an erect or inclined terminal raceme. The racemes, to 30cm/1ft, are inclined almost horizontally; crowded with short-stalked, red flowers that are held in dense rows along the stem. The perianth segments are bright crimson to deep red, linear, erect. Each flower has six free tepals and six free stamens with persistent filaments. The fruit is purplish, with numerous black seeds.

Distribution: New Zealand (Poor Knights Islands).
Height and spread: 1m/39in.
Habit and form: Perennial herb.
Leaf shape: Linear.
Pollinated: Uncertain, insect or bird.

Perching Lily

Kowharawhara *Astelia solandri*

This grass-like plant, known locally as Kowharawhara, is found in the wet lowland forests of New Zealand, where it is usually epiphytic on tall trees but will also grow on the ground. The sweetly scented flowers appear in January and February on branched panicles and are followed about one year later by distinctive, translucent, green to yellowish fruits. Birds eat the fruit and disperse the seeds.

Distribution: New Zealand.
Height and spread: 1–2m/39–78in.
Habit and form: Herbaceous perennial (usually epiphytic).
Leaf shape: Linear.
Pollinated: Insect.

Identification: An evergreen perennial herb that is usually epiphytic. The rhizomes are short and thick. The leaves are linear, crowded at the base of the stem and 1–2m/39–78in long, to 3.5cm/1⅜in wide, with a spreading, recurved habit. They are glabrous above, three-veined, with a pronounced midrib and covered with chaffy or silky hairs or scales particularly beneath, sometimes so densely as to form a solid covering, amplexicaul. The panicles are few-branched and many-flowered, on stalks 30–100cm/12–39in long, held in leaf rosette, nodding in fruit. The flowers are 15mm/⅝in long, crowded with six lemon-yellow tepals. They can be thin-textured or fleshy, spreading or reflexed.

OTHER SPECIES OF NOTE

Christmas Bells *Blandfordia punicea*
Found in Tasmania, growing in sandy places and acidic moorland, often on wet sites. The coarse leaves are narrow with rough edges, and the tall flower stem is terminated by a beautiful cluster of bell-shaped, tubular flowers that taper to the base. They are scarlet outside and golden-yellow inside.

Common Fringe Lily *Thysanotus tuberosus*
The common fringe lily is found mostly in the eastern parts of mainland Australia, in a variety of situations, ranging from dry hillsides, heath and open forest to grasslands. The bright purple flowers each have three petals with frilly edges that are produced over a long season. The grass-like leaves die off at flowering time.

Spreading Flax Lily *Dianella revolute*
The spreading flax lily is found in New South Wales and Tasmania, on sandy soils near creeks on heaths and in sparse woodlands. It is a tufted plant with flax-like leaves, suckering to form clumps with bright blue flowers borne on branched stems and followed by bright blue fruits. Similar to *D. tasmanica* but favouring drier sites.

Vanilla Lily *Sowerbaea juncea*
Vanilla lily is a plant with soft, onion-like leaves and an erect flower stem that bears a dense cluster of more than 20 soft lilac flowers. Found on wet or waterlogged soils along the coast from Queensland to Victoria it was formerly plentiful and conspicuous in its spring-flowering season, but is now threatened by development.

Flax Lily

Dianella tasmanica

This evergreen perennial plant, found wild in the cool, moist forests of Tasmania and southeast Australia, has arching, thick, strap-like leaves. It bears tall spikes of clustered, nodding, beautiful, star-shaped, bright blue to purple flowers with prominent yellow anthers during spring and summer. These are followed by glossy, deep blue berries that hang for several weeks on delicate stalks.

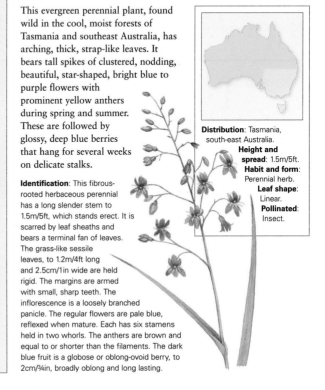

Distribution: Tasmania, south-east Australia.
Height and spread: 1.5m/5ft.
Habit and form: Perennial herb.
Leaf shape: Linear.
Pollinated: Insect.

Identification: This fibrous-rooted herbaceous perennial has a long slender stem to 1.5m/5ft, which stands erect. It is scarred by leaf sheaths and bears a terminal fan of leaves. The grass-like sessile leaves, to 1.2m/4ft long and 2.5cm/1in wide are held rigid. The margins are armed with small, sharp teeth. The inflorescence is a loosely branched panicle. The regular flowers are pale blue, reflexed when mature. Each has six stamens held in two whorls. The anthers are brown and equal to or shorter than the filaments. The dark blue fruit is a globose or oblong-ovoid berry, to 2cm/¾in, broadly oblong and long lasting.

ORCHIDS

The Orchidaceae, or orchid family, are terrestrial, epiphytic, or saprophytic herbs comprising one of the two largest families of flowering plants. They often display ingenious relationships with their pollinators. The epiphytic types all depend upon the support of another plant and are generally forest dwellers, many living their entire lives on another plant. They include some of the showiest of all flowers.

Banana Orchid

Tiger orchid, Cymbidium canaliculatum

This widespread species of orchid is found in the northern parts of western Australia, Northern Territory and north-eastern Queensland down to central New South Wales. It favours the dry inland areas where it shelters in the branch forks and hollow, broken off limbs of large trees in light woodland cover. The deep maroon flowers, have white marks on the lip, and are fragrant, appearing mostly during spring.

Identification: This epiphytic orchid has thick, white branching roots growing from a narrow pseudobulb. The leaves are persistent, glossy, glabrous, to 65cm/26in long, 4cm/1½in wide and stiff. They are olive green, linear, acute, and deeply grooved above. The scapes are arching, crowded, often with several per pseudobulb. Flowers to 4cm/1¾in diameter are variable. The sepals and petals are equal, lanceolate to elliptic, abruptly acute, green, brown or maroon beneath, olive green to pale bronze, streaked or spotted maroon or oxblood above. The lip is ivory, spotted purple or red, minutely pubescent within; midlobe ovate, acute. The callus is pale green or cream, pubescent. The lateral lobes are small, forward-pointing: column half length of lip, thick and incurved.

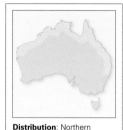

Distribution: Northern Australia.
Height and spread: 65cm/26in.
Habit and form: Epiphytic orchid.
Leaf shape: Linear.
Pollinated: Insect.

Golden Orchid

Dendrobium discolour

This large tropical epiphytic orchid species, found in Papua New Guinea and Queensland, Australia can commonly be seen perched high up in dead trees of lower altitude rainforests, open forests, mangroves and even on exposed rocky coasts and islets. It often forms extensive colonies, taking root wherever a pocket of soil is available, and its large racemes of flowers are particularly long lasting.

Identification: This erect epiphytic orchid has stems to 5m/16ft tall, to 5cm/2in wide. They are cylindrical, but swollen at the base and in the middle, green or brown in colour, sometimes purple-striped. The leaves, 5–20cm/2–8in long, 2.5–7.5cm/1–3in wide, are elliptical or ovate. The racemes, to 60cm/2ft, are arched and densely flowered. The flowers are cream, yellow, bronze or brown, often flushed with brown or purple. The lip is purple-veined, 2.5cm/1in, trilobed, lateral lobes erect, midlobe recurved, often twisted, ovate. The callus is white with five ridges on the basal half.

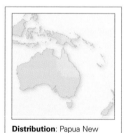

Distribution: Papua New Guinea, Australia (Queensland).
Height and spread: To 5m/16ft.
Habit and form: Erect, epiphytic orchid.
Leaf shape: Elliptical.
Pollinated: Insect.

Beard Orchid

Calochilus robertsonii

The beard orchid is aptly named, its lip much resembling a little beard, giving it a unique appearance. It is mostly found on poor soils and in full sun in dry forests, grassy forests, woodlands, heaths and dunes in Tasmania, western Australia, South Australia, Victoria, New South Wales, Queensland and in neighbouring New Zealand. Despite its widespread occurrence, it is never particularly common or abundant where it does occur. The reddish-brown flowers with darker stripes, appear in September to December, opening in succession, resulting in only one open flower per stem at a time.

Identification: A terrestrial orchid, 15–40cm/ 6–16in high when in flower. The solitary leaves are fleshy, linear to lanceolate, thick, forming a v-shape in cross-section, basal, alternate, channelled. Up to six flowers appear on a terminal raceme, each to 2.5cm/1in long, greenish-red with red stripes, appearing in October to December.

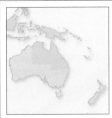

Distribution: Australia, New Zealand.
Height and spread: 15–40cm/6–16in.
Habit and form: Terrestrial orchid.
Leaf shape: Linear.
Pollinated: Wasp.

Left: The flowers open in succession with only one per plant at any one time.

OTHER ORCHIDS OF NOTE

Winika *Winika cunninghamii*
This is a sparsely flowered epiphytic orchid that grows mostly high up in the trees in almost full sun in the forests of New Zealand, being endemic to North, South, Stewart and Chatham Islands. It has a special significance to the Maori people as it grew on trees used to make the hull of a sacred war canoe, which they named Te Winika, after the orchid.

Daddy Longlegs
Caladenia filamentosa
Spider orchid
The daddy longlegs or spider orchid is an Australian native found from south-east Queensland to Tasmania, where it occurs in open forests and grassland. A terrestrial orchid, it has a single, narrow, hairy leaf and a basal inflorescence with one to four, greenish-white to reddish or crimson, hairy flowers, appearing from July to October.

Purple Enamel Orchid *Elythranthera brunonis*
Known as purple enamel orchid on account of its large flowers with glossy petals, looking somewhat look like porcelain, this orchid grows fairly commonly on sandy soils north of Perth and east toward Esperance. The solitary leaf appears at the base of the stem and the flowers appear in late summer and midwinter with one to three flowers on an erect scape.

Corybas rivularis

This tiny, but fascinating, orchid bears a solitary, heart-shaped, leaf which lies flat on the ground and produces a stalkless, single, large flower. Endemic to New Zealand throughout the North, South, Stewart, and Auckland Islands, it is mostly found growing within damp, wooded ravines from sea level to 600m/2,000ft. It bears small, pink flowers with long, filamentous tips to the petals and lateral sepals that give it a very characteristic appearance.

Distribution: New Zealand.
Height and spread: 6cm/2¼in.
Habit and form: Terrestrial orchid.
Leaf shape: Ovate.
Pollinated: Insect.

Identification: A terrestrial orchid to 6cm/2¼in high when in flower. The solitary leaf is up to 4cm/1½in long and 2cm/¾in broad. It is ovate-acuminate in shape, cordate at the base, light green above, silvery below, with conspicuous reddish veining. Leaves of young plants are reniform or broadly cordate, without the reddish veining. The usually solitary flower is more or less translucent, with dull red striae. The dorsal sepal is up to 4cm/1½in long. Lateral sepals are filiform, erect and very long, exceeding the flower by as much as 6cm/2¼in. The petals are similar, smaller, horizontal or deflexed. The very short column is hidden in the flower and has a large basal callus.

Peka-a-waka

Hanging tree orchid *Earina mucronata*

This robust epiphytic species is the most common of New Zealand's perching orchids. It is found on trees in many lowland forests, or in open bush beside tracks, where it grows in huge grassy-looking mats, covering well-lit branches and trunks. The flower stems carry many tiny, yellow-and-orange, sometimes slightly fragrant, flowers in drooping clusters between September and early February. These racemes often persist and flower again the following season.

Identification: A robust epiphytic or lithophytic orchid with creeping, branching fibrous rhizomes that form a thick, tangled mass attached to the tree bark. The stems, to 1m/39in long and marked with black spots, are pendulous. The leaves 5–15cm/2–6in long, to 6mm/¼in wide, are linear, grass-like, slender and pointed. The flower panicle, to 10cm/4in long, with several branches, appears in September to January, with many flowers. Racemes often persist into the following season and flower again. The flowers are slightly fragrant, creamy-yellow, less than 1cm/⅜in across, with oval petals and sepals. The labellum is orange, broad and lobed at its base and outer end.

Distribution: New Zealand.
Height and spread: 1m/39in.
Habit and form: Robust, epiphytic or lithophytic orchid.
Leaf shape: Linear.
Pollinated: Insect.

Left: The creeping fibrous rhizomes often form grassy mats of growth in lowland forests.

Below right: The yellow-and-orange flowers are often slightly fragrant.

Hooded Orchid

Pterostylis banksii

This small, widespread and variable species is common throughout New Zealand. It can be found in lowland to montane forests and forest margins as well as scrub. It is distinctive in having flowers equipped with a mobile lip, which is a pollination adaptation. The pollinating insect lands on the flower, and alights on the lip; its weight causes the lip to tip, thereby forcing the insect into a position where it pollinates the flower. It is one of the larger green-hooded orchids having green flowers marked with translucent, white stripes that appear from October until December.

Identification: A terrestrial deciduous orchid, to 35cm/14in tall, with subterranean, fibrous tubers. The stems are basally sheathed. Each has four to six leaves, to 20cm/8in long, in a basal rosette. They are linear, keeled beneath, pale green, with a paler midrib. The flowers are pale green with darker stripes. The petals and sepals are tipped orange-pink. The lip has a single red ridge above, and green margins. The dorsal sepal is incurved and arched, and has the petals pressed against it, forming a hood and concealing the column.

Distribution: New Zealand.
Height and spread: 35cm/14in.
Habit and form: Terrestrial orchid.
Leaf shape: Linear.
Pollinator: Insect.

Far left: The distinctive green, hooded flowers are borne singly on long stems.

Left: The flowers are equipped with a mobile lip that aids in insect pollination.

Varavara

Spathoglottis pacifica

This large terrestrial orchid with rhizomes and pseudobulbs is common along roadsides, forest margins, open forest and open areas, ranging from sea-level to 1,000m/3,250ft in its native Fiji, where it is also widely cultivated as a garden ornamental. Restricted to Fiji, Vanuatu, Wallis Islands and Samoa, the large, showy, pink or mauve flowers are borne profusely on many-flowered racemes, which arise from the base of the pseudobulbs, with flowers and fruit being visible on each plant throughout the year.

Identification: A fibrous-rooted terrestrial orchid, with rhizomes and broad, conical to ovoid, sheathed pseudobulbs. The stem is thin, erect and bears few leaves. The leaves are lanceolate and basally sheathing. The inflorescence is a many-flowered raceme arising from basal leaf axils. The many large flowers are showy, pink or mauve.

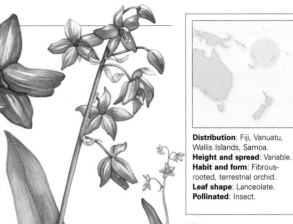

Distribution: Fiji, Vanuatu, Wallis Islands, Samoa.
Height and spread: Variable.
Habit and form: Fibrous-rooted, terrestrial orchid.
Leaf shape: Lanceolate.
Pollinated: Insect.

Top left: The showy flowers are large and pink.

Left: This large orchid is terrestrial and often seen by roadsides.

OTHER ORCHIDS OF NOTE

Common Onion Orchid *Microtis unifolia*
This is a variable plant with a single tubular leaf and flower stem. It has 5–40 green flowers emerging from the leaf about a third to half way up the stem. It occurs practically everywhere in New Zealand except for dark forests and is the country's most common orchid species to be seen flowering between November and January.

Dotted Sun Orchid *Thelymitra ixioides*
A relatively small terrestrial orchid species found in scrub and roadsides in scattered localities from the northwest of South Island, New Zealand. It has a single, wide, fleshy, deeply channelled leaf and up to 20 or more flowers, which are blue with darker spots that appear from October to December.

Cowslip Orchid *Caladenia flava*
This orchid has a wide distribution on sandy soils across much of Australia. The flowers appear between September and November. It is variable in flower colour, the yellow flowers sometimes having little or no red colouring, while others are quite streaked and spotted.

Tahitian Vanilla
Vanilla tahitiensis
Tahitian vanilla has large and attractive, cream-coloured flowers with a sweet scent. Its leaves are thick and leathery, and it is occasionally grown for its pods, which when dried, become an alternative source of the spice vanilla.

Nodding Greenhood

Pterostylis nutans

This terrestrial orchid, widespread in all states except western Australia and the Northern Territory, also occurs as a small, vagrant population on New Zealand's North Island. It can be found from sea level to almost 1,000m/3,300ft in light scrub and is a distinctive species because of its drooping, hooded flowers occurring singly during the winter and spring.

Identification: A deciduous orchid to 30cm/1ft tall with subterranean tubers. It has three to six ovate to oblong leaves held in a basal rosette to 3cm/1¼in long and 2cm/¾in wide. Each has one or two translucent, green striped flowers, sometimes tipped red, with the dorsal sepal incurved and arched, forming a hood that conceals the column. The lateral sepals loosely embrace the hood, and are fused into a lower lip. The lip has a mobile claw and often a basal appendage. It is sharply recurved, to 15mm/⅝in, green in colour with a central red-brown ridge.

Distribution: Australia, New Zealand.
Height and spread: 30cm/1ft.
Habit and form: Terrestrial orchid.
Leaf shape: Ovate to oblong.
Pollinated: Insect.

Right: The sepal and petals combine to form a hood.

Left: The plant is noticeable in winter and spring.

GLOSSARY

Annual a plant which completes its entire life-cycle within a year.

Anther the pollen-bearing portion of the stamen.

Areole elevation on a cactus stem, bearing a spine.

Axil the upper angle between an axis and any off-shoot or lateral organ arising from it, especially a leaf.

Axillary situated in, or arising from, or pertaining to an axil.

Basal leaf arising from the rootstock or a very short or buried stem.

Beak a long, pointed, horn-like projection; particularly applied to the terminal points of fruits and pistils.

Beaked furnished with a beak.

Beard (on flower) a tuft or zone of hair as on the falls of bearded irises.

Berry indehiscent (non-drying) fruit, one- to many-seeded; the product of a single pistil. Frequently misapplied to any pulpy or fleshy fruit regardless of its constitution.

Biennial lasting for two seasons from germination to death, generally blooming in the second season.

Boss-like (of the standard) Taking on the appearance of a boss (round metal stud in the centre of a shield or ornamental work).

Bract a modified protective leaf associated with the inflorescence (clothing the stalk and subtending the flowers), with buds and with newly emerging shoots.

Branched rootstock a branching underground stem.

Bromeliad a type of South American plant predominantly found growing on other plants but not parasitically.

Calcicole a plant dwelling on and favouring calcareous (lime-rich) soils.

Calcifuge a plant avoiding and damaged by calcareous soils.

Callus ridge (calli) superficial protuberances on the lip of many orchid flowers.

Capsule (of fruit) a dry (dehiscent) seed vessel.

Carpet-forming with a dense, ground-hugging habit; hence "carpet-like".

Cauline (of leaves) attached to or arising from the stem.

Chlorophyll green pigment that facilitates food production, is present in most plants.

Cleistogamous with self-pollination occurring in the closed flower.

Climbing habit any plant that climbs or has a tendency to do so, usually by means of various adaptations of stems, leaves or roots.

Clubbed spur a tubular or sac-like basal extension of a flower, generally projecting backward and containing nectar, gradually thickening upward from a slender base.

Clump-forming forming a tight mass of close-growing stems or leaves at or near ground level.

Column (of the flower) a feature of orchids, where the style and stamens are fused together in a single structure.

Composite (of flowers and leaves) a single leaf or petal divided in such a way as to resemble many.

Compound (of flowers and leaves) divided into two or more subsidiary parts.

Contractile roots roots which contract in length and pull parts of a plant further into the soil.

Convex petal with an outline or shape like that of the exterior of a sphere.

Cordate heart-shaped.

Cormous perennial a plant or stem base living for two or more years with a solid, swollen, subterranean, bulb-like stem.

Corolla a floral envelope composed of free or fused petals.

Corona a crown or cup-like appendage or ring of appendages.

Corymb an indeterminate flat-topped or convex inflorescence, where the outer flowers open first.

Creeping habit trailing on or under the

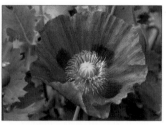

surface, and sometimes rooting.

Culms the stems of grasses.

Cupped (flowers) shaped like a cup.

Curving spur a tubular or sac-like basal extension of a flower, generally projecting backward and containing nectar, being curved in shape.

Cyathia flower form, shaped like a cup.

Cylindrical follicle cylindrical elongated fruit, virtually circular in cross-section.

Cyme (flowers) a more or less flat-topped and determinate flowerhead, with the central or terminal flower opening first.

Decumbent base (of the stem) lying horizontally along the ground but with the apex ascending and almost erect.

Decurrent where the base of a leaf extends down to the petiole (if any) and the stem.

Deeply cut petals or leaves with deeply incised lobes.

Deeply segmented petals or leaves that are sharply divided into several segments.

Deltoid an equilateral triangle attached by the broad end rather than the point; shaped like the Greek letter delta.

Dilated concavity dilating, broadened, expanded, in the manner of the outer surface of a sphere.

Dioecious with male and female flowers on different plants.

Disc floret part of the central flowerhead in the Asteraceae. Short tubular florets as opposed to the peripheral ray florets.

Dissected leaf shape cut in any way; a term applicable to leaf blades or other flattened organs that are incised.

Domed flowerhead Compound flowerhead arranged in a dome shape.

Drupe a one- to several-seeded fruit, contained within a soft, fleshy, pericarp, as in stone fruits.

Ellipsoid resembling an ellipse shape.
Epidermis the outer layer of plant tissue; skin.
Epiphytic growing on plants without being parasitic.
Ericaceous in broad terms, resembling *Erica* spp. In habit, plants preferring acidic soil conditions.
Evergreen plant with foliage that remains green for at least a year, through more than one growing season.

Farinose having a mealy, granular texture on the surface.
Filament stalk that bears the anther at its tips, together forming a stamen.
Floret a very small flower, generally part of a congested inflorescence.

Genus The first name of a plant described under the binomial system of botanical naming.
Glandular bearing glands, or hairs with gland-like prominence at the tip.
Glandular inflorescence a compound flowerhead with a glandular surface.
Glycoside A compound related to sugar that plays many important roles in living organisms, with numerous plant-produced glycosides used as medications.

Hastate arrow-shaped, triangular, with two equal and approximately triangular basal lobes, pointing laterally outward rather than toward the stalk.
Haustorium a sucker in parasitic plants that penetrates the host.
Hemi-parasite only parasitic for part of its life cycle; not entirely dependent upon the host for nutrition.
Hemispheric a half sphere shape.
Herb abbreviation for herbaceous. Not the culinary herb.
Herbaceous pertaining to herbs, i.e. lacking persistent aerial parts or lacking woody parts.
Herbaceous perennial herbaceous plant living for three or more years. Referred to as herb.
Hip the fleshy, developed floral cup and the enclosed seeds of a rose.
Hooded flowers one or more petals, fused and forming a hood over the sexual reproductive parts of the flower.
Hooked spurs a tubular or sac-like basal extension of a flower, generally projecting backwards and containing nectar; being hooked in shape.

Inflorescences the arrangement of flowers and their accessory parts in multiple heads, on a central axis or stem.

Keeled (leaves) a prominent ridge, like the keel of a boat, running longitudinally down the centre of the undersurface of a leaf.

Labellum a lip, especially the enlarged or otherwise distinctive third petal of an orchid.
Layering stems rooting on contact with the earth and forming colonies of cloned plants.
Leaf
 Lobed divided into (usually rounded) segments, lobes, separated from adjacent segments.
 Toothed possessing teeth, often qualified, as saw-toothed or bluntly toothed.
 Uneven margins with one margin exceeding the one opposite.
 Wavy margin having a wavy edge.
Leaf axil the point immediately above the point of leaf attachment, often containing a bud.
Leaf tip
 pointed ending in a distinct point.
 rounded with no visible point.
Leaflet units of a compound leaf.
Lenticel elliptical and raised cellular pore on the surface of bark or the surface tissue of fruit, through which gases can penetrate.

Liana a woody climbing vine.
Lignotuber a starchy swelling on underground stems or roots, often used to survive fire or browsing animals.
Lip petal, or part thereof, which is either modified or differentiated from the others, on which insects can alight.
Lithophytic growing on rocks or stony soil, deriving nourishment from the atmosphere rather than the soil.
Low-growing plants that do not reach any significant height; ground hugging.

Membranous capsule seedpod with thin walls.
Mesic a type of habitat with a moderate or well-balanced supply of moisture, e.g. a mesic forest.
Midrib the primary vein of a leaf or leaflet, usually running down its centre as a continuation of the leaf stem.
Monocarpic dying after flowering and bearing fruit only once.
Monopedal a stem or rhizome in which growth continues indefinitely from the apical or terminal bud, and generally exhibits no secondary branching.
Monoecious A plant with both male and female flowers/flower parts on the same plant (Syn. Hermaphrodite)
Morphologically pertaining to the study of the form of plants.
Mucilage viscous substance obtained from plant seeds exposed to water.

Nectary a gland, often in the form of a protuberance or depression, which secretes and sometimes absorbs nectar.
Node the point on a stem where one or more leaves, shoots, whorls, branches or flowers are attached.

Open habit growing loosely with space between the branches.

Panicle indeterminate branched

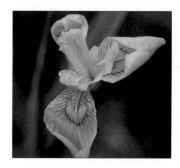

inflorescence, the branches generally resemble racemes or corymbs.

Pea-like flowers that are like those of the pea (*Psium* spp.)

Pendent hanging downward, more markedly than arching or nodding but not as a result of the weight of the part in question or the weakness of its attachment or support.

Pendent raceme raceme inflorescence with a pendent habit.

Pendulous branch branch with a pendent habit.

Perennial a plant lasting for three seasons or more.

Perfoliate a sessile leaf of which the basal lobes are united, the stem seems to pass through the blade.

Perianth the collective term for the floral envelopes, the corolla and calyx, especially when the two are not clearly differentiated.

Perianth tube the effect of fused petals resulting in a tubular flower shape

Petaloid sepal segment that encloses the flower when in bud that resembles a true petal.

Petaloid tepal tepal that resembles a petal.

Photosynthesis the synthesis of sugar and oxygen from carbon dioxide and water, carried out by all green plants.

Pinnate feather-like; an arrangement of more than three leaflets in two rows.

Pinnatifid pinnately cleft nearly to the midrib in broad divisions, but without separating into distinct leaflets or pinnae.

Pistil the female reproductive organs of a flower consisting of one or more carpel.

Pod appendage containing seeds:
Inflated pod fruits that are inflated and balloon like

Cylindrical pod elongated fruits, virtually circular in cross-section.
Flattened distinctly flattened along one plane.

Pinnatisect shape deeply and pinnately cut to, or near to, the midrib; the divisions, narrower than in pinnatifid, are not truly distinct segments.

Pouched bracts a modified protective leaf associated with the inflorescence and possessing a pouched shape.

Primary rays The outer petaloid rays, usually associated with a composite flower such as those in Asteraceae.

Procumbent trailing loosely or lying flat along the surface of the ground, without rooting.

Prostate lying flat on the ground.

Pseudobulb the water-storing thickened "bulb-like" stem found in many sympodial orchids.

Pseudostem not a true stem but made up of leaf sheaths.

Quadrangular stem four-angled, as in the stems of some *Passiflora* and succulent *Euphorbia* spp.

Raceme an indeterminate, un-branched and elongate inflorescence composed of flowers in stalks.

Ramicaul thin leaf stem usually associated with orchids.

Rambling habit an unruly spreading or partially climbing growth habit.

Ray floret a small flower with a tubular corolla and the limb expanded and flattened in a strap-like blade, usually occupying the outer rings of a capitulum (daisy flower).

Reflexed abruptly deflexed at more than a 90 degree angle.

Reniform kidney shaped.

Reniform scale kidney-shaped leaf scale.

Rhizome underground stem.

Rhizomatous producing or possessing rhizomes; rhizome-like.

Rhombic ovate oval to diamond-shaped; angularly oval, the base and apex forming acute angles.

Root sucker stem arising directly from the roots of a parent plant.

Rootstock the roots and stem base of a plant.

Rosette forming leaves arranged in a basal rosette or rosettes.

Runcinate a leaf, petal or petal-like structure, usually oblanceolate in outline and with sharp, prominent teeth or broad, incised lobes pointing backward toward the base, away from a generally acute apex, as in *Taraxacum* (dandelion).

Runner prostrate or recumbent stem, taking root and giving rise to a plantlet at its apex and sometimes at nodes.

Sagitate arrow- or spear-shaped, where the equal and approximately triangular basal lobes of leaves point downward or toward the stalk.

Saprophytic deriving its nutrition from dissolved or decayed organic matter.

Scalloped rounded in outline in the manner of a scallop shell.

Scape an erect, leafless stalk, supporting an inflorescence or flower.

Scrambling habit not strictly climbing but vigorous with a tendency to grow over surrounding vegetation.

Seed ripened, fertilized ovule; an embryonic plant.

Seedhead describes the fruiting bodies of a plant.

Seedpod describes the enclosing body around developing seeds.

Semipendent flowerhead only partially pendent in nature.

Sepal modified leaf-like structure, enclosing and protecting the inner floral parts prior to its opening.

Serrated toothed margin, with teeth resembling those of a saw.

Shrub a loose descriptive term for a woody plant which produces multiple stems, shoots or branches from its base, but does not have a single trunk.

Shrublet a small shrub or a dwarf, woody-based and closely branched plant.

Sickle-shaped crescent-shaped.

Single flowers with one set of petals.

Solitary flowers borne singly (i.e. not in an inflorescence).

Spadix (Spadisces pl.) a fleshy, columnar flower, often enclosed in a spathe and typical of plants in the family Araceae.

Spathe a conspicuous leaf or bract subtending a spadix or other inflorescence.

Spathulate spatula-shaped, essentially oblong, but attenuated at the base and rounded at the apex.

Species the second name used to identify a plant with particular characteristics under the binomial system of botanical naming.

Spike an indeterminate inflorescence bearing sessile flowers on an un-branched axis.

Sprawling spreading in an untidy manner.

Spreading stems or branches extending horizontally outward.

Spur a tubular or sac-like basal extension of the flower, projecting backward and often containing nectar.

Stalked a general term for the stem-like support of any organ.

Stamen the male floral organ, bearing an anther, generally on a filament, and producing pollen.

Staminode sterile stamen or stamen-like structure, often rudimentary or modified, sometimes petal-like and frequently antherless.

Standard (1) in pea flowers, the large, uppermost petal; (2) an erect or ascending unit of the inner whorl of an *Iris* flower.

Stigma the end of a pistil that receives the pollen and normally differs in texture from the rest of the style.

Stipule leafy or bract-like appendage at the base of a leaf stem, usually occurring in pairs and soon shed.

Stolon a prostrate or recumbent stem, taking root and giving rise to plantlets at its apex and sometimes at nodes.

Stoloniferous possessing stolons.

Straggly untidy, rather stretched in appearance.

Subopposite more or less opposite, but with one leaf or leaflet of a pair slightly above or below its partner.

Suborbicular more or less circular.

Subshrub a perennial with a woody base and soft shoots.

Subspecies a species further divided into distinct populations.

Succulent thickly cellular and fleshy.

Suckering shrub shrub with a tendency to produce root suckers as part of its normal growth.

Tendril a modified branch, leaf or axis, filiform, scandent, and capable of attaching itself to a support either by twining or adhesion.

Tepal perianth segment that cannot be defined as either petal or sepal.

Terminal at the tip or apex of a stem.

Terrestrial living on land; growing in the soil.

Tessellated chequered, composed of small squares as in the flower of *Fritillaria meleagris* or the intersecting vein pattern of some leaves.

Thorn sharp hard outgrowth from the stem wood.

Throat the central opening of tubular or bell-shaped flowers.

Toothed margin leaf edge possessing teeth, often qualified, as saw-toothed or bluntly toothed.

Trailing prostrate but not rooting.

Trefoil leaf divided into three leaflets.

Trifoliate three-leaved.

Tuberoid in the manner of a tuber.

Tuberous bearing tubers, tuberous-bearing tubers, or resembling a tuber.

Tulip-shaped similar shape to the flower of a tulip.

Tussock-forming forming a tight mass of close growing stems or leaves at or near ground level, with grass-like leaves.

Twining vine a climbing plant that twines around a support.

Two-lipped (flower) with two lips.

Umbellate pattern resembling an umbel.

Umbel a flat-topped inflorescence like a corymb, but with all the flowered

pedicels (rays) arising from the same point at the apex of the main axis.

Unisexual a flower that is either male or female.

Upright a flowerhead that is held vertically or nearly so.

Upright habit Growth that is vertical or nearly so.

Variety a distinct population that does not merit the status of species or sub-species in its own right.

Vein/veinlets an externally visible strand of vascular tissue.

Vestigial a leaf that was functional and fully developed in ancestral forms, but is now smaller and less developed.

Vine a general term to describe some climbing plants.

Whorl when three or more organs are arranged in a circle at one node or, loosely, around the same axis.

Woody ligneous (containing the plant protein lignin), approaching the nature of wood.

Acknowledgements

With thanks to Spillifords Wildlife Garden, Devon, and The English Cottage Garden Nursery, Kent.

The publishers would like to thank the following people and picture libraries for permission to use their images:

Alamy page 141, 148, 152, 168.

Ardea page 26br, page 27tc, 29,

DW Stock Picture Library page 164, 171, 192, 202b, 212, 218b, 226.

Garden Matters page 56, 96, 170, 172.

Natural Science Image Library page 203, 208, 218t, 223, 230.

OSF page 166, 236.

Peter Barrett page 23bc.

Photos Horticultural page 26bl, 72, 115, 123, 149, 176, 180, 196, 202t, 206.

INDEX

BW|11|14